ANTIQUITIES Trade or Betrayed
Legal, ethical and conservation issues

ANTIQUITIES Trade or Betrayed
Legal, ethical and conservation issues

Edited by
Kathryn Walker Tubb

**An Archetype publication
in conjunction with
UKIC Archaeology Section
1995**

Archetype Publications Ltd,
31-34 Gordon Square, London WC1H 0PY

© 1995 Archetype Publications
An Archetype publication
in conjunction with
UKIC Archaeology Section
ISBN 1 87313 2 70 0

Cover design: Mic Claridge
Cover Illustration: Gold pin with acorn tassles, 6th C BC.
Property of the Republic of Turkey, reproduced here with permission,
© 1993, all rights reserved.

Contents

Personal Profiles

Peter Addyman
Director of York Archaeological Trust since its inception in 1972 and currently President of the Council for British Archaeology, Peter Addyman is a mediaeval archaeologist with interests in Anglo Saxon settlements, urban archaeology, and in the popular presentation of the results of archaeology.

Patrick Boylan
Patrick Boylan was a museum and arts director for 22 years and is now Professor and Head of Department of Arts Policy and Management, City University, London. He chaired both the Institutional Ethics Working Party of the Museums Association, 1975–1977, and the Ethics Committee of the International council of Museums (ICOM), 1974–1988, in which capacity he was the principal drafter and editor of ICOM's *Code of Professional Ethics*, adopted in 1986. He is currently Vice-President of ICOM, and represented ICOM at the UKIC Archaeology Section conference on *Conservation and the Antiquities Trade*.

John Browning
John Browning was educated at St Edward's School, Oxford, and Shuttleworth Agricultural College in Bedfordshire. He has been farming in Suffolk since 1970 and since 1976 he has owned a 56 acre Scheduled Ancient Monument Site at Icklingham. Though having no archaeological or legal background he has acted as voluntary custodian of 'his' site and secured successful prosecutions against 13 metal-detecting thieves. Since 1982 he has been vigorously pursuing the repatriation of the 'Icklingham Bronzes' from New York and has ensured their ultimate return to the British Museum. His motivation is Government apathy, the absence and/or inadequacy of both domestic and international law, criminal activity, and the reputations 'enjoyed' by too many international dealers, collectors and auction houses. He is now proud to have been dubbed the Rambo of British Archaeology!

John Butler
Detective Chief Inspector Butler was the administrative head responsible for policy and deployment of the Arts and Antiques Squad at New Scotland Yard.

Peter Cannon-Brookes
Dr Peter Cannon-Brookes, a scientist (Cambridge) turned art historian (Courtauld Institute), was Keeper of Art in Birmingham (1965–78) and at the

National Museum of Wales (1978–86) before joining Stipple Database Services as its Museum Services Director. He founded the international journal *Museum Management and Curatorship* in 1981 and remains its Joint Editor. Since 1990, he has been a partner of Cannon-Brookes Associates, international museum consultants, and is deeply involved in all aspects of museum activities, not least conservation and security.

Christopher Chippindale
Christopher Chippindale is Senior Assistant Curator, responsible for world prehistory at Cambridge University Museum of Archaeology and Anthropology. His current fieldwork, in Aboriginal Australia, forcefully reminds him of the interest of the dispossessed in these matters. He has just published a detailed paper, 'Material and intellectual consequences of esteem for Cycladic figures', in the *American Journal of Archaeology* for October 1993.

Etienne Clément
Etienne Clément qualified as a lawyer at the Université Libre de Bruxelles in 1978 and then specialized in International Law in 1980. He has been working for UNESCO since 1984, first in Africa (Senegal) from 1984 to 1987, then at the Division of Cultural Heritage, International Standards Section, from 1987. In this present position he is in charge of the UNESCO programmes for the implementation of the *Convention for the Protection of Cultural Property in the Event of Armed Conflict* (The Hague Convention) 1954 and the *Convention on the Means of Prohibiting and Preventing the Illicit Import, Export and Transfer of Ownership of Cultural Property* 1970.

He has published several articles for *Museum* and *Museum International* (from 1987 to now), has contributed to a guide on the implementation of UNESCO operational projects (1988) and has been one of the drafters of the United Nations model treaty for the prevention of crimes against the cultural property of peoples (1990).

Brian Cook
Brian Cook was the Keeper of the Greek and Roman Antiquities Department, British Museum from 1976 until his retirement in February 1993. From 1960 to 1976, he worked in various different capacities in the same department. He worked in the Department of Greek and Roman Art in the Metropolitan Museum of Art, New York, from 1956 to 1958. He has published extensively on Greek, Etruscan and Roman antiquities.

James Ede
James Ede is the Managing Director of Charles Ede Ltd, a long established firm of antiquity dealers in London and is the Chairman of the International Association of Dealers in Ancient Art.

Jerome M. Eisenberg
Jerome Eisenberg is the Editor-in-Chief of *Minerva* and Director of both the Royal-Athena Galleries, New York and Seaby Gallery, London. Ancient art has been his speciality for 34 years. Since 1968 Dr Eisenberg has

concentrated on expertise in ancient art and in the detection of ancient art forgeries. In 1969 and 1970 he lectured on Ancient Art Forgery at New York University. In 1970 he presented his first paper at the annual meeting of the Archaeological Institute of America on *The Non-Aesthetics of the Forger: Stylistic Criteria in Art Forgery*. His *Forgery and Fraud in Ancient Art* (Mss) is the largest single work ever written on ancient art forgery. A major purchase by the J Paul Getty Museum enabled him to devote two years to full-time research in this challenging field. He has appeared as an Expert in the Courts and has conducted appraisals for the Internal Revenue Service, the J Paul Getty Museum and many other prominent institutions.

Ricardo J. Elia

Ricardo J. Elia is Director of the Office of Public Archaeology at Boston University and Adjunct Associate Professor in the University's Department of Archaeology. He directs a Master's program in Archaeological Heritage Management and teaches archaeological ethics and cultural resource management. He is currently chair of the Archaeological Heritage Management Committee of US/ICOMOS and chair of the UNIDROIT Subcommittee of the Archaeological Institute of America.

Richard Ellis

Detective Sergeant Ellis was educated at Oundle School, Northamptonshire. He joined the Metropolitan Police in 1968 serving in uniform in Westminster. He did a short tour on Royalty Protection before joining the Criminal Investigation Department. Most of his service involved investigating virtually every type of crime in east and north-east London. He became involved in investigating international art theft at Hampstead in 1986. He transferred to the International and Organised Crime Branch at New Scotland Yard in 1988. He founded the Art Squad in 1989 and since then has been investigating art, antiques and antiquities theft internationally and has spoken at a number of conferences concerning art theft.

Patty Gerstenblith

Patty Gerstenblith has been Associate Professor of Law at DePaul University College of Law since 1989. She was awarded a J.D. *cum laude* from Northwestern University School of Law in 1983. Between 1977 and 1980 she was a lecturer in Archaeology at Hebrew Union College-Jewish Institute of Religion in Cincinnati following the award of a PhD from Harvard University. She also holds an AB *cum laude* in Classical and Near Eastern Archaeology with honours. She has published extensively in both fields.

David Gill

David Gill is Lecturer in Ancient History and Curator of the Wellcome Museum at the University College of Swansea. He is currently engaged in fieldwork in the Argolid, Greece. He has just published a detailed paper 'Material and intellectual consequences of esteem for Cycladic figures', in the *American Journal of Archaeology* for October 1993 with Christopher Chippindale.

Rosamond Hanworth

Rosamond Hanworth is a Fellow of the Society of Antiquaries. She holds an extra-mural Diploma from the Institute of Archaeology. She is a former President of the Surrey Archaeological Society. Publications include the results of two major excavations in Surrey and an illustrated general history, *The Heritage of North Cyprus*.

Lawrence M. Kaye

Lawrence M. Kaye graduated in 1970 from St John's University School of Law in New York City, where he was Editor-in-Chief of the St John's Law Review. He has practiced law in New York since that time, specializing, among other things, in international and art litigation. Mr Kaye is presently a member of the law firm of Herrick, Feinstein, where he heads the firm's Art and International Law Practice Groups. Mr Kaye has been involved in a number of important cultural property litigations. Among other notable cases, he was one of the lead attorneys in the landmark case of *Federal Republic of Germany v. Elicofen*, in which two early masterpieces by Albrecht Dürer stolen at the end of the Second World War were successfully recovered and returned to the Weimar Art Museum. Mr Kaye has also served as counsel to the Republic of Turkey in cultural property matters. Most recently, he brought to a close the Republic's six year litigation against the Metropolitan Museum of Art to recover the fabled Lydian Hoard antiquities. In September, the case was settled, with more than 360 artifacts dating to the 6th century BC being returned to Turkey. Mr Kaye has also served as an Adviser to the Republic of Turkey's delegations to the Third and Fourth Sessions of the UNIDROIT Committee of Governmental Experts on the international protection of cultural property considering adoption of a draft Convention on stolen and illegally exported cultural objects. Mr Kaye has lectured extensively on international art litigation and the repatriation of cultural property.

Eamonn Kelly

Eamonn Kelly was awarded a BA Archaeology/Geography (Hons) in 1971 and an MA Archaeology (Hons) in 1973. He joined the permanent staff of the National Museum of Ireland in 1975 and was promoted to Acting Keeper of Irish Antiquities in 1992. The Irish Antiquities Division is the largest division in the National Museum of Ireland. For many years, he was responsible for Late Bronze Age and Early Iron Age collections. He conducted excavations extensively on sites ranging in date from Mesolithic to modern times. He directed underwater excavations and collaborated in the joint National Museum of Ireland/Cornell University Crannog Archaeology Project in the course of which he investigated the royal crannog of Cro Inis, Lough Ennell, Co. Westmeath. He has had curatorial responsibilities for many exhibitions mounted in Ireland as well as those shown in Canada, USA, Sweden, Denmark, Germany, Holland, France and Australia. In 1986, he was assigned the responsibility to assist the State's efforts to combat illegal excavations and/or export of Irish antiquities. He is a

Founder member of the Irish Underwater Archaeological Research Team and current committee member. He is the author of *Early Celtic Art in Ireland* and has published extensively.

Maria Papageorge Kouroupas

Ms Papageorge Kouroupas is the Executeve Director of the Cultural Property Advisory Committee, which advises the President with respect to US implementation of the 1970 UNESCO Convention on illicit trade in cultural property.The Committee's work and the executive responsibilities of the President in connection with the 1970 Convention are administered by the United States Information Agency.

Prior to joining USIA in 1984, Ms Papageorge Kouroupas administered the international programs of the American Association of Museums. There she developed 'International Partnerships Among Museums', the only museum-to-museum institutional linkage program of its kind. While at the AAM she was the columnist for the international section of *Museum News*. She has written several articles relating to US participation in the 1970 Convention.

Ms Papageorge Kouroupas holds a Master's Degree in history and education.

Carla T. Main

Carla T. Main graduated from the Washington University School of Law in St Louis, in 1987, after earning her Bachelor's Degree at New York University, with a concentration in art history. She joined the firm of Strook & Strook & Lavan in New York as an associate in 1987, where she worked on a variety of commercial litigations, as well as *pro bono* constitutional matters. In 1991, Mrs Main joined the firm of Herrick, Feinstein as a litigation associate. She has participated in the firm's varied commercial litigation practice, and puts her art history background to use through a specialization in art related cases. In particular, Mrs Main has assisted in the firm's representation of the Republic of Turkey in its lawsuit against the Metropolitan Museum of Art, which was recently settled with the return of the Lydian Hoard antiquities to the Republic. Mrs Main has also worked closely with Lawrence M. Kaye, the head of the firm's Art and International Law Practice Groups, on a number of cultural matters, and participated with Mr Kaye in an international conference at the British Academy on the subject of stemming the tide of illicit trade in antiquities.

Carolyn Morrison

Carolyn Morrison first embarked on an academic career, as Official Fellow and Lecturer, Girton College, Cambridge 1969-1973 (Modern History and Political Studies). She then joined the Civil Service in 1972 firstly as Lecturer and Course Director, European Training, Civil Service College. In this post she established Anglo-French, Anglo-German and Anglo-Dutch exchange programmes and introduced the mechanics of the EEC to the British Civil Service. Then followed various postings in central government,

including a Private Secretary post in the Lord President's Office, supervising the operation of the Lib-Lab Pact, 1976–7. In 1983 she was seconded to the Office of Arts and Libraries to lead a small Bill team to deal with the problems caused by the proposed abolition of the GLC and Metropolitan County Councils for various performing arts and museum bodies. After implementation of the successor arrangements, she headed the newly created Movable Heritage Unit, subsequently the Cultural Property Unit (including Export Licensing) in the Department of National Heritage.

Geraldine Norman
Geraldine Norman is Art Market Correspondent of the *Independent* and the author of many articles on smuggled antiquities, notably the Sevso treasure, the Lydian hoard and other Turkish treasures in America, and the acquisitions of the Getty Museum.

Patrick O'Keefe
Patrick O'Keefe is an International Legal Consultant in Cultural and Natural Heritage Law in Paris. He worked on the 1992 revision of the European Convention on Protection of the Archaeological Heritage and is now consultant to the Committee on Movable Heritage and Decorative Complexes, Council of Europe. He is conducting a study for the Canadian Heritage Information Network on automatic international electronic access to cultural heritage databases. As Chairman of the Cultural Heritage Law Committee of the International Law Association, he is deeply involved in preparing a draft Convention on Protection of the Underwater Cultural Heritage. He is co-author of the five volume series *Law and Cultural Heritage* being published by Butterworths as well as some 100 articles etc. on the same general topic.

Norman Palmer
Norman Palmer is Rowe & Maw Professor of Commercial Law at University College London and a practising Barrister at 2 Field Court, Greys Inn, London where he is Head of Chambers. He has formerly held Chairs at the Universities of Reading, Essex and Southampton. He is the author of *Bailment* (2nd Ed 1991) and co-editor of *Emdens Construction Law* (1990) and *Crossley Vains on Personal Property* (5th Ed 1973). He is a contributor to the 4th edition *Halbury's Laws of England* and specialises in the fields of personal property and cultural property law. He is a Director of the International Cultural Property Society and the Editor of the *International Journal of Cultural Property*.

Lyndel V. Prott
Lyndel V. Prott is the Chief of the International Standards Section of the Division of Physical Heritage of UNESCO.

She took up this position in September 1990. She was Professor of Cultural Heritage Law at the University of Sydney where she taught from 1973-1990. She is a specialist in International Law, Comparative Law and Jurisprudence and holds degrees from the Universities of Sydney, Brus-

sels and Tübingen. She is the author or co-author of more than 120 publications (articles and books) in these three areas. *Law and the Cultural Heritage* (co-author P. J. O'Keefe), a series of five volumes of which two (concerning the law of archaeology and the movement of cultural objects) have already been published, examines the development of national and international law for the protection of the cultural heritage.

At UNESCO she is responsible for the implementation of the *Convention for the Protection of Cultural Property in the Event of Armed Conflict* (The Hague Convention) 1954, the *Convention on the Means of Prohibiting and Preventing the Illicit Import, Export and Transfer of Ownership of Cultural Property* 1970 and the ten UNESCO Recommendations concerning the protection of the heritage, assistance to States wishing to prepare or modify legislation in this respect, and meetings of the Intergovernmental Committee for Promoting the Return of Cultural Property to its Countries of Origin or its Restitution in case of Illicit Appropriation.

Colin Renfrew
Colin Renfrew, Baron Renfrew of Kaimsthorn, 1991 (Life Peer), has been Disney Professor of Archaeology, University of Cambridge, since 1981 and Master of Jesus College since 1986. He became a Fellow of the British Academy in 1980. He was Professor of Archaeology at Southampton University from 1972–1981. Before that, he was a Lecturer and then Reader in Archaeology at the University of Sheffield. He served as a member of the Ancient Monuments Board for England from 1974–1984 and has been a member of the Ancient Monuments Advisory Committee since 1984. He has also served as a member of the Royal Commission on Historical Monuments (England) from 1977–1987, on the Historic Buildings and Monuments Commission for England from 1984–1986 and on the UK National Commission for UNESCO, again from 1984–1986. He has been a Trustee of the British Museum since 1991. He has written and published extensively. His books include *Before Civilisation*, *Approaches to Social Archaeology*, *Archaeology and Language* and *The Cycladic Spirit*.

Catherine Sease
Catherine Sease has degrees in anthropology from Bryn Mawr College and in archaeological conservation from the Institute of Archaeology, University of London. She has extensive experience as a field conservator on archaeological excavations in Britain, the Mediterranean, and the Middle East and is the author of *A Conservation Manual for the Field Archaeologist*. In 1979, she joined the staff of the Metropolitan Museum of Art where she was the conservator in charge of the installation of the Michael C. Rockefeller Wing of Primitive Art. After working for two years as a private conservator, she became conservator at the Field Museum of Natural History in 1986 where she is currently Head of the Division of Conservation. In 1994, she was awarded the Rome Prize.

Harvey Sheldon

Harvey Sheldon was Field Officer for Southwark and Lambeth Archaeological Excavation Committee from 1972–1991 and was Head of the Department of Greater London Archaeology at the Museum of London between 1975 and 1991. He has also been the Chairman of Rescue, Trust for British Archaeology and is currently President of the London and Middlesex Archaeological Society. He also teaches extensively for the Extra-mural Department of Birkbeck College, University of London. He has also published extensively particularly on archaeological rescue work in Greater London.

Alison Sheridan

Alison Sheridan joined the National Museums of Scotland on a permanent basis in October 1987, as the Assistant Keeper of Archaeology. She has also had some Head of Department responsibilities since January 1992 when the Keeper took up his additional role as Head of Exhibitions for the new Museum of Scotland. She is currently engaged in work on developing the Archaeology brief for the Museum of Scotland. Other current research includes a project on Scottish prehistoric jet and jet-like artefacts.

Danaë Thimme

Danaë Thimme is the Associate Director of Conservation, Indiana University Art Museum. She is also a Research Associate, Program in Classical Archaeology, Indiana University. She has worked as conservator for the National Archaeological Museum, Athens, and the Corinth and Agora Museums during the 60's. She has also worked extensively in the field, predominantly on excavations in Greece. She was awarded a diploma in archaeological conservation with distinction in 1964 from the Institute of Archaeology, London.

Kathryn Walker Tubb

Kathryn Tubb was awarded a BA Biology in 1970 and a diploma in archaeological conservation with distinction in 1975 from the Institute of Archaeology, London. Since 1977 she has been responsible for practical training in archaeological conservation at the Institute of Archaeology. She has also worked extensively as a field conservator in the Near East. Her current research interest involves the technological examination, development and execution of conservation techniques on a cache of approximately 26 lime plaster statues dating to the Pre-Pottery Neolithic B period, 6700 BC, from 'Ain Ghazal, Jordan. She has been a committee member of the Archaeology Section of the United Kingdom Institute for Conservation and is an ordinary member of the Executive Committee of UKIC. She is also a member of the UKIC Code of Ethics Advisory Group.

Preface

Some readers may know something of the inception of this volume, others may know nothing. Some may feel that the title is inflammatory and provocative. Certainly, if it encourages people to pick up the book and begin to browse through its pages, it will have served its purpose.

The rights and wrongs of trading in antiquities are highly contentious. Proponents and opponents are often deeply entrenched in starkly contrasting positions holding convictions which are passionately believed and defended. The sole point of commonality may be the sharing of an abiding interest in cultural heritage.

This collection of papers is wide-ranging and diverse. The authors' backgrounds and experiences are equally diverse. The opinions expressed are their own. The differences of opinion are legion and no consensus view emerges which might serve as a pointer to the solution to the problems which bedevil trading in antiquities. The editor and publisher have been committed to preserving the individuality of the voices of the authors so that the diversity can be savoured by the reader in its rich, sometimes harmonious, occasionally cacophonous, blend.

That debate is essential among those concerned with the preservation of cultural heritage is abundantly clear since it is impossible to escape an awareness of the fact that cultural heritage is under increasing threat from many sources—including war, modern development, agricultural pressure, vandalism and treasure hunting. Art theft is clearly contributing and, worryingly, is obviously a booming business. The burgeoning retrieval industry supported by insurers attests to this. No one advocates involvement with stolen works of art. Unfortunately, antiquities which have been clandestinely excavated cannot easily be accorded such protection because of the difficulties in establishing not only that they have been stolen but from whom.

Indeed, there is a vociferous and strong lobby of dealers and collectors arguing for a relaxation of those laws and conventions which already exist to protect the archaeological heritage, maintaining that such instruments are manifestly failing to achieve their intended aim. It is further stated that a free, self-regulating market will ensure increased protection of the archaeological heritage. It is not surprising that the archaeological and museum communities are not entirely sanguine about this proposition.

Interestingly, the increasing, and arguably, huge volume of traffic in stolen works of fine art and antiques has not led to calls for the repeal of legislation against theft despite the fact that such legislation could be deemed to be failing in its intended aim also.

Clearly, where there is a chance for an owner to prove title to an artifact because it has been photographed, catalogued and inventoried in some way, there is no argument for relaxation of the laws against theft despite increaed incidence and low recovery rates. Only when antiquities are concerned is it strenuously suggested and argued that the legislation should be abolished since it does not work.

The prospect of self-regulation in a free market is not reassuring for a general public and academic community increasingly cognizant of the destruction of the archaeological record and aware that the loss is irretrievable.

The much maligned 1970 *UNESCO Convention on the means of prohibiting and preventing the illicit import, export and transfer of ownership of cultural property* has, at the very least, served to focus light on the issues and influence museum collecting policies.

Certainly, all those concerned with the preservation and care of antiquities need to be informed. Although there is disagreement, greater understanding of the arguments and issues which are involved can only be helpful. Debate, too, must be fostered.

Acknowledgements

That this book exists at all is due to the stalwart support of the United Kingdom Institute for Conservation Archaeology Section, whose Committee, chaired by Robert White, decided to organise a conference entitled *Conservation and the Antiquities Trade* from which this book is largely derived. Helena Jaeschke, co-organiser of the conference, must be commended for her unstinting efforts throughout the project.

UKIC Archaeology Section, the Editor and Archetype Publishers are also extremely grateful for the generosity of the British Academy; the Council for British Archaeology; Herrick, Feinstein; the Samuel H. Kress Foundation; the Leventis Foundation; and Thesaurus Information.

Gratitude is also due to the Republic of Turkey for kind permission to use the photograph of the Lydian Hoard gold pin on the cover of this volume.

Kathryn Walker Tubb
October 1995

Introduction

Professor Lord Renfrew of Kaimsthorn

This volume, and the conference from which it is largely derived, is timely because the looting of archaeological sites has become what is probably the world's most serious threat to our archaeological heritage. By looting I mean the excavation of sites without the maintenance of a competent record for publication, and with the subsequent sale of the finds for commercial gain. As such, looting stands alongside urban development with intense exploitation of land as a third main cause of damage. This matters deeply, because the archaeological record is the principal, and sometimes the only, source of information on the early human past. It is a crucial part of our shared cultural heritage. However, the archaeological record is in no sense a sustainable resource because what is destroyed is irreplaceable. These issues are obviously central to the papers in this book which record such catastrophes as the looting of the Icklingham hoard in Britain, and other cases in Britain and overseas where the archaeological record has been irreparably destroyed. Such objects may exist in a private collection or some museum, but the vital information that those objects could impart about our shared past is something we shall never know.

We need to distinguish clearly between looted goods from illicit excavations and stolen goods. When speaking of stolen goods, the implication is usually that the goods are already known and documented, which is often the case. The Kanakariá mosaics in Cyprus fall into this category. In the case of stolen goods, the legal position is often more clear cut since there is usually no doubt about the identity of the original owner (although establishing title may be a different matter). In such cases at least some aspects of the situation are clear. Evidently, the Kanakariá mosaics or the Shiva Nataraja of the Chola period, briefly 'owned by', or rather, in the collection of, the late Mr Norton Simon, are cases in point and there are may other famous *causes célèbres* of this type. Obviously, such stolen works, ie, works where the original title is clear, (albeit not necessarily from a legal standpoint), should be returned. Most dealers are agreed on this and will generally return goods known to be stolen from a museum or a private collection. But, of course, there is a statute of limitations in many countries and the relevant term is sometimes astonishingly short, as is the case in Japan, for instance, where it is just a few years. Surely, one international objective that might be worked towards should be increasing the time span

of the statute of limitations and achieving an international agreement on an appropriate period. The Getty Museum, admirable in this respect as in many others, circulates details of objects to all likely national governments before making a purchase, and will not acquire objects known to be stolen. An example of this is the 'Getty *kouros*', a previously unknown *kouros*, unnamed before its purchase. Indeed, there are few public institutions which would follow a different policy.

Looting means clandestine excavation and that is another matter for, by its very nature, it is secretive. The finds are not publicly known and cannot be documented in an effective manner. If a museum such as the Metropolitan Museum of Art buys an Attic red-figure vase, for instance, the *Death of Sarpedon* painted by Euphronios, it can claim that, far from being looted recently from Etruria, as some have supposed, it came from an ancient shoe box curated by an antiques dealer in the Lebanon. Where looted goods are concerned, or goods whose source from looting may be inferred, the worlds' museums are often less than scrupulous and this is one of the central issues which needs to be addressed. The British Museum and the University Museum in Philadelphia are at one end of the spectrum, and, in general, do not buy goods without sound provenance. The Metropolitan Museum of Art is an example at the other end of the scale where purchases of antiquities are seemingly made even if their derivation from looting seems probable. In these matters, as in others, the position of the J. Paul Getty Museum, because of its great purchasing power, is influential. However, its position seems still to be a shade equivocal. If the Getty Museum buys a hitherto unknown *kouros*, it can hope that it does not derive from looting, but how does it know? Indeed, how else could it arrive on the market, unless the recently acquired *kouros* is a fake as some have argued? Let us be clear, as archaeologists and lovers of the past, that it is the looting, the ripping of finds from a context which gives objects meaning, that is the true disaster. Whether they remain in the country of origin or not is a secondary issue. I have Greek colleagues, for instance, who I know do feel that as long as a looted, that is to say a clandestinely excavated object from Greece, remains in Greece, then less harm is done. In my view, however, it is much worse that illicitly excavated objects should be dug up at all, than that they should leave the country.

It is obvious that there are powerful voices levelled against policies of conservation in these areas. But, as conservators, archaeologists, art historians and art lovers, it is essential that we reach a consensus on several key problems if our views are to prevail. This is one of the important roles of this publication and of the conference which preceded it. There are still many unresolved questions between those who are seriously and altruistically, or fairly altruistically, involved in these issues, and those who, at any rate, derive no direct commercial benefit from them. These controversies and points of discussion do need to be resolved before rushing out to change national and international legislation. Of course, there are may changes that are desirable and many that are, indeed, projected, and these

are addressed in greater detail in this volume. One such issue in need of resolution, which is of interest in the United Kingdom, is metal detecting outside the context of a controlled excavation. Is this activity, of necessity, always bad? Many archaeologists, except perhaps for strand looping and going along the seashore and riverbanks, would answer in the affirmative. However, others now feel that, in this country, metal detecting is, perhaps regrettably, here to stay, and that what is needed is a partnership, (for instance with the National Council for Metal Detectors), between themselves and metal detectorists so that all finds can be recorded.

The Council for British Archaeology, the Society of Antiquaries and the Museums Association have recently agreed on a long term policy for recording antiquities as they are discovered in this country which would explicitly permit the sale of those finds not pre-empted and paid for in full by a museum. That piece of legislation, if it ever becomes such, would probably meet with the approval of the metal detecting fraternity. However, even in this case, there are issues and value judgments that have to be made that seem unlikely to be agreed within the archaeological profession, never mind universally.

A much more powerful force is the London art market, or perhaps, more specifically, the antiquities market with which conflict has at times arisen. This applies mainly in international terms. In a letter to *The Times* by David Possnet and others in October 1992, it is estimated that imports of fine art and antiques in 1991 exceeded £1.45 billion, a golden egg indeed. But surely, we do not need to seek to kill the goose even if we might diminish the force feeding. One point that must be made is that art and antiquities are spoken of in one breath. I, personally, see nothing wrong with, and much in favour of, a highly thriving market in London for art including Old Masters. It is a great pity when that mild twinge of sadness which may be felt if Canova's *Three Graces* is sold overseas, is confused with the real tragedy that happens when the London art market acts as the home for the sale of something like the Sevso Treasure. This treasure of Roman silver objects was put on the market by Sotheby's, although they then withdrew it, and contested a law case in New York. It was rather clearly looted either from Croatia or from Hungary or maybe elsewhere in Eastern Europe. Originally, there was a claim by the Lebanese government, not surprisingly, since, at one point, the treasure had associated with it an export license from Lebanon which may have given some grounds for feeling that it was of Lebanese origin.

This is the sort of area where the London art market or antiquities market needs cleaning up. I think that it is a disgrace that Sotheby's should sell looted antiquities in this way, even if acting within the British law, and I am not in any way suggesting at any point (I do not want to be sued for libel or slander) that Sotheby's have infringed United Kingdom law. Rather, the situation may be a reflection on United Kingdom law and on the failure of the United Kingdom to subscribe to the 1970 UNESCO convention. This clearly is something that requires a great deal more respect than it has been

accorded by some nations including our own. In my view, the way that progress has to be made is to seek a distinction between a very appropriate pride in displaying Old Masters and works of art on the one hand, and an element of shame on the other when works of art, which are antiquities, are displayed despite being clearly looted or lacking proper provenance. Until a position is achieved where it is as shameful in the public eye to display looted antiquities as it is to walk down the street wearing a fur coat from some protected species I do not think we shall be able to do our work. Clearly, it must be stressed that debate is necessary here.

Where the line is drawn in all this is not an easy matter . It is certainly easier for archaeologists who have no commercial stake in these matters, to take a much more purist line than it is for dealers who earn their daily bread in this way sometimes, usually, licitly, some occasionally illicitly even in terms of existing laws. Powerful forces are ranged against a change in attitude. The publication of *Control of National Treasures* (a report of the Select Committee of the House of Lords on the European Community) concerning the European Community Directive on the return of national treasures and regulation on the export of antiquities and works of art was deficient in that no evidence was taken from the archaeological world: none from the British Museum, the Council for British Archaeology nor from the Museums Association. There was evidence only from the Department of National Heritage, from Sotheby's, and from the Treasury's solicitor. That was going to be the position with the Commons Select Committee also until those archaeological bodies got in on the act. I am not criticising here the Department of National Heritage, or at any rate, not strongly. It was the job of the archaeological interests to be involved. It must be said to those of us who are archaeologists, that, hitherto, we have not been very effective at intervening publicly in these matters and it is indeed our responsibility to do so.

My final observation is this; that moralities are changing. I was shocked when I saw the exhibition of the antiquities acquired by Leon Levy and Shelby White in the Metropolitan Museum of Art a few years ago. Here on show in a public place were objects some of which had clearly been looted. Lifesize Roman statues even had labels indicating the site in Turkey from which they had come and from which they had, therefore, been looted in recent years. I subsequently met Mr and Mrs Levy who are very charming people. Their good intentions and their love, in a general sense, of the past is in no doubt. However, it is our job to try to show such people the monstrosity of what they are doing without making it a cause for undue censoriousness. Moralities are changing, times are changing. The British Museum would not today acquire the Elgin marbles and it is not particularly fruitful to pin labels around the necks of those who have committed these faults. Rather it is useful to try and persuade them to do otherwise in the future. No respectable museum should show such stuff. That is why I have chosen the Metropolitan Museum for my principal contumely on this occasion. Sadly, the United Kingdom has hosted its own fiasco of that kind.

The collection of Mr George Ortiz was recently shown in the Royal Academy. It is our job collectively to deprecate this, and to ensure that Mr Ortiz goes away a little more ashamed than when he came since he is doing the past great damage by financing the large scale looting which is the ultimate source of so much of what he is able to exhibit. It is vital that the current situation is analysed to clarify some elements which are problematical, to establish what is not acceptable, and then try to give clear guidelines to society.

Legal Issues

Recovering stolen art

Norman Palmer

1. The scope of the problem

Readers of the Raffles stories by E W Hornung[1] may recall an exploit involving a Velasquez picture. The *Infanta Maria Teresa* had been stolen from Sir Bernard Debenham by his son, 'one of the most complete blackguards about town'. Young Debenham sold the *Infanta* to an 'ill-bred and ill-informed' Queensland senator named Craggs. The senator, knowing that Sir Bernard could not afford the scandal of a legal action, jeeringly dismissed his offer to buy back the picture.[2] Sir Bernard's agent, a solicitor of questionable antecedents named Bennett Addenbrooke, thereupon engaged A. J. Raffles, the amateur cracksman and legendary spin bowler, to recover it discreetly. Retrieval had to be made from the senator's hotel bedroom on the eve of his return to Australia. The task of diverting Craggs in the sitting room while Raffles performed acts of self-help in the bedroom fell to one Bunny, Raffles's accomplice: an amiable ditherer, to whom the episode offered fertile opportunities for cardiac and other arrest.[3]

This story, 'Nine Points of the Law,' falls some way short of typifying the modern trade in stolen art. In fact, its archaic flavour is the sole reason for its citation. It conjures up a vanished (perhaps mythical) world of privately-educated burglars, devious solicitors and unpolished Australian politicians; a world where the gentleman thief was a familiar social phenomenon and his crimes (however dastardly) were underpinned by a code.[4]

We live in a very different world. It is a world in which art theft is commoner, less discriminate, more violent, less scrupulous, better organised, better paid and more closely linked to organised crime as a whole. If some newspaper reports are to be believed, practices like designer theft (the commissioned theft of selected works of art) and artnapping (the capture of works of art for future ransom) have emerged in consequence.[5] Even allowing for embroidery, there is scant cause to be complacent. Consider some of the facts.

(a) Not even our most venerable institutions are immune from this plague. The British Museum was the victim of a serious theft last year,[6] though the objects were recovered. In February of this year it was the turn of The National Museum of Norway, which suffered

the theft of Edvard Munch's *The Scream* in a thirty second episode vividly recorded by security cameras.[7] In April, an Iron Age sword was stolen from the Peterborough Museum; officials confessed that their security measures were less exacting than those of the British Museum, which had hoped to acquire the sword.[8] In the United States, one museum (the Isabella Stewart Gardner Museum) was so thoroughly ransacked four years ago that it was forced to close (though not permanently). Nothing appears safe, even if nailed or concreted down.

(b) Art thieves are becoming more versatile and less fastidious. Their depredations extend beyond museums, galleries, stately homes and bank vaults (the obvious victims) to private houses, churches, cathedrals, cemeteries, London clubs, Inns of Court, universities and schools. They encompass almost anything of 'heritage' value: a saint's jaw-bone stolen from the church of St Anthony at Padua,[9] stuffed rats stolen from the Gloucester Waterways Museum.[10] To an extent, the catholic quality of modern theft seems to be inspired by an increasing demand for privately owned 'heritage items', or instant personal history.[11]

(c) Accompanying this lack of fastidiousness may be an increasing violence towards the objects themselves. Aside from the obvious risks attendant on unsatisfied ransom demands, evidence suggests that handlers are partitioning larger or more readily identifiable pictures so as to create several marketable works from a single unmarketable parent.[12] There is a chilling prospect that such mutilated fragments as Holbein's *Squirrel without a Lady or a Starling*, or Van Gogh's *Iris*, may one day appear on the market.

(d) Art theft is said to be closely linked to organised crime as a whole. At the upper end of the scale, works of art are allegedly used both to provide initial collateral for narcotics transactions and to launder the profits. Of illicit world markets, that in stolen art is said to be second in turnover only to drug-trafficking.[13]

(e) Security problems have almost undoubtedly played a part in reducing public access to certain works of art. One reason why direct public contact with the owners of a conditionally exempt work of art is said to be virtually impossible,[14] is the fear that such works (held on private premises) will attract criminals. On the other hand, it is arguable that some works would not be on loan to public collections at all were their owners not motivated by a conviction that the objects are safer there than on private premises, or at least by a desire to deflect the costs of security and insurance.

(f) The general problem is not confined to England. It has been fanned by the political upheaval in Eastern Europe, bringing in its

wake an epidemic of theft as well as destruction: icons from Romanian churches, countless objects from Bosnia. In Russia in 1990 burglaries were reported by 1441 churches, 18 museums and numerous private collections;[15] virtually all the stolen objects went abroad. Massive removals from Kuwaiti museums followed the Iraqi invasion in 1991.[16]

(g) In Europe, reliable statistics are elusive, but the estimates are disturbing. In January 1994, the Arts and Antiques Unit at New Scotland Yard estimated that the annual value of stolen art stands at around £300 million nationally and £3 billion across the world.[17] The Unit pointed out that the rate of theft is increasing at around 10 per cent annually, that for every reported crime there is one unreported crime, and that average general crime detection rates do not exceed 9 per cent in the United Kingdom.[18] In December 1993 the *Sunday Times* reported that in 1992 insurers paid out £500 million in respect of insured works of art alone; many works are uninsured or inadequately insured.[19] In 1992, the Paris based Yearbook of Stolen Works of Art reckoned that art worth £600 million had been stolen in Europe over the past five years.[20] Given that anything between 50 per cent and 75 per cent of European Community art trade is handled through London[21] these figures are less than reassuring. Even worse, Geraldine Norman has claimed that some 80 per cent of antiquities which enter the London market have been illegally excavated and smuggled.[22] This figure has been contested,[23] but given that some 85 per cent to 90 per cent of European Community antiquities business is estimated to run through London,[24] a lower figure would scarcely be more reassuring. The spate of thefts has spawned a thriving retrieval industry, mainly in the form of databases: Trace Magazine, the Yearbook of Stolen Art, State of the Art, the International Foundation for Art Research and its associate body the International Art Loss Register, Thesaurus, etc.[25] There is a Council for the Prevention of Art Theft, founded 'To promote crime prevention in the fields of art, antiques, antiquities and architecture'.[26]

And yet some things are unchanged. Virtuoso art theft, attended by the almost ritual embarrassment of museum and gallery officials, is a recurrent twentieth century entertainment: the *Mona Lisa* in 1911, the *Duke of Wellington* in 1961.[27] Volumes have been written on the subject, many purportedly autobiographical.[28] The ingenuity of the art thief continues to enthral, and some modern episodes have a Hornungian flavour: for example, the theft of the Renoir *Vase of Flowers* from Wildenstein's gallery in London, evidently by means of a fishing rod deployed from the street.[29] After every significant theft (particularly where the work is too well-known to be resaleable) the media teem with conjecture about the motive.[30]

Clearly, the public are no less fascinated by tales of purloined art than in Hornung's day, and rather more perturbed.[31] The violence, frequency and sometimes pointlessness of such activity serve only to heighten public concern.

In the light of that concern, it seems important to examine the ways in which United Kingdom law is responding to the challenges of art theft and to ask whether it is serving its constituents. Some of the legal issues which arise from this modern epidemic and the measures United Kingdom law is taking to combat them shall be identified.

2. Limits on the inquiry

So far as possible, the discussion will be limited to theft in its literal sense: that is, the taking of cultural objects from an owner's possession without the owner's consent, and with the intention of depriving the owner of them permanently. The owner may be a private person, or a commercial entity, or a public museum, or a church, or a local authority or a sovereign State. The object may be taken from a building during a break-in, purloined from a public gallery by a dishonest curator, amputated by ram-raiders from its mounting in a public monument, or clandestinely excavated by 'nighthawks' on publicly or privately owned land.[32]

Other forms of activity are often colloquially termed theft by those aggrieved by them, or are (perhaps extravagantly) classed as its moral or legal equivalent. An example in the first category is the unauthorised commercial reproduction of an artist's work, as alleged in the long-running dispute over the Henry Moore Trust;[33] or the sale of a bequeathed painting by an institution contrary to the inferrable wishes of its donor.[34] An example in the second category is the unlawful export of an object by its owner without necessary authority. While theft and illegal export can of course co-exist, and are treated collectively by the recent Regulations drafted in response to the EC Directive on Removal of Cultural Property,[35] unlawful export can raise quite different issues from those which arise from simple theft. The owner is normally the wrongdoer and not the victim, the claimant state was not normally the owner before the wrong was committed. Identifying the difference between theft and illegal export has been one of the most important contributions of United States authors on this subject,[36] influencing both case-law[37] and at least one international instrument.[38] An example which perhaps falls in both categories is the overseas purchase of objects of art or antiquity from officials of an occupying authority.[39] These wider forms of alleged misappropriation raise fascinating questions but they must be set on one side in this paper.

In what follows, 'art' is interpreted widely, to include all objects of substantial artistic or historical significance: artefacts of antiquarian interest as well as modern 'flat' art. Confessedly, this is to skate over the problem, perhaps even to emasculate the inquiry. Definition is one of the thorniest issues in this area and perhaps the greatest single impediment to effective

international agreement.[40] Even so, the author plans to make it a matter of assumption: to take cultural significance for granted. The reader is invited to imagine that the subject of the ensuing discussion is a stolen Cézanne or an illegally excavated Bronze Age torc: a work of unimpeachable aesthetic quality and undeniable significance to the history of human expression. Part of the theme here is that, if the law cannot devise effective safeguards for works of that character, what hope is there for the necessary protection of lesser items?

3. The positive signals

A superficial glance at modern events would suggest that, in the case of major objects at least, there are grounds for believing that art theft is being valiantly, even effectively combated.

3.1 Forensic successes. One positive sign is the outcome of modern international litigation in the field. There are several recent cases, in England and elsewhere, where a court has ordered the return of demonstrably-stolen works of art to a dispossessed owner, be that owner a sovereign State, a Church, a public institution or an individual. Perhaps the most important (and morally least ambiguous) is *Autocephalous Greek Orthodox Church of Cyprus* v. *Goldberg*[41] where, in an action before the courts of Indiana, the Church succeeded in its claim to the mosaics of the Panagia Kanakariá against Peg Goldberg, a dealer who had bought them (allegedly in good faith) in the free port area of Geneva airport. An English judgment presumably encouraging to the advocates of restitution is *Bumper Development Corpn Ltd* v. *Commissioner of Police of the Metropolis and others.*[42] There a bronze Nataraja representing the Hindu God Siva and proved to be the Pathur Nataraja, unearthed at Pathur village in Tamil Nadu, India, by a labourer in 1976 near the site of a ruined 12th century Temple, and later sold under a false provenance to a Canadian oil company by a London dealer in 1982, was successfully claimed by the Temple itself, which was held to be a juristic entity recognisable by the English courts. The idol was in due course returned to India. A significant American decision where a museum triumphed over a later good faith purchaser is *Guggenheim* v. *Lubell*,[43] a dispute over Chagall's *Merchant of the Beasts*. The New York court's ruling that it is the date of the claimant's demand for the return of goods and the defendant's refusal to return them that triggers the limitation period offers further encouragement to the proponents of restitution.

While reluctant to turn swallows into summers, or geese into swans, one might infer that litigation works—at least where it is relentlessly pursued and where the object is precious enough to

justify the investment. It is notable that in neither *Goldberg* nor *Bumper* was recovery assisted by any international convention.

3.2 Agreed recovery. In addition to these forensic victories, there are many cases where legal claims are settled out of court, or where agreement is otherwise reached, on terms that the object returns to its dispossessed owner. Of their nature, such cases rarely attract public notice, but sometimes the outstanding nature of the object brings it into relief. The Wildenstein Renoir, for example, was retrieved from Japan in 1992 after the insurers took action under their subrogation rights.[44] Recovery was assisted by the fact that someone unwittingly took it for appraisal to the Wildenstein Gallery in Tokyo.[45] The Samuhel manuscript (or 'Quedlingburg Bible') donated by Queen Mathilde to the cathedral at Quedlingburg in Saxony-Anhalt around the year 1000, and liberated by Jack Meador, a Texan army officer, in 1945, finally returned to Germany in 1990. The Federal Ministry of Internal Affairs and the Cultural Foundation of German States paid $3 million to the Meador's heirs.[46] In January 1994, it was announced that the Michael Ward Gallery was to hand over to the Society for the Preservation of the Greek Heritage a collection of some 50 buttons, beads, rings and seals looted from a 3500 year old tomb in the Peloponnese and previously offered for sale in New York at $1.5 million.[47] Last year, a Swiss museum paid a relatively modest sum to recover a plaque which had been stolen from it several decades earlier, which had resurfaced at auction.[48] Such cases are numerous.

Many consensual returns are without admission of any wrong by the party making restitution. They may be accompanied by co-operative agreements. Sometimes the buyer's agreement to return a work to its dispossessed owner is matched by the owner's agreement to loan it to the buyer. In October 1993 the Metropolitan Museum of Art in New York agreed to return to Turkey the Lydian hoard: a collection of over 300 ancient silver vessels and utensils, allegedly plundered in digs at burial mounds in the Uşak region in 1966, and sold to the Metropolitan by dealers in Switzerland and New York. The decision came after legal proceedings instituted by Turkey in the United States District Court had dragged on for some seven years. The compromise was reached as the action approached discovery stage, at which point[49] the Museum's 'own records suggest that some museum staff during the 1960s were likely aware, even as they acquired these objects, that their provenance was controversial'.[50] As part of the settlement, the Museum and the Turkish Government are reported to have agreed to co-operate on future excavations and exhibitions. One commentator[51] has stigmatised the benefit to the Museum as nothing more

than a sop for losing what never belonged to it in the first place.[52] There are interesting echoes of this criticism in the debate on the compensation[53] provisions of the recent EC Directive.

3.3 Codes of practice. Another positive signal is the emergence of professional codes of practice. The contractual acceptance of voluntary professional standards regulating transactions in art and antiquities can be witnessed among two principal groups, dealers and museums.

3.3.1 Dealers
There are several codes currently in force.

By Article 12.1 of the *Rules of the International Association of Dealers in Ancient Art* [54] members of the Association undertake 'to the best of their ability to make their purchases in good faith'.[55] By Article 12.3 they undertake 'not to purchase or sell objects until they have established to the best of their ability that such objects were not stolen from excavations, architectural monuments, public institutions or private property'.[56]

The IADAA Code is not the first such initiative. As long ago as 1984, representatives of British auctioneers and dealers signed a *Code of Practice for the Control of International Trading in Works of Art*, which provided *inter alia* [57] that 'Members of the UK fine art and antiques trade undertake, to the best of their ability, not to import, export or transfer the ownership of such objects where they have reasonable cause to believe (a) (that) the seller has not established good title to the object under the laws of the UK, ie whether it has been stolen or otherwise illicitly handled or acquired, and (b) that an imported object has been acquired in or exported from its country of export in violation of that country's laws.' Signatories also undertake[58] that, if they come into possession of any article which can be shown beyond reasonable doubt to have been illegally exported from its country of export, they will take reasonable steps to co-operate in the return of the object to that country, subject to three conditions: (i) the country of export must have sought the return of the object within a reasonable period, (ii) where the code has been unintentionally breached satisfactory reimbursement should be agreed between the parties, and (iii) the duty to make restitution applies only where the trader is legally free to do so.

Clause 1 of the *Antique Dealers Association Code* is more starkly phrased. Members undertake 'to use their best endeavours to ascertain that no piece sold has been acquired in any illegal or illicit way'. The London and Provincial Antique Dealers Association (LAPADA) Code says nothing specifically on stolen or illegally-exported or illegally-excavated objects. Members of the Society of London Art Dealers subscribe to the 1984 Code.

3.3.2 *Museums*

Adherence to the *Museums Association Code of Practice for Museum Authorities* [59] is a condition of a museum's registration by the Museums and Galleries Commission. Registration brings substantial benefits and the exercise has been adjudged a success. Under cl 4.5 of the Code, a museum:

'shall not acquire, whether by gift, purchase, gift, bequest or exchange, any work of art or object unless the governing body or responsible officer as appropriate is satisfied that the museum can acquire a valid title... and that in particular it has not been acquired in, or exported from, its country of origin (and/or any intermediate country in which it may have been legally owned) in violation of that country's laws.'

Clause 4.5 largely conforms with cl 3.2 of the *Code of the International Council of Museums* (ICOM), adopted at Buenos Aires in 1986.[60]

Some museum officials are optimistic that the Code will enhance acquisition standards and cause the questionable practice of acquiring objects without a provenance to be discarded. In an Introduction to the Ashmolean Museum Supplement section on 'Recent Acquisitions of Greek and Etruscan Antiquities 1981 – 1990,' Michael Vickers, in reference to the lack of provenance of many of the objects, has written:[61]

'It is unlikely there will be another Museum Report quite like this one from the Ashmolean. In 1992, the Museum registered with the Museums and Galleries Commission, and as a consequence of this our acquisitions policy is now in line with that laid down by the Museums Association Code of Practice for Museum Authorities. This is no bad thing, especially in the light of the sleaziness and corruption which has recently come to characterise some aspects of commercial dealing in antiquities, activities for which serious scholars can only be the fall guys.'

3.4 Professional co-operation. Professional vigilance is responsible for many recoveries. It was through the intervention of Dr Marion True at the Getty Museum that the Autocephalous Greek Orthodox Church located the mosaics of the Panagia Kanakariá. It was also through the Getty that the Kingdom of Spain was able to identify the current holders of the Goya *Marquesa de Santa Cruz*, alleged to have been illegally exported through the use of forged export documents.[62] A later example is the reporting to the police by Sotheby's[63] of the arrival at their front office of two portraits, stolen from Lincoln's Inn[64] in September 1990. The pictures were brought to Sotheby's in a bin-liner by a man claiming

to have bought them at Bermondsey market for £145. They are currently in police custody.[65]

Such vigilance reflects, of course, a healthy self-interest. No self-respecting institution (whether museum, dealer or auction house) will risk strict liability in conversion to the owner, or strict liability under section 12 Sale of Goods Act 1979 to a later buyer, by dealing in stolen property. Less scrupulous bodies may, of course, favour a more risk-specific approach. They find a ready accomplice in the law of market overt.[66]

3.5 The retrieval industry. The proliferation of practical prevention and retrieval methods has made a valuable contribution to the suppression of art theft. *Trace Magazine* claims responsibility for the recovery of over £25 million worth of insured objects.[67] The value of objects logged on the database of the International Art and Antiques Loss Register stands at over £300 million, of which £29 million was logged over the preceding eighteen months.[68] In the three years since its institution, the Register has been instrumental in the recovery of property worth over £14 million.[69] Leading professional associations, such as the Society of London Art Dealers, are among its shareholders. Its existence has led to suggestions that the question whether a buyer acted in good faith or with reasonable diligence for the purposes of the various compensation provisions should depend (perhaps exclusively) on whether that buyer consulted an appropriate register of stolen art.[70]

3.6 The EC Directive. There is now a positive initiative on this subject from Europe. Wide concern was felt that the dawn of the Single Market and the attendant disappearance of border controls on the movement of goods and personal baggage within the community would encourage the illegal removal of national treasures, making it simpler to smuggle them from one member State to another.[71] The Community's response is a Council *Directive*[72] *on the Return of Cultural Objects Unlawfully Removed from the Territory of a Member State*[73] and a Council *Regulation on the Export of Cultural Goods.*[74]

The statutory instrument which implements the Directive in the United Kingdom came into force on March 2nd 1994.[75] Its central provision is Regulation 6(1), which grants to every member State a right of action to recover certain defined cultural objects which have been unlawfully removed from its territory, provided that removal has not become lawful from the national territory of the member State at the time the proceedings are initiated.[76] To fall within the Directive, the object must simultaneously constitute (i) national treasures of artistic, historic or archaeological value under national legislation in the context of Article 36 of the Treaty

of Rome[77] and (ii) a cultural object within one of the categories specified in the Schedule to the Directive.[78] The obligation to return is confined to objects unlawfully removed from the territory of a member State on or after January 1st 1993.[79]

The right of action itself is against the possessor or, failing him, the holder of the object.[80] However, the Regulations impose obligations of assistance on the Secretary of State for National Heritage. The procedure required to activate the right of action is closely defined. The normal triggering mechanism is an application by a member State, specifying the object.[81] The document initiating the proceedings must be accompanied by (i) a document describing the object covered by the request and stating that it is a cultural object[82] and (ii) a declaration by the competent authorities of the member State that the object has been unlawfully removed from its territory.[83] In order to place the Secretary of State under any duty at this stage, the application must also include all information needed to facilitate the search and, in particular, information with reference to the actual or presumed location of the object.[84] If these requirements are satisfied, the Secretary of State is thereupon obliged to seek the object,[85] to take steps to identify any possessor or holder,[86] to notify the member State if the object has been found in the United Kingdom (whether as the result of a search under para 3(1) or not) and there are reasonable grounds for believing that it has been unlawfully removed from the territory of that State,[87] to take steps to enable the competent authorities of the member State to check that the object is a cultural object,[88] to take any necessary measures, in cooperation with the member State, for the physical preservation of an object which appears as the result of such a check to be a cultural object,[89] and to prevent, by necessary interim measures, any action to evade the return procedures set out in the Regulations.[90] The last three duties are subject to para 3(5), whereby the member State has two months in which to check that the object in question is covered by the Regulations; failing such check by the requesting member State within the time limit, the Secretary of State ceases to be under any duty to preserve the object or to perform these other duties.

The member State will also lose its right of action if (a) it fails to commence proceedings within a year of becoming aware of the location of the object and the identity of its possessor or holder,[91] or (b) it fails in any event (that is, irrespective of such knowledge) to commence proceedings within 30 years of the unlawful removal[92] (or within 75 years in the case of objects from public collections or certain ecclesiastical goods).[93] But if the relevant periods are complied with, and the court finds the object (i) to be the cultural object covered by the request[94] and (ii) to have been removed unlawfully from the national territory of the member

State,[95] the court shall order the return of the object.[96]

Regulation 4 empowers the court to make orders ancillary to the foregoing obligations. Not the least controversial part of the 1994 Regulations is Regulation 5, which confers powers of entry and search: an almost unprecedented event in a piece of subordinate legislation. [97]

3.7 The UNIDROIT proposals. In September/October 1993 the third and last session of government representatives and delegates of international organisations met in Rome and prepared a revised version of the draft *UNIDROIT Convention on the International Return of Stolen or Illegally Exported Cultural Property*. This version will be submitted to a diplomatic conference in 1994 which may formulate a final draft to be opened for signature by the participating States.[98]

Articles 3 and 4 of this instrument deal with stolen objects. Art 3(1) states flatly that the possessor of a cultural object which has been stolen shall return it; for this purpose unlawful excavation or unlawful retention following lawful excavation counts as theft.[99] The right of action can be exercised by individuals and is not limited to States.

Time limits for claims are currently undecided, but there is likely to be a one-to-three year limit from the date of the claimant's actual or constructive knowledge of the location of the object and the identity of its possessor, a cut-off 30 or 50 year limit from the time of the theft irrespective of knowledge, and a special 75 year limit from the time of theft for objects belonging to the public collection of a contracting State.

By article 4(1), however, a possessor who is required to return the stolen object, but who (i) neither knew nor ought reasonably to have known that the object was stolen, and (ii) can prove the exercise of due dligence when acquiring the object, is entitled to be paid fair and reasonable compensation by the claimant. In determining whether the possessor exercised due diligence, regard must be had to the circumstances of the acquisition, including the character of the parties, the price paid, whether the possessor consulted any reasonably accessible register of stolen cultural objects, and any other relevant information and documentation which the possessor could reasonably have obtained.[100]

4. The negative signals

There is, however, a negative side to the modern picture, which calls into question many of the foregoing causes for optimism. If we rub hard at some of these initiatives, some of the shine comes off.

4.1 Common law and domestic legislation. Not even the most partisan observer could claim that English law unequivocally promotes the prevention of art theft. The laws which conduce to the protection of cultural property in England are, for the most part, permissive and general. Leaving aside the 1994 Regulations,[101] we have very few rules of statute or common law specifically designed for this task. The absence of special provision can be beneficial but it can also be pernicious.

Consider, first, our domestic protection of indigenous cultural objects. It has been said[102] that England has the worst antiquities laws in the world. Although harsh,[103] this criticism is not without substance. The Crown's acquisition of discovered antiquities through the doctrine of[104] treasure trove is a mediaeval lottery, and will remain so until reforms comparable to those prescribed in the Earl of Perth's Treasure Bill 1994 are enacted.[105]

An antiquity which fails to qualify as treasure trove is normally private property. Its preservation is therefore at the mercy of the private law owner: occupier, finder, finder's employer, as the case may be.[106] The owner is, in turn, at the mercy of the thief and of any later innocent purchaser, at home or abroad. If the thief knows his business, the object will be spirited to London or the continent. If to London, there may follow the surreal charade of a sale in market overt, or even worse, the irrefutable allegation of one. The effects of this doctrine need not be dwelt on.[107] Though nominally committed to the principle of *nemo dat quod non habet* (nobody can give a title which he/she does not have), English law permits a sale in market overt to extinguish ownership in favour of a good faith buyer.[108] In so doing, it sanctions a preposterous loophole, feared by private owners and opposed by the reputable market (who are themselves increasingly the direct victims of theft). It is gratifying that the Government now proposes to support Lord Renton's Sale of Goods Act (Amendment) Bill 1994, which will expunge the market overt exception.[109] It is said by some that abolishing market overt will reduce crime at no public cost; Lord Renton has claimed that the reform could even reduce public expenditure by saving police time.[110]

In cases of cross-border theft, we encounter yet another general rule of the common law, applicable to cultural goods and commercial commodities alike, which has the capacity to trump the original owner. That is the *lex situs* rule, under which a title validly acquired in England will be lost if a later sale to a good faith buyer in an overseas country has the effect under that country's law of giving the buyer a good title.[111] The earlier title defers to the later, and becomes inexigible even if the cultural object later returns to this country. The object can then be sold under the nose of the original owner.[112] The consequences of the *lex situs* rule were averted in

Goldberg[113] only, perhaps, at the cost of some intellectual rigour.

4.2 Forensic difficulties. We would do well not to be too sanguine about cases like *Goldberg* and *Bumper.*[114] Success was achieved there only at the cost of massively expensive litigation, involving intricate questions of fact and law. Consider, for example, counsel's description of the expert evidence as to the identity and source of the idol which it was necessary to accumulate in the *Bumper* case: [115]

'Experts in stylistic comparison, metallurgy, statistical analysis, soil analysis— even an expert on termite workings—were all involved in this complicated and difficult inquiry, some of them spending considerable time "in the field" in Tamil Nadu in order to pursue inquiries…'[116]

Factual issues of even greater complexity confronted the court in the *Sevso* case,[117] where the Trustee of the Marquess of Northampton recently defeated claims by Hungary and Croatia (Lebanon having lately withdrawn) to the celebrated Sevso hoard: a collection of 4th and 5th century silver plates, amphorae, buckets and pitchers, which the Marquess had bought through dealers and later offered through Sotheby's for US$70 million. The evidence supporting each national claim was remarkably meticulous. The following account is taken from *IFAR Reports*:[118]

'This summer, the parties… agreed to a physical inspection of the treasure. The examination yielded slivers of wood, traces of soil, and tiny organic particles. Each of these samples was divided four ways among the parties and sent to forensic laboratories for analysis. A lab in California identified the slivers as oak, and not the cedar wood more common to Lebanon. Part of the soil samples were irradiated in Missouri, and part in London on behalf of Lord Northampton. Dr Louis Sorkin at the American Museum of Natural History in New York identified the organic particles as caterpillar remains of a moth species that probably nested in the cloth in which the silver was wrapped.'

Even where place of origin and original ownership are readily proved, the juridical defences may prove no less complex and discouraging. Consider, for example, the hurdles which the Church in *Goldberg* had to surmount in order to regain its property.[119] The case involved a minutely detailed forensic debate about the legal characterisation of the claim, the applicable conflict of law principles, the governing !aw, an alleged abandonment of title, the state of mind of the purchaser, the pertinacity with which the Church had

prosecuted its claim and whether that claim was statute-barred.[120] One is tempted to ask whether anyone, other than a State, a State-supported party, an oil company or a private citizen of enormous wealth, could seriously contemplate litigation on this scale.[121]

In the light of these considerations, it is hardly surprising that John Browning has relinquished his claim to the Icklingham Bronzes. Mr Browning has consistently maintained that these were illegally removed from his farm over a decade ago and smuggled abroad. He bases that conviction on the assurances of archaeologists and others.[122] But neither the question of title nor that of excavatory origin has been judicially tested. Under an agreement made in 1992, announcing the termination of the pending litigation in the US District Court for the Southern District of New York, 'Leon Levy and Shelby White have agreed to bequeath the Bronzes to the British Museum upon the latter of their deaths.' The other terms of the settlement are confidential.

The statement announcing this agreement[123] recounts that the agreed termination is 'satisfactory to all parties'. It may also, of course, be highly satisfactory to the public, which will eventually have access to the Bronzes. But such benefits are largely adventitious. Had the action proceeded to trial and Mr Levy chosen to stand on his strict rights, the chances of a return to the United Kingdom may have been less than certain. In theory, the Bronzes could have remained in private custody indefinitely. The episode also holds some sobering lessons for Mr Browning. He has spent over £100,000 to no personal avail, and considers that he has been ill-served by the United Kingdom authorities.

4.3 Non-subscription to UNESCO. The EC Directive is the only international instrument for the return of cultural objects which has passed into United Kingdom law. In contrast to the USA, Canada, Australia, New Zealand and 64 other countries, but in common with (*inter alia*) France, Germany, Switzerland, Japan and the Scandinavian countries, the United Kingdom has declined to implement the 1970 UNESCO *Convention on the Means of Prohibiting and Preventing the Illicit Import, Export and Transfer of Ownership of Cultural Property*. This Convention, unlike the Directive, makes an explicit distinction between stolen objects and objects which have been illegally exported. Article 7(b)(i), which deals specifically with stolen cultural property, requires States which are parties to the Convention to prohibit the import of cultural property stolen from a museum or a religious or secular public monument or similar institution in another State party after the entry into force of the Convention, provided the property is properly documented as appertaining to the inventory of that institution. Article 7(b) (ii) requires the relevant State, at the request of the State Party of

Origin, to take appropriate steps to recover and return any such cultural property imported after the Convention has entered into force.

Over the past five years, the United Kingdom Government has given a wealth of reasons for declining to adhere to UNESCO:[124] the bureaucratic burden of implementing it, the preference for relying on the dealers' and museums' codes, the breadth of the relevant definition of cultural property, the inexpediency of a national inventory, the problems of verification and compilation of registers, the need to enact legislation, the general resource implications, and the consequent interference with rights of ownership. It is interesting to speculate how many of these inhibitions remain plausible after enactment of the EC Directive.[125] Perhaps the most commonly invoked justification is the preferred reliance on codes of practice, a view perhaps fortified by proliferation of such codes in recent years. Whether they go far enough is considered later.[126] For the present, it is right to point out one advantage for claimants which the Directive has over UNESCO: that it gives a positive right of recovery of illegally-exported objects. [127]

4.4 Limitations of the Directive. The Directive is a supplement to and not a substitute for those restitutionary rights of action which arise from ordinary private ownership of a cultural object. The statutory right of action is conferred only on member States, not on private citizens.[128] In consequence, the Directive 'does not affect any civil proceedings that may be brought under the national law of the Member States by the owners of the cultural objects that have been stolen' and 'in no way prejudices the rules governing the ownership of cultural objects'.[129] So, in a case which falls within the 1994 Regulations, the right of action conferred on the member State from which the object was unlawfully removed does not extinguish any title acquired by a good faith buyer under a post-theft sale of the object when the object was located in a country which regards that sale as conferring a good title. If, under normal rules of private international law,[130] the post-theft sale extinguishes the original owner's title and confers a good title on the buyer, that second title prevails. The *lex situs* rule does not give way where the EC Directive applies.

The EC Directive is of restricted scope for reasons other than that it cannot be invoked by private owners.

(a) It applies only among member States of the Community. It can, however, apply not only to an object which is unlawfully removed from one member State to another, but also to an object which, having left the Community following an unlawful removal from the territory of a member State, has re-entered the Community and is

now situate on the territory of another member State. On the other hand, UNESCO is, and UNIDROIT is designed to be, worldwide.

(b) It is questionable whether the Directive is likely to play a significant role as an instrument of cultural retrieval. Its machinery is elaborate and the bureaucracy may be discouraging. The Minister himself, noting the cost and other factors likely to deter member States from claiming under the Directive, appears to accept that on a 'pragmatic view... very few relevant cases' will arise.[131]

(c) A successful claimant State may have to compensate the current possessor.[132] The duty to compensate is limited to cases where the court is satisfied that 'the possessor exercised due care and attention in acquiring the object',[133] but it seems to apply regardless of the fact that, under ordinary rules of private international law, the requesting member State can establish an enduring title, unimpaired by any later sale to a good faith buyer as in *Winkworth*.[134] In short, the successful member State may find itself buying back its property if it follows the Directive path. Other heads of indemnity are also payable: (i) the requesting member State[135] must bear the expenses incurred in preserving an object under para 3,[136] and (ii) the requesting member State must bear the expenses incurred in implementing a court order for the return of a cultural object under the Regulations.[137]

The obligation to compensate the possessor has been vigorously defended,[138] and it is hard to see how agreement could have been reached among the member States without it. Moreover, the obligation must be seen in context: the main thrust of the Regulations may be against objects which are not stolen from owners but are unlawfully exported by owners, and here the reciprocal rights of action given to member States in the courts of fellow member States is a vast advance on normal rules of private international law, whereunder one State may refuse to enforce the fiscal, penal and public laws of another (even, in certain cases, where these laws are underpinned by confiscation provisions).[139] That advance may not have been achieved without the counterbalance of the compensation provisions. Moreover, comparable compensation rules apply under the UNESCO Convention[140] and the draft UNIDROIT convention.[141] Even so, it would be hard to imagine that the Directive is the *dernier cri*. Both the existence, and the necessary limitations of the 1994 Regulations, fortify the case for adoption of the UNIDROIT draft convention in due course.[142]

4.5 The professional codes (however well-intentioned) are of questionable value.

4.5.1 *Dealers' codes*
(a) Having (at most) purely contractual force, these codes can be enforced only by and against members of the relevant group or their disciplinary body. They give no direct rights to third parties such as dispossessed owners. They may not, however, be legally insignificant to buyers: proof of purchase from a dealer who sub-scribes to a code may, for example, assist in establishing the buyer's good faith or due attention under one or other of the international restitutionary regimes.[143] That consideration alone may hardly reassure the dispossessed owner.

(b) It is also objected that the codes may be narrowly construed within their constituencies. A complaint of differential interpreta-tions by dealers and museologists of the phrase 'reasonable cause' in the 1984 Dealers' Code, for example, was made by Brian Cook four years ago.[144] Three years earlier he had argued that, despite the 1984 Code, the traffic in looted or illegally-exported antiquities was continuing largely unabated.[145] In *Kingdom of Spain* v. *Christie Manson & Woods Ltd*,[146] Christie's evidently contended that the duty under the 1984 code to abstain from transferring the ownership of an illegally-exported artefact did not apply to any artefact entrusted to the trader for sale by a purchaser in good faith, who had acquired such artefact innocently of any involvement in the illegal export. It seems that, in Christie's view, a springing title (or even a purchase in good faith which does not create a springing title) expunged the illegal export and neutralised the normal embargo on handling its trophies. A springing title is a new title arising by way of the *nemo dat* rule (above) and displacing/ extinguishing the title of the previous owner. One might be forgiven for inquiring how such objects cease to have been illegally ex-ported simply because someone buys them in good faith after the export. Whether textually justifiable or not, however, the *Kingdom of Spain* construction hardly strengthened the Code. The question may also arise as to the basis of fact on which a dealer must satisfy himself as to the seller's good faith in this context.

(c) Other codes are arguably too flabby and platitudinous to present an effective challenge to illicit traffic in cultural objects. A possible example is the one-line treatment of the subject in the Antique Dealers Association Code.

4.5.2 *Museum codes*
All responsible museums and galleries have or are in the process of adopting an acquisitions policy. The standard policy debars the

museum from receiving in any manner an object acquired by any illegal means. A leading example, already noted,[147] is the MA Museums Code, first adopted in 1977 and amended in 1987.

The MA Museums Code is highly influential because,[148] as has been seen, registration of a museum with the Museums and Galleries Commission (hereinafter MGC) depends on its adoption of a policy in line with the Code.

We have observed the optimism with which at least one museum official has greeted the MA Museums Code.[149] There seems no reason to doubt that it will play a part in marginalising 'illicit traffic'. Even so, the Code is not without its legal and textual shortcomings. This is not the occasion for a detailed textual analysis, but a few criticisms may be adumbrated.

(a) Privity. The MA Museums Code appears no more capable of direct invocation by a dispossessed owner than the dealers' codes.[150]

(b) Self-interest. At first sight, the primary part of cl 4.5 seems better designed to protect the museum from liability in conversion than to marginalise illicit trade as such. Acquisition is forbidden unless 'the governing body or responsible officer as appropriate is satisfied that the museum can acquire a valid title' to the object. As has been seen, [151] it would be a foolhardy institution that courted the risk of liability in conversion to the real owner. But what of cases where the need to avoid liability in conversion and the refusal to touch illegally-procured objects do not coincide? Such divergence may occur where a former owner has lost his title before the object is offered to the museum. Suppose a museum official knows that, immediately before its offer to the museum, the object in question was stolen from a museum abroad and then sold by the thief to a good faith purchaser in a country which gives such purchaser good title? Or suppose the official knows that the object was stolen from a Cotswold church and then sold to an innocent purchaser in market overt? However clear the museum's capability to acquire good title, there are cogent arguments for saying that it should decline to buy.

It is believed that, at least where the object is known to have been stolen from another museum, an offeree museum will indeed refuse to acquire it.[152] Thefts from overseas cathedrals, schools and private gardens may be a different matter. There is much to be said for the view that a museum's acquisition policy should not confine itself to the necessary self-protection involved in a refusal to acquire objects in which the museum cannot be sure of getting a good title.

(c) Illegal export. Museum officials may well reply that most cases

which do not fall literally within the first part of cl 4.5 will be prohib-
ited by the second part. It will be recalled that, by this, members
must satisfy themselves 'in particular' that the object 'has not been
acquired in, or exported from, its country of origin (and/or any
intermediate country in which it may have been legally owned) in
violation of that country's laws'.

A lawyer might detect a certain ambiguity in the Code's defini-
tion of a museum's responsibility in cases of 'pure' illegal export.
The use of the connecting words 'and that in particular' in cl 4.5
implies that the second part of the clause is merely a manifestation
of (and is therefore limited by) the first. That may be thought to be
the normal effect of an explicit descent from the general (in the first
part) to the particular (in the second part). On that analysis, prior
illegal acquisition and/or export of an object would not be a sepa-
rate ground on which a museum must refuse to acquire. Prior
illegal acquisition and/or export would be relevant only in so far as
they disabled the museum from gaining title; they would be irrel-
evant where they did not affect title or where events following them
(such as a good faith transaction conferring title under the *lex situs*
rule) enabled the museum to assert an overriding title.

There may be grounds for inferring that museum officials would
adopt a broader analysis of cl 4.5, which would treat the prior
illegal acquisition and/or export of an object as an independent
ground for refusal to acquire, regardless of whether the acquisition
would grant the museum a good title.[153] Some intention to produce
a broader effect might be inferred from other provisions of the
Code. These include:

(a) The general endorsement 'in principle' in cll 4.2 and 4.3 of the
provisions of UNESCO. The return provisions of UNESCO apply,
subject to restrictions both to illegally exported and to stolen
objects, regardless in either case of whether someone has after
the illegal act acquired good title. But the Code's endorsement of
UNESCO falls short of outright adoption.

(b) The provision in cl 4.7 that museums should not acquire by
purchase British or foreign archaeological antiquities (including
excavated ceramics) in any case where the governing body or
responsible officer has reasonable cause to believe that the cir-
cumstances of their recovery involved 'a failure to disclose the
finds to the owner or occupier of the land, or to the proper authori-
ties in the case of possible Treasure Trove (in England and Wales)
or *Bona Vacantia* (Scotland)'.

(c) The drawing by cl 4.8 of the Code of 'special attention' to the
undertaking by each Contracting Party to the European *Convention
on the Protection of the Archaeological Heritage*, under Article
6(2)(a) of that Convention, 'as regards museums and other similar

institutions whose acquisition policy is under State control, to take the necessary measures to avoid their acquiring archaeological objects suspected, for a specific reason, of having arisen from clandestine excavations or of coming unlawfully from official excavations'.

These extensions do not, however, cover every case where a prior illegal acquisition and/or export has no adverse effect on the museum's ability to acquire title. The result of this patchy coverage may be to place the museum in a dilemma in cases where it can potentially gain a good title but feels it should not because of some episode in the object's history. The gaps in the Code are at best productive of uncertainty and at worst likely to lead to its evasion. To a lawyer some of its provisions also appear hopelessly vague and poorly co-ordinated.

Despite the ambiguity of cl 4.5 of the MA Museums Code, it is understood that a museum would refuse to acquire an illegally-exported object, whether the illegal export affected title or not. It may be that this spacious interpretation of cl 4.5 owes as much to political as to legal or moral considerations: offend the State from which illegal export took place and you jeopardise future excavations there.[154]

The ambiguous approach of the MA Museums Code to illegally exported objects may be contrasted with two other codes.

The policy of the Council of American Maritime Museums (CAMM)[155] states shortly that members should not

'knowingly acquire or exhibit artifacts which have been stolen, illegally exported from their country of origin, illegally salvaged or removed from commercially exploited archaeological or historic sites'. [156]

The Code's outright opposition to the purchase by its respective members of illegally exported objects, irrespective of whether the illegal export casts any shadow on the vendor's title, is both clearer and, it is submitted, more satisfying than the corresponding provisions of the MA Museums Code.

The same may be said of another Code much closer to home. Not infrequently, museums acquisition codes are supplemented by codes of practice governing those who work in museums. An example is again afforded by the Museums Association. Clause 3.12 of its *Code of Conduct for Museums Professionals*[157] states that museum professionals 'must not evaluate, accept on loan or acquire by any means an object which there is good reason to believe was acquired by its owner in contravention of the UNESCO convention..., or by any other illegal means'. Museum professionals are enjoined, in consequence of this provision, to take reason-

able steps to ascertain the relevant laws, regulations and proce-dures of the country or countries of origin.

The MA Professionals Code therefore declares a general ban on obtaining illegally-acquired objects. Again, the prohibitions on acquiring illegally exported goods appear stronger than in the MA Museums Code. The MA Professionals Code positively requires the non-acceptance by museum professionals of any object if there is good reason to believe that it was acquired in contravention of the UNESCO Convention. This is much more compelling than the references to UNESCO in the Museums Code. The Professionals Code acknowledges that UNESCO has not been ratified by the United Kingdom but declares that UNESCO is nonetheless 'sup-ported by the Museums Association'. As we have seen, the Muse-ums Code does not expressly demand conformity with UNESCO.

It may be that the duplicated constituency of these two MA codes means that the deficiencies of one are automatically re-paired by the other. It is, after all, the museum professional who will be acquiring objects and will be charged with implementing both codes. Even so, one might have preferred to see a greater co-ordination or correspondence between the two sets of provisions. Lawyers know the perils of using different phrases to mean the same thing.

(d)The divergent treatment of loans. The Professionals Code is not confined to acts of buying and selling. If an object has been illegally-acquired, cl 3.12 also forbids a Museum to accept it by gift or bequest, or on loan, or for purposes of evaluation. Tainted objects are therefore cast into a general outer darkness and made untouchable for all practical purposes. [158] The outer reaches of the embargo may perhaps attract reservations.

There is, again, quite a sharp contrast between cl 3.12 and cl 4.9 of the Museums Code, whereby 'If appropriate and feasible the same tests as are outlined in (*paragraphs 4.5 to 4.8*) should be applied in determining whether to accept loans for exhibition or other purposes'. While the latter provision lacks certainty, some might argue that the less compromising stance taken by the Professionals Code (though intellectually more satisfying) threat-ens to frustrate one of the greatest advantages of international art loans, that they encourage cultural exchange by marginalising questions of title. Others would reply that this objection is naïve. Where an object was once stolen from a private individual in a country to which it now returns on loan, the safety of the object from judicial recapture while on loan would require national legisla-tion depriving that individual of his normal property rights: an improbable (though not unknown)[159] accompaniment. Where the object was illegally removed from State custody or ownership, and

has been persistently claimed by that State during its absence abroad, a proposal that the State borrow the object for a limited period or purpose is unlikely to be seen as a diplomatic solution. No-one who has put this suggestion to a Greek museum director is likely to forget the response.

(e)Sales by non-owners. The prohibition in cl 3.12 of the MA Professionals Code applies to objects reasonably believed to have been illegally acquired by their 'owner'. This pre-supposes that the prior illegality has not inhibited the getting of title by the prospective seller, donor, lender or entruster for evaluation. On the interpretative principle *expressio unius est exclusio alterius* (ie the express statement of one thing belonging to a particular class implicitly excludes other things within the same class), it might be objected that cl 3.12 does not inhibit a museum professional from accepting illegally acquired objects where the other party to the transaction is not the 'owner'. Of course, any such anomaly is unlikely to be exploited, even by the most cynical museum official, since a museum which buys from someone who is not the owner at the time of purchase buys at its peril. Even so, the temptation may not always prove irresistible, given the prohibitive costs of cross-border litigation. One might have preferred to see the cl 3.12 embargo more widely stated.

(f) Where pragmatism must prevail over principle. Sometimes a museum's policy is publicly explained by its officials. Such clarification can be extremely interesting and helpful.

The *Report of the Trustees of the British Museum* for 1990-1993 flatly declares the Museum's refusal 'to acquire objects which have been illegally excavated or exported from their countries of origin'.[160] The relevant cut-off date for identifying an unlawfully-removed object is the date on which the overseas country imposed the relevant export or excavation control.[161] Cyprus, for example, introduced relevant laws in 1935, so the British Museum will refuse to acquire objects which have been illegally removed from Cyprus from 1935 onwards.[162] In one sense, the embargo is therefore retrospective, in that it covers objects unlawfully exported before the date on which either the Museum's policy or the UNESCO Convention (1970) was promulgated. But this must be put in context.

1. It does not follow that the British Museum will return **any** object currently in its collection which is shown to have been illegally acquired in the past. In this sense, the policy is not retrospective. The return of past acquisitions appears to depend purely on the legal viability of the claim and (perhaps in extreme cases) on case-sensitive diplomatic factors. A legal claim, as we have seen,[163] can

require the claimant to negotiate the domestic and cross-border implications of the *nemo dat* and *lex situs* rules, the complexities of the law of limitations, and the general practicalities of civil litigation. Most potential claimants will give up, and wisely so.

In 1989 Sir David Wilson, then Director of the British Museum, wrote that there were 'good philosophical reasons' for letting sleeping dogs lie.[164] Foremost among them was curatorial responsibility: the need to maintain the universal role of the Museum and the integrity of its collection. Other reasons touched upon by Sir David Wilson were:

(a) the 'domino effect' on other museums if the British Museum were 'the first to give in,'

(b) the fact that the acquisition culture of the eighteenth and nineteenth centuries was different from our own ('History... moves on: laws change; views of morality are altered'),

(c) the Museum's need to deal with dealers, whether it likes it or not,

(d) the scrupulous care now taken to avoid illegal acquisitions, and

(e) the fact that while our nation, no less than any other, has suffered grievous losses of heritage in the past, we have taken it on the chin: so 'What is sauce for the goose is sauce for the gander.'

Collections in national museums and galleries are legally inalienable, subject only to narrow powers of disposal in the Museums and Galleries Act 1992 or other legislation.[165] It need scarcely be said that the Act does not list among the grounds for disposal the fact that an object is reasonably believed to have been stolen or otherwise illegally acquired prior to its acceptance into the collection. In his book on the British Museum in 1989, however, Sir David Wilson declined to rely on the fact that restitution of currently held objects would contravene the Museum's governing legislation: 'Acts of Parliament can be repealed or amended.' [166]

2. The British Museum distinguishes, for the purposes of its acquisitions policy, between objects of domestic origin and objects of overseas origin. Here again, the approach is pragmatic. For example, the Museum may acquire domestically excavated items of treasure trove though their excavation has been accompanied by the commission of a civil or criminal offence.[167] Illegal excavation by a trespasser is no barrier to acquisition by the Museum, or to the grant of a reward to the finder. It is understood that no reward has ever been reduced on account of trespassory behaviour alone.[168]

The fact that there is so slender a line between legal and illegal acquisition is tacitly admitted in a British Museum Trustees' Public Policy Statement:[169]

'The British Museum deplores the deliberate removal of ancient artefacts from British soil other than by properly directed archaeological excavation, especially when the context of those artefacts is thereby left unrecorded and severely damaged. However, although the unauthorised excavation of such material from a scheduled monument is illegal and never be condoned, much of what is discovered elsewhere is brought to light lawfully; persons in possession of it often have legal title to dispose of it as they think fit. In these circumstances, the Museum has an overriding duty to try to acquire such finds as it considers to be appropriate to the national collection. To refuse to follow this course would entail a serious loss to our heritage, since we would then lose the chance to see and record a great many objects. The Museum understands, and shares, the concern of the archaeological world, but since there is a ready market both here and abroad, the situation will not be remedied by a museum embargo. Selective acquisition remains, in our view, not only the practical, but also the proper course.'

The policy of selective acquisition which the Museum here defends seems to be limited to legally excavated objects whose disposers have good title. But, of course, the Museum may also acquire things unearthed by a trespasser who does not have title.

In the case of treasure trove, this is to an extent defensible. Since treasure trove is Crown property, its acquisition by the British Museum or some other museum does not give the Crown a new title in substitution for a title formerly vested in another.

The Museum's acquisition of other, non-treasure trove objects may suggest a more resourceful interpretation of its policy. An example is the recent agreement for the bequest to the Museum of the Icklingham Bronzes. [170] Wherever the Bronzes were buried and excavated, it was certainly not the United States; they must have been illegally exported from somewhere.[171] On what grounds, then, can their acquisition be jusitified?

It is, of course, arguable that the bequest to the Museum is entirely beneficial and vindicates a policy of privately agreed solutions, reinforced perhaps by tax incentives.[172] Moreover, Mr Levy may have acquired title by virtue of a good faith purchase outside the United Kingdom, rendering an agreed acquisition from him the only viable solution. Even so, the Museum's acceptance of the Bronzes does not appear immediately compatible with a policy of declining objects 'illegally excavated or exported from their countries of origin'.

Legal Issues

One possible interpretation is that the Museum's policy is qualified by some form of 'rehabilitation of offenders' rule, whereby a later acquisition of good title under the *lex situs* rule purges any original illegal excavation or export from the country of origin. An exception of such breadth could substantially neutralise a prohibition on the fruits of illegal excavation, especially if objects are presumed to have been lawfully discovered unless the contrary is shown. Such an interpretation may, however, be simplistic in that it pays insufficient regard to the original situs of the Bronzes and the identity of the parties to the agreement. It might be argued that the case of the Icklingham Bronzes is so exceptional in those two respects as to justify the position taken.

First, the bequest agreement under which the Museum is to acquire the Bronzes [173] is one to which the possessory claimant was party. John Browning[174] consented to the arrangement and his consent can be assumed to be legally binding. There is a clear difference between a museum acquisition which occurs without reference to the interest of the dispossessed owner and one derived from an agreement to which that owner is privy. Whether or not that distinction is immediately clear from the Museum's policy, it may be thought to carry a certain ethical weight. Of course, there is also a difference between a possessory owner whose participation in an acquisition agreement is unaffected by the costs and hazards of litigation, and one who feels obliged to make a commercial decision as to whether a pending legal claim shall be pursued.

Secondly, it can be assumed that the Bronzes are, by virtue of the bequest agreement, to return to the country in which they were originally deposited and from which they were allegedly removed. Again, there is a clear distinction between this result and that occurring where (say) a Philadelphian museum acquires from a United States citizen a private collection of illegally excavated Turkish objects.

Given these exceptional factors, the Museum may claim not only to have secured a bargain which advances the cause of scholarship and indigenous public access, but to have maintained intact the spirit, if not the letter, of its policy. The same factors perhaps lend perspective to the words of Lord Renfrew of Kaimsthorn:[175]

'I was... shocked, on visiting the exhibition of Leon Levy and... Shelby White at The Metropolitan Museum of Art in New York a couple of years ago, to find the most extraordinary treasure store of looted antiquities from all over the Ancient World. Life-sized Roman statues from Turkey jostled with Cycladic figures, which competed for space with gold from Mesopotamia. No respectable

museum, I felt (and continue to feel), would give space to such a store of loot, however attractive—certainly the British Museum has a policy that would prevent it from doing so.'

5. Conclusion

This is a realm of vivid contrasts and wildly conflicting ideals. There is the contrast between the art-rich nation and the market nation: a contrast sharply reflected in their respective laws. There is the contrast between the ex-colonial power and the new nation, anxious to consolidate its identity. There is the contrast between the collector who maintains that, without his intervention, many chance finds would be abandoned by their finders, [176] and the museologist who contends that collectors stimulate illegal excavation.[177] Less obviously, there is the contrast between the scholarly value of an excavated antiquity (robbed of its provenance by detachment from an unknown site) and that (say) of an eighteenth century European painting, whose provenance and appreciation are less likely to be subverted by buying and selling.

Above all, there is the diversity of interests among those involved in the field: scholars, nations, collectors, dealers, investors, insurers, governments and public. To each of them, a work of art may mean something peculiar. The mosaics of the Panagia Kanakariá, for example, may be a saleable commodity to some, a national icon to others. To some (like the landless Indian labourer who discovered it in 1976) the Pathur Nataraja represents subsistence or survival, to others the common heritage of humankind, an unfit subject of national, let alone private, property.

Perhaps the sharpest contrast lies in national attitudes. Some countries make resounding declarations of the importance of promoting and sustaining national ownership of national treasures. The tendency is not confined to politicians, nor to ancient civilisations. In *Webb* v. *Ireland and the Attorney General*[178] the Supreme Court of Ireland invoked the fact that the Derrynaflan chalice and other ecclesiastical treasures were among 'the keys to our ancient history' to justify a judge-made doctrine of treasure trove notable for its unsentimental view of precedent.[179] A similar view was taken by Noland J at first instance in *Goldberg* towards the Cypriot Republic's standing to sue (alongside the Church) for the return of the Panagia Kanakariá mosaics.[180] Shortly before the 1990 general election in Australia, Mr Hawke, then Prime Minister, pleaded for this country to return his nation's birth certificate (the original copy of its Constitution).[181] Whenever entry charges for the British Museum are debated, critics can be relied on to ask why Greeks and Egyptians should pay a foreign museum for the privilege of seeing their own past exhibited.

United Kingdom authorities are less prone to attitudes of national property or cultural nationalism. Our art export laws are clement and (subject to funding) largely effective; their balance and moderation are much praised.[182] We seldom find ourselves in the position of asking other

nations to return our blood and soul, or to restore the keys to our ancient history. Our museums (no doubt for good reasons) are likely in ambiguous cases to interpret their new acquisition rules by reference to broad institutional interests rather than according to abstract notions of right and wrong.

Such attitudes are shared in other, non-source nations. The list of non-subscribers to UNESCO is not, in general, a catalogue of countries whose cultural resources outstrip the economic resources needed to safeguard them. Even critics outside the market are not unanimous in approving the automatic return of unlawfully removed objects to their countries of origin. Some, like Professor Merryman,[183] maintain that in certain cases the search for truth and the preservation of the object or of the integrity of its parent monument should prevail over national claims.[184] Others like Ricardo Elia[185] and (semble) Lord Renfrew of Kaimsthorn[186] see the acquisitive demands of collectors as the true villainy: 'collectors are the real looters'.[187] Some who see collectors as the source of the evil would abolish private collecting, and with it the market; fashions change, and at least one critic has suggested that the private antiquities trade may eventually attract the same ostracism as the fur trade.[188] Collectors, in turn, may point to the fact that their collections may come to rest in public museums (or are frequently loaned to such institutions) as justifying tolerance of their activities and those of their suppliers.[189] It will be interesting to see whether, in the light of the new codes of practice, museums accept such benisons.[190]

Our national restraint may have its virtues, not least for the economy. Four years ago, the value of the London art market was gauged at over £3 billion a year.[191] Some argue vigorously that a legitimate market is vital to the control of illicit excavations.[192] Others believe that a market will exist somewhere for as long as there are collectors, that to drive it abroad would be economically insane, and that no overall compensating benefit would result.

Whatever the merits of these positions, our clemency to the market and to private property law are not without price. Such attitudes can puzzle and alienate those in England who, believing themselves the possessory owners of national treasures, are obliged to fight a lonely battle for their recovery, without overt official support. And they may impede our understanding of others who regard such objects with greater passion. Some of those responsible for policy in this area have not been reticent about characterising certain national claims as 'unthinking' and 'emotional', albeit 'understandable'. [193]

At the end of the day, it is hard to deny that a preference for pragmatism has its advantages: that the relaxed tone of our policy on national treasures is its strength, and that our system achieves more than those which take a head-on approach.

However murky their recent history, and whatever the ethical scruples, the Icklingham Bronzes seem set to return. Those inclined to self-congratulation might see in our stance reflections of the national character: a proclivity for minimal regulation, a keen regard for trade, a jealous eye on

the public purse, a tendency to be embarrassed by rhetoric (domestic or external) and a haphazardly-derived system that, against all the odds, works. Our national creed might almost be that of our most pragmatic Prime Minister this century: 'you know it makes sense'.

More importantly, in this particular context, it also makes dollars, pounds and yen.

Acknowledgements

This paper is a revised version of an inaugural lecture delivered at University College London on January 20th 1994. It was first published in the volume *Current Legal Problems*: for that year, and is reproduced here by kind permission of the Editor of that work. I acknowledge the assistance of Ben Ward, Managing Editor of the *International Journal of Cultural Property* in preparing this paper for publication. I also wish to thank Ian Longworth FSA, Keeper of Prehistoric and Romano-British Antiquities, British Museum, for his comments. Responsibility for views expressed remains my own.

Abbreviations for Journals and Law Reports

UK Appeal Cases (AC)
UK All England Reports (All ER)
USA Federal Supplement (F Supp)
USA International Foundation for Art Research (IFAR))
UK International Journal of Cultural Property (IJCP)
IRELAND Irish Reports (IR)
UK Journal of Hellenic Studies (JHS)
EU Official Journal (OJ)
UK Times Law Reports (TLR)

Notes

[1] Ernest William ('Willie') Hornung, 1866-1921, the youngest son of a Middles-brough lawyer, was friendly with Sir Arthur Conan Doyle and married his sister Constance. Conan Doyle once described him as 'a Dr Johnson without the learning but with a finer wit': see Peter Haining's Foreword to The *Complete Short Stories of Raffles—the Amateur Cracksman* (Souvenir Press, 1984), p.16.

[2] Presumably, Craggs got no title, and it did not occur to him (being Australian) to buy in market overt; cf Davenport and Ross, 'Market Overt' in *Interests in Goods* (1993), eds N. E. Palmer and E. McKendrick, chapter 17, esp at p. 472 note 20. Raffles's own analysis of the transaction was confused, and his robust view seems to have misled even the lawyer Addenbrooke:
RAFFLES: 'But... surely it's a clear case? The sale was illegal; you can pay him back his money and force him to give the picture up.'
ADDENBROOKE: 'Exactly... '

This exchange (to which Bunny did not contribute) anticipates the approach of the UNIDROIT draft convention: see pp. 11, 16 *et seq.*

3 Raffles successfully recaptured the *Infanta* and collected a £4,000 fee from Addenbrooke. He lived on to plunder many other institutions, including the British Museum, from which he stole a gold Assyrian cup. In a fit of patriotic zeal, however, he relented and posted the object to Queen Victoria in a Huntley & Palmer's biscuit tin: see 'A Jubilee Present'.

4 As to that code, see George Orwell's celebrated Essay, 'Raffles and Miss Blandish', published in the complete edition of the Raffles stories, cited at note 1 above, p. 25.

5 *Sunday Times,* (London), December 12th 1993.

6 *Times,* (London), *Independent*, July 24th 1993.

7 *Times,* (London), February 14th 1994.

8 *Times,* (London), *Independent* (London), April 18th 1994.

9 *Times,* (London), October 12th 1991.

10 *Daily Telegraph,* (London), August 7th 1993.

11 *Quaere*, however, whether the acquisition of stuffed rats can be explained on this basis.

12 Dalya Alberge, 'Unkindest Cuts of the Thieves Who Trade in Stolen Paintings' *Independent on Sunday,* (London), January 31st 1993, which quotes Italian police sources as estimating that as many as two or three per cent of stolen pictures are being cut up in this way.

13 National Heritage Committee, *Export of Works of Art*, First Report (Draft Directive on the Return of Cultural Objects Unlawfully Removed from the Territory of a Member State and Draft Regulation on the Export of Cultural Goods) H C Session 1992-1993, November 1992, para 21 (hereinafter HC First Report) citing evidence from the Council for British Archaeology.

14 Davison and Hadfield, '£600m Tax Lost in Art Loophole' *Sunday Times,* (London), November 21st 1993.

15 Boguslavskij (1994) 3 *IJCP* 243.

16 *Independent,* (London), June 1st 1991.

17 Private interview, January 6th 1994.

18 *Ibid.*

19 *Sunday Times,* (London), December 12th 1993.

20 See on this, and on retrieval techniques generally, David Thurlow, 'Chasing the Immovable' *Daily Telegraph,* (London) March 31st 1993, which discusses the question of 'architectural theft'; Anne Caborn, 'Insurers Join Antique Trade in Tracking Stolen Goods' *Times,* (London), March 20th 1993; Dalya Alberge, 'Art Finds Place on Computer' *Independent,* (London), March 20th 1993; Paul Rambali, 'Booming Chronicle of Stolen Art' *Independent on Sunday,* (London), September 13th 1992.

21 H C First Report, para 28.

22 *Independent,* (London), October 27th 1990.

23 Cf Chesterman (1991) 65 *Antiquity* 538.

24 H C First Report, para 15, citing Mr McAlpine 'one of the world's leading dealers in antiquities'.

25 See note 9, above.

26 The council is campaigning vigorously for (*inter alia*) the abolition of the doctrine of market overt, as to which see p.12.

27 See Milton Esterow, *The Art Stealers* (Millington, 1975).

28 For example, Edward Moat, *Memoirs of an Art Thief* (Arlington Books, 1976).

29 *Times,* (London), November 30th 1992.
30 Chippindale (1993) 67 *Antiquity* 699: 'Apocryphal stories circulate of crazed collectors whose private and lonely apartments are lined with Manets and Monets, stolen to order. This is the trouble with stuff you know is nicked: you can enjoy it yourself, but you cannot tell the world or let the experts study it.'
31 Especially when they are the victims: see, eg, the letter from a believed victim of the market overt rule in *The Times,* (London) March 25th 1993.
32 Looting in times of armed conflict raises separate issues which will not be discussed. As to legal constraints, see the Hague *Convention for the Protection of Cultural Property in the Event of Armed Conflict* (1954) which applies both to movable and immovable property; and recent articles by Clément (1994) 3 *IJCP* 11; Eirinberg (1994) 3 *IJCP* 27. For an account of the relation between Napoleon's military expeditions and the Louvre collections, see Gould, *The Trophy of Conquest* (Faber & Faber, 1965).
33 See, eg, Dalya Alberge, 'Moore Forgeries Flood Market' *Independent on Sunday,* (London) October 24th 1993.
34 Cf the sale by the Royal Holloway College of the Turner seascape, *Van Tromp, going about to please his masters* to the Getty Museum for £11 million. In its 39th Report (1992-1993) paras 6 to 11, the Reviewing Committee on the Export of Works of Art expressed profound concern about the implications of this transaction.
35 See pp.9-11, 15, 16.
36 See, most recently, John Henry Merryman, 'The Nation and the Object' (1994) 3 *IJCP* 61.
37 Eg, *Government of Peru* v. *Johnson and others* 720 F Supp 810 (CD Cal 1989); affirmed by the US Court of Appeals, without reference to this question, in an unpublished decision: 1991 US App Lexis 10385. See Merryman (1992)1 *IJCP* 169.
38 See the UNESCO Convention of 1970 and the UNIDROIT draft Convention: below, pp. 11, 14-16 *et seq.*
39 On the Parthenon Marbles, see generally St Clair, *Lord Elgin and the Marbles* (Oxford University Press, 1967); Hitchens, *The Elgin Marbles* (Chatto & Windus, 1987). On King Priam's Treasure, see Easton, 'Priam's Gold: The Straightforward Story of a Controversial Treasure' (lecture to the British Institute of Archaeology at Ankara, January 12th, 1994).
40 Note, for example, the two tier definition set out in the recent Directive: see pp.9, 10.
41 771 F Supp 1374 (5 D Ind 1989), upheld on appeal (1990) No 89-2809; noted by Byrne-Sutton (1992) 1 *IJCP* 151.
42 [1991] 4 All ER 638, CA.
43 *Solomon R Guggenheim Foundation* v. *Lubell* 153 AD 2d 143, 550 NYS 2d 618 (1990), aff'd 77 NY 2d 311, 569 NE 2d 426, 567 NYS 2d 623 (1991); noted by Gerstenblith (1992) 2 *IJCP* 359.
44 Cf a case reported in the *Independent,* (London) July 16th 1992, where the owner's insurers recovered eight paintings (with a combined value of £150,000) in Sweden. The pictures had been stolen from the Trinity Gallery in London, which had ceased trading some six months before the recovery. The paintings were the property of the insurers (Star Assurance), whose manager reported that, whereas recovered art was normally returned to its owner on repayment of the insurance monies, these pictures would now be auctioned.
45 *Times,* (London) November 30th 1992.

[46] Siehr (1992) 1 *IJCP* 215.

[47] *Times*, (London) January 20th 1994. The return was to be without cost to the Greek nation, though it was understood that the proprietor would be entitled to a tax deduction for the amount (an estimated £150,000) paid by him for the objects. A negotiated return usually offers the best solution where a re-emerging object has simply disappeared rather than been stolen. At the end of 1993, for example, the 1834 George Scharf picture depicting the House of Commons after the fire (which disappeared in the 1860s but had lately resurfaced in a shop in South Africa) was repurchased for a 'bargain', albeit undisclosed, price.

[48] Private information made available to author.

[49] According to Philippe de Montebello, the current Director of the Metropolitan.

[50] 14 *IFAR* Reports, Number 10 (October 1993) p.3.

[51] Chippindale (1993) 67 *Antiquity* 700.

[52] The Turkish Government's success in this claim is said to have inspired a series of further claims against Swiss, German, British and US museums; see *Times*, (London) November 13th 1993.

[53] See p. 16.

[54] Accepted by the vote of the Founding Assembly of the Association on 4th July 1993.

[55] The notion of a duty to act in good faith to the best of one's ability suggests interesting opportunities for escape on the part of the ethically challenged.

[56] See also Articles 12.7, 13.

[57] Clause 2.

[58] Clause 4 of the 1984 Code.

[59] Hereinafter the MA Museums Code: adopted in 1977 and amended in 1987.

[60] The MA Museums Code further provides that the phrase 'country of origin' includes the United Kingdom, and again there is equivalent provision in the ICOM code. Supplementary provisions (cll 4.8.2, 4.10, and 4.11) impose obligations of dissemination, co-operation, consultation and return.

[61] (1992) 112 *Journal of Hellenic Studies* 246.

[62] *Kingdom of Spain* v. *Christie Manson & Woods Ltd* [1986] 3 All ER 28; for the background, see Agnew and Farrer (1992) 1 *IJCP* 137.

[63] Following identification of the pictures by the International Art and Antiques Loss Register.

[64] Reynolds's *Francis Hargrave* and Gainsborough's *Sir John Skinner*.

[65] *Times*, (London) March 6th 1993. Owing to the law of market overt, the resultant delivery of the pictures into police custody does not mean that the Inn's insurers will necessarily regain them: see p.12.

[66] See p. 12.

[67] See the source cited in note 9, above.

[68] July 1992 to January 1994.

[69] Private interview, January 19th 1994.

[70] Article 4(2) of the UNIDROIT draft Convention would specifically make such consultation a factor to be taken into account in determining whether a possessor has exercised due diligence in the acquisition of a cultural object.

[71] House of Lords, Select Committee on the European Communities, Sixth Report, Session 1992-1993: *Control of National Treasures* (hereinafter H L Sixth Report) Part I, paras 1-10.

[72] No 93/7/EEC (OJ No L74/74, 27th March 1993).

[73] OJ No L74/74, 27th March 1993.

74 EC 3911/92.
75 The Return of Cultural Objects Regulations 1994, 51. No 501 of 1994.
76 Reg 6(2).
77 Directive, Art 1(1).
78 In some cases the object must have a monetary value above certain financial thresholds. The financial thresholds applicable to the various categories of cultural objects are set out in sterling in the Schedule to the Regulations: see Reg 2(3). The Schedule categories are:
VALUE: 0 (Zero)
- 1 (Archaeological objects)
- 2 (Dismembered monuments)
- 8 (Incunabula and manuscripts)
- 11 (Archives)
£11,900.00
- 4 (Mosaics and drawings)
- 5 (Engravings)
- 7 (Photographs)
-10 (Printed maps)
£39,600.00
- 6 (Statuary)
- 9 (Books)
-12 (Collections)
-13 (Means of Transport)
-14 (Any other item)
£119,000.00
- 3 (Pictures)
An object may alternatively fall within this second category if it is in the inventory of a public collection or ecclesiastical institution: see Explanatory Note to Regulations.
79 Reg 1 (3).
80 Reg 6 (1).
81 Reg 3 (1).
82 Reg 6 (4) (a).
83 Reg 6 (4)(b).
84 Reg 3(2)
85 Reg 3 (1) (a).
86 Reg 3 (1)(b).
87 Reg 3 (3).
88 Reg 3 (4) (a).
89 Reg 3 (4)(b).
90 Reg 3 (4)(c).
91 Reg 6 (6) (a).
92 Reg 6 (8).
93 Reg 6 (7).
94 Reg 6 (5) (a).
95 Reg 6 (5)(b).
96 Reg 6(5).
97 See the H C First Report, paras 166, 167, and Annex Note by Mr Charles Bird on powers of entry, search and seizure under subordinate legislation.
98 See generally Siehr (1994) 3 *IJCP* 301.
99 Art 3(2).

[100] Art 4(2), and see Art 4(3). Separate provisions of the UNIDROIT draft deal with illegal export: see Arts 5-8.

[101] Pp.9-11.

[102] Peter Addyman, Director of the York Archaeological Trust and President of the Council for British Archaeology (CBA), speaking at a Conference on *Conservation and the Antiquities Trade*, organised by the United Kingdom Institute for Conservation (UKIC) Archaeology Section and held at the British Academy in December 1993.

[103] For example, the current reward system has its virtues. It compares favourably with the lack of incentive to disclose finds under the laws of some other countries.

[104] Incidentally, national acquisition through the doctrine of treasure trove can result in the rewarding of a finder who has been guilty of trespass and/or theft in recovering or removing the find. See further note 124, below.

[105] Since this was written, the Government has adopted and substantially amended the Treasure Bill. There is now a serious prospect of legislation before the end of 1994. Among other amendments, the Bill now specifies the parties to whom rewards may be granted in respect of finds of treasure (under current provision, rewards for treasure trove are given only to finders) and indicates the potential division and destination of rewards.

[106] One cannot be certain that the landowner will succeed against the finder. For a recent case where the landowner's claim failed and the object (a gold Tudor brooch worth £35,000) was awarded to the finder, a metal detectorist, see *Waverley Borough Council* v. *Fletcher* (1994) unreported, February 17th, Judge Fawcus QC; discussed by Owen Dyer *Sunday Times,* (London), February 20th 1994.

[107] See generally Davenport and Ross, *loc cit supra*.

[108] Section 22(I), Sale of Goods Act 1977. The sale must take place between the hours of sunrise and sunset: *Reid* v. *Commissioner of Police of the Metropolis* [1973] 2 All ER 97, CA.

[109] Earlier governmental reaction was less enthusiastic: HL Deb 12 Jan 1994 (Second Reading) cols 219-221 (Lord Strathclyde, Minister of State, Department of Trade and Industry).

[110] HL Deb 12 Jan 1994, col 222 (Second Reading).

[111] See generally Lyndel V. Prott, 'Problems of Private International Law for the Protection of the Cultural Heritage', *Recueil des Cours* 217 (1989-V) 219-317.

[112] *Winkworth* v. *Christie Manson & Woods Ltd* [1980] Ch 496.

[113] Above, note 41.

[114] Above, notes 41 and 42.

[115] Above note 42.

[116] Text of an unpublished paper delivered by David Calcutt QC, counsel for Bumper, to members of the art trade: October 1990, p. 10.

[117] *Republic of Croatia and Republic of Hungary* v. *The Trustee of the Marquess of Northampton 1987 Settlement* (1993) unreported, November 18th (Supreme Court of the State of New York, New York County).

[118] October 1993, p. 5.

[119] Above, note 41.

[120] Limitation period defences are a standard feature of cultural property litigation and a particular scourge to claimants. Time bar defences were raised both in *Bumper* and in *Solomon Guggenheim Foundation* v. *Lubell* (note 43, above).

[121] One estimate puts the legal fees incurred by Turkey in eight-year claim against

The Metropolitan Museum of New York at £1.3 million: *Times* (London), November 13th 1993.

[122] Private interview with Mr Browning, December 1st, 1993. In his evidence to the House of Commons Select Committee on National Heritage (1992-1993), Lord Renfrew of Kaimsthorn described the bronzes as a glaring example of looting and illegal exportation: see H C First Report, paras 228 *et seq*, and H C Deb October 27th 1993, cols 944-947 (Richard Spring MP).

[123] The statement was publicly read for the first time by Mr Browning at a conference on *Conservation and the Antiquities Trade* at the British Academy on December 2nd 1993, held under the auspices of the UKIC Archaeology Section.

[124] See, eg, H C First Report para 188; H L Sixth Report paras 19-22.

[125] The Government has an open mind on implementation of the draft UNDROIT Convention, when finalised: H C Deb October 23rd 1993, col 950 (Iain Sproat MP, Parliamentary Under-Secretary of State for National Heritage).

[126] See p. 17 *et seq*.

[127] H L Sixth Report para 20.

[128] Reg 6(1). Contrast the UNIDROIT rules on stolen goods, which give a dispossessed owner a direct right of action.

[129] H L Sixth Report p. 23.

[130] See pp. 12, 13.

[131] H C First Report para 220 (Rt Hon Peter Brooke MP, Secretary of State for National Heritage). Cf HC Deb 14 February 1994 col 722 (Iain Sproat MP, Parliamentary Under-Secretary of State for National Heritage).

[132] Cf the compensation provisions contained in the draft UNIDROIT convention: above, p. 11.

[133] Reg 7(2); and see Reg 7(1).

[134] Above, note 112.

[135] Or, where no application has been made, the member State to which relevant notification is made and which seeks the return of the object.

[136] Reg 3(6).

[137] Reg 8.

[138] For comment as to its operation, see H C First Report paras 178 *et seq*; H L Sixth Report para 97.

[139] See, generally, *King of Italy and Italian Government* v. *De Medici Tornaquinci* (1918) 34 TLR 623; *Attorney-General of New Zealand* v. *Ortiz* [1984] AC 1.

[140] Article 7 (b) (ii).

[141] Article 4.

[142] Note further the draft Mauritius Scheme for the Protection of Cultural Heritage within the Commonwealth, as to which see O'Keefe (1994) 3 *IJCP* 295.

[143] H C First Report para 183.

[144] (1991) 65 *Antiquity* 535.

[145] *Sunday Times*, (London) August 28th 1988.

[146] [1986] 3 All ER 28.

[147] See p. 8.

[148] See p. 8.

[149] Michael Vickers; see p. 8.

[150] See p. 17.

[151] See p. 6.

[152] Private conversations with author, 1993-1994.

[153] *Ibid.*

[154] *Ibid.*

[155] The CAMM policy applies to misremovals which have occurred from 1990 onwards. In 1993 it was adopted by the International Congress of Maritime Museums.

[156] *Ibid*, cl 3.

[157] Hereinafter 'the MA Professionals Code'.

[158] *Quaere*, as to something bailed to a museum for restoration, namely something loaned or otherwise delivered while retaining ownership, thereby giving merely possession and not title.

[159] The United States has had such legislation since 1965: Immunity from Seizure Statute, 22 USC Para 2549.

[160] Report, p. 24.

[161] Brian Cook, *op cit*, note 144 above.

[162] Brian Cook, *ibid*.

[163] See pp. 12-16.

[164] *The British Museum: Purpose and Politics* (1989), pp.116-117.

[165] See generally Forder (1994) 3 *IJCP* 131.

[166] *Op cit*, note 164 above, at p. 115.

[167] See generally Palmer (1993) 2 *IJCP* 275, at 282-288.

[168] The position here is likely to change by virtue of cl 8 of the Treasure Bill 1994, following amendments introduced at Report Stage in the House of Lords (April 20th 1994).

[169] Report of the Trustees, 1987-1990.

[170] See p. 14.

[171] See the observations by Lord Renfrew of Kaimsthorn, above, note 122.

[172] Cf the case of the Michael Ward Gallery; see p. 6.

[173] And to which, it must be stressed, the Museum is not recorded as a party.

[174] The land-owner from whose land the Bronzes were allegedly taken.

[175] (1993) *46* (3) *Archaeology* 16-17 .

[176] Eg, Mr George Ortiz, at a forum on Legal Issues in the Antiquities Trade chaired by Professor John Merryman, New York, May 15th 1991. Cf the story of the illegally excavated Afghan silver coin hoard, rumoured to be at risk of being melted down because, in the light of ethical considerations, no museum will acquire it: *Independent*, (London), April 27th 1994. It is understood that the story has been greeted sceptically by some archaeologists.

[177] Cf Chippindale, *op cit supra*.

[178] [1988] IR 353.

[179] See esp [1988] IR 353 at 388 *et seq*, per Finlay CJ; see also at 390-391, per Walsh J.

[180] See above, note 41, for the reference to this case. Noland J thought that the Republic had a 'legally cognizable interest in the mosaics sufficient to confer standing', but he considered further analysis of this interest unnecessary since the return that was requested was to the Church.

[181] *Times*, (London) February 13th 1990.

[182] For a modern account, see Maurice and Turnor (1992) 1 *IJCP* 273.

[183] Sweitzer Co-operating Professor of Art and Law Emeritus at Stanford University.

[184] See, eg, 'The Nation and the Object' (1994) 3 *IJCP* 61.

[185] Director of the Office of Public Archaeology at Boston University.

[186] Disney Professor of Archaeology at the University of Cambridge.

[187] The phrase is Elia's, in a book review of Lord Renfrew's *The Cycladic Spirit* (1993) 46 *Archaeology* 1: issue 1. Lord Renfrew himself seems inclined to accept the aphorism: see the reference cited above, note 175.

[188] Chippindale, *op cit*, above, note 30.
[189] Cf Chesterman, *op cit*, above, note 23.
[190] Cf Lord Renfrew in the article cited above, note 175.
[191] *Cultural Trends* 8, 1990, p. 33.
[192] See, eg, Editorial, *Art Newspaper*, December 1993, p. 1.
[193] Wilson, *op cit*, p.116.

Bibliography

Agnew, J. and Farrer, M., 'Goya's The Marquessa de Santa Cruz.' *IJCP* 1 (1992): 137-141.

Boguslavskij, M.M., 'Contemporary Legal Problems of Return of Cultural Property to its Country of Origin in Russia and the Confederation of Independent States.' *IJCP* 3 (1994): 243-256.

Byrne-Sutton, Q., 'The Goldberg Case: A Confirmation of the Difficulty in Acquiring Good Title to Valuable Stolen Cultural Objects.' *IJCP* 1 (1992): 151-168.

Chesterman, J., 'A Collector/Dealer's View of Antiquities.' *Antiquity* 65 (1991): 538.

Chippindale, C., Editorial. *Antiquity* 67 (1993): 699-700.

Clément, E., 'Some Recent Experience in the Implementation of the 1954 Hague Convention.' *IJCP* 3 (1994): 11-25.

Cook., B., 'The Archaeologist and the Art Market: Policies and Practice.' *Antiquity* 65 (1991): 535.

Davenport, B. and Ross, A., 'Market Overt.' Chapter 17 in N.E. Palmer and E. McKendrick, eds, *Interests in Goods*. London 1993.

Eirenberg, K., 'The United States Reconsiders the 1954 Hague Convention.' *IJCP* 3 (1994): 27-35.
Esterow, M., *The Art Stealers* (1975).

Forder, C., 'The Museums and Galleries Act 1992.' *IJCP* 3 (1994): 131-158.

Gerstenblith, P. 'Guggenheim *v*. Lubell.' *IJCP* 1 (1992): 359-367.

Gould, C., *TheTrophy of Conquest*. London 1965.

Hitchens, C., *The Elgin Marbles*. London 1985.

Hornung, E.W., *The Complete Short Stories of Raffles – The Amateur Cracksman*. London 1984.

Maurice, C. and Turnor, R., 'The Export Licensing Rules in the United Kingdom and the Waverley Criteria.' *IJCP* 1 (1992): 273-295.

Merryman, J.H., 'The Nation and the Object.' *IJCP* 3 (1994): 61-76.

Moat, E., *Memoirs of an Art Thief*. London 1976.

O'Keefe, P.J., 'Mauritius Scheme for the Protection of the Material Cultural Heritage.' *IJCP* 3 (1994): 295-300.

Palmer, N.E., 'Treasure Trove and Title to Discovered Antiquities.' *IJCP* 2 (1993): 275-318.

Prott, L.V., 'Problems of Private International Law for the Protection of the Material Cultural Heritage.' *Recueil des Cours* 217 (1989): 219-317.

Renfrew, C., 'Collectors are the real looters.' *Archaeology* 46 (3) (1993): 16-17.

St. Clair, W., *Lord Elgin and the Marbles*. Oxford 1967.

Siehr, K., 'Manuscript of the Quedlingburg Cathedral Back in Germany.' *IJCP* 1 (1992): 215-217.

Siehr, K., 'The UNIDROIT Draft Convention on the International Protection of Cultural Property.' *IJCP* 3 (1994): 301-307.

Vickers, M., 'Recent Acquisition of Greek and Etruscan Antiquities by the Ashmolean Museum, Oxford 1981-90.' *Journal of Hellenic Studies* 112 (1992): 246-248.

Wilson, D.M., *The British Museum: Purpose and Politics*. London 1989.

The aims of the 1970 UNESCO Convention

on the Means of Prohibiting and Preventing the Illicit Import, Export and Transfer of Ownership of Cultural Property and action being taken by UNESCO to assist in its implementation

Etienne Clément

Most countries in the world have adopted laws to protect their cultural heritage. However a great number of them, mostly in the Third World, do not have sufficient resources to ensure adequate implementation of their laws when cultural objects are increasingly affected by theft and illegal exportation. This is also the case in Eastern Europe where many religious and cultural objects are stolen from churches and subsequently offered for sale on the international art market (a workshop was organised by UNESCO on this subject in Keszthely, Hungary from 21- 23 March 1993 and the list of recommendations adopted is available from UNESCO). In Latin America and Western Africa many archaeological sites are looted (and sometimes even completely destroyed in order to delete all evidence of the looting) thus permanently suppressing any possibility for archaeologists to study the remains of those ancient civilizations. There is no doubt that thefts and clandestine excavations are encouraged by the high prices offered for works of art and antiquities on the international art market. It is therefore understandable that many countries have adopted measures to reduce or even prohibit the export of cultural property. However, it may happen that, in spite of these measures, an object crosses an international border. In such cases the possibility for its country of origin to recover it is rather limited. It is a field in which States must cooperate and UNESCO has undertaken to develop that cooperation.

Such cooperation can take the form of international conventions containing rules which States party to the Convention are obliged to observe. Among the three conventions adopted under the auspices of UNESCO for the protection of cultural heritage, two contain provisions on movable cultural property: the *Convention for the Protection of Cultural Property in the Event of Armed Conflict* (The Hague, 1954) and the *Convention on the Means of Prohibiting and Preventing the Illicit Import, Export and Transfer of Ownership of Cultural Property* (Paris, 1970).

The 1954 Hague *Convention for the Protection of Cultural Property in the Event of Armed Conflict* could be the subject of a separate presentation. I shall only mention that it applies for both movable and immovable cultural property and that it is now under review at UNESCO (Boylan, 1993; UNESCO, 1993).

As to the 1970 Convention against illicit traffic in cultural property, its aim is to reinforce international solidarity between signatory States, in particular between countries victimised by such traffic and countries of destination for such material. It is currently the only universal convention dealing entirely with that question. The United Kingdom is not a State Party to this Convention and people are still not familiar with its aims and content.

According to the Convention it is the responsibility of each State to decide in full sovereignty on the nature of the measures to adopt to comply with the provisions of the Convention, taking into account compatibility with its own internal legal system. The States are invited :

- to create protection services;
- to draft legislative texts;
- to establish, on the basis of the national inventory, a list of important cultural property whose export would constitute an appreciable impoverishment of the national cultural heritage;
- to promote and develop institutions such as museums, libraries and archives;
- to supervise archaeological excavations;
- to establish rules of ethics for curators, collectors and antique dealers;
- to adopt educational measures to stimulate, and develop respect for, the cultural heritage;
- to ensure appropriate publicity for the disappearance of items of cultural property; and
- to institute a system for issuing export certificates which should accompany all items of cultural property exported, to prohibit export without the certificate and to publicise that prohibition, particularly among persons likely to export or import cultural property.

The States Parties are invited to request UNESCO's assistance in this respect.

One of the main provisions **(Article 5)** of the Convention deals with the importation of cultural property. Indeed the States Parties undertake to:

- prevent museums and similar institutions from acquiring cultural property originating in another State Party which has been illegally exported after the entry into force of the Convention in the States concerned;
- to prohibit the import of cultural property stolen from a museum or a religious or secular public monument or similar institution in another State Party after the entry into force of the Convention for the States concerned, provided that such property is in the inventory of that

institution; and
* to take steps, at the request of the State of origin, to recover and return any such cultural property imported after the entry into force of the Convention in both States concerned, provided that the requesting State shall pay just compensation to an innocent purchaser or to a person who has valid title to that property.

This is an essential provision of the Convention. It requests the States Parties to take measures for the return of cultural property to the country of origin even if it is in possession of someone who acquired it legally. Moreover there is no time limitation on that obligation. However, just compensation must be paid to the *bona fide* purchaser, namely, the one who did not know that the object was a stolen one. States who do not require holders of stolen cultural property to be compensated may make a reservation to that provision, as the United States has done.

At the initiative of UNESCO, the International Institute for the Unification of Private Law (UNIDROIT) has undertaken studies on the particular questions of private law regarding the return of cultural property. An experts' working group was set up initially, followed by a meeting of Governmental experts which prepared a draft Convention on the *International Return of Stolen or Illegally Exported Cultural Objects* which would complement the provisions of the 1970 Convention.

In order to deal with the situation of archaeological objects illegally plundered from archaeological sites, which by definition are not registered in an inventory, the Convention contains a specific provision **(Article 9)** by which each State Party whose cultural patrimony is in jeopardy from pillage of archaeological or ethnological materials can call upon other affected States Parties and those States Parties undertake, in these circumstances, to participate in a concerted international effort to determine and to carry out the necessary concrete measures to redress the situation. Moreover, in another provision of the Convention **(Article 13b)**, it is requested that competent services in all States Parties cooperate to facilitate the restitution of illicitly exported cultural property. A concrete example of such cooperation is illustrated by the law adopted by the United States of America to implement the Convention (Convention on Cultural Property Implementation Act, Public Law 97-446, signed by the President of the United States of America on 12 January 1983). The US has banned the import into its territory of archaeological materials from regions of El Salvador, Bolivia, Guatemala, Peru and Mali. To this end these States have submitted to United States authorities, not a list of stolen objects, but a catalogue of the kind of objects which are pillaged in a given area and illegally exported. Some States Parties to the Convention prohibit the import of any cultural object which has been illegally exported from another contracting State.

The Convention also provides **(Article 8)** that penalties should be imposed on any persons who have not respected the prohibition of

exportation or importation. Moreover **(Article 10a)**, the States must oblige antique dealers, subject to penal or administrative sanctions, to maintain a register recording the origin of each item, names and addresses of the supplier, and the description and price of each item sold. These persons should also inform the purchaser of the cultural property of the export prohibition to which such property may be subject.

Eighty-one countries are parties to the Convention, most of them being countries which suffer from illicit traffic. However, because this traffic is international, it cannot be solved only by victim countries. Measures should also be adopted by countries of destination. In order to become a fully efficient instrument for international cooperation it is essential for these countries to become Parties. So far, of these, Argentina, Australia, Canada, Italy and the United States of America have ratified the Convention. Switzerland has announced that it will also become State Party.

The impact of the Convention on the acquisition of cultural property can be seen in the codes of ethics adopted by many museums in the industrialised countries, based on the code of professional ethics of the International Council of Museums (ICOM). Other examples are the codes of practice of antique dealers' associations such as the Code of Practice for the Control of International Trading in Works of Art adopted by members of the United Kingdom's Fine Art and Antiques Trade.

The role of UNESCO is essentially to encourage States to ratify the Convention and, once they have ratified it, to assist them in its implementation. This can be done by assisting in the drafting of national legislation, and in the organisation of regional and national workshops to develop regional cooperation and collaboration between museums, archaeologists, police and customs, (workshops have been organised in South-East Asia, Eastern Europe, Eastern Africa). UNESCO also collects legislative texts on the matter and disseminates them widely: so far legislative texts of 78 countries have been published. A manual on export laws in force in more than 150 countries has also been published (O'Keefe and Prott, 1988). UNESCO also occasionally circulates notices on stolen cultural objects. However, in that field, UNESCO cooperates with other institutions such as INTERPOL, the Customs Cooperation Council, the International Council of Museums, national public institutions and, more recently, with existing private databases such as the International Foundation for Art Research (IFAR) or the Art Loss Register. As to the criminal aspect of the question, UNESCO cooperates with the United Nations Commission for the Prevention of Crimes which is now dealing with the question of crimes against cultural property. The result of such cooperation is a model treaty for the prevention of crimes against the cultural heritage of peoples (United Nations, General Assembly, Resolution 45121 of 14 December 1990) which can be used between States if they want to strengthen their cooperation in the struggle against the loss of cultural property.

The case of Cambodia

As an example of what can be done to assist a country in implementing this Convention, UNESCO's response to the request by the Cambodian authorities for assistance is explained. Cambodia is facing a veritable haemorrhage of its cultural heritage. Statues, bas-reliefs, stone sculptures and entire lintels disappear each day from the famous monuments of Angkor and other lesser-known sites. Thieves attack by night and day, selling extremely valuable objects to unscrupulous traders who will pass them on through a number of hands before they end up gracing the shelves of private collectors in Europe, Japan and North America.

Having ratified the 1970 UNESCO Convention, Cambodia became the first signatory State to call upon UNESCO to assist in laying down a series of measures to combat a traffic which is gradually depriving the country of its exceptional cultural heritage, whose history is still largely unexplored. These measures were presented in a broad programme which was submitted in March 1992 to members of the Supreme National Council of Cambodia presided over by HM Prince Norodom Sihanouk. Before the recent elections which led to the designation of a new Government, the administrative structures of the country after several decades of instability did not allow it to struggle with efficiency against illicit traffic.

In order to define the steps that would have to be taken in cooperation with the national authorities, UNESCO organised a national workshop in July 1992 in Phnom Penh, capital of Cambodia, on the following subjects: education, public information, legislation, site and museum security, export controls by police and customs authorities, and preparation of inventories of cultural goods. More than 120 participants attended, including representatives of several components of the Supreme National Council, the United Nations, Interpol and the International Council of Museums (ICOM). High-level civil servants, police and customs officers, educators, journalists, jurists, conservators and students thus familiarised themselves with specific techniques and participated in short training sessions. Several government ministers took part in the workshop and in the small group sessions. The workshop ended by elaborating an action plan in four major target areas: training, communication, legislation and education. Completely financed by UNESCO, the meeting paved the way for a series of measures which began immediately afterwards with the preparation of legislation for the protection of cultural property which was adopted in February 1993 by a decision of the Supreme National Council.

Action was also taken to strengthen security against theft in museums and storehouses, and an ICOM expert advised officials of the Museum of Phnom Penh on the organisation of a security service and the use of mechanical security devices. Security at the conservation storehouse at Angkor was also reinforced, however the armed attacks on the building that took place in February and in April 1993 demonstrated that much more stringent measures are urgently required.

These recent events and the general situation in Cambodia render it all the more imperative to pursue public information campaigns and to improve the level of awareness and the training of local agents in a variety of disciplines. To this end, a number of initiatives have been undertaken. A poster competition was organised in cooperation with the University of Fine Arts and the prize-winning posters were distributed nationwide to various audiences: the general public, students and tourists. Tourists also receive brochures warning them against the export of cultural goods without appropriate export licenses.

UNESCO has also conducted a far-reaching information programme which has thus far included 120 customs officials, 24 Cambodian journalists, 450 Cambodian police officers responsible for guarding the monuments of Angkor (some of whom received practical training in cooperation with the French police in early 1994), and a number of police officials of the United Nations Transitional Authority in Cambodia (UNTAC).

Alongside these measures UNESCO has supported the efforts of several institutions to compile inventories of movable cultural property, a costly and time consuming effort for which large-scale funding is being sought.

However, it must be recalled that the traffic in cultural goods cannot be stemmed simply by taking measures in the countries victimised by this practice; because the trade is international, action must also be taken in the receiving countries, and, in particular, those with flourishing art markets. This is, of course, the purpose of the 1970 UNESCO Convention, and in order to make its provisions better understood, a regional workshop was organised in Thailand in 1992 for 15 Asian countries, including Cambodia. On this occasion the Thai authorities announced that they were prepared to return to Cambodia cultural goods seized in Thailand. Discussions are under way with Thailand and France to encourage their ratification of the 1970 Convention.

UNESCO, for its part, continues to inform the international media, and programmes and articles have appeared on Radio-France, the BBC, Australian television and in the Thai press. Most recently, the Organisation spearheaded a worldwide information effort with regard to the head of a statue stolen in Cambodia in February 1992. UNESCO also supported the publication of a booklet prepared by the International Council of Museums in cooperation with the École française d'Extrême-Orient which contains photographs and descriptions of 100 cultural objects stolen from Cambodia (ICOM, 1993). This is a very useful document which makes it difficult now to put on sale the objects presented in it. Major auction houses all over the world have received it and additional copies are available from the International Council of Museums.

The example of Cambodia, which must simultaneously confront a difficult political situation and the threat of losing a large part of its cultural heritage, demonstrates clearly the need for a genuine mobilisation of the international community. UNESCO sincerely hope that conferences such

as *Conservation and the Antiquities Trade* and this volume will contribute to this movement of solidarity for the preservation of our cultural heritage.

Abbreviations:

BBC: British Broadcasting Corporation
EFEO: École française d'Extrême-Orient
ICOM: International Council of Museums
INTERPOL: International Criminal Police Organisation
UNESCO: United Nations Educational Scientific and Cultural Organisation
UNIDROIT: International Institute for the Unification of Private Law
UNTAC: United Nations Transitional Authority in Cambodia

References

Boylan, P.J., 1993 *Review of the Convention for the Protection of Cultural Property in the Event of Armed Conflict (The Hague, 1954).* Paris: UNESCO (document CLT-93/WS/12).

ICOM, 1993 *One Hundred Missing Objects, Looting in Angkor.* Paris: ICOM-EFEO.

O'Keefe, P.J. and Prott, L.V., 1988 *Handbook of National Regulations concerning the Export of Cultural Property.* Paris: UNESCO (document CC.88/WS/27).

UNESCO, 1993 *Report by the Director-General on the reinforcement of UNESCO action for the Protection of the World Cultural and Natural*

ANNEX

United Nations Educational, Scientific and
Cultural Organization

Convention on the Means of Prohibiting and Preventing the Illicit Import, Export and Transfer of Ownership of Cultural Property

Adopted by the General Conference at its
sixteenth session, Paris, 14 November 1970

Illicit import, export and transfer of ownership of cultural property

The General Conference of the United Nations Educational, Scientific and Cultural Organization, meeting in Paris from 12 October to 14 November 1970, at its sixteenth session,

Recalling the importance of the provisions contained in the Declaration of the Principles of International Cultural Co-operation, adopted by the General Conference at its fourteenth session,

Considering that the interchange of cultural property among nations for scientific, cultural and educational purposes increases the knowledge of the civilization of Man, enriches the cultural life of all peoples and inspires mutual respect and appreciation among nations,

Considering that cultural property constitutes one of the basic elements of civilization and national culture, and that its true value can be appreciated only in relation to the fullest possible information regarding its origin, history and traditional setting,

Considering that it is incumbent upon every State to protect the cultural property existing within its territory against the dangers of theft, clandestine excavation, and illicit export,

Considering that, to avert these dangers, it is essential for every State to become increasingly alive to the moral obligations to respect its own cultural heritage and that of all nations,

Considering that, as cultural institutions, museums, libraries and archives should ensure that their collections are built up in accordance with universally recognized moral principles,

Considering that the illicit import, export and transfer of ownership of cultural property is an obstacle to that understanding between nations which it is part of Unesco's mission to promote by recommending to interested States, international conventions to this end,

Considering that the protection of cultural heritage can be effective only if organized both nationally and internationally among States working in close co-operation,

Considering that the Unesco General Conference adopted a Recommendation to this effect in 1964,

Having before it further proposals on the means of prohibiting and preventing the illicit import, export and transfer of ownership of cultural property, a question which is on the agenda for the session as item 19,

Having decided, at its fifteenth session, that this question should be made the subject of an international convention,

Adopts this Convention on the fourteenth day of November 1970.

Illicit import, export and transfer of ownership of cultural property

Article 1

For the purposes of this Convention. the term 'cultural property' means property which, on religious or secular grounds, is specifically designated by each State as being of importance for archaeology, prehistory, history, literature. art or science and which belongs to the following categories:

(a) Rare collections and specimens of fauna, flora, minerals and anatomy, and objects of palaeontological interest;

(b) property relating to history, including the history of science and technology and military and social history, to the life of national leaders, thinkers, scientists and artists and to events of national importance;

(c) products of archaeological excavations (including regular and clandestine) or of archaeological discoveries;

(d) elements of artistic or historical monuments or archaeological sites which have been dismembered;

(e) antiquities more than one hundred years old. such as inscriptions, coins and engraved seals;

(f) objects of ethnological interest;

(g) property of artistic interest, such as:

(i) pictures, paintings and drawings produced entirely by hand on any support and in any material (excluding industrial designs and manufactured articles decorated by hand);

(ii) original works of statuary art and sculpture in any material;

(iii) original engravings, prints and lithographs;

(iv) original artistic assemblages and montages in any material;

(h) rare manuscripts and incunabula, old books, documents and publications of special interest (historical, artistic, scientific, literary, etc.) singly or in collections;

(i) postage, revenue and similar stamps, singly or in collections;

(j) archives, including sound, photographic and cinematographic archives;

(k) articles of furniture more than one hundred years old and old musical instruments.

Article 2

1. The States Parties to this Convention recognize that the illicit import, export and transfer of ownership of cultural property is one of the main causes of the impoverishment of the cultural heritage of the countries of origin of such property and that international co-operation constitutes one of the most efficient means of protecting each country's cultural property against all the dangers resulting therefrom.

Illicit import, export and transfer of ownership of cultural property

2. To this end, the States Parties undertake to oppose such practices with the means at their disposal, and particularly by removing their causes, putting a stop to current practices, and by helping to make the necessary reparations.

Article 3

The import, export or transfer of ownership of cultural property effected contrary to the provisions adopted under this Convention by the States Parties thereto, shall be illicit.

Article 4

The States Parties to this Convention recognize that for the purpose of the Convention property which belongs to the following categories forms part of the cultural heritage of each State:

(a) Cultural property created by the individual or collective genius of nationals of the State concerned, and cultural property of importance to the State concerned created within the territory of that State by foreign nationals or stateless persons resident within such territory;

(b) cultural property found within the national territory;

(c) cultural property acquired by archaeological, ethnological or natural science missions, with the consent of the competent authorities of the country of origin of such property;

(d) cultural property which has been the subject of a freely agreed exchange;

(e) cultural property received as a gift or purchased legally with the consent of the competent authorities of the country of origin of such property.

Article 5

To ensure the protection of their cultural property against illicit import, export and transfer of ownership, the States Parties to this Convention undertake, as appropriate for each country, to set up within their territories one or more national services, where such services do not already exist, for the protection of the cultural heritage, with a qualified staff sufficient in number for the effective carrying out of the following functions:

Illicit import, export and transfer of ownership of cultural property

(a) Contributing to the formation of draft laws and regulations designed to secure the protection of the cultural heritage and particularly prevention of the illicit import, export and transfer of ownership of important cultural property;

(b) establishing and keeping up to date, on the basis of a national inventory of protected property, a list of important public and private cultural property whose export would constitute an appreciable impoverishment of the national cultural heritage;

(c) promoting the development or the establishment of scientific and technical institutions (museums, libraries, archives, laboratories, workshops...) required to ensure the preservation and presentation of cultural property;

(d) organizing the supervision of archaeological excavations, ensuring the preservation 'in situ' of certain cultural property, and protecting certain areas reserved for future archaeological research;

(e) establishing, for the benefit of those concerned (curators, collectors, antique dealers, etc.) rules in conformity with the ethical principles set forth in this Convention; and taking steps to ensure the observance of those rules;

(f) taking educational measures to stimulate and develop respect for the cultural heritage of all States, and spreading knowledge of the provisions of this Convention;

(g) seeing that appropriate publicity is given to the disappearance of any items of cultural property.

Article 6

The States Parties to this Convention undertake:

(a) To introduce an appropriate certificate in which the exporting State would specify that the export of the cultural property in question is authorized. The certificate should accompany all items of cultural property exported in accordance with the regulations;

(b) to prohibit the exportation of cultural property from their territory unless accompanied by the above-mentioned export certificate;

(c) to publicize this prohibition by appropriate means, particularly among persons likely to export or import cultural property.

Article 7

The States Parties to this Convention undertake:

(a) To take the necessary measures, consistent with national legislation, to prevent museums and similar institutions within their territories from acquiring cultural

Illicit import, export and transfer of ownership of cultural property

property originating in another State Party which has been illegally exported after entry into force of this Convention, in the States concerned. Whenever possible, to inform a State of origin Party to this Convention of an offer of such cultural property illegally removed from that State after the entry into force of this Convention in both States;

(b) (i) to prohibit the import of cultural property stolen from a museum or a religious or secular public monument or similar institution in another State Party to this Convention after the entry into force of this Convention for the States concerned, provided that such property is documented as appertaining to the inventory of that institution;

(ii) at the request of the State Party of origin, to take appropriate steps to recover and return any such cultural property imported after the entry into force of this Convention in both States concerned, provided, however, that the requesting State shall pay just compensation to an innocent purchaser or to a person who has valid title to that property. Requests for recovery and return shall be made through diplomatic offices. The requesting Party shall furnish, at its expense, the documentation and other evidence necessary to establish its claim for recovery and return. The Parties shall impose no customs duties or other charges upon cultural property returned pursuant to this Article. All expenses incident to the return and delivery of the cultural property shall be borne by the requesting Party.

Article 8

The States Parties to this Convention undertake to impose penalties or administrative sanctions on any person responsible for infringing the prohibitions referred to under Articles 6(b) and 7(b) above.

Article 9

Any State Party to this Convention whose cultural patrimony is in jeopardy from pillage of archaeological or ethnological materials may call upon other States Parties who are affected. The States Parties to this Convention undertake, in these circumstances, to participate in a concerted international effort to determine and to carry out the necessary concrete measures, including the control of exports and imports and international commerce in the specific materials concerned. Pending agreement each State concerned shall take provisional measures to the extent feasible to prevent irremediable injury to the cultural heritage of the requesting State.

Illicit import, export and transfer of ownership of cultural property

Article 10

The States Parties to this Convention undertake:
(a) To restrict by education, information and vigilance, movement of cultural property illegally removed from any State Party to this Convention and, as appropriate for each country, oblige antique dealers, subject to penal or administrative sanctions, to maintain a register recording the origin of each item of cultural property, names and addresses of the supplier, description and price of each item sold and to inform the purchaser of the cultural property of the export prohibition to which such property may be subject;
(b) to endeavour by educational means to create and develop in the public mind a realization of the value of cultural property and the threat to the cultural heritage created by theft, clandestine excavations and illicit exports.

Article 11

The export and transfer of ownership of cultural property under compulsion arising directly or indirectly from the occupation of a country by a foreign power shall be regarded as illicit.

Article 12

The States Parties to this Convention shall respect the cultural heritage within the territories for the international relations of which they are responsible, and shall take all appropriate measures to prohibit and prevent the illicit import, export and transfer of ownership of cultural property in such territories.

Article 13

The States Parties to this Convention also undertake, consistent with the laws of each State:
(a) To prevent by all appropriate means transfers of ownership of cultural property likely to promote the illicit import or export of such property;
(b) to ensure that their competent services co-operate in facilitating the earliest possible restitution of illicitly exported cultural property to its rightful owner;
(c) to admit actions for recovery of lost or stolen items of cultural property brought

Illicit import, export and transfer of ownership of cultural property

by or on behalf of the rightful owners;

(d) to recognize the indefeasible right of each State Party to this Convention to classify and declare certain cultural property as inalienable which should therefore *ipso facto* not be exported, and to facilitate recovery of such property by the State concerned in cases where it has been exported.

Article 14

In order to prevent illicit export and to meet the obligations arising from the implementation of this Convention, each State Party to the Convention should, as far as it is able, provide the national services responsible for the protection of its cultural heritage with an adequate budget and, if necessary, should set up a fund for this purpose.

Article 15

Nothing in this Convention shall prevent States Parties thereto from concluding special agreements among themselves or from continuing to implement agreements already concluded regarding the restitution of cultural property removed, whatever the reason, from its territory of origin, before the entry into force of this Convention for the States concerned.

Article 16

The States Parties to this Convention shall in their periodic reports submitted to the General Conference of the United Nations Educational, Scientific and Cultural Organization on dates and in a manner to be determined by it, give information on the legislative and administrative provisions which they have adopted and other action which they have taken for the application of this Convention, together with details of the experience acquired in this field.

Article 17

1. The States Parties to this Convention may call on the technical assistance of the United Nations Educational, Scientific and Cultural Organization, particularly as regards:

Illicit import, export and transfer of ownership of cultural property

(a) Information and education;
(b) consultation and expert advice;
(c) co-ordination and good offlces.

2. The United Nations Educational, Scientific and Cultural Organization may, on its own initiative conduct research and publish studies on matters relevant to the illicit movement of cultural property.

3. To this end, the United Nations Educational, Scientific and Cultural Organization may also call on the co-operation of any competent non-governmental organization.

4. The United Nations Educational, Scientific and Cultural Organization may, on its own initiative, make proposals to States Parties to this Convention for its implementation.

5. At the request of at least two States Partics to this Convention which are engaged in a dispute over its implementation, Unesco may extend its good offices to reach a settlement between them.

Article 18

This Convention is drawn up in English, French, Russian and Spanish, the four texts being equally authoritative.

Article 19

1. This Convention shall be subject to ratification or acceptance by States members of the United Nations Educational, Scientific and Cultural Organization in accordance with their respective constitutional procedures.

2. The instruments of ratification or acceptance shall be deposited with the Director-General of the United Nations Educational, Scientific and Cultural Organization.

Article 20

1. This Convention shall be open to accession by all States not members of the United Nations Educational, Scientific and Cultural Organization which are invited to accede to it by the Executive Board of the Organization.

Illicit import, export and transfer of ownership of cultural property

2. Accession shall be effected by the deposit of an instrument of accession with the Director-General of the United Nations Educational, Scientific and Cultural Organization.

Article 21

This Convention shall enter into force three months after the date of the deposit of the third instrument of ratification, acceptance or accession, but only with respect to those States which have deposited their respective instruments on or before that date. It shall enter into force with respect to any other State three months after the deposit of its instrument of ratification, acceptance or accession.

Article 22

The States Parties to this Convention recognize that the Convention is applicable not only to their metropolitan territories but also to all territories for the international relations of which they are responsible; they undertake to consult, if necessary, the governments or other competent authorities of these territories on or before ratification, acceptance or accession with a view to securing the application of the Convention to those territories, and to notify the Director-General of the United Nations Educational, Scientific and Cultural Organization of the territories to which it is applied, the notification to take effect three months after the date of its receipt.

Article 23

1. Each State Party to this Convention may denounce the Convention on its own behalf or on behalf of any territory for whose international relations it is responsible.

2. The denunciation shall be notified by an instrument in writing, deposited with the Director-General of the United Nations Educational, Scientific and Cultural Organization.

3. The denunciation shall take effect twelve months after the receipt of the instrument of denunciation.

Illicit import, export and transfer of ownership of cultural property

Article 24

The Director-General of the United Nations Educational, Scientific and Cultural Organization shall inform the States members of the Organization, the States not members of the Organization which are referred to in Article 20, as well as the United Nations, of the deposit of all the instruments of ratification, acceptance and accession provided for in Articles 19 and 20, and of the notifications and denunciations provided for in Articles 22 and 23 respectively.

Article 25

1. This Convention may be revised by the General Conference of the United Nations Educational, Scientific and Cultural Organization. Any such revision shall, however, bind only the States which shall become Parties to the revising convention.

2. If the General Conference should adopt a new convention revising this Convention in whole or in part, then, unless the new convention otherwise provides, this Convention shall cease to be open to ratification, acceptance or accession, as from the date on which the new revising convention enters into force.

Article 26

In conformity with Article 102 of the Charter of the United Nations, this Convention shall be registered with the Secretariat of the United Nations at the request of the Director-General of the United Nations Educational, Scientific and Cultural Organization.

Done in Paris this seventeenth day of November 1970, in two authentic copies bearing the signature of the President of the sixteenth session of the General Conference and of the Director-General of the United Nations Educational, Scientific and Cultural Organization, which shall be deposited in the archives of the United Nations Educational, Scientific and Cultural Organization, and certified true copies of which shall be delivered to all the States referred to in Articles 19 and 20 as well as to the United Nations.

Illicit import, export and transfer of ownership of cultural property

The foregoing is the authentic text of the Convention duly adopted by the General Conference of the United Nations Educational, Scientific and Cultural Organization during its sixteenth session, which was held in Paris and declared closed the fourteenth day of November 1970.

IN FAITH WHEREOF we have appended our signatures this seventeenth day of November 1970.

The President of the General Conference
Atilio dell-Oro Maini

The Director-General
Rene Maheu

National and international laws
on the protection of the cultural heritage

Lyndel V. Prott

Introduction

Conservators are often asked to advise, or work, on archaeological objects. In some cases, as where an object has been in a museum for a very long time, the provenance, or at least the later history of the object, is well recorded. In others, however, the provenance is less clear. This poses a practical question as well as a moral problem for the conservator: does the object come from an illegal excavation? If so, servicing the object may add to its value, thus encouraging those who acquire objects from clandestine excavation.

The damage done by illicit excavation is well known but bears repeating here. It destroys the scientific value of the site by damaging the site's stratigraphy, and of the object, by wrenching it out of its context. Information for comparative dating, style assessment or relation to other objects in the site is thus lost. The site itself is destroyed by inexpert excavation, non-recording and non-publication. The excavated objects are very often damaged by inexpert excavation and by lack of proper conservation—this is particularly true of artefacts 'salvaged' from underwater sites. Part of the cultural record is also lost to expert assessment by the disappearance of these objects into private collections which are not accessible to the public or to researchers and by the find itself being not professionally recorded, curated and published.

Objects also appear on the market which have been stolen. In ten years from 1978 to 1988 in Tamil Nadu, only one of the 21 states comprising the Union of India, there have been between 800–1,000 temple idol thefts *(Bumper Development Case*, 1988). Pieces detached from monuments, such as the heads of Khmer statues, are also common. Pre-Colombian grave-goods are frequently looted (examples are the case of *Republic of Ecuador* v. *Danusso*, where 12,000 artefacts were recovered from Italy—all the work of one dealer, and the grave-goods of Sipán, so badly looted that they are now the subject of an import ban in the United States)—these need to be brought to pristine condition for lucrative sale. In all such cases conservators may be applied to for their services.

National legal controls

One argument that is often made is that the States whence these objects are taken have not themselves taken adequate measures to prevent clandestine excavation or theft, and that, therefore, there should be no guilt in servicing objects taken from their territory. This raises the question of what measures of control can, in fact, be taken by national States to protect the archaeological heritage.

Standards for national control of excavation were set in the UNESCO Recommendation on International Principles Applicable to Archaeological Excavations 1956. This Recommendation has become the *de facto* standard for the legal control of archaeological activity and, though it could be updated in some respects, it still remains the basic reference. It provides (Art. 29) that all UNESCO members should take all necessary measures to prevent clandestine excavation.

Firstly, excavation without a licence should be legally prohibited. Almost all States with important archaeological resources have taken this step, though some such legislation requires updating. Second, many States have claimed property in the archaeological subsoil, so that all finds belong to the State. (It is perhaps noteworthy that the United Kingdom has taken neither of these steps.) Most States also provide for a duty to report finds, and some reinforce this by providing some kind of reward. A few States forbid the use of metal detectors: Sweden absolutely forbids their use without a licence; Ireland and Israel provide that, where a person is found on an archaeological site with a metal detector, that person is presumed to intend to excavate. Other States expressly provide for the confiscation of objects clandestinely excavated, and yet others for the forfeiture of equipment used for this purpose.

None of these provisions, however severe, will deter the clandestine operator unless the risks of detection and prosecution are high. This means adequate site control. Unfortunately, there are some States with great archaeological riches which do not have the resources to patrol them sufficiently—perhaps because the sites are in sparsely populated areas, are difficult of access or simply because the density of important sites is beyond the resources of their police or even military forces to cover adequately .

No country has succeeded in completely deterring theft, and theft of cultural objects is increasing dramatically. Museums in the West with the most sophisticated security apparatus have been robbed. The prospect for rural communities in poor countries, for indigenous populations and for religious buildings everywhere, faced with the rapacity of the international market for cultural goods, is dismal. As a support to the provisions on clandestine excavation and theft, many countries have introduced controls on the export of cultural objects. However these controls are not recognised nor applied by many 'art-importing' or 'art market' countries. Thus it is very difficult for 'art exporting' countries to control illicit excavation.

Furthermore, it should be borne in mind that often the actual digging is done by impoverished local populations who are exploited by runners and dealers. While their plight must have our sympathy, it is clear that the pittance they are paid for destroying the cultural heritage of their country bears very little relation to the rewards reaped by the middle men. To give some examples: the Taranaki panels, carved of wood, were sold by their excavator in New Zealand to an English dealer for $6,000, resold by the dealer in New York a few weeks later for $65,000 and assessed for sale at Sotheby's five years later at £300,000. The landless illiterate labourer who found a buried Siva Nataraja in the Indian state of Tamil Nadu was paid 200 rupees (about £12) by a dealer's runner. Six years later it was sold in London for £250,000.

By profession, conservators are those who preserve the cultural heritage and use their skills on individual items to ensure their survival. However, it is clear that they are sometimes asked to provide their expert services for objects which have been illegally excavated in the country of origin, very often also illegally exported, with the consequences listed above, as well as with the further result of encouraging the exploitation of poverty-stricken groups in the country involved.

International Co-operation

The impossibility, for many States, of achieving adequate control over illicit excavation has led them to seek international co-operation in the application of their rules on illegal excavation and illegal export. Etienne Clément has discussed the principal international instrument in this field, the *1970 UNESCO Convention on the Means of Prohibiting and Preventing the Illicit Import, Export and Transfer of Ownership of Cultural Property* (see Clément in this volume). However many 'art importing' and 'art market' States have not become Party to that Convention. Major art market States such as Belgium, France, Germany, Japan, the Netherlands and the United Kingdom have not become Party, although the United States has. Switzerland has announced its intention to become so and is currently consulting its cantonal authorities in the necessary constitutional process to enable its accession.

However, since 1970, attitudes have been evolving. Although some States such as the United Kingdom have not become Party to the UNESCO convention, professionals within those States may be subject to Codes of Ethics or Practice which limit their activities in relation to illegally excavated goods. The major auctioneers and dealers in the United Kingdom have adopted a Code of Practice which obliges the signatories not to import, export or transfer the ownership of objects which have been acquired in or exported from their country of export in violation of that country's laws. This applies also to objects acquired dishonestly or illegally from an official excavation site or monument or which have originated from an illegal, clandestine or otherwise unofficial site (full text of this Code in Annex I).

If dealers are committed not to handle such material, professionals in the preservation of the cultural heritage should *a fortiori* be constrained. This is reflected in the ICOM *Code of Ethics* of 1986 which provides that members of the museum profession should not identify or otherwise authenticate objects where they have reason to believe or suspect that these have been illegally or illicitly acquired, transferred, imported or exported and that it is highly unethical for museums or the museum profession to support *either directly or indirectly* the illicit trade in cultural or natural objects. Under no circumstances, states the Code, should they act in a way that could be regarded as benefitting such illicit trade, directly or indirectly. Where there is reason to believe or suspect illicit or illegal transfer, import or export, the competent authorities should be notified.

Evaluation, authentication or conservation by a qualified conservator will probably increase the saleability and the sale value of an object. For instance, the Northern Kwakiutl thunderbird headdress, subject of an application for an export licence under Canadian legislation: its value was estimated in the application as Can$45,000. The expert examiner recommended that the permit be refused and the dealer appealed. Before the hearing of the appeal, extensive restoration work was carried out, the object shown to an American client and an offer of US$75,000 received (Department of Communications, Canada, 1984). The dealer's action had the effect of substantially increasing the price of the object (and perhaps, in view of the controversial nature of the 'restoration', of lessening the interest of the Canadian museums in the object). In any event, no Canadian institution was prepared to pay the asking price and the export permit was issued. This gives an indication of the 'mark-up' which a restoration may bring, and of the incentive for dealers to find compliant 'conservators'.

Although many conservators are bound by the ICOM *Code of Ethics*, their own professional organisations could well consider whether their Codes of Ethics should include similar restraints on the servicing of objects which do not have a sure provenance excluding illicit excavation or illicit export. Professional Codes now exist for conservators such as that of The International Committee for Ethics in Conservation established in 1977 at the Royal Swedish Academy of Fine Arts, the United Kingdom Institute for Conservation (UKIC), the American Institute for Conservation (AIC), the Canadian Conservation Institute and the Australian Institute for the Conservation of Cultural Material Inc. (AICCM). These Codes deal with relations of the conservator to the object, to its owner, and sometimes also to the general public. The AIC Code, for example, provides (Art. V.B.) that:

> In the interests of the public as well as their own profession, conservators should observe *accepted standards and laws*, uphold the dignity and honour of the profession and accept its self-imposed disciplines. They should do their part to safeguard the public against illegal or unethical conduct by referring the facts of such delinquency to the appropriate professional committee.

The Australian Code precedes rules of 'Guidance for Conservation Practice' by a 'Code of Ethics for the Practice of Conservation of Cultural Material in Australia' which includes six general principles the first of which reads:

> It is the responsibility of the *conservator*, acting alone or with others, to constantly strive to maintain a balance between the *cultural needs of society* and the preservation of cultural material.

'Accepted standards and laws' should include rules against encouraging the illicit trade, and the 'cultural needs of society' should include the need to inhibit as far as possible the illicit trade. Although none of these Codes, therefore, has specific provision excluding work on objects which have been illicitly excavated or traded, it is appropriate to include that provision among the conservators' responsibilities. In future provisions of the Code, conservators may wish to include specific provision to this effect.

UNIDROIT Draft Convention on Stolen or Illegally Exported Cultural Objects

Apart from the developments in terms of professional codes of ethics, there have also been efforts to improve international co-operation by legal means.

The European Community has adopted a Directive and Regulation which provides that cultural objects 'illegally removed' (this would appear to include clandestine excavation) from member States would be returned.

The Law Ministers of the Commonwealth of 51 States with Common Law based legal systems agreed in Mauritius in November 1993 to adopt a scheme which will involve the recognition and application of the export laws of countries within the Commonwealth relating to the cultural heritage.

Finally there is the UNIDROIT Draft *Convention on Stolen or Illegally Exported Cultural Objects*. In 1984 UNESCO asked UNIDROIT (the International Institute for the Unification of Private Law) to work on the rules applicable to illicit traffic in cultural objects to complement the 1970 UNESCO *Convention on the Means of Prohibiting and Preventing the Illicit Import, Export and Transfer of Ownership of Cultural Property*. UNESCO was concerned with enhancing the effectiveness of the 1970 UNESCO Convention and ensuring its wider universality. It noted that the Convention raised, but did not solve, a number of important issues of private law (such as the impact on existing rules of national law concerning the protection of the *bona fide* purchaser) which an international organisation of private law would be the proper forum to resolve. It was also aware that the drafting of the 1970 Convention was felt by some States to be not sufficiently clear eg there was a general obligation to respect the laws of export control of other States (Art. 3) but specific provisions spelt out these obligations only in respect of cultural objects which were stolen from museums and similar

institutions and were inventoried (Art. 7) and in respect of objects of archaeological interest (Art. 9). Finally it knew that a number of States felt that the scope of application of the Convention (eg the precise relationship of Article 1 to the rest of the Convention) was not sufficiently clear, and that a broad interpretation would create an unmanageable interference with the legal trade in cultural objects.

UNIDROIT began by preparing two expert reports (Reichelt, 1985, 1988) on the subject. Subsequently, three meetings were held, in 1988, 1989 and 1990 of a Study Group of Experts who developed the text of a Preliminary Draft. This Study Group comprised legal experts from various legal systems and from 'exporting' as well as from 'importing' countries, including experts with special experience in illicit traffic and in legal trade in cultural objects, and included two consultants to UNESCO. The text which they prepared was studied at four sessions of a meeting of governmental experts held in Rome in May 1991, January 1992, February 1993 and September-October 1993. These meetings discussed the complex of problems raised by legal techniques which would restrain illicit traffic, and the particular solutions suggested by the Study Group. The broadest participation in any one meeting was by 53 States, but altogether 74 States have been involved in the negotiations at one time or another.

The fourth session of the meeting of governmental experts settled a text which will be put before a Diplomatic Conference for adoption towards in June 1995. The text represents a compromise of diverse positions between legal systems based on very different principles (see Annex II). One critical issue which will have to be settled by the diplomatic conference is that of the length of time within which claims can be made (prescription/ imprescriptibility) and whether longer periods should be allowed for specific categories of cultural object.

The draft Convention, if finally adopted, will not affect the legal status of items transferred before its entry into force. Claims for these objects, if not subject to the 1970 UNESCO Convention (now in force for 81 States), will still have to be resolved through bilateral negotiation or through UNESCO's Intergovernmental Committee for Promoting the Return of Cultural Property to its Countries of Origin or its Restitution in case of Illicit Appropriation.

Most Continental European States, which are not at present Party to the UNESCO Convention, are being asked to institute a fundamental change by returning stolen cultural property and some illicitly exported cultural objects rather than protecting the *bona fide* purchaser; in return they will also profit by being able to claim cultural property stolen or illegally exported from them. All the States of the Common Market, Switzerland, Austria and the Scandinavian countries have been present at the negotiations. The change in rules protecting the *bona fide* purchaser is a major legal revolution for most of these coutnries. In cases where the Constitution guarantees the right to private property and the ownership of the property at present is declared by the Civil Code of the country to pass to the *bona*

fide purchaser after no lapse (Italy) or a relatively short period of time, the new rules will have to be very carefully presented to the public in those countries. Nonetheless, the present indications are that the majority of these States recognises the very serious problem of illicit traffic and is prepared to take major steps to assist in international cooperation.

Although most Common Law States will be able to retain their rules on the return of cultural property (which are more generous than those in the draft in recognising the rights of the original owner), they will need to look to their rules on the time restrictions of claims. The United Kingdom seems to be the least generous to the original owner before vesting the title on the *bona fide* purchaser, but at least gives him six years to claim the object stolen from him. In other Common Law systems, restitution to the original owner is generally subject only to the rules placing a time limit on claims. Legal decisions in the United States, for instance, assess the time limit from the date on which the owner knew, or ought reasonably to have known, where the object was (Prott, 1989: 259–260). Common law countries, including the United Kingdom, will, if the daft is adopted, have the opportunity to recover objects previously irrecoverable because they are in the hands of a *bona fide* purchaser in a State which gave protection to that *bona fide* purchaser.

The Convention, if adopted, should also have the effect of reversing the practice in the art trade whereby little information is given and few questions asked. If purchasers begin to ask questions, it should be less easy for traffickers to pass on their illegally acquired goods and illicit traffic should become, therefore, less attractive to its perpetrators. In any event, it should become impossible for well-meaning private collectors, as it already is for responsible, ethically aware museums, to contribute to the illicit traffic by not insisting on proper documents of provenance.

One of the most difficult issues faced by the drafters of the UNIDROIT Convention was the question of defining cultural objects. In whatever way this is finally worked out (and the present proposal is to have a definition provision which runs parallel to that of the UNESCO Convention) it is absolutely certain that objects of archaeological interest will be dealt with.

There has been a complex discussion as to whether objects which are the result of clandestine excavations should be covered in Chapter II, which deals with stolen cultural objects as well as in Chapter III, which deals with illegally exported cultural objects. The chief difference is the stricter degree of care required of an acquirer under Chapter II (stolen cultural objects) than under Chapter III (illegally exported cultural objects). The preliminary draft which was the basis of the further work of governmental experts had the merit of allowing recovery of clandestinely excavated objects *when they could be proved to be stolen* subject to the stricter duty of diligence, and leaving other clandestinely excavated objects to be recovered, where no offence against ownership could be shown, according to the provisions of Chapter III.

While the UNESCO Convention refers to cultural objects which have been 'specifically designated by each State as being of importance for archaeology, prehistory, history, literature, art or science', the view of the experts who drew up the preliminary draft was that there was wide agreement on the necessity of returning stolen objects, whether those objects were in public or in private hands, and whether or not they were subject to designation by a national State. Some States do not have designation systems: recovery of stolen cultural objects from those countries should nonetheless be possible under the UNIDROIT draft which speaks only of 'cultural objects which… are of importance for archaeology, prehistory, literature, art or science'. The UNIDROIT formulation is also important for the many countries where a great deal of cultural material is in the hands of private owners: no additional remedy to that given by national private law is given in the UNESCO Convention, but the provisions of Chapter II of the UNIDROIT Draft will now oblige States to create such a remedy where it previously did not exist (eg where a *bona fide* purchaser is protected to the exclusion of the robbed owner).

Whatever time limit is finally selected for the barring of claims, the draft lays down rules for the date from which the time runs. There will be hard decisions to take between those who want no time limitation of claims at all, and those who want a very short one. However, whatever period is selected, the draft provides that the claim is to be brought within the period 'from the time when the claimant knew or ought reasonably to have known the location of the object and the identity of its possessor'. The present draft provides for a short period to apply from this acquisition of knowledge, and a longer, complete bar irrespective of when the knowledge is acquired. Both these periods will be the subject of lively negotiation at the diplomatic conference.

A revolutionary aspect of the draft for many legal systems is Article 4 (2) which requires that compensation will only be paid to an acquirer who has to return an object if he has exercised due diligence in acquiring it.

> In determining whether the possessor exercised due diligence, regard shall be had to the circumstances of the acquisition, including the character of the parties, the price paid, whether the possessor consulted any reasonably accessible register of stolen cultural objects and any other relevant information and documentation which it could reasonably have obtained.

This provision will place purchasers on notice that various registers of stolen cultural property applicable to the kind of object being acquired should be consulted and their ownership will not be protected if they do not do so. It is also evident that, where the object is an antiquity, appropriate journals concerning the particular culture from which the antiquity comes which have reported losses, or excavation reports which indicate the likely origin of goods, should be consulted.

Legal Issues

The Limits of the Law

Despite these current efforts, it must be noted that it is extremely difficult to ensure the return of illegally excavated objects to their country of origin and it is also, from a cultural view, no substitution for proper recorded excavation. Once removed from its context, much of the scientific value has been lost. The difficulty of proving that a particular object found in another country has been illegally excavated has been shown in numerous cases—looters do not keep records which will prove the origin of the goods. The most that the new international legal provisions can do is to try to affect the consumers' end of the market by alerting them to the colossal damage being done to the world cultural heritage by the organised looting done to feed the international market. A higher level of awareness by public and professionals alike would have a major effect on the traffickers' ease of disposal and estimates of profit.

Conclusion

The expertise in art works and antiquities in art market countries tends to organise the art trade so that if flows through them. Without the services provided by their residents in authenticating, evaluating, conserving, restoring, auctioning and publicising these objects, much of the drive behind the trade would be lost. Unfortunately, these services may be applied as much to the illicit trade as to the licit trade. Increasing the profits of the middle man or unscrupulous buyer by adding to the value of illicitly acquired goods increases the incentive to trade in them. Professional conservators therefore need to be particularly fastidious when asked to give their expertise on archaeological objects.

Update

On 23 June 1995 the Diplomatic Conference held in Rome to adopt the UNIDROIT Convention accepted a compromise package on the substance negotiated with difficulty in the last week by a small group of countries from both sides of the issue who had major problems with the text as it was emerging from the conference.

The text now expressly excludes retroactivity, but also stipulates that illegal transfers of cultural property before its entry into force are not legitimated in any way. Claims for a stolen cultural object must be made within three years of knowing its location and the identity of the holder and at any rate within 50 years. Where an object is from a public collection (specially defined) or monument, or is for the ritual or traditional use of an indigenous community, a State which does not place time limits on such claims for its own such objects may not limit claims for such objects stolen from other contracting parties, but those which do may by declaration limit claims to 75 years. Rules of diligence apply both to stolen and (more mildly) to illicitly imported objects.

References

Department of Communications (Canada), *Annual Report 1982-1983*, 19-20.

ICOM, 1993. *One Hundred Missing Objects: Looting at Angkor*. Paris.

Kirkpatrick, S.D., 1992. *Lords of Sipan*. New York: Morrow.

Prott, L.V., 1989. 'Problems of Private International Law for the Protection of the Cultural Heritage' 1989 *Recueil des Cours* 217: 219–317.

Reichelt, G., 1985. 'International Protection of Cultural Property' (1985) *Uniform Law Review* 43.

Reichelt, G., 1988 . 'Second Study Requested from UNIDROIT by UNESCO on the International Protection of Cultural Property with Particular Reference to the Rules of Private Law Affecting the Transfer of Title to Cultural Property in the Light also of the Comments Received on the first Study.' Rome: UNIDROIT.

Republic of Ecuador v. *Danusso* (District Court of Turin, 4410/79; Court of Appeal of Turin, 593/82).

Union of India v. *Bumper Development Corporation Ltd.* (unreported decision, Queens Bench Division - 17 February 1988).

ANNEX I

CODE OF PRACTICE FOR THE CONTROL OF INTERNATIONAL TRADING IN WORKS OF ART

1. In view of the world-wide concern expressed over the traffic in stolen antiques and works of art and the illegal export of such objects, the U.K. fine art and antiques trade wishes to codify its standard practice as follows:

2. Members of the U.K. fine art and antiques trade undertake, to the best of their ability, not to import, export or transfer the ownership of such objects where they have reasonable cause to believe:

(a) The seller has not established good title to the object under the laws of the U.K., i.e. whether it has been stolen or otherwise illicitly handled or acquired.

(b) That an imported object has been acquired in or exported from its country of export in violation of that country's laws.

(c) That an imported object was acquired dishonestly or illegally from an official excavation site or monument or originated from an illegal, clandestine or otherwise unofficial site.

3. Members also undertake not to exhibit, describe, attribute, appraise or retain any object with the intention to promote or fail to prevent its illicit transfer or export.

4. Where a member of the U.K. fine art and antiques trade comes into possession of an object that can be demonstrated beyond reasonable doubt to have been illegally exported from its country of export and the country of export seeks its return within a reasonable period, that member, if legally free to do so, will take responsible steps to cooperate in the return of that object to the country of export. Where the code has been breached unintentionally, satisfactory reimbursement should be agreed between the parties.

5. Violations of this code of practice will be rigorously investigated.

6. This code which is intended to apply to all objects usually traded in the fine art and antiques market and to all persons active in that market has been subscribed by the following organisations: Christie Manson & Woods Ltd., Sotheby Parke Bernet & Co., the Society of London Art Dealers, the British Antique Dealers' Association, the Society of Fine Art Auctioneers, the Incorporated Society of Valuers and Auctioneers, the Antiquarian Booksellers' Association, the Royal Institute of Chartered Surveyors, the Fine Art Trade Guild, the British Association of Removers and the Antiquities Dealers' Association.

ANNEX II
DRAFT UNIDROIT CONVENTION ON THE
INTERNATIONAL RETURN OF STOLEN OR ILLEGALLY EXPORTED
CULTURAL OBJECTS
as resulted from the fourth session of the Unidroit committee
of governmental experts on the international protection of cultural property
(Rome, 29 September - 8 October 1993)

CHAPTER I - SCOPE OF APPLICATION AND DEFINITION

Article 1

This Convention applies to claims of an international character for

(a) the restitution of stolen cultural objects removed from the territory of a Contracting State;

(b) the return of cultural objects removed from the territory of a Contracting State contrary to its law regulating the export of cultural objects because of their cultural significance.

Article 2

For the purposes of this Convention, cultural objects are those which, on religious or secular grounds, are of importance for archaeology, prehistory, history, literature, art or science such as those objects belonging to the categories listed in Article 1 of the 1970 UNESCO Convention on the Means of Prohibiting and Preventing the Illicit Import, Export and Transfer of Ownership of Cultural Property.

CHAPTER II - RESTITUTION OF STOLEN CULTURAL OBJECTS

Article 3

(1) The possessor of a cultural object which has been stolen shall return it.

(2) For the purposes of this Convention, an object which has been unlawfully excavated or lawfully excavated and unlawfully retained shall be deemed to have been stolen.

(3) Any claim for restitution shall be brought within a period of [one] [three] year[s] from the time when the claimant knew or ought reasonably to have known the location of the object and the identity of its possessor, and in any case within a period of [thirty] [fifty] years from the time of the theft.

(4) However, a claim for restitution of an object belonging to a public collection of a Contracting State [shall not be subject to prescription] [shall be brought within a time limit of [75] years].

[For the purposes of this paragraph, a "public collection" consists of a collection of inventoried cultural objects, which is accessible to the public on a [substantial and] regular basis, and is the property of

(i) a Contracting State [or local or regional authority],

(ii) an institution substantially financed by a Contracting State [or local or regional authority],

(iii) a non-profit institution which is recognised by a Contracting State [or local or regional authority] (for example by way of tax exemption) as being of [national] [public] [particular] importance, or

(iv) a religious institution.]

Article 4

(1) The possessor of a stolen cultural object who is required to return it shall be entitled at the time of restitution to payment by the claimant of fair and reasonable compensation provided that the possessor neither knew nor ought reasonably to have known that the object was stolen and can prove that it exercised due diligence when acquiring the object.

(2) In determining whether the possessor exercised due diligence, regard shall be had to the circumstances of the acquisition, including the character of the parties, the price paid, whether the possessor consulted any reasonably accessible register of stolen cultural objects, and any other relevant information and documentation which it could reasonably have obtained.

(3) The possessor shall not be in a more favourable position than the person from whom it acquired the object by inheritance or otherwise gratuitously.

CHAPTER III - RETURN OF ILLEGALLY EXPORTED CULTURAL OBJECTS

Article 5

(1) A Contracting State may request the court or other competent authority of another Contracting State acting under Article 9 to order the return of a cultural object which has

(a) been removed from the territory of the requesting State contrary to its law regulating the export of cultural objects because of their cultural significance;

(b) been temporarily exported from the territory of the requesting State under a permit, for purposes such as exhibition, research or restoration, and not returned in accordance with the terms of that permit [, or

(c) been taken from a site contrary to the laws of the requesting State applicable to the excavation of cultural objects and removed from that State].

(2) The court or other competent authority of the State addressed shall order the return of the object if the requesting State establishes that the removal of the object from its territory significantly impairs one or more of the following interests

(a) the physical preservation of the object or of its context,

(b) the integrity of a complex object,

(c) the preservation of information of, for example, a scientific or historical character,

(d) the use of the object by a living culture,

or establishes that the object is of outstanding cultural importance for the requesting State.

(3) Any request made under paragraph 1 shall contain or be accompanied by such information of a factual or legal nature as may assist the court or other competent authority of the State addressed in determining whether the requirements of paragraphs 1 and 2 have been met.

(4) Any request for return shall be brought within a period of [one] [three] year[s] from the time when the requesting State knew or ought reasonably to have known the location of the object and the identity of its possessor, and in any case within a period of [thirty] [fifty] years from the date of the export.

Article 6

(1) When the requirements of Article 5, paragraph 2 have been satisfied, the court or other competent authority of the State addressed may only refuse to order the return of a cultural object where

(a) the object has a closer connection with the culture of the State addressed [, or

(b) the object, prior to its unlawful removal from the territory of the requesting State, was unlawfully removed from the State addressed].

(2) The provisions of sub-paragraph (a) of the preceding paragraph shall not apply in the case of objects referred to in Article 5, paragraph 1(b).

Article 7

(1) The provisions of Article 5, paragraph 1 shall not apply where the export of the cultural object is no longer illegal at the time at which the return is requested.

(2) Neither shall they apply where

(a) the object was exported during the lifetime of the person who created it [or within a period of [five] years following the death of that person]; or

(b) the creator is not known, if the object was less than [twenty] years old at the time of export

except where the object was made by a member of an indigenous community for use by that community].

Article 8

(1) The possessor of a cultural object removed from the territory of a Contracting State contrary to its law regulating the export of cultural objects because of their cultural significance shall be entitled, at the time of the return of the object, to payment by the requesting State of fair and reasonable compensation, provided that the possessor neither knew nor ought reasonably to have known at the time of acquisition that the object had been unlawfully removed.

(2) Where a Contracting State has instituted a system of export certificates, the absence of an export certificate for an object for which it is required shall put the purchaser on notice that the object has been illegally exported.

(3) Instead of requiring compensation, and in agreement with the requesting State, the possessor may, when returning the object to that State, decide

(a) to retain ownership of the object; or

(b) to transfer ownership against payment or gratuitously to a person of its choice residing in the requesting State and who provides the necessary guarantees.

(4) The cost of returning the object in accordance with this article shall be borne by the requesting State, without prejudice to the right of that State to recover costs from any other person.

(5) The possessor shall not be in a more favourable position than the person from whom it acquired the object by inheritance or otherwise gratuitously.

CHAPTER IV - CLAIMS AND ACTIONS

Article 9

(1) Without prejudice to the rules concerning jurisdiction in force in Contracting States, the claimant may in all cases bring a claim or request under this Convention before the courts or other competent authorities of the Contracting State where the cultural object is located.

(2) The parties may also agree to submit the dispute to another jurisdiction or to arbitration.

(3) Resort may be had to the Provisional, including protective, measures available under the law of the Contracting State where the object is located even when the claim for restitution or request for return of the object is brought before the courts or other competent authorities of another Contracting State.

CHAPTER V - FINAL PROVISIONS

Article 10

Nothing in this Convention shall prevent a Contracting State from applying any rules more favourable to the restitution or the return of a stolen or illegally exported cultural object than provided for by this Convention.

Conservators and Actions
for Recovery of Stolen or Unlawfully Exported Cultural Heritage

Patrick J. O'Keefe

Recovery Actions

Over the past decade the number of legal proceedings taken by States to recover stolen or unlawfully exported cultural heritage has greatly increased. The names are familiar to all involved in the area: *Attorney-General of New Zealand* v. *Ortiz; Kingdom of Spain* v. *Christie, Manson & Woods Ltd.; Iran* v. *Wolfcarius; Republic of Ecuador* v. *Danusso; Union of India* v. *Bumper Development Corporation Ltd.; Government of Peru* v. *Johnson; Autocephalous Greek-Orthodox Church of Cyprus* v. *Goldberg & Feldman Fine Arts Inc.; Republic of Turkey* v. *Metropolitan Museum of Art; Lebanon, Croatia, and Hungary* v. *Earl of Northampton Trust and Sotheby's* (detailed discussion of all except the most recent of these cases can be found in O'Keefe & Prott, 1989). Some, such as those of *Greece* v. *Michael Ward* and *Republic of Turkey* v. *OKS Partners*, are pending while yet others are being prepared. Undoubtedly a significant motive for the State concerned is not only to recover the heritage at issue but also to create precedents. This was expressed very plainly by Cater during the *Ortiz* case: 'We hope our experience in this case might help to define legal principle and precedent that will assist others' (Cater, 1982, 258). These recovery actions thus send a message to the international art market: a message to the effect that anyone who buys heritage without a proper provenance must anticipate the possibility of being involved in a major law suit and the possible loss of all they have invested.

Identification

For any State contemplating a recovery action, the first difficulty it faces is that of identifying the object in question. This is particularly true for antiquities and especially those which have been clandestinely excavated. It was fatal to the Government's case in *Government of Peru* v. *Johnson*. There the plaintiff failed to prove that the antiquities came from what is now Peru. In the words of the United States District Court, the

73

archaeologist called on by the Government of Peru to identify the antiquities 'admitted that an item may have come from Ecuador or Columbia or Mexico or even Polynesia'. A similar argument will be relied on by the defendant in *Greece* v. *Michael Ward*. It is reported that the Greek Government believes that the group of Mycenaean gold seals, beads and ornaments were looted from a tomb in Aidonia and smuggled out of Greece in trucks carrying a cargo of apricots in 1978. The defendant will argue that the gold antiquities were found outside Greece (Borodkin, 1993).[1]

Nevertheless, despite the absence of records for clandestine excavations, it may be possible to prove the origin of a particular antiquity. The proceedings in *Attorney-General of New Zealand* v. *Ortiz* never reached that point, but the precise origin of the excavated carving could be proven because the Maori who dug it up struck it with his spade, making a gouge mark. There were photographs showing the carving in his garage in New Zealand and the carving offered for sale at Sotheby's by Ortiz had exactly the same marks. In the case *Republic of Ecuador* v. *Danusso*, the defendant illustrated an interview with the magazine *Epoca* with 'a number of sophisticated models displaying, as in a mannequin parade, masks, earrings, bracelets, pectorals and other gold jewellery used for ceremonial purposes in ancient civilizations that had once existed on what is now Ecuadorian territory' (Pallares Zaldumbide, 1982, 132). In the interview the defendant said that he had made the collection in Ecuador but also that he had been born in 1942 in Piedmont. As he had no export permit for the antiquities and the law requiring this came into force in 1945, he virtually admitted unlawful export.

In other cases the decision turns on the evidence of expert witnesses and it is here that the conservator may play a significant role. In *Union of India* v. *Bumper Development Corporation Ltd.*, at issue was whether a Nataraja seized in London in 1982 by the Metropolitan Police and claimed by the Government of India was one and the same as that found in the Indian state of Tamil Nadu in about September 1976. The latter had been found in the grounds of a ruined temple by a man digging a pit and, after having passed through several hands, its trail disappeared in Bombay in 1976-77. The Court ruled that the statue in London was the same Nataraja. In reaching this decision, the Court relied on stylistic evidence but also on subsidiary evidence such as 'the termite runs, the fragments of brick and the similarity in colour of the soil brushed from the idols'. More recently, in the Sevso Treasure Case, an attempt was made to identify the place of origin of the antiquities by analysis of slivers of wood, traces of soil and other small organic particles.

Each of these samples was divided four ways among the parties and sent to forensic laboratories for analysis. A laboratory in California identified the slivers as oak, and not the cedar wood more common to Lebanon. Part of the soil samples were irradiated in Missouri, and part in London on behalf of Lord Northampton. Dr Louis Sorkin at the

American Museum of Natural History in New York identified the organic particles as caterpillar remains of a moth species that probably nested in the cloth in which the silver was wrapped. (Borodkin,1993)

The above paragraph shows that the composition of the antiquity and any remains attaching to it from its previous resting place could become crucial evidence in establishing its origin. No doubt this is already coming to the attention of those who participate in the unlawful trade in antiquities. They will doubtless seek to remove all possible indications of the true origin before offering it for sale. Contrariwise, would it be impossible to imagine the invention of a fake provenance by the insertion of material?

Evidence Arising from Conservation

To remove indications of true origin, the person they will turn to is the conservator who will be asked to clean and make the antiquity attractive for the market. This will place the conservator in a very difficult position. Neither the law nor statements of ethics help. If the conservator accepts the task, he/she will owe the client a duty of care defined by the law of tort and contract. The contract may include a secrecy clause. In itself this is not damning as a client may have many respectable reasons for wanting to limit the number of people who know of the antiquity; for example, to avoid theft, to conceal his wealth from relatives, or (less respectably) the taxation authorities.

If there are any legal proceedings seeking return of the antiquity, the conservator who worked on it may well be called on to give evidence as to the condition of the antiquity when it was handed over for conservation. The giving of evidence can be compelled if necessary. Accurate records of what was done to the antiquity and of any features which might indicate its possible origin will be essential. As can be seen from the cases above, these could include very fine remains. However, they are the property of the owner of the antiquity and would have to be returned to him if requested. For example, the Code of Ethics of the Australian Institute for the Conservation of Cultural Material Inc. states that 'the conservator will produce a full report detailing the work carried out, with full documentation, photographs, drawings, etc., where relevant, and including samples or other material removed from the object... This report, or a condensed version, will be delivered to the owner, curator, or custodian of the object.' More to the point under consideration here is a provision in the Canadian Association of Professional Conservators Code of Ethics whereby:

Where relevant and with the agreement of the owner, material removed from an object shall be retained as part of the documentation of a cultural property.

But this does not adequately deal with the issue of unlawful trade for, if the antiquity is stolen or unlawfully exported, the person presenting it for conservation will be unlikely to agree to the conservator retaining anything that may enable identification. A standard form contract allowing the conservator to retain material removed from the treated object would be one way to deal with the matter. At the very least codes of ethics should bring the possibilities to the attention of conservators.

Legal Proceedings

It is difficult to say generally how a legal action for recovery would proceed. Much depends on the precise points in dispute and how the parties decide to tackle the issues. For example, in *Union of India* v. *Bumper Development Corporation Ltd.*, the identity of the Nataraja came first because if it could not be shown that the one found in India and the one seized in London were one and the same, no further questions arose. In *Attorney-General of New Zealand* v. *Ortiz*, the parties agreed to first of all deal with the issue of whether the English courts had jurisdiction to decide the dispute. Consequently, a conservator may be called at any stage of a case depending on the nature of the case and how counsel and their clients decide to raise the points at issue.

Giving Evidence

The conservator called to give evidence should prepare for this by studying the treatment accorded the object at the time: the procedures that were used; the nature of any material removed and what was done with it. Careful attention should be paid to the range and type of evidence required. The conservator should not go beyond his knowledge or expertise. If he or she does so, counsel may not even challenge because the witness appears stupid and evidence even within competence is discounted. For example, of the procedure adopted for presenting evidence in the case of *Government of Peru* v. *Johnson*, one commentator writes:

> Instead of offering the expertise of Alva, who had already examined and identified photographs of the pieces seized from Johnson's collection, Peru enlisted Francisco Iriarte, the same archaeologist who claimed to have made the original discoveries at Huaca Rajada and who later tried to engineer Alva's downfall. On the witness stand, Iriarte was unable to differentiate between Moche and Chimu artistic styles or identify any objects that may have come from Huaca Rajada.
> (Kirkpatrick, 1992, 193)

The Court of Appeals in that case specifically mentioned that Iriarte had spent only one hour examining the antiquities and he used the phrase 'from

Peru' to encompass ancient Peru which covered much more territory than the present State. Witnesses must be precise and accurate in what they say and this must be based on expert knowledge of the subject matter.

Concepts of Ownership

In the course of working on the antiquity the conservator has to examine it in great detail. Certain aspects may indicate its probable origin. The conservator may know something of the legal regime there. For example, a licence may be required for excavation and export and only institutions can get the former. Should the client's possession of the antiquity then be seen as suspicious? What does the conservator do?

In the first place it must be said that there are many antiquities on the market perfectly legally. These come from excavations made before there were laws regulating excavation and export at the place where they were found. Moreover, many excavations result in a division of the finds with foreign collaborators and these sometimes find their way onto the market. For example, a number of jurisdictions in the United States of America permit underwater excavation by commercial organisations with a division of the finds between the State and the excavator which then puts its share on the market.

It is essential to remember that at present there is no prohibition on bringing into England antiquities that have been unlawfully exported from another country. The same is not true, for example, in Australia where such importation is an offence punishable by fine and/or imprisonment plus forfeiture of the antiquities (*Protection of Movable Cultural Heritage Act* 1986 [Cwth.]). Consequently, under English law, unless the situation falls within the scope of the European *Directive on the Return of Cultural Objects Unlawfully Removed from the Territory of a Member State*, a foreign State would have great difficulty getting the antiquities back merely because they were unlawfully exported.

A different situation would arise if the antiquities were covered by what some call 'a blanket claim of ownership'. In a number of countries legislation declares the State to be the owner of all, or certain classes, of antiquities found after a specified date. For example, in Malaysia, the *Antiquities Act* 1976 states in s.3(3):

> All undiscovered antiquities (other than ancient monuments), whether lying on or hidden beneath the surface of the ground or in any river or lake or in the sea, shall be deemed to be the absolute property of the Government.

Furthermore:

> In any legal proceedings relating to an antiquity it shall be presumed until the contrary is proved that it was discovered after the date of coming into force of this Act.

Under the *Antiquities Act* 1975 of New Zealand, any 'artifact found anywhere in New Zealand or within the territorial waters of New Zealand' after the commencement of the Act was declared 'as deemed to be prima facie the property of the Crown'. An artifact, in the terms of the Act, is 'any chattel, carving, object, or thing which relates to the history, art, culture, traditions, or economy of the Maori or other pre-European inhabitants of New Zealand' and was manufactured or modified in, or brought to, New Zealand prior to 1902. Provisions for State ownership of undiscovered antiquities can be found in the legislation of other countries, for example: Belize, Brunei, Cyprus, Gibraltar, Greece, Iceland, Italy, Kenya, Kuwait, Sri Lanka, Tanzania, Tunisia, Turkey.

A common case would be that of an antiquity found, for example, in Malaysia and smuggled out of the country to be sent for conservation in England. An English court would probably regard Malaysia as being the owner of the antiquity and at least its export from Malaysia without a licence as theft—by analogy to the law in England under which the Crown has property in treasure trove and dishonest appropriation of it can be prosecuted under the law of theft (Palmer, 1993). It may even be that the court would regard removal of the antiquity from the place where it was found coupled with failure to disclose as the act of theft.

Some commentators, mainly American, have criticized State declarations of ownership. For example, Bator said (1982, 350):

> A blanket legislative declaration of state ownership of all antiquities, discovered and undiscovered, without more, is an abstraction—it makes little difference in the real world.

This is nonsensical. Such claims are widespread, for example, in respect of natural resources and any attempt to argue that they were abstractions would meet with short shrift. The fact that the State has never had possession is irrelevant. The English Court of Appeal said in *Reg* v. *Hancock* that:

> ... it is not necessary for the offence of theft that the property alleged to have been stolen is in the possession, actual or constructive, of the owner at the time when it is appropriated.

In that case Hancock, using a metal detector, had found a number of coins near Guildford dating between 50 B.C. and 30 A.D. but failed to declare them. The Court ruled that it was for the jury in a criminal prosecution to decide whether the coins were treasure trove and thus the property of the Crown. Thereafter, they would have to determine whether the elements of theft had been proven.

If the antiquities do not come from a clandestine dig but have been stolen from a collection, the true owner can sue in the English courts to recover them. But what is meant by 'stolen'? In England, a person is guilty

of stealing something if 'he dishonestly appropriates property belonging to another with the intention of permanently depriving the other of it'. Other countries may have different definitions but in any action brought by a foreign owner to recover an antiquity found in England the court would apply the foreign test unless it were found to be contrary to English public policy.

Only the owner can sue to recover the stolen antiquity. However, taking legal proceedings in a foreign country is very expensive and many institutions and individuals do not have the resources for it. This is one of the reasons why some countries, for example, Spain, say that the antiquity is forfeited to the State if it is illegally exported (Article 29, *Law 13/1985 of 25 June 1985 concerning the Spanish historic heritage*). The assumption, of course, is that the thief is unlikely to seek an export permit for a stolen antiquity. Where such a provision applies the State then becomes the owner and can sue in foreign courts to recover the antiquity. What it does with the antiquity when it is returned is up to the State concerned. Much would depend on internal rules and the degree of blameworthiness of the former owner. For example, Article 29 of the Spanish Law referred to above states:

> When the former owner claims that the property has been stolen or lost before being illegally exported, it may request its restitution from the State, with an undertaking to pay the sum total of the expenses related to the recovery of the property, and, where appropriate, to pay the price that may have been paid by the State to a *bona fide* purchaser. The illegally exported property shall be presumed lost or stolen when the former owner was a public body.

To make the matter even more complicated, there may have been intervening transactions between the time the antiquity was unlawfully exported and when it is brought to the conservator in England. Suppose an ancient Greek vase is stolen from the Nicholson Museum in the University of Sydney and exported from Australia without a permit as required by the *Protection of Movable Cultural Heritage Act* 1986. Under that Act, Australia becomes the owner of the antiquity immediately it commences to leave Australia. Suppose the antiquity is taken to Italy and there sold to a person who buys in good faith. Under Italian law the purchaser immediately acquires a good title. There is English authority to the effect that that title would be recognised in England (*Winkworth* v. *Christie's Ltd.*).

All the above shows that, while the conservator may be suspicious of the client, the law as to ownership can be so complex that a major court case is needed to sort it out. The conservator may feel the need to inform someone of his/her suspicions. The police have no authority to act unless the antiquity is stolen and there is reasonable cause to believe that this is so. As we have seen, it may be very difficult to establish such reasonable cause. Alternatively, if there is reason to believe that the antiquity has been stolen from a particular person or institution the conservator could notify

him or it. For example, it is not unknown for antiquities to come on the market with the accession number of the museum from which they have been stolen still attached. It would then be for the person concerned to commence civil proceedings for recovery of the antiquities. If the suspicion is only that the antiquities come from a particular place, the conservator could notify the Government of that State. How effective this will be depends on a number of factors, for example, who gets the message; how good the lines of communication are between the home State and its representatives in the United Kingdom; how concerned the government approached is with unlawful excavation and trade; how much money it has to fight any court case.

Ethics

Law can well crystallise out of ethical positions and it may be that conservators should be looking to the codes of ethics maintained by their professional associations. None of the codes of conduct used by the national associations of conservators has yet incorporated rules for deal-ing with unlawfully excavated, stolen or unlawfully exported objects. This stands in marked contrast with, for example, the Code of Professional Ethics produced by the International Council of Museums, statements of policy issued by specialised institutes such as the German Archaeological Institute, and many individual museums. The nature of any rules would need to be carefully considered. For example, it would be easy to include a provision in an Association's Code of Ethics to the effect that members should not do any work on an object that they suspect has been stolen or unlawfully exported. But what effect would this have in practice? What is a conservator to do if asked by a curator to work on an antiquity that appears to have been unlawfully excavated or exported but which has been bought by the museum after due deliberation and the museum's Collection's Policy Statement says that it will not acquire objects so tainted? What of an independent conservator who is approached to prepare for display an antiquity covered in clay and with straw still attached? One suggestion would be to require the client to provide a provenance on request. If this were made a necessity for all conservators, there would be less likelihood of the client picking and choosing among those available.

Conclusion

There are more fundamental issues involved. The status of the objects that conservators work on is changing. Once thought of merely as personal property it is now coming to be recognised that there are other interests involved: that of the public, the State and possibly humanity in general. As these develop, pressure will grow for formalisation of the role of the conservator. The profession is likely to be regulated and only those licensed to work as such will be allowed to handle major items of the

heritage or those owned by public collections. Failure to perform at the required standard will result in deregistration and possibly penalties more severe.

Is this a nightmare? Perhaps not, if conservators are prepared to take steps now to regulate themselves. One aspect that requires attention is the formation and publication of a category of professional conservators—persons who have certified qualifications and experience as well as a recognised reputation. This needs to be backed up by substantial sanctions for those who abuse their position. Secondly, a position should be taken on applying conservation procedures to unknown objects of dubious provenance. Certainly such work means that the conservator gets to know of the object's existence. It can improve the life of the object as well as its value to art scholarship and commerce. But much is lost. The object without a history may be beautiful but it is a partial object. Its conservation promotes art scholarship and commerce at the expense of other values. The conservation profession must decide where it stands on this issue.

Note

[1] This action was settled in early 1994 with the Michael Ward Gallery donating the objects to the Society for the Preservation of the Greek Heritage under an arrangement whereby they remain in the United States and will be available for loan to museums on request.

References

Bator, P.M., 1982. An Essay on the International Trade in Art. *Stanford Law Review*. 34:275-384.

Borodkin, L.J., 1993. Greek Gold and Roman Silver in Legal Disputes. *IFAR reports*. 14:4-6.

Cater, R.R., 1982. The Taranaki Panels—a Case-Study in the Recovery of Cultural Heritage. *Museum* 34:256-258.

Kirkpatrick, S.D., 1992. *Lords of Sipan: A True Story of Pre-Inca Tombs, Archaeology, and Crime.* New York: William Morrow.

O'Keefe, P.J. & Prott, L.V., 1989. *Law and the Cultural Heritage: Volume III; Movement.* London: Butterworths.

Pallares Zaldumbide, R., 1982. Cases for Restitution. *Museum* 34:132-134.

Palmer, N.E., 1993. Treasure Trove and Title to Discovered Antiquities. *International Journal of Cultural Property* 2: 275-318.

Cases

Attorney-General of New Zealand v. *Ortiz* [1982] 2 W.L.R. 10; [1982] 3 W.L.R. 570; [1983] 2 W.L.R. 809.

Autocephalous Greek-Orthodox Church of Cyprus v. *Goldberg & Feldman Fine Arts Inc.* 717 F.Supp. 1374 (1989); 917 F.2d 278 (1990).

Government of Peru v. *Johnson* 720 F.Supp. 810 (1989).

Kingdom of Spain v. *Christie, Manson & Woods Ltd.* [1986] 1 W.L.R. 1120

Reg v. *Hancock* [1990] 2 W.L.R. 640.

Republic of Ecuador v. *Danusso* (1982) 18 *Revista di diritto internazionale privato e processuale* 625; Court of Appeal of Turin, First Civil Section, No. 4410/79.

Republic of Turkey v. *Metropolitan Museum of Art* 762 F.Supp. 44 (1990).

Union of India v. *Bumper Development Corporation Ltd.* [1991] 4 All ER 638.

Winkworth v. *Christie Manson and Woods Ltd.* [1980] 1 Ch. 496 (English).

United States Efforts to Protect Cultural Property:

Implementation of the 1970 UNESCO Convention

Maria Papageorge Kouroupas

Background

As a member of UNESCO, the United States was an active participant in the late 1960s at the drafting sessions of the *Convention on the Means of Prohibiting and Preventing the Illicit Import, Export and Transfer of Owner-ship of Cultural Property*. Concern for the issues the Convention was to address, had already captured national attention in the US with reports of wanton destruction to pre-Columbian monumental structures in Mesoamerica. In response, Congress passed the Pre-Columbian Monumental and Architectural Sculpture and Murals Statute of 1971 which banned importation into the US of material such as stelae and wall frescoes taken from immovable structures. This action effectively caused a diminution in the US market for this material. In the same year the US entered into a treaty with our art-rich neighbour, Mexico, pledging mutual assistance in the recovery and return of cultural property.

On this crest of concern about pillage, the 1970 UNESCO Convention was given unanimous advice and consent for ratification in 1972 by the US Senate. However, implementing legislation was required, and despite the heightened awareness about the twin issues of looting and illicit trade in cultural property, it was not until 10 years later that Congress enacted the Convention on Cultural Property Implementation Act. This hiatus suggests the difficulty that was experienced in adopting the legislation which enabled the United States to become a party to the Convention. Although the Act represents a compromise among diverse interested parties—primarily museums, archaeologists and art dealers—it is felt to be a workable text and is being successfully applied in numerous cases which will be discussed later in this paper.

The Convention itself establishes a framework for international cooperation to reduce the incentive for pillage by restricting the illicit movement of archaeological and ethnographic material. With the beginning of US implementation of the Convention, it is believed this framework became

operational; operational, that is, from the perspective of art-source countries that have suffered vast losses to their national cultural patrimony through looting and unauthorised trade. Such countries, if they are a State Party, now have recourse under Article 9 of the Convention to request import restrictions from a major art-importing country, the US.

US enabling legislation authorises the President to make a bilateral or multilateral response to requests from State Parties when US imposed import restrictions, with respect to archaeological or ethnographic material, 'will be applied in concert with similar restrictions implemented, or to be implemented, by those nations… having a significant import trade in such material' (Sec. 303(c)(1)). Although an exception clause to this provision gives the President an enlarged discretionary space in which to proceed bilaterally with the requesting country, the ideal of a concerted international effort remains an important concern of those who opposed implementing legislation in our country as well as of those who supported it; for the maximum benefit of US participation in the Convention can be realised only with the participation of other major art-importing countries. Therefore, the US enthusiastically welcomes Switzerland's recent decision to become a State Party and encourages similar action by other major art-importing countries such as the UK, France, Germany, The Netherlands, Belgium and Japan[1].

The United States is eager to implement the 1970 UNESCO Convention where applicable by working with other signatories on a multilateral basis to minimise the problems of pillage and illicit export. The underpinning of this readiness is in a statement of policy issued by our State Department at the time of ratification of the Convention:

> US foreign policy supports the restoration of stolen cultural objects to their countries of origin… There has been an expanding trade in archaeological and [ethnographic] artifacts deriving from clandestine activities and excavations that result in the mutilation of ancient centers of civilization… The appearance in the US of important art objects of suspicious origin has often given rise to outcries and urgent requests for return. The US considers that on grounds of good foreign relations it should render assistance. In following this policy, we are motivated also by ethical and moral principles… [that] the US should not become a thieves' haven.

State Party Requests

Except in instances of the theft of articles of cultural property that are accounted for in museum inventories or other record, the US enabling legislation offers no automatic protection to other State Parties. Rather, the enabling legislation authorises the President to receive requests from other parties to the Convention that seek US import controls on certain archaeological or ethnographic material.

An individual State Party must take the initiative to submit a request seeking the protection of US import controls on archaeological material that may yet be unearthed or ethnographic material that remains in its societal context. These requests should, under US law, include: documentation that the national cultural patrimony is in jeopardy from the pillage of this material; that internal protective measures are in place; that the US is a market for the material; to the extent known, any information about the worldwide market in the subject material; and, if applicable, that certain emergency conditions obtain. In other words, the requesting country puts forth as compelling a case for import controls as possible; and in so doing, a 'dialogue' evolves between the US and the art-source country.

Each request is evaluated by the Cultural Property Advisory Committee. The committee submits its findings and recommendations to the Director of the US Information Agency who exercises the decision-making power on behalf of the President. Should the disposition of the request be favorable, an import restriction is put into effect by the US Customs Service. Enforcement of such controls is significant, for it essentially removes a major art-consuming nation from the marketplace for specific material and has the effect of enforcing the export controls of the requesting country. The US does not otherwise recognise the export laws of other countries.

It is important to note that US import restrictions apply to material exported from the country of origin only after the date on which the 'designated list' of objects restricted from importation is published in the *Federal Register* a US government publication that gives official notice to the public. The import restriction applies even if the material is directly imported into the US from a country other than the country of origin. The 'designated list' is a list of descriptive objects representative of the types of material the requesting state wishes restricted from importation into the US.

US protection under the Act is *prospective* only. One could say the implementing legislation is less an instrument for interdiction and more an instrument for protection. Its emphasis is not the recovery of past losses but rather the protection of cultural property that remains *in situ* in the country of origin; the undocumented material, that, stripped of its provenance feeds a large clandestine trade bringing high yield with little risk to the participants in this trade. Most vulnerable are those countries where there is a large universe of unexcavated sites; where the cultural patrimony is deprived of financial resources and skilled personnel to preserve it; and where protective measures may be inadequate, not enforced, or unenforceable.

US Action Under the Cultural Property Implementation Act

The United States Information Agency (USIA) has the lion's share of responsibility for implementing US participation in the 1970 UNESCO Convention. The Agency not only administers the Cultural Property Advisory Committee, but also carries out most of the President's executive

responsibilities under the Cultural Property Act. The Director of the Agency, on behalf of the President, has received six requests for import controls—from Canada, El Salvador, Bolivia, Peru, Guatemala and Mali. Mali has the distinction of being the first African country to submit a cultural property request under the Convention and the first outside the western hemisphere to do so.[2]

All of these requests were reviewed by the Cultural Property Advisory Committee—eleven individuals appointed by the President who include archaeologists, anthropologists, ethnologists; experts in the international sale of art; representatives of museums and the general public. The Committee's recommendations on these requests were submitted to the Director of USIA who, in turn, rendered favorable decisions with respect to the Salvadoran, Bolivian, Peruvian, Guatemalan, and Malian requests. A decision on the Canadian request is yet to be announced.

Most of these requests have been treated under the emergency provision of the Cultural Property Act which enables unilateral US response to clearly circumscribed situations of pillage. El Salvador, for example, needed protection of pre-Hispanic material originating in a well-defined archaeological zone where an estimated 5,000 looters pits had already been dug, posing a serious threat to any scientific archaeology.[3]

Bolivia needed US import protection on unique antique textiles belonging to Coroma, a small Andean community visited by art dealers and middlemen who, it is alleged, arranged for the systematic removal of the textiles from their ceremonial bundles. Subsequently, they began to appear on the US commercial market and some were mounted in a travelling exhibition sponsored by a major American museum, a move that likely enhanced their value as commodities. These textiles are not considered commodities by the villagers of Coroma, however; for they are integral to their political, social and religious practices. Handed down through generations, the textiles are the single most vital link between the past, present, and future of Coromans. But, their unique stylistic characteristics made them a desirable commodity on the art market.

Peru sought protection of newly discovered Moche material—mostly gold, silver and copper objects—found on its northern coast at the site of Sipán. It is claimed that this site has yielded the richest intact tomb yet found in the western hemisphere. The site had already been partially looted before armed guards were brought in to protect it and some of the looted material had quickly made its way to California, to England, and supposedly to Europe as well.

Guatemala, too, petitioned the US for an emergency import ban on all Maya artifacts originating in the Petén region. Guatemala's petition explained how 'this magnificent cultural legacy, in which all Guatemalans take pride, and which foreigners admire, has been greatly damaged and diminished by pillage and theft.'

All of the material described above is prohibited from entry into the US unless accompanied with an export certificate issued by the country of

Legal Issues

origin. Even if the restricted material passes the port of entry without inspection, or passes through other countries before entering the US, it may be seized subsequently by the Customs Service if a violation of the import restriction is found to have occurred.

With the first action by the US on the African continent, Mali now has the benefit of emergency US import restrictions on archaeological material originating in the region of the Niger River Valley. This action followed a determination by USIA, made on behalf of the President, that the level of pillage from archaeological sites in this region is of crisis proportions and that Mali's cultural heritage is in jeopardy. The action includes protection of sites at Djenne and Guimbala of the Inland Niger Delta and Bougouni of the Upper Valley.

The Canadian request seeks an agreement with the United States—an agreement that imposes import controls on both archaeological and ethnographic material making it much broader in scope than the other requests, with the exception of Mali. Mali, too, seeks a cultural property agreement with the United States. In the interim, however, emergency US import restrictions have been granted, as illustrated above.

A distinguishing feature of Canada's request is that it comes from a western industrialised country with which the US shares a long border and a common heritage. It demonstrates that even a country with sufficient resources to protect and conserve, house and exhibit its cultural and artistic heritage, may itself be a victim of pillage. In the US as well, knowledgeable sources frequently report the loss of vast amounts of native American artifacts to the international art market. Foreign financing, it is said, supports much of the clandestine looting of native American sites in the Southwest and other parts of the US.

Ameliorating Influence of US Implementation

There is evidence that US implementation of the Convention has stimulated broad compliance with the spirit of the law. Many American anthropologists and archaeologists working throughout the world have been joined by their foreign colleagues in advancing this spirit. They strive to find ways to assist their host country colleagues and cultural officials in making small but steady gains to implement policies that will strengthen the efforts of museums and other institutions necessary to protect and manage what remains of their irreplaceable cultural resources.

A pro-active stance was taken a few years ago by members of the Society of Africanist Archaeologists who endorsed a resolution condemning the illicit market in African antiquities and pledging the Society's efforts to undermine this trade through ethical practices and by searching for reasonable alternatives to the trade. More recently, a group of concerned Africanists in the US has begun organising a Fund for African Archaeology.

Additionally, in recent years, curators, conservators and other professional groups in the US have taken steps to modify their own codes of ethics

that set forth guiding principles in handling unprovenanced objects that may have been acquired outside prevailing legal and ethical parameters.

Within the past year, the US National Endowment for the Humanities (NEH), a federal grant-making agency, has undertaken a review of its policy and grant guidelines with respect to support of grant proposals that may involve unprovenanced cultural property (eg, museum exhibitions). Any changes would likely advance a policy that is in harmony with the spirit of US implementation of the Convention.

Several museums around the US have adopted stricter acquisitions policies, some as long ago as 1970. For example, the policy of the University of Pennsylvania Museum states that the Museum's Board and staff 'will not knowingly acquire ... any materials known or suspected to have been exported from their countries of origin since 1970 in contravention of the UNESCO Convention of that year to which the Museum fully subscribes; nor will they knowingly support this illegal trade by authenticating or expressing opinions concerning such material... Objects offered to the Museum prior to the adoption of the UNESCO Convention of 1970 will be considered in the light of the laws in place in their countries of origin at the time of their documented appearance in the United States.'

The Smithsonian Institution has a policy that prohibits the acquisition and/or display of material that has been unethically acquired, unscientifically excavated or illegally removed from its country of origin after the date on which the policy went into force.

Yet another interesting development, albeit subtle, is illustrated in the March/April 1990 issue of *Museum News* in an article by Stephen E. Weil, Deputy Director of the Hirshhorn Museum and Sculpture Garden. Weil writes about a new paradigm of basic museum functions that emerges from the paradigm of five that have served museum operations for well over a generation. According to Weil, the original paradigm of essential functions—to collect, to conserve, to study, to interpret, and to exhibit—is evolving into three—to preserve, to study, and to communicate. Perhaps it is no accident that in an atmosphere of growing sensitivity to cultural property issues and to the relationship of museums to those issues, that the function 'to collect' is being subsumed by the function 'to preserve.' This emphasis on preservation promotes more responsible museum stewardship by urging museums to preserve mankind's artistic and cultural heritage through more prudent collecting practices consistent with international standards and regulations affecting the movement of cultural property.

All this may suggest a developing dynamic that, in time, could encourage the pursuit of new avenues of access to protected material. The Cultural Property Act seeks to ensure such access and is explicit in providing 'that the application of import restrictions... is consistent with the general interest of the international community in the interchange of cultural property among nations for scientific, cultural and educational purposes' (Section 303(a)(1)(D), *Convention on Cultural Property Implementation Act*).

Already we see that US action with respect to the site of Sipán in Peru has stabilised the situation of pillage to the extent that systematic archaeology has taken place there; permanent museum exhibition space is being created for the excavated objects; access for the general public has been made possible by an international traveling exhibition featuring the objects; and, the archaeologist in charge has provided the local population, the original looters, the opportunity to develop an appreciation for the ancestral importance of the site.

In El Salvador, the imposition of US import restrictions has stimulated authorities to strengthen their cultural patrimony legislation which now mandates a national inventory of cultural resources. USIA has been supportive of this undertaking by sponsoring, with the cooperation of the Getty Art History Information Program, an expert assessment of needs to accomplish this daunting task in El Salvador.

Conclusion

As mentioned earlier, the lion's share of responsibility under the Cultural Implementation Act rests with USIA, an independent agency of the Executive Branch responsible for the overseas information, educational and cultural programs of the United States Government. USIA also provides administrative support to the Cultural Property Committee. The Agency's foreign service officers work alongside their State Department colleagues in US embassies and consulates throughout the world to 'increase mutual understanding between the people of the United States and the people of other countries…' USIA supports the academic exchanges of the Fulbright program and sponsors many other international exchanges.

USIA recently sponsored two regional symposia, one in Asia and the other in the Middle East and North Africa, focussing on policy development and implementation with respect to the protection of cultural heritage. The symposia examined how land use, tourism development, economic development, the environment and other factors such as looting combine to threaten both the movable and immovable cultural heritage; and how efforts to deal with these threats must be integrated for coherence and maximum effectiveness.

Increasingly it is realised that laws are not the ultimate answer to the problem of pillage and illicit trade. Rather, they are an essential stimulus for change in the way the importance of our cultural resources are perceived. They are most effective in an integrated partnership with the policies and infrastructures that support the role of museums and other institutions in serving the long-term protection of cultural resources. Towards that end, USIA supports, among other things, worldwide conservation and preservation, museum training, collections management, inventorying of cultural and artistic resources, systematic archaeology and site management.

USIA has become an important catalyst in advancing worldwide efforts to mitigate the irreplaceable loss of mankind's cultural heritage. The

active participation of other art-importing nations in these efforts is essential or the looted history will simply continue its flow along the paths of least resistance.

Notes
[1] In late 1994, France announced its intention to ratify the Convention.
[2] In eary 1995, USIA received its seventh request.
[3] In early 1995, El Salvador submitted a second request seeking a bilateral agreement with the US that would protect all its pre-Hispanic archaeological sites. This resulted in the first bilateral agreement under the US implementing legislation. It was signed on March 8, 1995 (text attached).

MEMORANDUM OF UNDERSTANDING BETWEEN THE GOVERNMENT OF THE UNITED STATES OF AMERICA AND THE GOVERNMENT OF THE REPUBLIC OF EL SALVADOR CONCERNING THE IMPOSITION OF IMPORT RESTRICTIONS ON CERTAIN CATEGORIES OF ARCHAEOLOGICAL MATERIALS FROM THE PREHISPANIC CULTURES OF THE REPUBLIC OF EL SALVADOR

The Government of the United States of America and the Government of the Republic of El Salvador;
Acting pursuant to the 1970 Convention on the Means of Prohibiting and Preventing the Illicit Import, Export and Transfer of Ownership of Cultural Property, to which both countries are States Party; and

Desiring to reduce the incentive for pillage of certain categories of irreplaceable archaeological material representing the prehispanic cultures of El Salvador;

Have reached the following understanding:

ARTICLE I
A. The Government of the United States of America, in accordance with its legislation entitled the Convention on Cultural Property Implementation Act, will restrict the importation into the United States of the archaeological material listed in the Appendix to this Memorandum of Understanding (hereafter 'Designated List') unless the government of the Republic of El Salvador issues a certification or other documentation which certifies that such exportation was not in violation of its laws.

B. The Government of the United States of America shall offer for return to the Government of the Republic of El Salvador any material on the Designated List forfeited to the Government of the United States of America.

C. Such import restrictions will become effective on the date the Designated List is published in the U.S. *Federal Register*, the official United States Government publication providing fair public notice.

ARTICLE II

A. The Government of the Republic of El Salvador wil use its best efforts to permit the exchange of its archaeological materials under circumstances in which such exchange does not jeopardize its cultural patrimony.

B. The representatives of the Government of the United States of America will participate in joint efforts with representatives of the Government of the Republic of El Salvador to publicize this Memorandum of Understanding.

C. The Government of the United States of America will use its best efforts to facilitate technical assistance in cultural resource management and security to El Salvador, as appropriate under existing programs in the public and/or private sectors.

D. Both countries will seek to encourage academic institutions, nongovernmental institutions and other private organisations to cooperate in the interchange of knowledge and information about the cultural patrimony of El Salvador, and to collaborate in the preservation and protection of such cultural patrimony through appropriate technical assistance, training, and resources.

E. The Government of the Republic of El Salvador will use its best efforts to effect, as soon as possible, final approval and promulgation of its regulations to implement its 1993 Special Law for the Protection of the Cultural Heritage, especially those related to the registration and export of cultural property, and the granting of excavation permits; and will use its best efforts to proceed expeditiously with the registration of cultural property as required by law.

F. The Government of the Republic of El Salvador will continue, and strengthen where possible, its efforts to educate the public regarding its 1993 Special Law and the importance of protecting archaeological sites.

G. In order to reestablish public and scholarly access to the collections in the 'David J. Guzman' National Museum which suffered structural damage during an earthquake, the Government of the Republic of El Salvador will use its best efforts to reopen the Museum at the earliest practicable time.

H. The Government of the Republic of El Salvador will endeavour to strengthen cooperation within Central America, and especially with immediately neighbouring states, for the protection of the cultural patrimony of the region.

ARTICLE III

The obligations of both countries and the activities carried out under this Memorandum of Understanding shall be subject to the applicable laws and regulations of each country, including the availability of funds.

ARTICLE IV

A. This Memorandum of Understanding shall enter ino force upon signature. It shall remain in force for a period not to exceed five years, unless extended.

B. This Memorandum of Understanding may be amended through an exchange of diplomatic notes.

C. The effectiveness of this Memorandum of Understanding will be subject to continuing review.

IN WITNESS WHEREOF, the undersigned, being duly authorized by their respective Governments, have signed the present Memorandum of Understanding.

DONE at Washington, this eighth day of March, 1995, in the English and Spanish languages, both texts being equally authentic.

FOR THE GOVERNMENT OF THE UNITED STATES OF AMERICA:

--
United States Department of State

--
United States Information Agency

FOR THE GOVERNMENT OF THE REPUBLIC OF EL SALVADOR:

--
The Ambassador of the Government of the Republic of El Salvador to the United States of America

Illicit Trafifficking in Antiquities and Museum Ethics

Patrick J. Boylan

Following the change of government in the summer of 1970, at a crucial point in relation to the negotiations on what in November 1970 became the UNESCO *Convention on the Means of Prohibiting and Preventing the Illicit Import, Export and Transfer of Ownership of Cultural Property*, it became clear that the new United Kingdom government was at the very least indifferent, and more probably positively hostile, to the fundamental principles of the *Convention* following political lobbying by the London art and antiquities trade. Consequently, the British Academy joined with the then Standing Commission on Museums and Galleries (now the Museums and Galleries Commission), the British Museum and the Museums Association (representing the other relevant museums in the United Kingdom) in a solemn *Joint Declaration*, issued by the Commission on behalf of both the museum and scholarly communities, declaring that:

'(i) they attach the highest importance to preventing the destruction of the records of man's past and the despoliation of archaeological and other historical sites;

'(ii) they recognise the importance, in the scientific study and interchange of archaeological and other cultural material, of mutual confidence and assistance between countries concerned and will do everything in their power to promote it;

'(iii) they affirm that it is and will continue to be the practice of museums and galleries in the United Kingdom that they do not and will not acquire any antiquities or other cultural material which they have reason to believe has been exported in contravention of the current laws of the country of origin.' (Standing Commission on Museums and Galleries, 1972; Boylan, 1981).

It has to be said that twenty years ago much of the museum world was still somewhat ambivalent on these issues. Some senior directors and curators of that generation were still more than willing to argue that the inherent artistic and aesthetic values of an object should always take precedence in

the museum's priorities over boring details such as archaeological context, accurate identification and dating, or mere legality. Also, in the early 1970s British and other western governments at least privately still looked on attempts to control looting and exports as unacceptable constraints on the profitability of the world's multi-billion international art trade. Even more frequently, it was often argued (as some apologists for what is almost certainly the world's third largest field of international crime— after trafficking in drugs and the illegal arms trade—continue to do today), that if unauthorised excavation, looting, theft and export are taking place the victim countries must take the blame for failing to protect their own property and patrimony. (Blaming the victim rather than the criminal in this way seems to be becoming more and more fashionable today: if cars are stolen it is apparently the motor manufacturers, not the thieves, who are villains for producing 'insecure' products, and defence lawyers almost routinely blame the victims of serious personal assaults, particularly rape, for giving the attacker the opportunity to commit the crime by being alone after dark in the street, or for inadequately fortifying their own home.)

One confrontation that occurred in 1976 at the annual conference of the Museums Association in Bristol, when the author was chairing the Association's working group on institutional ethics and introducing an interim report on what later became its *Code of Practice for Museum Authorities* was particularly memorable. Immediately after both the 1972 *Joint Declaration* and the museum acquisitions code adopted by my own museum authority, Leicestershire County Council, in 1975 (Boylan, 1976) had been outlined, one of the Association's most distinguished and respected past presidents publicly attacked the proposals, arguing that acquisitions policies and restrictions of this kind were 'inimical to basic nature of museums and museum work', claiming—at least half-seriously, that 'the very essence of curatorship is sublimated kleptomania!' This was, however, by then already very much a minority viewpoint among the UK profession and the following year both the *Code of Practice for Museum Authorities*, with the ethics of acquisition provisions very largely based on the *Leicestershire Code*, and interim Guidelines for Professional Conduct with similar provisions, were adopted unanimously at the next annual general meeting of the Association, (Boylan, 1987).

In fact, both the *Leicestershire Code* and the Association's *Code of Practice for Museum Authorities* went further than the 1972 *Joint Declaration* in two important respects. First, while the Declaration considered possible acquisitions from a negative viewpoint, that is, rejecting those 'which they have reason to believe' had been acquired or transferred unlawfully or through illicit trafficking, para. 4.5 of the Museums Association *Code of Practice* required museums to be sure that they had positive evidence of legality and lawful transfers and export:

'A museum should not acquire, whether by purchase, gift, bequest or exchange, any work of art or object unless the governing body or

responsible officer as appropriate is satisfied that the museum can acquire a valid title to the specimen in particular, and that in particular it has not been acquired in, or exported from, its country of origin (and/ or any intermediate country in which it may have been legally owned) in violation of that country's laws. (For the purpose of this paragraph 'country of origin' shall include the United Kingdom.)'

Further, para. 4.9 of the Association *Code of Practice* extended the same tests to the acceptance of inward loans including exhibitions:

'If appropriate and feasible the same tests as are outlined in the above four paragraphs should be applied in determining whether to accept loans for exhibition or other purposes.'

The International Council of Museums (ICOM), is the official UNESCO-linked world body which brings together 750 museum authorities and over 12,000 museum professionals in over 140 countries. Hence it represents (and is democratically controlled by) a membership that spans both the 'importing' and the so-called 'victim' countries in terms of the international antiquities trade. In 1970 ICOM had issued an interim statement on the ethics of museum acquisitions, and in 1984 its Executive Council resumed work on the preparation of a comprehensive code of professional ethics by appointing a broadly based Ethics Committee to research and draft the required code. Part of the work of this committee was to carry out a comprehensive survey of museum practice at the national, local and individual museum levels. This demonstrated that enforceable ethical codes were already in widespread use across the world at various levels from that of individual museums through to regional and national museum profession bodies (and in at least one case a museum ethics code had been incorporated into national legislation). There was also very extensive consultation with ICOM's worldwide membership: under the terms of ICOM's constitution, adherence to a defined Code of Professional Ethics is a condition of membership, and provides for the termination of the membership of both institutional and individual members 'for serious reasons relating to professional ethics' (Articles 2(2) and 9 (d) of the ICOM Statutes), and hence it was important to achieve the wholehearted support of the world's profession, as represented in ICOM's membership.

The ICOM *Code of Professional Ethics*, adopted unanimously by the 15th General Assembly of ICOM held in Buenos Aires, Argentina, on 4 November 1986, was in essence a fairly conservative document, reflecting a consensus position of the common ground of the many existing codes examined, and the views and representations submitted to the Ethics Committee both in response to the initial survey and request for evidence, and in very extensive discussion and consultation on the first and second working drafts of the Code that the committee prepared.

Legal Issues

The provisions in the final Code relating to museum acquisitions were quite explicit, and followed very much the *Leicestershire* and Museums Association's *Code of Practice* principles. However, ICOM in addition recognised that, often very unwillingly, museums had a very significant relationship to the illicit art and antiquities trade. Though by the mid 1980s the great majority of the world's museums would no longer buy stolen or smuggled antiquities on their own account, indirect museum support was still seen as one of the most significant factors in maintaining the illicit international antiquities trade. Museums were still seen as the eventual destination for much stolen and smuggled material in the very long term, and certainly played an important role in establishing the perceived aesthetic and even monetary value of objects within both the legitimate and illicit trade.

Of particular relevance were the following provisions of the 1986 ICOM *Code of Professional Ethics*:

'3.1 Collecting Policies
'Each museum authority should adopt and publish a written statement of its collecting policy. This policy should be reviewed from time to time, and at least once every five years. Objects acquired should be relevant to the purposes and activities of the museum, and be accompanied by evidence of a valid legal title…

'3.2 Acquisition of Illicit Material
'The illicit trade in objects destined for public and private collections encourages the destruction of historic sites, local ethnic cultures, theft at both national and international levels, places at risk endangered species of flora and fauna, and contravenes the spirit of national and international patrimony. Museums should recognise the relationship between the marketplace and the initial and often destructive taking of an object for the commercial market, and must recognise that it is highly unethical for a museum to support in any way, whether directly or indirectly, that illicit market.

'A museum should not acquire, whether by purchase, gift, bequest or exchange, any work of art or object unless the governing body and responsible officer are satisfied that the museum can acquire a valid title to the specimen in particular, and that in particular it has not been acquired in, or exported from, its country of origin and/or any intermediate country in which it may have been legally owned (including the museum's own country) in violation of that country's laws.

[The next sub-paragraph relating to biological and geological material has been omitted.]

'So far as excavated material is concerned, in addition to the safeguards set out above, the museum should not acquire by purchase objects in any case where the governing body or responsible officer have reasonable cause to believe that their recovery involved the recent

unscientific or intentional destruction or damage of ancient monuments or archaeological sites, or involved a failure to disclose the finds to the owner or occupier of the land, or to the proper legal or governmental authorities.

'If appropriate and feasible, the same tests as are outlined in the above four paragraphs should be applied in determining whether or not to accept loans for exhibition or other purposes.

'3.3 Field Study and Collecting

'Museums should assume a position of leadership in the effort to halt the continuing degradation of the world's natural history, archaeological, ethnographic, historic and artistic resources. Each museum should develop policies that allow it to conduct its activities within appropriate national and international laws and treaty obligations, and with reasonable certainty that its approach is consistent with the spirit and intent of both national and international efforts to protect and enhance the cultural heritage.' (International Council of Museums, 1987).

Apart from the more detailed provisions of the Code, the clear denunciation of the effects of the illicit trade in relation to the national and international patrimony and the explicit declaration that there is a relationship between the market place and the initial illicit collecting in the first subparagraph of para. 3.2 reflect the widespread concern about illicit trafficking amongst the great majority of ICOM members. Its inclusion was especially important in terms of achieving an overall consensus over the text of the ICOM *Code of Professional Ethics*, particularly since very many institutional and individual members in all parts of the world covering museums of all types were no longer prepared to support the purchase of exhibits from the antiquities market under any circumstances. Since 1986 the proportion of the profession taking this view, ie that the commercial trade in excavated antiquities, even that which is legal under relevant national laws, is inherently unethical, has grown markedly.

Even if museums are now only rarely alleged to be direct parties in the illicit trade, private collectors and dealers close to some museums, eg as board members, may not be so constrained, and illicit material can be expected to be offered to the legitimate museum sector either as tax-efficient gifts of individual objects or groups of items, or through the establishment (again with tax benefits) of new donor-memorial museums to hold and exhibit private collections of antiquities that are still being built up in various parts of the world. Within the ICOM, therefore, the clear message that legitimate museums will in future never accept even as gifts, bequests or for temporary exhibitions, the products of illicit and unauthorised excavations and smuggling is considered of the greatest importance.

Although short-term market manipulation may be possible, in the longer term markets and monetary values are controlled by supply and

demand. Scarcity—whether in absolute terms or resulting from a lack of legitimate material— can obviously greatly inflate monetary values, at least in the short term. In 1972 the author was called as one of a number of witnesses in an ecclesiastical court case in the Diocese of Exeter concerning a proposal by St Mary's, Barnstaple, to sell its early church plate, including a 16th century communion cup. The case (though it is believed not to have been formally reported) was of considerable importance in clarifying the application of the then recent *Treddington* judgement of the Court of Arches.

Particularly relevant were the views of expert witnesses on the parish's valuation of the plate. It was common ground that a leading international auction firm expected to be able to raise a very large sum (some tens of thousands of pounds or, putting things another way, around three hundred times the value of the silver content). However it was equally accepted by both the expert witnesses and the learned Chancellor that this was very largely due to the extreme rarity of such pieces on the market, so that the small number of specialist institutions and collectors internationally could confidently be expected to compete ferociously for such a rare object. (Until *Treddington* there had been a virtually absolute prohibition on such sales by churches.) It was argued, and accepted by the Chancellor, that if all or most of the more than 300 West Country parishes with directly parallel 16th century sacred vessels were to offer these for sale the market would not be able to absorb them, and prices would fall to a very small percentage of the valuation presented by the St Mary's Barnstaple parish as justification for the proposed sale.

Similarly, the removal of a significant part of a potential market for any reason, whether financial, legal or ethical, can drastically affect the market. In the first half of the 1970s two of the most active investor-dealers in early Chinese art were forced to withdraw from the market: in one case due to the impact of the Portuguese revolution and the second because of the failure of its parent company, a London financial institution, due to unwise real estate investments. Without the competition from these two the market collapsed.

The concept of 'hope value' is now very well established in the valuation of otherwise low-value property such as agricultural land: the potential profit to be made at some time in the future from increased demand for building land, mineral extraction or other profitable development not currently contemplated and/or permissible. The very large amount of apparently unprovenanced high quality antiquities held by dealers and by wealthy 'art investment' collectors suggests to me that there is likely to be a similar 'hope value' factor at work in the pricing mechanism. Although quite obviously some antiquities are of significant intrinsic monetary value, particularly works in precious metals, in the majority of cases a high proportion of the value is surely attributable to the apparent rarity of the ancient work of art within the legitimate market place.

ANTIQUITIES Trade or Betrayed

The lesson seems clear: museums are still seen by many in the clandestine trade as the ultimate destination of much of the illicit antiquities trade by many less scrupulous dealers and collectors—perhaps not immediately, but in a generation or so's time when the smuggler's trail has grown cold, at which time this long-term expectation of financial benefit, whether directly through sales or indirectly through valuable tax concessions against other tax liabilities can be realised.

However, if that is still the position that the trade and the 'investor' collector is taking they are very wrong indeed. Bluntly, both trade and private investors in the antiquities market do not yet seem to have woken up to, or possibly simply refuse to believe, the fact that in future they will not be able to pass on unprovenanced or other dubious material to museums through sales or tax-beneficial gifts and bequests. The message from both the world museums community, as expressed in the ICOM *Code of Professional Ethics* and in the internal policies and rules of individual museums, is that negatives, the absence of proof or suspicion of unauthorised excavation and/or illicit trafficking, are no longer enough. Museums will nowadays only acquire where there is positive proof of the provenance and legality of discovery, transfer and movement, either from a legitimate excavation or other discovery, or from a genuinely old collection.

It seems certain that the enormous significance of this fundamental change in the position of the world's museums towards the collecting of antiquities has not yet been reflected, as it should have done, in valuations within the art trade, and it is suspected that few dealers in suspect material are rushing to explain to their clients that the withdrawal of museums from the dubious end of the trade must be seriously compromising their antiquities 'investment' strategies. (Perhaps countries need to bring art and antiquities 'investment' advice within the various national systems of regulation of financial and investment advice and practice.)

Those who still believe that this will never happen should examine what has happened in barely thirty years in the directly parallel area of natural history collecting—a field in which, in the 18th century, prices of rare and exotic animal, plant and mineral specimens were considerably higher than those of antiquities or many kinds of works of art. When the author joined the museum profession in 1964 few museums had any scruples at all about either direct collecting of live material, however rare, or of buying from the flourishing international trade in exotic plants, shells, insects, birds or mammals etc. Apart from the United Kingdom, few countries had any restrictions or controls on collecting or the trade, and even in Britain the prohibition of egg collecting and limited protection of some rare bird species was only a decade old.

Changing public attitudes, often pioneered by natural history museums, has transformed the situation across the world, with regional and national protective legislation being now the norm rather than the exception, and the *Convention on the International Trade in Endangered Species of Wild Fauna and Flora* (*CITES*), now severely limits the international

trade in not just museum, zoo, botanic garden or horticultural specimens etc. but also in all products using material from the animals or plants protected under the Convention. As a result of the ratification of *CITES*, after a short transitional period, some hundreds of tons of elephant ivory and many thousands of specimens of newly-protected species held by the natural history and fur trades as stock in trade, even where the dealers claimed that the material had been acquired legally prior to the *CITES* restrictions, were no longer of any value within the legitimate market. Obviously few, if any, categories of antiquities have the emotional appeal of brutally slaughtered elephants or large cats, but the speed with which public and hence inter-governmental opinion turned against the international wildlife trade, leading quickly to the virtual closing down of significant parts of it, ought to be a serious warning to the unscrupulous elements in the international antiquities trade. The action that governments have been prepared to take to—in effect—close down much of the international wildlife trade could very easily be copied in respect of the international antiquities trade if there is comparable cause for concern following highly publicised breaches of legal or ethical standards at the national level.

There are at least two other factors that ought to be giving the unethical elements in the antiquities trade serious cause for concern. First, ethical considerations apart, museums, both public and independent, are subject to increasingly strict national laws and regulation in respect of the exercise of proper trusteeship over the museum's financial resources, with such legal obligations applying to both governing body members such as trustees and to the senior staff of the institution. In the case of United Kingdom museums, such regulations are applied through government accounting rules in the case of national museums, through local government law in the case of local authority museums and through charity law, and company law where applicable, in the case of independent museums.

An important responsibility under all such provisions is to ensure that the funds of the museum are used both prudently and only for lawful purposes. In the case of the acquisition of capital assets such as new exhibits, museum directors and trustees are plainly obliged to take all reasonable steps to ensure that the museum is gaining an unchallengeable legal title to the object in return for the expenditure of public or trust funds, and that the acquisition is not going to be successfully reclaimed without compensation by its rightful owner at some future date. It is interesting to speculate how a more interventionist regulatory authority would regard the spectacle of strongrooms of New York's Metropolitan Museum being emptied of the Lydian Treasure, purchased at enormous cost from dealers now believed to have been implicated in smuggling it out of Turkey during the late 1960s and early 1970s. Had such circumstances arisen under English charity law, the museum trustees and senior staff who authorised such purchases knowingly, recklessly or merely without adequate investigation could be held personally liable for the charity's very substantial financial loss. The possibility of such a substantial personal financial risk

must certainly focus the minds of those involved in museum acquisitions of all kinds, stiffening the resolve of anyone looking for short cuts or for personal glory and future advancement through spectacular, albeit questionable, museum acquisitions.

The second factor that has to be taken into consideration is that of public and professional opinion. The true origin and the post-excavation history of unprovenanced material always presents the museum, the private collector, or indeed the reputable and ethical dealer, acquiring it with a continuing cause for concern. A negative 'absence of evidence' provenance must always be seen as a ticking time bomb, which can at any time be overturned by the disclosure of missing evidence of the circumstances of the original discovery or subsequent history, as was the case with the Metropolitan Museum's Lydian Treasure already mentioned. There have also been very damaging allegations about the history of the same museum's most important and expensive antiquities acquisition of the 1970s, the Euphronios vase. Many in museums now argue that the risk of such damaging (and potentially expensive in legal and other terms) revelations or allegations about doubtful or unprovenanced antiquities greatly outweighs the value to the museum of the object as a prized acquisition, and hence would not contemplate such acquisitions any more, regardless of ethical considerations.

The growing reluctance of museums around the world to support either directly or indirectly the international antiquities trade in any form, plus the longer term restrictions on the acceptance of suspect or unprovenanced material from private collections has very important implications for the antiquities trade, for 'investor' collectors, and for the price structure within the market. Even without any substantial toughening of international law or its enforcement major changes seem very likely over the coming few years. Both the legitimate art trade and the world's heritage would be far better off if these changes squeeze out those parts of the trade that support, whether directly or, more usually, indirectly, clandestine excavations, the concealment of chance finds and the subsequent international smuggling.

The existence and strength of the illicit international trade has one other very negative effect on museums. Contrary to popular belief very many countries—probably a majority—do offer official financial compensation schemes to encourage those discovering new archaeological sites or making chance archaeological finds of all kinds within their territories to report such finds and hence ensure their proper recording and the preservation of the finds in an appropriate national or local museum. Indeed, England and Wales are exceptional in restricting such compensation to objects of gold or silver (under the medieval Treasure Trove concept).

The widespread existence of the clandestine market makes the negotiation of appropriate levels of compensation for such finds a constant problem. Sophisticated finders inevitably regard the value of their discoveries in terms of the reported prices achievable in the leading western art

and antiquity markets. However, national authorities and museums responsible for paying such compensation, not surprisingly, reject the argument that the true value of the object in its country of origin should be calculated on the basis of the added value of an illegal act, ie smuggling the antiquity out of the country of origin. Apart from this, the market value in the United States or western Europe is usually an artificial one, distorted by the non-availability within the legitimate market of what might in fact be quite a common type of object in its country or region of origin. (There is a direct parallel here to the very artificial auction estimate for the St Mary's Barnstaple church silver as a result of the general prohibition of sales for such items discussed above.)

As part of a civic twinning programme between the county of Leicestershire and the province of Sichuan, China, at the end of 1988 the author had extended discussions on these matters with his opposite number, the provincial director of museums and antiquities, during an official visit to Sichuan. Like many similar regions the province is suffering very large-scale losses of antiquities through clandestine excavations and exports, the latter frequently including highly distinctive types of material previously completely unknown in the academic literature, let alone public or private collections or the art trade. As in other areas, such as ancient Etruria or some areas of eastern England, the scale of the clandestine 'archaeology' is alarming in both cultural and environmental terms. However Chinese colleagues also stressed the negative effects in both economic and social terms. In fact the financial rewards of those carrying out illicit excavations are virtually negligible compared with those further along the trade chain. The peasant farmer carrying out a clandestine excavation or concealing an important chance find (and liable to severe punishment up to and including the death penalty in China) would typically receive less than 1 per cent of the eventual price paid by a western collector. An item sold for the equivalent of $US100 by the original finder might typically pass through two or three intermediary dealers before selling on the lower Yangtze at $1,500 to $2,000, jumping to perhaps $10,000 by the time it reached Hong Kong or Macao and $50,000 or more in London or New York a few weeks later.

The claim of the illicit trade's apologists that its activities are in reality little more than clandestine means of ensuring that those making accidental finds in archaeology-rich countries are properly rewarded for their efforts is, at least in the great majority of cases, a cynical lie. The amount of money getting down to the impoverished illicit excavator or finder in the developing world, as a proportion of the multi-billion dollar trade, must be quite negligible. Indeed in many cases the payments to the original discoverers are probably less than the reward or compensation that would be payable to a bona fide accidental discoverer by the public authorities or museums of the country of origin under its national laws. It is the shadowy world of 'runners', smugglers and intermediary dealers which gets the bulk of the rapidly escalating value, not the romanticised peasant saving his family from otherwise certain death by starvation.

The world's museums, through their international *Code of Professional Ethics,* already reject all direct or indirect support for the clandestine trade by applying two very clear tests; ie (1) is there good, positive, evidence as to the true provenance of this item or collection demonstrating that it has not been derived from clandestine or other unlawful or unethical excavation, the concealment of chance finds, or otherwise in breach of relevant legal and/or ethical standards within recent times? and (2) has its subsequent history of transfers or movement, including any transfer out of an historic collection, been entirely in accordance with both relevant domestic and international law and standards of ethics?

Museums are becoming increasingly concerned about the direct and indirect impact of their activities on both the environment and on the social fabric of communities, and there is already serious discussion on possible ways of encompassing such issues within ethical codes. Consequently, I think that it may not be too long before museum ethical standards begin to take into account also the grave social, economic (and in some cases environmental) impacts of illicit trafficking on the communities of the most seriously plundered areas of the developing world, (and indeed of some developed countries as well, particularly around the Mediterranean basin), and adds a third test to the two summarised above.

This third test would stress that museums must recognise that they have an ethical responsibility towards the peoples subject to serious direct or indirect negative effects because of illicit collecting and trafficking. These problems cannot be solved by simply blaming the victims for the negative effects of an international crime in the 'South', the ultimate driving force of which is thousands of kilometres away in the museums, galleries and private collectors' cabinets of the 'North', to use the now conventional terminology.

References

Boylan, P.J., 1976. The Ethics of Acquisition: the Leicestershire Code. *Museums Journal* 75: 169 - 170.

Boylan, P.J., 1977. Museum Ethics: Museums Association policies. *Museums Journal* 77 : 106 - 111.

Boylan, P.J., 1981. Towards a Code of Ethics in Museums. *Museum Professional Group Transaction*, 16: 9 - 32.

International Council of Museums, 1987. *ICOM Statutes; Code of Professional Ethics, adopted by 15th General Assembly, Buenos Aires*, 4 Nov 1986. Paris: International Council of Museums [2nd edn1990].

[Standing Commission on Museums and Galleries], 1972. Preventing the illicit import and export of antiquities. *Museums Association Monthly Bulletin* 12 (2) (May 1972): 13-14.

Case Histories

The Kanakariá Mosaics and United States Law
on the Restitution of Stolen and Illegally Exported Cultural Property

Patty Gerstenblith

Fragments of a sixth century Byzantine mosaic were stolen from a Greek Orthodox Church on the island of Cyprus and appeared several years later on the art market in the United States. The mosaics were ultimately restored to their homeland after a legal battle which illustrates several of the legal doctrines emerging in the United States to resolve conflicts over the ownership and restitution of stolen and illegally exported cultural property. While this paper will focus on the fate of those mosaics, it will also attempt to explain how this case fits into the law of the United States on this subject and the differing doctrines which the courts have utilised in attempting to resolve these difficult questions.

Background to the Kanakariá Mosaics Case

The story of the Kanakariá mosaics began nearly 1400 years ago when a Byzantine mosaic depicting Jesus and the Twelve Apostles was placed in the apse of the Church of the Panagia Kanakariá in the village of Lythrankomi along the northern coast of Cyprus.[1] The mosaic shows Jesus as a young boy in the lap of his mother, the Virgin Mary, seated on a throne. They were surrounded by two archangels and a frieze depicting the twelve apostles. The mosaics remained there, undisturbed, surviving the Iconoclastic period, which destroyed most early Byzantine art, the Crusades, and the many different empires which held sway over the island of Cyprus until the last of these, the British, departed in 1960. Unfortunately, the friction between the two populations of Greek Cypriots and Turkish Cypriots intensified and, in 1974, culminated in a military coup against the Greek-Cypriot dominated government, followed by an invasion of the northern third of the island by Turkey. From 1974 until the present day, the island remains divided with the Republic of Cyprus controlling the southern two-thirds of the island and the Turkish Republic of Northern Cyprus controlling the northern one-third. Along with the political division of the island, a

population transfer was effected so that Greek Orthodox churches in the northern sector, such as that at Lythrankomi, were left vacant and were subsequently used as cattle and sheep pens.

In the late 1970s, rumors began to reach government officials and officials of the Cypriot Orthodox Church that churches in the northern part of the island, including the Kanakariá Church, were being attacked and vandalized, with everything of value being removed. While the Cypriot government made extensive efforts to notify various international agencies, such as UNESCO, the International Council of Museums, the Council of Europe, and academic institutions, it took another ironic set of coincidences before the mosaics of the Kanakariá Church were again located.

In the summer of 1988, an Indianapolis art dealer, Peg Goldberg, went to Amsterdam to search for 20th century art works to bring back to her gallery. While there, disappointed that she was unable to complete the purchase of a Modigliani painting for a client, she fell into the hands of two unscrupulous dealers, Robert Fitzgerald (with whom she was slightly acquainted) and Michel van Rijn. Van Rijn had had several previous encounters with the law, including a conviction in France for art forgery. On July 1st, Fitzgerald and van Rijn showed Goldberg photographs of four Byzantine mosaics. They claimed that the mosaics had been excavated by a Turkish archaeologist and that the Turkish Cypriot government had given permission for their export.

By July 3rd, Goldberg, van Rijn, Fitzgerald, and an attorney, Ronald Faulk, had negotiated an agreement to purchase the mosaics from their owner for US$1,080,000 and to split the profits from their resale among all four parties. The agreement was executed July 4th and on July 5th, Goldberg and Fitzgerald travelled to Geneva to meet Faulk and the mosaics' possessor, Aydin Dikman, who were bringing the mosaics from Munich. They met in the free port area of the Geneva airport, without the mosaics ever passing through Swiss Customs. Goldberg met Dikman briefly and then inspected the mosaics, which she was determined to buy. Goldberg later testified at trial that, during these days, she also attempted to contact several international agencies which deal with stolen art and the customs offices of several countries which might be involved, although not that of Cyprus. However, these contacts were questioned at trial and she was unable to establish reliably that she had in fact engaged in these efforts.

Meanwhile, Goldberg was also involved in raising the financing necessary to complete the purchase. She contacted an Indianapolis bank officer, whom she knew well, and eventually arranged for a loan of $1,224,000 to purchase the mosaics. The loan was secured by her personally, her gallery, and the mosaics themselves. Later, after returning to Indianapolis, Goldberg also signed an agreement with the bank giving it a 5 per cent interest in the profits from the resale of the mosaics.

With the financing arranged, the sale was completed on July 7th. Although the bill of sale stated a price of $1.2 million, Goldberg kept

$120,000 and delivered the rest in $100 bills placed in two satchels. The $1.08 million was split almost in thirds among Dikman, van Rijn and Fitzgerald, with various attorneys receiving smaller amounts. Upon her return to Indianapolis with the mosaics, Goldberg, van Rijn and Fitzgerald sold part of their interests in the resale profits to Goldberg's friend at the bank and another friend who obtained a loan from the same bank to purchase his interest. Altogether, an additional $1,155,000 were paid to van Rijn and Fitzgerald for these interests.

Goldberg then set about attempting to resell the mosaics, reputedly asking a $20,000,000 purchase price. In addition, she decided to have the mosaics 'restored' in order to make them more attractive. Because the mosaics had come from the apse of the church, they had curved surfaces. An Indianapolis conservator and Goldberg thought they would be more saleable if they were 'flattened'. The conservator therefore reset the individual tiles so that they would fit better on a flat surface. Goldberg also started to make contacts in her attempt to resell them, including eventually the curator of the Getty Museum. The Getty curator, Dr Marion True, contacted Dr Vassos Karageorghis, the head of the Cypriot Department of Antiquities. The Cypriot government within a few months learned the location of the mosaics, requested their return from Goldberg, and, when she refused, filed suit for their recovery.

As interesting and complex as the facts are, the ultimate disposition of the Kanakariá case turned on a very simple and somewhat routine legal doctrine, that is, whether the statute of limitations had run so as to bar the plaintiff's claim. This paper will turn now to an overview of the different approaches utilised in American law to resolve questions of ownership of personal property, then review some of the more significant cases involving stolen art works, and finally return to the Kanakariá mosaics and other recent cases to explain how they fit into the general body of law on the subject.

Law of the Recovery of Stolen Property

Many cases involving stolen art works or archaeological materials concern objects stolen during wartime. Well-known cases have included art works stolen by the German Nazi government during World War II and art works stolen from the German government by American soldiers at the end of the War. Only recently the Russian government announced that it has hidden troves of art works taken from Germany at the end of World War II, including the famed mid-3rd millennium BC Treasure of Priam excavated by the German archaeologist, Heinrich Schliemann, at the reputed site of Troy in northwestern Turkey.

The Kanakariá case, in fact, presented a far simpler scenario from a legal perspective than do most cases involving the international trade in stolen art. The case of the Cypriot mosaics was simpler, first, because the Dumbarton Oaks publication of the mosaics in 1977 presented a verified

source and original ownership of the mosaics (Megaw, 1977). Second, the current possessor, Goldberg, had the mosaics for a relatively short period of time when the rightful owner learned their whereabouts and brought suit.

Law of Sales and the Uniform Commercial Code

The law in the United States concerning transfer of title of personal property follows two distinctly different doctrines. The first of these, encompassed by the law of sales and now embodied in the Uniform Commercial Code or UCC, holds that the transferor of goods can only convey as good title as he or she has.[2] The corollary to this is that a thief cannot convey good title under any circumstances regardless of the status of the transferee. This approach conflicts with the civil law tradition, prevalent on most of the European continent, according to which a thief can transfer title of stolen goods to a good faith purchaser (Collin, 1993: 21-24; Levmore, 1987: 56-57). On the other hand, the Uniform Commercial Code makes somewhat liberal use of the concept of 'voidable' title. This provision permits a transferor to convey title to a good faith purchaser when the original owner has delivered the goods under a transaction of purchase, even if the transaction later proves to have been the result of fraud or deception, or when the original owner has entrusted the goods to a 'merchant who deals in goods of that kind' (Gilmore 1954; Gilmore 1981).[3] Nonetheless, the UCC clearly distinguishes between circumstances of entrustment, which can lead to transfer of title, and circumstances involving theft in which case title cannot pass.

Statutes of Limitation and Adverse Possession

The second branch of law concerning title to personal property has taken a somewhat different approach. This branch is governed by the statutes of limitation which provide that a law suit must be filed within a certain time period from the accrual of the cause of action. Such statutes of limitation, which exist for all civil actions and some criminal actions, represent a policy that after a certain period of time an individual should be safe from legal proceedings for an alleged wrongdoing. This policy accords with the notion that after this time, evidence becomes stale, and people's memories become unreliable. Furthermore, a potential plaintiff should not be permitted to sit on his or her rights, delaying a lawsuit until after the time that the defendant can best obtain the evidence necessary to resolve such a lawsuit fairly. The question, however, of how the policy of the statutes of limitation should operate when a potential plaintiff does not have the facts necessary to bring the lawsuit is the subject of considerable disagreement. The various state legislatures have taken different approaches to this problem, often depending on the substance of the suit, and even the judges within a particular state may take different approaches, depending on the particular sympathies presented by the parties to the suit.

Statutes of limitation apply to suits for the recovery of both real and personal property and, as such, are interwoven with the common law doctrine of adverse possession. This doctrine defines the accrual of the cause of action for purposes of the running of the statute of limitation as the time when the claimant's possession becomes open, notorious, hostile and continuous (Casner, 1952: § 15.2). The underlying policy purpose of these requirements for the accrual of the cause of action is to give notice to the true owner that he or she is in danger of losing title to the property. In the context of personal property, courts have struggled with the applicability of these same requirements (Helmholz, 1986: 1233-1237; Gerstenblith, 1989). While these requirements may be well suited to giving the diligent true owner of real property actual or constructive notice of the adverse claim, they do not as clearly accomplish the same objective when personal property is at issue. It has been suggested that when personal property is in question, the good faith of the current possessor should substitute for the open and notorious requirement for the accrual of the cause of action (Gerstenblith, 1989: 126-131).

There thus appears to be a conflict in the treatment of the acquisition of title to personal property between the laws governing commercial transactions and those governing time bars to suits. The statutes of limitation exist to bar stale claims for which evidence may no longer be available. In most cases involving art works or cultural property, the time periods are so long that the original owner will not be permitted to present a claim for the recovery of the allegedly stolen property and the statutes of limitation in effect supersede the UCC rules. It is therefore not necessary for the court to engage in questions of original ownership or void and voidable title. Unlike the UCC, which governs the transfer of title, the statutes of limitation do not transfer title to the possessor.[4] They do, however, bar the claim of the true owner and, at least when personal property is at issue, the practical effect is the same. On the other hand, if the time that has elapsed since the theft is shorter than the statutory time period, then the UCC would prevail because the time bar would not apply.

The statutes of limitation for the recovery of personal property are relatively short, ranging from two to six years (Gerstenblith 1989: 122).[5] The time periods involved in the recovery of stolen art are usually considerably longer. The case law dealing with this question has thus focussed almost exclusively on whether the statutes of limitation should bar the plaintiff's suit and, more specifically, on how to calculate the time period for the running of the statute.

Most statutes of limitation are written so that the time period for the running of the statute begins when the cause of action accrues. Courts and legislatures have struggled with the definition of the accrual of the cause of action. The simplest interpretation would place accrual at the time that the injury is done. In the case of the Cypriot mosaics, for example, this would be the time at which the mosaics were removed from the church, sometime in the late 1970s. Because the Indiana statute of limitation for the recovery

of personal property is six years, this would mean that the lawsuit would be barred and Goldberg could keep the mosaics. The essential problem, however, is what to do when the plaintiff has been unable to bring the suit within the time period because the plaintiff lacks some of the necessary information; for example, the fact of the injury, the location of the art works, or the identity of the current possessor of the art works.

Particularly when faced with situations of stolen art works, often in times of war and often with unusually sympathetic plaintiffs, courts have attempted to fashion various doctrines which would modify the operation of the statute of limitations and delay the running of the time limit. The reason for this is clearly the particular nature of the property at stake, its considerable value, both monetary and cultural, and its uniqueness, as well as the various courts' apparent sympathies with the particular parties involved in this type of dispute. Generally, courts have done this by redefining the accrual of the cause of action so as to require, in some fashion, the plaintiff's knowledge of the facts necessary to institute a law suit.

Application of Statutes of Limitation to the Recovery of Stolen Art Works

The first modern case addressing the accrual of a cause of action for replevin of stolen art works was *Menzel* v. *List*.[6] The New York courts had developed a rule, known as the 'demand and refusal' rule, which states that the cause of action does not accrue, at least against a good faith purchaser of stolen personal property, until the true owner has made a demand for its return and the possessor has refused the demand. This rule originated in the mid-nineteenth century and was probably intended merely to protect the good faith purchaser from liability for accidental injury to the property (Gerstenblith, 1989: 132-136). It was first applied to art works in this case in which a plaintiff attempted to recover her Chagall painting which had been taken from her when the Nazi forces occupied her homeland of Belgium. Although approximately twenty years had passed from the time her painting was taken, the New York Court of Appeals held that the cause of action did not accrue until she located her painting, made a demand for its return and was refused.

This judicial gloss on the statute of limitations for the recovery of personal property effectively delays accrual until the plaintiff not only knows the exact location of the stolen property but also chooses to act upon this knowledge. However, this rule applies only when the current possessor does not know that the property is stolen and is therefore considered to be acting in good faith. The practical effect of the 'demand and refusal' rule is that the original owner's claim will never be barred if the current possessor has acted in good faith, and the original owner will recover the stolen property under UCC principles. This rule has been criticised for delaying the statute of limitation only when the defendant acts in good faith but not in bad faith and for protecting the plaintiff's rights excessively (Ward, 1981/

1982: 554; Petrovich, 1980: 1138-1140; Hayworth, 1993: 337-338). None-theless, the rule was reaffirmed by the New York Court of Appeals in a 1991 decision involving the theft of a painting from the Guggenheim Museum in New York, which will be discussed at greater length below.

The other approach which has been used, not only in cases involving stolen art works but also in cases involving various types of torts such as medical malpractice (Owens, 1983), is called the 'discovery rule' (Eisen, 1991: 1086-1094; Franzese, 1989). The New Jersey Supreme Court first applied this approach in a 1980 case in which Georgia O'Keeffe attempted to recover two of her paintings.[7] The artist claimed the paintings had been stolen, but the defendant claimed that O'Keeffe's husband had given them as gifts. The court concluded that the statute of limitations would not run until the plaintiff knew or reasonably should have known the location of the stolen property. Under the discovery rule, the court thus focusses on the due diligence of the plaintiff in searching for her stolen property and, so long as the plaintiff demonstrates such diligence, the statutory time period will not run. While this approach is clearly more sympathetic to the plaintiff's case than simply defining accrual at the time of the injury, it focusses too much attention on the plaintiff's conduct and not enough on the defendant's conduct. Ironically, it puts the burden on the true owner, who does not know the location of the property, to show due diligence in searching for it, rather than placing the burden on the purchaser, who has the property in hand, to demonstrate good faith in the acquisition of the property.

After two cases were decided in federal court interpreting New York State law,[8] there seemed to be a move toward adoption of the 'discovery rule', as articulated in the *O'Keeffe* decision.[9] In the case of *Solomon R. Guggenheim Foundation v. Lubell*,[10] however, the issue was returned to its proper forum, the New York state courts, for definition of the accrual of a cause of action for replevin of stolen property. The Guggenheim Museum discovered, sometime after 1965, that a Chagall painting, which had been in its collection since 1937, was missing. The theft was not definitely ascertained until the Museum conducted a complete inventory of its collection in approximately 1970, and the painting was formally 'deaccessioned' in 1974. The Museum made the tactical decision not to notify any authorities or organisations of the theft on the theory that publicity would drive the painting 'further underground' and thereby decrease the likelihood of its recovery.

In the interim, Mr and Mrs Lubell had purchased the painting from the Robert Elkon Gallery for $17,000 in 1967. Although the painting was subsequently exhibited at the Gallery, the Guggenheim did not learn of its location until 1985 when a dealer showed a transparency of the painting to a Sotheby's employee who had previously worked at the Guggenheim and thus recognised it. In 1986, the Guggenheim made a demand of Mrs. Lubell for return of the painting; after her refusal, the museum filed suit in 1987 for its recovery or, in the alternative, for $200,000.

The intermediate appellate court, and later the New York Court of

Appeals, rejected the application of the 'discovery rule' to the case. It reaffirmed the 'demand and refusal' rule as the proper interpretation of the statute of limitations. The New York court, however, characterised the defendant's argument that the Guggenheim had not been sufficiently diligent in searching for the painting as a defense based on the equitable doctrine of laches. Equitable doctrines, in general, rely on the so-called 'conscience of the court' and are a more flexible mechanism by which the court can attempt to do what ought to be done, as opposed to the stricter requirements imposed by legal doctrines.

The court in *Lubell* thus distinguished a statute of limitations defense, based on an 'unreasonable delay in making a demand upon a known possessor,' from a laches defense, based on 'lack of diligence in searching for stolen property'.[11] While a claim could not be barred, in the court's opinion, merely by delay in making a demand, the essential ingredient in a laches defense – that of prejudice caused by the delay – could cause such a result. Thus, although a suit would effectively never be barred at law because of the running of the statute of limitations, a defendant could perhaps have the suit barred in equity if the defendant can demonstrate that the plaintiff delayed unnecessarily in bringing the suit and that the defendant's case was prejudiced by the delay.

This approach represents an advance over the use of the 'demand and refusal' rule because it forces the plaintiff to act in a timely fashion, but not before it is possible to bring a suit, while protecting the defendant only when the underlying policy of the statute of limitation to prevent stale lawsuits is served. It thus focusses attention on both the conduct of the plaintiff and the ability of the defendant to bring a proper defense, rather than on either the mechanical passage of time or an unending delay in the running of the statute which prevents possessors of art works from ever being certain that they have good title.

In rejecting the 'due diligence' requirement of the discovery rule, the New York court clearly placed its imprimatur on the policy of protecting the original owner of stolen art works. Imposition of an 'additional duty of diligence before the true owner has reason to know where its missing chattel is to be found' was considered too great a burden.[12] The court expressed its concern that New York not become a haven for stolen art works through the operation of a statute of limitation which might impose an unreasonable burden on the original owner, thus protecting those who traffick in stolen art.[13] The court concluded that the burden is more appropriately placed on the potential purchaser of art works to discover the provenance of the art than on the original owner to locate, or even to demonstrate due diligence in attempting to locate, the stolen art.[14]

The *Guggenheim* case was set to go to trial during December 1993. However, after one day of trial, the parties settled the suit with Mrs Lubell and two art galleries agreeing to give the Guggenheim approximately $200,000; Mrs Lubell was then permitted to keep the painting.[15] The use of the equitable defenses as articulated in the *Guggenheim* case could

perhaps be criticised because it will decrease certainty in the outcomes of such cases and perhaps increase litigation. On the other hand, within a few months, two major cases, *Lubell* and the *Metropolitan Museum* case which will be discussed below, were settled without any need for trial in light of the standard articulated by the New York Court of Appeals.

In the case of the Kanakariá mosaics, the District Court in Indiana and later the Seventh Circuit applied the 'discovery rule' to determine that the statute of limitations would not run so as to bar the recovery suit by the Republic of Cyprus (Foutty, 1990: 1853-57). Nonetheless, this required the court to examine in considerable detail the actions of the Cypriot government and its Department of Antiquities in publicizing the theft, of which it had only sketchy details brought by individuals who had been able to brave near warlike conditions to obtain information from the northern part of Cyprus, and in continuously checking with the various international agencies to determine whether there were reports of the location of the mosaics.[16] On the other hand, under the discovery rule, the court need not examine the conduct of the purchaser, Peg Goldberg, to determine whether her actions were reasonable under the circumstances. A commercially reasonable purchaser should have questioned the provenance of the mosaics and refused to deal with them or at least been sufficiently suspicious so as to undertake more serious efforts to determine their legitimacy.

Because Goldberg attempted to use the mantle of Swiss law, which grants title immediately to a good faith purchaser, the District Court did make factual determinations concerning her good faith.[17] The court concluded that she was not a good faith purchaser because she knew little about the people with whom she dealt, the little she knew indicated their questionable backgrounds, the haste with which the transaction was completed, her lack of knowledge about Byzantine art, her failure to consult with a Byzantine art expert, and her questionable attempts to contact the various governments involved and international agencies which track stolen art. These were all factors under her control, but they are ignored by the use of the discovery rule which looks only at the conduct of the true owner in searching for the stolen art. The New York court's formulation of the equitable defense of laches, on the other hand, focusses on the purchaser's good faith and diligence in determining whether to purchase an art work.

Recent Cases involving the Recovery of Stolen Art Works

In addition to the settlement of the *Guggenheim* case, two other well-publicised cases in the United States were resolved in the fall of 1993. The first of these involved the attempt by the government of Turkey to reclaim from the Metropolitan Museum in New York the Lydian treasure. This treasure was a collection of gold, silver and bronze pitchers, bowls, ladles and incense burners, jewellery of gold, silver, carnelian and glass, wall paintings, and sculpted sphinxes. The objects dated from the 6th C BC and

had been plundered from ancient burial tombs in the 1960s. The Metropolitan had the objects from that time but did not display them until 1984. Turkey then asked for their return and filed suit in 1987.[18]

This case was governed by the law of New York State, as enunciated in the *Guggenheim* v. *Lubell* decision, which applied both the 'demand and refusal' rule and the equitable defense of laches. It was clear that the suit would not be barred by the statute of limitations because Turkey filed suit within the required time period after asking the Metropolitan to return the objects. On the other hand, the trial court would determine whether the plaintiff had unreasonably delayed in bringing suit so as to prejudice the defendant in defending against the claim. The Metropolitan, however, agreed to return the objects. At the time of the settlement agreement, Philippe de Montebello, the director of the Metropolitan, admitted not only that it was likely that the antiquities were stolen but that the Museum had found evidence during the discovery process that the staff was probably aware at the time the Museum acquired the objects that they came from clandestine excavations.[19] Under the equitable approach, it can be suggested that the defendant who knows that it has acted illegally or in bad faith is never prejudiced by a delay in the bringing of a law suit. It was thus clear, under New York law, that neither the legal defense based on the statute of limitations nor an equitable defense based on laches would serve to protect the Metropolitan from the claim.

The second recently decided dispute involved the Sevso Treasure, a group of 14 Roman silver objects purchased by Lord Northampton who then attempted to resell them for approximately $100 million. The Treasure, however, became the subject of a suit by Croatia, Hungary and, originally, Lebanon to recover it. A jury decided that neither Croatia nor Hungary was able to carry the burden of proving that the Treasure had been excavated within their respective borders.[20] The Late Roman Empire, at the time the items in the treasure were made, spanned the borders of approximately 40 modern countries. Without clear documentation of the circumstances of discovery and excavation, it seems difficult for any country to establish its ownership rights.

This leaves the Treasure in the hands of Lord Northampton. However, title to the Treasure seems uncertain and any purchaser would be undertaking the risk of another protracted law suit and the possible loss of the Treasure entirely, if its provenance should be established. What distinguishes the Kanakariá mosaics and the Metropolitan Lydian hoard from the Sevso Treasure was the ability of the respective plaintiffs to establish conclusively the provenance of the mosaics and of the Lydian hoard. The Sevso Treasure seems likely to remain 'ownerless' since although potential plaintiffs may not be able to establish their clear ownership rights or may eventually be barred from suing due to the statute of limitations, none of these legal mechanisms can actually create a clear legal title to the Treasure in Lord Northampton.

The Impact of International Law

At this point, it is useful to note the difficulties involved in attempting to apply principles of international law to the recovery of stolen antiquities in the United States. The United States signed the UNESCO Convention in 1972 but did so as an executory treaty. This meant that the treaty would not take effect until the United States Congress enacted implementing legislation. Congress, however, delayed in passing this legislation, largely as the result of lobbying efforts by those involved in the influential art market in New York.

In the late 1970s, the US Customs Service began unilaterally to seize, under its interpretation of the National Stolen Property Act, cultural property from Central and South America which it suspected was stolen or exported illegally from countries which had declared national ownership of their cultural property (Bator, 1982: 344-54).[21] As a result of this aggressive position, a compromise was reached in Congress and the Convention on Cultural Property Implementation Act became effective in 1983.[22]

However, one of its provisions is that our adherence to the UNESCO Convention applies only to property stolen after the effective date of the CPIA. Thus the UNESCO Convention did not apply to either the Lydian hoard in the Metropolitan or to the Kanakariá mosaics. The other CPIA provisions also serve to restrict considerably the applicability of the UNESCO Convention as an effective tool for the restitution of cultural property. On the other hand, the Unidroit Convention, now in various draft stages, represents a considerable compromise of the various conflicting interests and, if accepted by several art-importing nations, may provide some hope for an effective means to help in the restitution of cultural property (Kinderman, 1993). The concurring opinion in the Kanakariá decision attempts to take into consideration the requisites of international agreements and law, even though international law was not binding on the resolution of that particular case.[23]

The question of ownership is further complicated when title is based exclusively on a national declaration of ownership. Antiquities which were illegally excavated and exported and never reduced to ownership by a particular individual, museum or other public institution may thus be considered 'unowned' rather than stolen. Many art-source nations, at different times, have declared that all such antiquities, including unexcavated ones, are the property of the national government. However, the issue is whether or not the laws of the various states will recognise ownership based on such a national declaration of ownership of all antiquities (Bator, 1982). Again, the Kanakariá mosaics presented a relatively easy case from a legal viewpoint, because their provenance was clearly established through their extensive publication before their theft and title was clearly vested in the Church.

Conclusion

The legal issues involved in the recovery of stolen personal property have necessitated vexing policy determinations in the attempt to balance the rights of an injured and innocent owner against the interests of the good faith purchaser. The property rights of an owner deserve legal protection and any trafficking in stolen property should be discouraged. On the other hand, the legitimate expectations of one dealing in good faith should be protected and this may be essential to the viability of commercial transactions. These policy issues become more pronounced when the property at stake is art, unique and valuable from a monetary perspective, but even more so from a cultural and historical perspective. No reliable method for tracing title to art works yet exists and, at the same time, a market for stolen art thrives.

If the reason for protecting the possessor is to protect legitimate commercial expectations, then the possessor must act in a commercially reasonable manner. One who acts in bad faith or with notice of unclear title or without undertaking a search which would be reasonably diligent in light of the character, uniqueness and value of the property involved cannot be said to have relied on good title or to have been prejudiced by any alleged delay on the part of the original owner. The introduction of an approach based on the equitable defense of laches, as the New York courts have recently done, will focus attention on the possessor's conduct which is where it should be. It is the possessor who knows the location of the property and who makes the decision whether to deal with it. The use of the defense of laches thus presents a better resolution than the discovery or due diligence rule utilized in the Kanakariá mosaics case. By focussing on the obligation to be imposed on the purchaser of art works, laches should promote the proper balance between the conflicting policy goals which the art market poses.

Appendix: Glossary of Legal Terms

accrual of a cause of action: the time when a suit may be brought; whenever one person may sue another or has legal authority to demand redress.

actual notice: see notice.

adverse possession: a method of acquisition of title by possession for a statutorily prescribed period of time. It has been described as the statutory method of acquiring title to land by extinction of the cause of the action of the owner to recover possession from a trespasser.

bar: that which defeats, annuls, cuts off, or puts an end to. For example, a bar may prevent the plaintiff from further prosecuting an action at law and thus defeat or destroy the action altogether.

cause of action: right to bring suit, to enforce obligations, prosecute an action, to recover something from another, or to obtain relief in court.

constructive notice: see notice.

discovery: the ascertainment of that which was previously unknown; the acquisition of notice or knowledge of given acts or facts, as, for example, may affect the running of the statute of limitations.

discovery rule: a rule, either enacted in statute or imposed judicially, that an individual may be charged with notice of any facts which he or she might have discovered with due diligence; it operates based upon concepts of inquiry notice.

due diligence: such a measure of prudence, activity, care, or attention, as is properly to be expected from and ordinarily exercised by a reasonable and prudent person under the particular circumstances; not measured by any absolute standard, but depending on the relative facts of the special case.

entrustment: delivery of goods into the possession of another.

equity: in its broadest sense, this term denotes the spirit and the habit of fairness, justness, and right dealing among people. Equity courts existed as a distinct judicial system to administer remedial justice and utilized more flexible doctrines than the common-law courts applied. The object of equity was to render the administration of justice more complete, by affording relief where the courts of law were unable to do so or by exercising certain branches of jurisdiction independently of them. Today, although the same courts have jurisdiction to administer both equity and law, distinct legal and equitable doctrines are retained, particularly in the types of defenses and remedies which are available to the parties.

executory: that which is incomplete or remains to be performed or carried into operation or effect; depending upon a future performance or event.

forum: a court of justice; place of jurisdiction or litigation.

good faith: honesty of intention and lack of knowledge, information, or notice of facts or circumstances which ought to warn an individual.

good faith or bona fide purchaser: a purchaser in good faith for valuable consideration and without notice; one who pays valuable consideration in the absence of actual or constructive notice of outstanding rights of others as to the property.

inquiry notice: see notice.

jurisdiction: authority by which courts and judicial officers take cognizance of and decide cases; the legal right by which a judge exercises authority when the court has cognizance of the class of cases involved, the proper parties are present, and the point to be decided falls within the proper issues.

jurisdiction based on diversity of citizenship: a phrase used to describe one form of jurisdiction of the federal courts which, under the United States Constitution, extends to cases between citizens of different states; diversity exists when the party on one side of the lawsuit is a citizen of one state and the party on the other side is a citizen of another state or a foreign country.

laches: a defense relying on the principle that it would be inequitable to permit a claim to be enforced based on a delay accompanied by or inducing

a change of condition or relations or a delay or lack of diligence on the part of a plaintiff that results in disadvantage, injury, injustice, detriment or prejudice to the defendant; neglect or omission to assert a right such that, taken in conjunction with lapse of time and other circumstances, causes prejudice to the adverse party.

liability: responsibility or obligation.

notice: knowledge or observation of facts which may lead to knowledge.

 actual notice: notice expressly given and brought directly home to the party.

 constructive notice: information or knowledge of a fact imputed by law to a person, although he may not actually have it, because he could have discovered the fact by proper diligence, and his situation was such as to put upon him the duty of inquiring into it. Depending on the precise terminology used, constructive notice may be similar to or may even include the concept of inquiry notice.

 inquiry notice: notice inferred or imputed to a party by reason of his or her knowledge of facts or circumstances collateral to the main fact, of such a character that the reasonable person would be put upon notice, and which, if the inquiry were followed up with due diligence, would lead that person definitely to the knowledge of the main fact.

prejudice: something which acts to disadvantage one party to a law suit but is not based on the justice of the cause.

property: ownership; the unrestricted and exclusive right to a thing; more generally used to denote everything which is the subject of ownership.

 personal property: everything that is the subject of ownership, not falling within the category of real estate.

 real property: land, and generally whatever is growing upon or affixed to land.

replevin: an action brought to recover possession of goods unlawfully taken, if the party from whom the goods were taken wishes to have the goods themselves returned, rather than damages which represent the value of the goods taken; a possessory action in which the plaintiff may recover only on the basis of the strength of his own title, rather than on the weakness of the defendant's title.

statute of limitations: a statute prescribing limitations to the right of action on certain causes of action such that no suit may be maintained on such causes of action unless brought within a specified time period after the right has accrued.

title: a combination of all the elements which constitute ownership of property; generally, the evidence of right which a person has to the possession and ownership of property.

 void title: title which has no legal force or effect and is absolutely incapable of being enforced.

 voidable title: title which may be declared void or set aside but which is not void from its inception.

tort: a private or civil wrong or injury, independent of contract or private

Case Histories

agreement.

transfer: an act of the parties, or of the law, by which the title to property is conveyed from one person to another.

Uniform Commercial Code: one of several sets of laws promulgated by the Uniform State Laws Commission and adopted in several jurisdictions of the United States. The UCC has been adopted in most states and governs various commercial transactions.

Notes

1 The facts presented here are based on the facts reported in the two opinions concerning the Kanakariá mosaics. *Autocephalous Greek-Orthodox Church of Cyprus* v. *Goldberg & Feldman Fine Arts. Inc.*, 717 F. Supp. 1374 (S.D. Ind. 1989), aff'd, 917 F.2d 278 (7th Cir. 1990), cert. denied, 502 U.S. 941 (1991).

2 UCC § 2-403 (1) states: 'A purchaser of goods acquires all title which his transferor had or had power to transfer...'

3 UCC § 403 (2). UCC § 403 (3) defines 'entrustment' as including 'any delivery and any acquiescence in retention of possession regardless of any condition expressed between the parties...'

4 The Georgia and Louisiana statutes are exceptions to this principle in that they explicitly vest title in the adverse possessor after the expiration of the statutory time period. Ga Code Ann. § 85-1706 (Harr. Supp. 1986); La. Civ. Code arts. 3490, 3491 (1992).

5 Rhode Island provides a statutory period of ten years, as does Louisiana where it applies only to possessors who cannot demonstrate that they have acted in good faith. R.I. Gen Laws § 9-1-13 (1993); La. civ. code art. 3491 (1992).

6 22 A.D.2d 647, 253 N.Y.S.2d 43 (1964), and 49 Misc. 2d 300, 267 N.Y.S.2d 804 (Sup. Ct. 1966), modified on other grounds, 28 A.D.2d 516, 279 N.Y.S.2d 608 (1967), modification rev'd, 24 N.Y.2d 91, 246 N.E.2d 742, 298 N.Y.S.2d 979 (1969).

7 *O'Keeffe* v. *Snyder*, 170 N.J. Super. 75, 405 A.2d 840 (1979), rev'd, 83 N.J. 478, 416 A.2d 862 (1980).

8 In the United States, federal courts only have jurisdication over cases which either involve a federal question (that is, an issue based on federal statute or the federal Constitution) or involve citizens of two different states or citizens of a foreign country. In cases involving this latter type of jurisdiction, known as diversity jurisdiction, the federal court must nonetheless apply the law of the state in which the federal court sits and which governs the legal issue at stake. Thus, in two significant cases, *Elicofon* and *DeWeerth*, the federal court located in New York had jurisdiction because at least one of the parties in each case was a foreign citizen. However, the court was obligated to follow the New York law concerning recovery of stolen property in resolving the issues.

9 In the earlier case of *Kunstsammlungen zu Weimar* v. *Elicofon*, which involved two Dürer paintings allegedly stolen by American soldiers at the end of World War II, the Second Circuit still applied the demand and refusal rule. 536 F. Supp. 829 (E.D.N.Y. 1981), 678 F.2d 1150 (2d Cir. 1982). However, in the later case of *DeWeerth* v. *Baldinger*, the Second Circuit applied the discovery rule and barred the plaintiff's claim on the ground that she had not displayed sufficient diligence in searchng for her Monet painting also stolen during World War II. 658

F. Supp. 688 (S.D.N.Y. 1987), rev'd, 836 F.2d 103 (2d Cir. 1987).
10 153 A.D.2d 143, 550 N.Y.S.2d 618 (1990), aff'd, 77 N.Y.2d 311, 569 N.E.2d 426, 567 N.Y.S.2d 623 (1991). These facts are summarised at 77 N.Y.2d at 315-16, 569 N.E.2d at 427-28, 567 N.Y.S.2d at 625-26 (Hayworth, 1993: 369-72; Gerstenblith, 1992: 360-62).
11 153 A.D.2d at 149, 550 N.Y.S.2d at 622.
12 77 N.Y.2d at 320, 569 N.E.2d at 430, 567 N.Y.S.2d at 627. The Court of Appeals noted that the definition of 'due diligence' will vary considerably depending on the uniqueness and value of the stolen property, the position of the original owner and, particularly appropriate in this case, an assessment of what conduct is most likely to lead to recovery of the stolen art. Id. at 320, 569 N.E.2d at 430-31, 567 N.Y.S.2d at 627-28.
13 Id. at 320, 569 N.E.2d at 431, 567 N.Y.S.2d at 627-28.
14 Id. at 320, 569 N.E.2d at 430, 567 N.Y.S.2d at 627.
15 Perez-Pena, R., 'Stolen Chagall: An Art Museum and a Collector Reach a Quiet Compromise'. New York Times, 2 January 1994, § 4, p.2; Perez-Pena, R., Suit Over Chagall Watercolor is Settled Day After Trial Starts', New York Times, 29 December 1993, B3.
16 717 F.Supp. 1374, 1389-91 (S.D. Ind. 1989).
17 Id. at 1400-04.
18 Republic of Turkey v. Metropolitan Museum of Art, 762 F. Supp. 44 (S.D.N.Y. 1990).
19 Vogel, C., 'Metropolitan Museum to Return Turkish Art', New York Times, 23 September 1993, C13.
20 'Jury says Sevso silver belongs to English Lord', New York Times, 5 November 1993, C3. Republic of Croatia v. Trustee of the Marquess of Northampton 1987 Settlement, 203 A.D.2d167, 610 N.Y.S.2d 263 (1994).
21 Two well known cases were United States v. Hollinshead, 495 F.2d 1154 (9th Cir. 1974), and United States v. McClain, 545 F.2d 988 (5th Cir. 1977), 593 F.2d 658 (5th Cir.), cert. denied, 444 U.S. 918 (1979).
22 Public Law 97-446, 19 U.S.C. § 2601 et seq. (1983), as amended (1987).
23 This opinion discusses the various international agreements and the Cultural Property Implementation Act, 917 F.2d 278, 295-97 (7th Cir. 1990) (Cudahy, J., concurring).

Bibliography

Bator, P., 1982. An Essay on the International Trade in Art. Stanford Law Review 34: 275-384.

Casner, A.J. (ed.) 1952. American Law of Property Vol. 3.

Collin, R., 1993. The Law and Stolen Art, Artifacts, and Antiquities. Howard Law Journal 36: 17-42.

Eisen, L., 1991. The Missing Piece: A Discussion of Theft, Statutes of Limitations, and Title Disputes in the Art World. Journal of Criminal Law and Criminology 81: 1067-1101.

Case Histories

Foutty, S., 1990. *Autocephalous Greek-Orthodox Church of Cyprus* v. *Goldberg & Feldman Fine Arts, Inc.*: Entrenchment of the Due Diligence Requirement in Replevin Actions for Stolen Art. *Vanderbilt Law Review* 43: 1839-1861.

Franzese, P., 1989. 'Georgia on My Mind'—Reflections on *O'Keeffe* v. *Snyder*. *Seton Hall Law Review* 19: 1-22.

Gerstenblith, P., 1989. The Adverse Possession of Personal Property. *Buffalo Law Review* 37: 119-163.

Gerstenblith, P. 1992 *Guggenheim* v. *Lubell*. *International Journal of Cultural Property* 2: 359-367.

Gilmore, G., 1954. The Commercial Doctrine of Good Faith Purchase. *Yale Law Journal* 63: 1057-1122.

Gilmore, G., 1981. The Good Faith Purchase Idea and the Uniform Commercial Code: Confessions of a Repentant Draftsman. *Georgia Law Review* 15: 605-629.

Hayworth, A., 1993. Stolen Artwork: Deciding Ownership Is No Pretty Picture. *Duke Law Journal* 43: 337-383

Helmholz, R., 1986. Wrongful Possession of Chattels: Hornbook Law and Case Law. *Northwestern University Law Review* 80: 1221-1243.

Kinderman, S., 1993. The Unidroit Draft Convention on Cultural Objects: An Examination of the Need for a Uniform Legal Framework for Controlling the Illicit Movement of Cultural Property. *Emory International Law Review* 7: 457-584.

Levmore, S., 1987. Variety and Uniformity in the Treatment of the Good-Faith Purchaser. *Journal of Legal Studies* 16: 43-65.

Megaw, A.H.S. and Hawkins, E.J.W., 1977. *The Church of the Panagia Kanakariá at Lythrankomi in Cyprus: Its Mosaics and Frescoes*. Dumbarton Oaks Studies 14, Washington, D.C.:Dumbarton Oaks.

Owens, S.B., 1983. Torts – The Discovery Rule and the Statute of Limitations in Medical Malpractice Actions. *Memphis State University Law Review* 14: 115-123.

Petrovich, J., 1980. The Recovery of Stolen Art: Of Paintings, Statues, and Statutes of Limitations. *U.C.L.A. Law Review* 27: 1122-1158.

Ward, N., 1981/82. The Georgia Grind-Can the Common Law Accommo date the Problems of Title in the Art World, Observations on a Recent Case. *Journal of College & University Law* 8: 533-561.

The Kanakariá Mosaics:

the conservators' view

Catherine Sease and Danaë Thimme

Introduction

In 1989, four mosaic fragments from the Church of the Panagia Kanakariá in Lythrankomi, northern Cyprus (Plate 1), became the center of an important legal dispute. The trial to establish legal ownership of the fragments, which had been purchased by an Indianapolis art dealer, took place in Indianapolis, Indiana. As archaeological conservators working in midwestern United States, the authors were called upon as expert witnesses to examine the mosaic fragments with a view to testifying in a suit for damages in which the restorer, as well as the dealer, would have been involved. Originally, the damages issue was to be included along with the question of legal ownership, but it was subsequently treated as a separate suit and, eventually, was not brought to trial. Although conservation in the end did not play a role in the actual trial, it did play a major role in the fate of the mosaics themselves, as will be discussed below.

The Mosaic Fragments

The four mosaic fragments depict the heads of the North Archangel (Plate 2) and the Apostles James (Plate 3) and Matthew (Plate 4), and the upper half of the figure of Christ (Plate 5). Dating to the middle of the sixth century AD, they are 'among the most important monuments of Cyprus, their significance going well beyond the shores of the island' (Michaelides, 1989). Having survived the Iconoclastic period of the eighth century, these extremely rare mosaics are considered among the finest examples of early Christian art. These fragments are from one of the few surviving Byzantine church mosaics in pristine condition and, as a result, are of prime importance as a close reflection of the art of Constantinople. They also provide a valuable example of the high quality of church decoration in the provinces, even in relatively remote areas, during the sixth century (Megaw, 1977). Although the work of provincial craftsmen, the quality is of an extremely high order. The mosaicist's sensitive treatment of flesh and attention to anatomical detail through subtle shading sets these mosaics apart from their counterparts in Sinai and Ravenna (Megaw,

1977). Not only are they executed with a high degree of skill, but they preserve unique iconographic features, such as the depiction of Christ as a grown child rather than an infant and the mandorla surrounding the Virgin and Child, for which there is no sixth century parallel (Megaw, 1977).

The Kanakariá mosaics consist of stone and glass tesserae set in a lime plaster bed applied in three renderings: a fine layer underlaid by two layers of coarser lime plaster mixed with straw. The stone tesserae are made from marble and include white and various colours. Some of the white tesserae were dipped in red pigment prior to being set in the plaster. The glass tesserae are made of both opaque and translucent colored glass. The gold and silver tesserae consist of pieces of gold or silver foil sandwiched between two layers of fused clear glass. Varying sizes and shapes of tesserae were deliberately used throughout the mosaics to provide texture and depth to the figures.

Prior to setting the tesserae, a rough outline of the design, or *sinopia*, was painted in red, green, and black pigment onto the wet bedding plaster to serve as a guide for the mosaicist (Megaw, 1977). The *sinopia* was not intended to be entirely hidden by the tesserae; it served to tone in the white plaster setting bed visible in the interstices between the tesserae (Underwood, 1966). It was also meant to enhance colour, particularly of the gold tesserae. Light was of supreme importance to Byzantine taste and considerable pains were taken to set mosaic tesserae at varying angles in order to catch the light, particularly that of flickering candles, which gave movement to the figures (Runciman, 1990).

Examination

Once Cyprus's legal ownership was established, but before the dealer's appeal, the authors were called upon to examine the mosaics and prepare a condition report. Throughout the entire legal proceedings, the mosaics were stored in their travelling crates in a vault in Indianapolis. Since they could not legally be moved, the examinations had to be conducted under somewhat cramped and badly lit conditions. Examination consisted of detailed visual analysis using the naked eye, low power loupes, high power magnification, and ultraviolet light. The findings were documented photo-graphically.

The task was to see whether, while determining the overall condition of the fragments, it was possible to determine a chronological sequence of damage and, if so, to ascertain what portion of the damage was incurred while the mosaics were in the possession of the Indianapolis dealer. It was already known that the mosaics had been removed from the apse of the church of the Panagia Kanakariá. They had then been taken from there to Munich where they remained for some time before being sold in Geneva and finally transported to Indianapolis where they were restored. Subsequently, they crossed the Atlantic at least once more and travelled within the United States.

The only documentation which had been provided was the scant information provided by the prosecution lawyers. This consisted of: the monograph *The Church of the Panagia Kanakariá at Lythrankomi in Cyprus: Its Mosaics and Frescos* by Megaw and Hawkins in which the mosaics are thoroughly described and illustrated; a set of eight 3 x 5 inch colour photographs taken sometime after the mosaics left Cyprus, probably in Munich; an airline's damage report, including photographs, of the mosaics on their arrival in Indianapolis; one photograph taken by the restorer; and four colour photographs taken for sales purposes after restoration. For information of restoration methods and materials used, we had access to the restorer's deposition, the only extant record of treatment.

Condition of the Mosaics

Each fragment had been detached from the wall of the church and consisted of the tesserae and three layers of plaster: two under layers of lime plaster mixed with straw and the finer bed into which the tesserae were set. In Indianapolis, as part of the restoration treatment, three of the fragments were mounted on flat squares of masonite (a type of fibreboard made of pressed wood), as seen in Plate 6, with either screws or nail-like metal attachments. The fourth was also attached to a piece of masonite, but there was no sign of nails or screws. The sides of all four fragments were covered with a thick layer of plaster of Paris. As this effectively obscured all but the tesselated surface, our examination was confined to this surface and the substrate immediately below it.

The fragments originally conformed to the curved surface of the apse but now appeared more or less flat. The surface undulations on all of them were probably caused by either the disturbance of the underlying plaster bed or the buckling of the tesserae over possible voids underneath them. In many areas on all four fragments, adjacent tesserae or groups of tesserae no longer lay in the same plane, but had either sunk or been pushed up.

A network of cracks covered the surface of each fragment. Some of these cracks were structural, appearing to penetrate deep into the substrate, if not all the way through the piece, while others were smaller and more superficial. The larger structural cracks had caused considerable disruption to the surface and had been filled with a variety of compensation materials. The fills resulted in the distortion of certain features of the design by displacing tesserae and changing their relationships to each other. Examples of this were seen in the faces of Matthew (Plate 7) and James, where cracks extending through the eyes and down the nose had changed the shape of those features. These cracks were not evident in the Megaw and Hawkins photographs, but did appear, less wide and unfilled, in the Munich photographs.

Numerous hairline cracks, not evident on the Megaw and Hawkins, Munich, or dealer photographs, were seen on Matthew and James

(Plate 8). In some instances, they were severe enough to have cracked tesserae in two, for example, in the border around James's halo. Many of these cracks lay parallel to filled structural cracks.

On all four mosaic fragments, areas of tessera loss ranged from extensive sections to a few tesserae. As well as areas of actual loss, there were sections of partial loss where tesserae had sheared off horizontally (Plate 9). While this condition pertained to some glass tesserae, mainly the gold and silver, it was particularly prevalent on the marble areas. Even seemingly intact marble tesserae were riddled with tiny cracks and fissures. This condition had been noted by Megaw and Hawkins in the 1960s in the tesserae of the Archangel and Christ (Megaw, 1977).

The surfaces of all four fragments were obscured by a combination of yellowed flexible adhesive, polyvinyl acetate-based adhesive (PVA), white wax, and various compensation materials.

A yellowed adhesive was found extensively over the surfaces of all fragments. It contained the impression of a fine textured textile which was assumed to be a remnant of the adhesive used to adhere the protective cloth facings to the surface of the mosaic prior to its removal from the church.

A PVA-based adhesive was a shiny, milky white-to-yellow material found occasionally on the surface (for example, on the right edge of the James mosaic), but extensively in the interstices and crevices between the tesserae on all the fragments. The presence of this adhesive was consistent with the restorer's account of injecting Elmer's Glue, a proprietary PVA emulsion, into the surface of the mosaics.

A white wax was evident as a dull film on the surface of the tesserae and as a thick white residue on the sides of many of the tesserae and on the plaster setting bed. It was assumed that this was the 'conservation wax' mentioned by the restorer in his deposition.

Various compensation materials were used to fill areas where plaster or tesserae, or both, were missing. These materials included plaster of Paris, plaster-like substances, wax (Plate 10), PVA-like materials, and putty of various colors and hardnesses (Plate 7). Grains of sand were impressed into the surface of many of these materials, for example, on Matthew, and all were pigmented or painted. These materials filled gaps left by missing tesserae, cracks, crevices, and larger losses. They also served to secure and reset loose tesserae and plaster along the edges of each mosaic fragment. Not every compensation material was found on every fragment.

In addition to the above, loose and embedded particles were found on all the mosaic fragments, including loose grains of sand, fibres, dirt, and dust. Most of the fibres were white and were distributed extensively throughout the interstices on all four fragments. Under magnification, they showed the characteristic structure of cotton. Other fibres were paper fragments and brush hairs embedded in the wax and adhesives.

On all four fragments tesserae had been reset or secured in place. Resetting refers to instances where the tesserae were removed and the setting bed replaced with a substitute, usually a gray putty-like material. It also refers to the repositioning and reattaching of detached tesserae. Securing refers to the immobilisation of loose, but *in situ*, tesserae with either a putty or an adhesive. The most extensive areas of resetting occurred in the blue of the Virgin's robe surrounding Christ and in Christ's robes (Plate 10).

On all four mosaic fragments, patches of the red ochre *sinopia* were still visible in the plaster of the setting bed and in the deep crevices between tesserae. Particularly well preserved areas were seen in the upper right corner on Christ (Plate 11) and along the left edge of James. During their conservation work on the mosaics in the 1960s, Megaw and Hawkins noted significant amounts of preserved *sinopia*. It was now impossible to determine the exact extent of its preservation as the setting bed had been so extensively disrupted and what remained intact was obscured by fill, dust, wax, and adhesive.

The underlying layers of coarse plaster were exposed on some edges and appeared to be very friable and unstable (Plate 6). No attempt to consolidate these layers appeared to have been made. On all four mosaic fragments, the masonite to which they were attached was starting to warp and adhesion between the masonite and the plaster of Paris showed signs of failure.

Conclusions of Examination

From our examination, we found that the damage could be divided into five discrete phases:

1. The inexpert facing and hurried removal of the mosaics from the apse of the church. No provision was made for the fact that the fragments were curved. Each was a fragment of a larger composition which was crudely cut apart. This was particularly true of the figure of Christ, which had been cut in two and the pieces disposed of separately.
2. The removal of the facings. The amount of adhesive residue on the surface of the mosaics and the condition of the tesserae indicated that the facings were probably ripped off without use of solvent. Their removal in this manner resulted in the shearing off of surfaces already riddled with cracks as well as the loosening of many tesserae.
3. Transportation by air freight from Munich to Indianapolis via Geneva and New York. The mosaic fragments were inadequately packed for all stages of this journey. Each fragment was packed individually in a crate constructed of $1/4$ inch plywood. A minimum margin existed between the edges of the

fragment and the sides of the crate. A sheet of $^1/_4$ inch rubber foam was placed under each fragment and a $^1/_2$ inch sheet on top while small rolls of $^1/_4$ inch rubber foam were placed at two or three points around the edges to immobilise the fragment. This inadequate cushioning and support during transport was responsible for numerous new cracks, the widening of already existing ones, and further fragmentation, especially in the figure of Christ.

4. Restoration. During restoration work, cracks were realigned and filled and the surface of each fragment was brought into plane by raising or lowering the tesserae. This was accomplished by removing existing plaster or by adding fill material. This intervention altered the placement of tesserae, effecting subtle changes in expression in the faces and the composition. It also destroyed the original setting of the tesserae which had been so carefully arranged by the mosaicist to reflect light and provide movement to the figures.

Throughout the restoration work, irreversible materials were used and no documentation was carried out. No separating layer appeared to have been applied between the original plaster and the plaster of Paris on the edges of the fragments. Since the original plaster was not consolidated before being encased in a rigid plaster of Paris surround, it remains friable and unstable. At the time of examination, each fragment constituted a rigid package with a shifting and unstable center.

5. Post-restoration travel. For sale purposes, the fragments made at least two transatlantic flights as well as several within the United States. These trips contributed to further surface deterioration visible as hairline cracks running alongside fills and old cracks.

In July 1992, the mosaics were returned to Cyprus where they may undergo further treatment. In our opinion, even with further treatment, it is unlikely that these fragments could ever be reinstalled in their apse in the church in Lythrankomi.

Ethical Issues Presented by the Mosaics Case

To conservators working according to an approved code of ethics, the most distressing aspect of this case was the emphasis on financial gain. To all of the people involved with the mosaics from Lythrankomi to Indianapolis money was of sole and paramount importance. Concerns centered around where to go for the highest resale price, the sale to others of shares in the transaction and the payment of the restoration as a percentage of the final sale rather than on completion of the work. In short, the only consideration was how to extract the maximum gain from these fragments. After quoting

from Byron's *Siege of Corinth* in his opinion after the appeal, Chief Judge William J. Bauer (1990) wrote ' as Byron's poem laments, war can reduce our grandest and most sacred temples to mere "fragments of stone". Only the lowest of scoundrels attempt to reap personal gain from this collective loss. Those who plundered the churches and monuments of war-torn Cyprus, hoarded their relics away and are now smuggling and selling them for large sums, are just such blackguards.' Nowhere was it ever mentioned that perhaps there might be other aspects of the mosaics to be considered. Given the financial investment involved, this attitude should not come as a surprise. However, when one considers the artistic and historic significance of the mosaics, it is surprising that at least the qualifications of the restorer and the quality of his work were not a matter of importance. Since the dealer knew of and had access to the Megaw and Hawkins publication, it was not as if the importance of the mosaics was unknown at the time the restorer was hired. It would seem that the rationale for the choice of restorer was based on qualities of discretion rather than on any professional skills or qualifications. The disregard for the quality of the restoration certainly indicated a superficial and uninformed attitude towards the treatment suitable for the preservation of the mosaics and, by extension, towards the effects on the integrity of the mosaics that any such intervention might have. This presupposes that the concept of the integrity of a work of art was either considered to be of no relevance or that it was an unfamiliar concept.

To a conservator, respect for the integrity of a work of art governs all stages of the conservation process. A work of art is the creation of an artist and anything changed by adding to or subtracting from it by someone else impinges on the artist's original intent. In other words, at no time during treatment should the conservator impose his or her own artistic ideas on a work of art. What is done in conservation treatment should always be dictated to the conservator by the work of art rather than the other way around. Altering a work of art results in a departure from the artist's original concept and, consequently, in the loss of valuable information and the destruction of evidence. Sometimes the original intent of the artist is obvious, but when this is not the case, information can be obtained from contemporary publications and treatises on artists' methods and materials and from the results of art historical and conservation research. Additional information can be gathered from careful study of the piece itself and from comparison with other unaltered pieces from the same period.

To ensure that an object's integrity remains uncompromised, certain principles have been developed to guide a conservator's work. Whenever possible, conservation treatment tries not to be invasive: that is, does not add anything to or subtract anything from a piece. There are, however, times when treatment has to be invasive, but such a treatment would be used only as a last resort. On the whole, the principle of minimal intervention guides treatment and the least amount of materials are used to solve the problem. In all conservation treatment, conservators try always to use only those conservation materials that are reversible and compatible with the

materials of the work of art. A compulsory adjunct to the actual treatment is the keeping of meticulous written and photographic records of all its stages, documentation which then becomes part of the history of the piece.

In the case of the Kanakariá mosaics, the artist's intent and the integrity of the church building were compromised from the moment the mosaics were removed from its walls. According to Runciman (1990), ' the church building and all its decoration were integrated with the Liturgy. No part was to be considered in isolation'. Considering the mosaics now as individual pieces rather than as parts of a larger whole, it is clear that their integrity was further compromised by their being cut into sections and even further compromised by the clumsy and inept restoration they had undergone.

The restorer clearly did not understand the materials he was working on and it was clear that he did not consider it necessary to understand them. He knew nothing about the technology involved and does not seem to have felt that an understanding of it might have proved helpful in choosing a restoration treatment. In his deposition he mentions having seen the Megaw and Hawkins publication, but it seems unlikely that he read it. No background research was done and consultation with other conservators more experienced in working with mosaics was not deemed necessary. Thus, the most fundamental aspect of the appearance of the mosaics, namely that they had all been mounted on curved walls, and therefore were meant to be curved, was ignored. Much time and effort went into producing as flat and rigid a surface as possible. Compatibility and reversibility of restoration materials were ignored and documentation of treatment was not considered necessary. Luckily, the restorer's deposition contains at least some information which may be useful to the conservator who will have to re-treat the mosaics now that they have been returned to Cyprus.

Sadly, it is too late for the Kanakariá mosaics, but perhaps there is a lesson to be learnt from this case that could prevent other illegally acquired antiquities from being so grossly damaged through the very intervention that is supposed to preserve them. The question is, how can this be done?

The conservator approached for treatment of antiquities that are suspected or known to have been acquired illegally from their country of origin, is faced with serious ethical and legal dilemmas. If the conservator takes on the treatment out of a desire to ensure that it will be properly performed and documented and to prevent the object from being taken to a back-street restorer, legally he/she could be considered an accessory. By accepting the job, the conservator could also, perhaps, be seen as condoning and abetting the antiquities trade. If the conservator turns down the job and reports the antiquities, the legal implications are avoided, but the ethical problems of correct treatment and documentation persist.

How can we assure that the conservation of illegally acquired antiquities be entrusted to ethical and trained conservators so that not just the physical aspect of the work of art survives, but its integrity as well? Perhaps one way would be to make integrity, something that is largely unseen and

to which it is hard to assign a value, become a desirable quality in a work of art for both seller and purchaser.

Education might provide at least a partial solution. The conservation profession could make a significant contribution by disseminating more information to the public about conservation, conservation documentation, and the principles and ethics that govern responsible treatment. Conservators tend to lose sight of the fact that since conservation treatment and particularly its ethical considerations are invisible, it is not obvious that considerable time, thought, and effort have gone into the seemingly perfectly preserved objects seen on display or offered for sale. When presented with information about conservation treatment, photographic documentation, and the tools and results of technical examination, museum visitors are impressed and eager to learn more. By integrating such information into museum displays or by sometimes making it into a display of its own, public awareness of conservation and its ethics could be raised. At the same time, perhaps this heightened awareness might also extend to the sellers and purchasers of antiquities.

Certification of conservators might also help to address the problem by providing endorsement to those conservators who meet certain standards and abide by codes of ethics set by the profession as a whole or by professional organisations. No one could be made to base the selection of a conservator on such criteria, but the existence of a formal standard and, possibly, a directory, would certainly mean that no one with works of art needing treatment could use the excuse of not knowing where to turn for correct and ethical conservation treatment.

These are complex issues, but ones that we as conservators of antiquities must begin to address if other illegal antiquities are to be spared the fate of the Kanakariá mosaics. Perhaps education is the point at which to start.

References

Bauer, W.J., 1990. *Autocephalous Greek-Orthodox Church of Cyprus and the Republic of Cyprus v.Goldberg and Feldman Fine Arts, Inc. and Peg Goldberg,* United States Court of Appeals for the Seventh Circuit, No. 89-2809.

Megaw, A.H.S. and Hawkins, E.J.W., 197.7 *The Church of the Panagia Kanakariá at Lythrankomi in Cyprus, Its Mosaics and Frescos.* Dumbarton Oaks Studies 14, Washington, D.C.: Dumbarton Oaks.

Michaelides, D., 1989. The Early Christian Mosaics of Cyprus. *Biblical Archaeologist.* 52(4): 192-202.

Runciman, S., 1990. *Byzantine Style and Civilization,* London: Penguin.

Underwood, P.A., 1966. *The Kariye Djami,* vol.1, New York: Bollingen Foundation.

Cycladic figures:
art versus archaeology?

Christopher Chippindale and David Gill

Esteem for Cycladic figures

The substantive work reported at the conference is already published at length as: David Gill and Christopher Chippindale, 'Material and intellectual consequences of esteem for Cycladic figures', *American Journal of Archaeology* 97(4) (October 1993): 601–59—hereafter called 'Esteem'. That material has not been repeated here, and the interested reader is referred to that lengthy report for the full story. Instead, the salient points from 'Esteem' are summarised, and others of particular concern to the role of the conservator, or which arose in discussion at the conference, are noted.

The purpose in studying what has happened to prehistoric Cycladic figures over the past decades and in writing 'Esteem' has been to explore a lasting relationship—the old alliance, the old marriage between the connoisseurs and the archaeologists, those two groups of people who have special interests in old and beautiful things. For most distinct classes, especially those within the fine arts of the Graeco-Roman world, the two interests have danced together so long their personalities have melded. Cycladic is unusual and instructive, because Cycladic came late to archaeological attention and even later to be regarded as fine art. Esteem for Cycladic is a 20th-century affair, and within the 20th century has developed much in the post-war years, as the similarity of Cycladic forms to the modernist canons of our age led to its being given a new and a high value.

In 'Esteem', the present state of the Cycladic corpus has been explored, and then esteem for Cycladic figures has been looked at through its *material* and *intellectual* consequences.

The Cycladic corpus

A few Cycladic figures were excavated archaeologically or bought by museums in the 19th and early 20th centuries, and the genre gradually came into a scholarly notice as a primitive precursor to the advanced arts of classical Greece. Some of these few figures came to be noticed by artists, among them Epstein and Picasso, as part of the enthusiastic

discovery of non-western arts by European artists in the early years of the century. The modernist sculptors of the mid century, such as Moore and Modigliani, developed stripped-down expressive forms which echoed Cycladic; accordingly Cycladic came to find a place in modernist collections as a precursor of our own age, as well as reaching a raised plateau of regard within the range of ancient Aegean traditions. A collecting boom followed, peaking in the 1960s or 1970s, which was supplied by the looting of figures from prehistoric Cycladic sites and by faking.

The known corpus of Cycladic figures is now reckoned at about 1600; a few are casual finds, about 143 have been recovered archaeologically; the other 1400 or so have just 'surfaced'. By 'surfacing', it is meant that they have appeared on the market or in the possession of private collections inside or outside Greece with no declared recent history as to their movements between their places in the ground and the present proprietor; often, surfacing figures are 'said to be' from one or other island, often they are of 'no provenance', or provenanced only as Cycladic. When 92 Cycladic figures from north American collections were gathered for a temporary exhibition in 1987, not one had a certain provenance; 33 were 'said to be' from a stated island or place, 59 were quite without origin. The common context of a Cycladic figure is as accompaniment to an inhumation burial in a grave; many of those that surfaced in the 1960s seem to have come from the looting of a remarkable site on Keros, thought not to be primarily a place of burial, where the figures were numerous.

About 90 per cent of the corpus, then, is practically without history, and our understanding of this 'surfacing' material largely depends on our better record of the remaining 10 per cent.

Knowledgeable people in the worlds both of archaeology (such as Sinclair Hood) and of dealing (such as John Hewitt) are certain Cycladic figures were faked in quantity from the 1950s onwards. There being no secure physical-science means of distinguishing an old figure from a new, the security of the corpus of accepted figures depends simply on the expert eye's view as to whether a figure is good or not. Practically none has been denounced in public as fake. Doubt has been cast on a few. Particular concern surrounds those classes of Cycladic figure, such as the large standing figures and the detached heads of large size that would correspond to outsize figures, and the figures of musicians, which have all or mostly 'surfaced' rather than come from controlled excavation.

'Drifting' provenances are also evident, in which successive accounts of a surfacing figure give different accounts as to where it surfaced from. They further reduce confidence that what is now 'said to' come from where will remain so.

Similar difficulties apply to the other information offered about surfacing figures, such as whether a group of figures was found together, on the same island, at the same site, or associated together in the same grave.

Case Histories

Material consequences

By the 'material consequences' is meant what has happened to the figures themselves, and the ancient places they come from.

Suppose no fakes have deceived the experts, and the corpus of Cycladic figures is entirely genuine. Of the about 1600 accepted figures, a small number were recovered archaeologically, about 350 may come from the Keros deposit, and the remaining 1150 were looted from graves. On average about one grave in ten is known to contain a figure, so this may correspond to about 12,000 graves opened. Cycladic cemeteries, which vary in size, are commonly of about 15–20 graves, so this corresponds to several hundred looted cemeteries. (Indeed, there is not a single Cycladic cemetery left untouched now known to Professor Christos Doumas, the archaeologist responsible for the Cycladic islands during the boom in looting.)

Cycladic graves contain, as well as the human bones, other grave goods that include marble vessels (also in demand from collectors) and simply shaped or unshaped marble pebbles and stones: these last, not declaring themselves by form alone to be antiquities and therefore having no certain market value, were, one may fear, discarded by looters. Creative entrepreneurs, conversely, may have taken simply shaped or unshaped marble pebbles and stones from recent or other contexts and sold them as genuine antiquities.

A consequence of the loss of context for the large majority of figurines is a frail chronology for Cycladic figures and for the prehistoric sequence in the islands. Normally a chronology would depend on secure evidence of association and context, and on radiocarbon dates from organic materials securely associated with figures. Instead, the chronology is obliged to depend on a theoretical scheme for the ways in which characteristic forms among the figures might have transformed one into another, but this is not well tied into reliable information from the field. In the same way, studies of regional variation, attempts to identify distinct workshops or individual figure-carvers, and explorations of the size and function of the figures are undermined by the lack of secure information as to what is genuine, and just what comes from just what context in what place. Again, these obvious routes to a better understanding of Cycladic by reference to secure evidence are instead diverted into speculations that depend too much on investigators' expectations and not enough on empirical information.

Intellectual consequences

By the 'intellectual consequences' is meant the broader impact of esteem for figures on how the figures themselves and the Cyclades in prehistory are perceived .

First is the wholesale loss of information about Cycladic figures, their date, find-spots, contexts, islands of origin, associations and so on, plus

whatever false information has been provided by fakes inadvertently now treated as genuine, and any false information in the remarks that accompany surfacing figures with the qualification 'said to be'. Since the cemetery sites are thought to hold the majority of evidence for Cycladic prehistory, since the thin soils of the islands are not likely to hold many deep sites presently unknown, since much of the Cyclades has been explored archaeologically, it is likely that the destruction of burial sites in quest of figures has gravely reduced the material evidence that survives for the future; to the extent that one may doubt if an understanding of Cycladic prehistory is now possible—other than in the limited framework which can be made from the corpus of figurines, and its 90 per cent composition of 'surfacing' items without history.

It seems to us a remarkable fact that esteem for Cycladic figures has led to so many actions on, or beyond, the margin of legality. Since the number of figures exported from Greece long ago and legally must be very small, there is practically no supply outside Greece of first-rate figures of known and good history. The will of the collector, whether a private individual or a museum curator, drives the wish to acquire in a spirit of chase and capture, of the passionate acquirer taking possession of the prize. Behind this, and the readiness not to ask the questions 'Just where did this come from?', 'Just who dug it up?', 'Just how did it get here?' to which the answers may be uncomfortable, there must be some compelling motive. That motive is seen in the ideal of a spirit of redemption: this fine figurine, crafted with ancient genius, has been lost to the bare earth; it is given to the connoisseur to recognize that eternal spirit, to bring it from the dark earth into the light; since these things are eternal, it does not matter where the collector resides, just as long as he is moved by the spirit; the legal obstacles erected by unfeeling archaeologists or nationalist- and small-minded politicians are the creations of cold minds who do not understand the joy in the redemption.

A feature of Cycladic studies, and especially of Getz-Preziosi's work, has been the recognition of individual Masters, carvers whose distinctive hand can be identified in the style of different figures, which can together be identified as the work of a single carver. Unfortunately, of course, most of the figures that she has to work with are without history. For six of the Masters she identified in her *Sculptors of the Cyclades* (1987), all the identified works are from the set of 'surfacing' figures: neither their date nor their context are known, and one cannot even be sure any or all are genuine. For eight of the Masters, only one or two works come from secure provenances: one cannot have confidence in these, for what could be easier than to fake a figure after the manner of another? Only for two of the Masters are there more than two figures from secure contexts, and it is only for these that there may be a secure corpus.

There are severe and separate difficulties with the premises and methods in identifying individual master-carvers. The exemplar for the study is the identification by Beazley and others of individual painters in

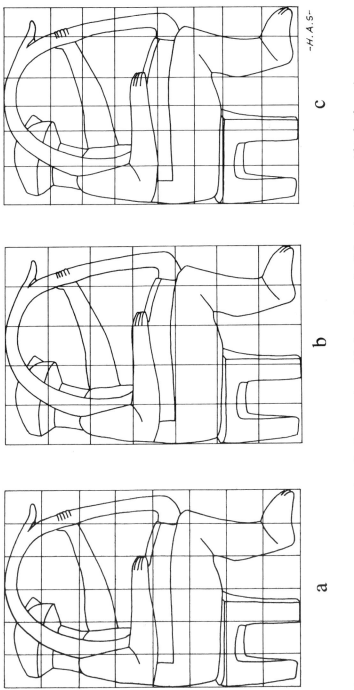

Figure 1 (figure 3 of 'Esteem' reproduced). Construction grids for a 'canonical' harpist figure, said to be from Amorgos.

a With Getz-Preziosi's postulated 6x8 grid, to which it is suggested it was designed.

b With a 5x7 grid, a canonic proportion not proposed for the figure.

c With a 6x8 grid in which the lines are spaced at haphazard distances.
 The Getz-Preziosi grid fits well enough—but so do the others.

Classical Greek pottery, which in turn follows the example of the Morelli method in the study of Renaissance art. If one looks at that field of study, as well stated many years ago by Berenson, one sees that the masters are to be identified not by gross features, but by the idiosyncrasies of detail— by the way hair or an ear is painted in Renaissance oils; and the known works of known Renaissance masters provide an independent account of just how variable an individual artist's work may be, against which a comparable body of work may be judged as the work of an unknown master. These two essential conditions do not apply to Cycladic: the figures do not show many small details, of the kind an artist unconsciously might repeat, because they have very few features; and we have no corpus of figures known to be by a single carver, against which to match the similarity and the variability in another potential Master's identified work. Neither fundamental of the method exists for Cycladic, and, consequently, the method fails.

Another field of study developed by Getz-Preziosi concerns the possibility of canonic proportions in the figures, which would have been made by reference to equal geometric units; for instance, the head may be consistently made as one-fourth of the height of the figure. Correspondingly, the harpist figures may have been made to a regular grid, with the key points and lines of the figure arranged accordingly. Certainly, lines *can* be drawn at regular intervals which correspond to some features of some figures; but it does not follow that these or many figures were actually designed in that way. A harpist figure is said to be drawn on a 6x8 grid (Figure 1a), and indeed its points and lines do fall on or near to lines of the grid; but a 5x7 grid (Figure 1b)—a canonic proportion not proposed for the figure—also fits well, even though it has fewer lines and points in it; and so does a 6x8 grid (Figure 1c) in which the lines are spaced not at equal and regular intervals, but at varying and haphazard distances. Canonic principles cannot be shown to have existed in Cycladic art, although the recent literature is largely written as if they are certain.

Cycladic figures appeal to modern taste because they resemble the art of our own time. They foreshadow ourselves, and therefore one sees a privileging of them as an early appearance or even the birth of that western tradition which flows from Cycladic through the arts of Classical Greece and on into our own cultural tradition, at last to be re-made as similar forms in the art of our own century. This continuous thread is a deception, for no link is known to connect Cycladic with the Classical or Archaic traditions in Greece, and the *kouros* figures of that later tradition clearly relate, not to prehistoric Greece, but to the sculptural traditions of Egypt. It may be agreeable, at a time when Europe is making a rhetoric of its unity, to see Cycladic as the birthplace of European genius; but it is not in conformity with the facts of the matter.

In the literature on this aspect to Cycladic, and others, one sees also a flattering of the collectors, the serious addressing of collectors' ideas even when these rest on elementary error and a reticence when it comes to addressing whether figures are fakes. The issue is noted in the generality

for most scholars agree many may be faked, but when the figure in question is the prized possession of the collector who has consented or encouraged the scholar to take an interest in it, the issue in the particular is not addressed.

Even the choice of words has its effect. The making of a Cycladic item may be described in these terms:

> 'The master sculpts the idol in his workshop.'
> 'The carver crafts the figure in his hut.'
> 'The rustic shapes the pebble in his hovel.'

These three sentences describe the same physical actions, in terms High, Medium or Low in social implications, level of artistic refinement and sensitivity, and physical context. Of course, no language is neutral, but one can see in the literature on Cycladic a preference for the words of high culture, expressed for instance in the word 'master', and the habit of capitalizing it as 'Master'. Echoing the masters of Renaissance art, it serves to project back the context of later western art on to the productions of the prehistoric world.

Both the market-makers and the scholars have need of secure information, for its own sake and as a means to give order to the mass of figures, but the two interests do not entirely coincide. A direct corruption is not known for Cycladic, in which scholarly conclusions were influenced by the scholar's involvement in the world of the market. Instead, one can see a blurring between the framework for Cycladic which suits the market and that which is valuable as a means to secure knowledge of the prehistoric Cyclades. The market-makers may choose any structure, without an obligation for that structure to follow prehistoric realities (insofar as they can be known); the blurring, or melding, of the two interests has led to a developing apparatus of canonic ideals, masters and workshops which has much to do with our own age, and our view of high art, and little to do with reliable knowledge of the social realities of Cycladic prehistory or the actual framework of the figures' production.

The prehistoric purpose or use of Cycladic figures is not known, nor whether they were kept standing up or lying down. Almost all have narrow feet, often with the toes pointing down; unstable, they do not stand upright by themselves, so one may think they were originally not kept upright. Nevertheless, they are invariably shown in museums and by private collectors, and reproduced in photographs, in upright stances, generally with a plastic or steel mount to hold them in that pose. Why is this? It is probably because they look grander, more monumental that way; they suit our contemporary perception of how a fine human sculpture should stand.

An element to our fondness for Cycladic is the strength (in our eyes) of their simple, clean and white forms; this is a trait they share with the modernist sculptures. Yet Cycladic figures, like Classical statues, were in many cases painted; many still bear traces of paint, or surface markings

that show where the paint once was. In the European perception during the Romantic period, Classical sculpture was admired for its whiteness; yet we know now that Classical sculpture was in fact brightly painted; the admired whiteness is an accident, in reality an *error* of survival. The same error is being repeated for Cycladic and for the same accidental reason; indeed, the 'pure simplicity' of the figures and their faces may arise from the sculpted figure itself being in no way the finished figure; rather, it is a blank, the vehicle on which is painted the design in blue and red pigment, later reduced by the wearing-off of the design to its unfinished state.

Our preferred vision, of stripped-down Cycladic in pure white, is congruent with our century's placing of Cycladic, as an idealised and inspired community of creative artists. Their appeal derives from their (less-than-chance) similarity to sculptural idioms of our own time, but is not couched in those terms, rather as manifestations of a universalizing aesthetic. Yet as the Modernist sculpture of the early decades of our century ceases to be where art *is* (and ought to be), and just becomes another place where art once *was*, so it becomes possible to see both Modernist and Cycladic genres in the fairer light, in the context of their own places, times and circumstances.

A failing Cycladic marriage?

This paper began with mention of the old alliance, the marriage between the archaeological and the art interests in Cycladic, as in so many other fields of Classical archaeology, which has provided the framework for Cycladic studies. Noticing how far the interests have diverged, it seems clear that the marriage is beginning to fail; either there must be a change in attitudes between the partners, so a sufficient degree of common ground is held together; or the marriage comes to an end.

Fakes and their detection

We stress in 'Esteem' and therefore repeat here our fears that the accepted Cycladic corpus may be largely corrupted by fakes. It is not disputed that fakes were made, perhaps on a workshop scale, and the knowledgeable John Hewitt, we notice, places that period of busy Cycladic faking back into the early 1950s. Jerome Eisenberg, in discussion after our paper, contended that today's expertise has purged the corpus of fakes, so that one can be sure that all the figures in, for example, the Goulandris collection are genuine.

We do not share Dr Eisenberg's confidence that the fakes can be and have been reliably detected.

The fundamental is that the figures are made of marble that is found commonly across the archipelago, and there are still no physical scientific tests which can distinguish with confidence an old marble figure from a new one. A casual or inexpert forger, or one supplying a casual or inexpert

sector of the market, may leave gross traces of modern technique, the rotary marks of grinding with an electric drill perhaps; otherwise, one cannot tell. Notice that the long and thorough study of the Getty *kouros,* for which every physical-science testing technique could have been employed, was inconclusive as to whether the *kouros* is genuine or fake (True, 1993); the same goes for Cycladic figures, equally made of undiagnostic marble.

The second approach to detecting fakes among Cycladic is the judgement of the experienced eye, which should detect anomalous, impossible or anachronistic features or combinations of features; again, one can look to the example of the Getty *kouros*, which declared itself genuine to some of the most expert eyes in Archaic sculpture studies, and fake to others. Cycladic is worse; for the proportion of *kouros* figures among the possible corpus thought or proven to be reliable seems higher than it is for the Cycladic; if so much of the Cycladic corpus is corrupt, then the expert Cycladic eye will also have been corrupted by it.

Finally, the circumstances of the Cycladic market-making must be noted; those in the market or supplying the market are not naïve idealists or—all of them—innocent of the world, so one cannot make sense of genuine as against fake by reasoned deducing from just what turns up in which circumstances, and from what a conscientious and ethical scholar would have done at any point on the route from the ground (or workshop) to the point of 'surfacing'. One of the biggest and grandest Cycladic figures was cut into three pieces with a chain saw before it 'surfaced'; does this fact make it genuine? No, because a faker would also know that the cutting-up of a figure tends to suggest it is a genuine figure made portable; chopping a fake into bits may reduce its perfection and so increase its plausibility.

We know no evidence for Dr Eisenberg's belief that the Cycladic corpus could be cleansed or has been cleansed of fakes; we would be grateful — as would all with Cycladic interests — for a clear statement from him or others with knowledge of these matters: just where were fakes being made, when, by whom, in what numbers, with what market outlets? how does one reliably tell a fake? what do the known fakes look like (this last with plentiful illustrations please)? which groups in the Cycladic corpus may one have more or less confidence in?

Conservation, restoration, respect for the object, and ethics

In considering Cycladic, it is useful to distinguish between the related practices and professions of *conservation* and of *restoration*. Though they go naturally and normally together, they are not identical. One of us has defined the difference in these terms (Chippindale, 1994):

'Archaeology, the branch where I work, is concerned with learning about the past from its material remains, without a necessary first concern for the beauty of the stuff; the professional in our field is

generally called a *conservator*, and the expectation is increasingly to clean and to stabilise the object so it holds its state as found. In the art business, more concerned with aesthetics, the equivalent professional is called a picture *restorer*; the common practice, once the later varnishings and accretions have been stripped off, and the original stabilised, is to supply missing portions in new paint so as to return the piece closely to the original perfection. Those two professional names stand for two stances within a wide range of "good modern practice".'

The distinction has particular importance for Cycladic because aspects we especially like in Cycladic are at variance with what we know of the figures' finished state in antiquity. Cyprian Broodbank (1992), reviewing Renfrew's *Cycladic spirit*, said of the painting on the figures:

'Let me suggest a visual experiment. Trace a figurine on to white paper. Add (not in time-faded hues or modest black-and-white stippling, but bright hematite red and azurite blue): head and pubic hair, lycanthropic eyebrows and staring almond eyes, densely tattooed dots or vertical gashes over most of the face, and neck-laces and bracelets at throat and wrist. Alternatively, look at the rare figurines that do depict features such as eyes, ears or baldric in relief; these get a hard time for their 'fussiness', but in fact tell us much about how their bleached sisters once looked. Whichever method one chooses, what looks back at us is something extraor-dinary but utterly 'other'. Detail in no sense intends to emphasize form or line, and, if anything, distracts from it. Rather, its aim is to send out messages significant to an early Cycladic observer. Indeed, the range of tattooed motifs and hair arrangements at-tested may indicate that the painted surface records crucial mes-sages concerning *diversity* over the neutral and standard canvas of the marble form.'

Paint survives on some Cycladic figures, whilst on others it survives as a 'shadow' where the surface texture is different on the once-painted area. The recognition of painting on Cycladic is recent, and one wonders how many restorers removed paint traces unknowingly. And have paint traces also been removed *knowingly* from some figures, as not befitting what the modern audience and the market-makers want from a Cycladic master-piece?

An old and a good premise for an ethic of conservation is that the conservator's first responsibility is to the object, its safety, survival and well-being. This does not, however, offer guidance when there is a difference of view between the conservator's ethic—to hold steady as it has survived—and the restorer's—to return to its original intended state. Those conflicts are present in Cycladic, as they are for many classes of ancient object.

A further aspect is the discrepancy between our modern views and what we know of ancient intentions: now Cycladic figures are expected to

be aesthetic objects, held upright in the showcases of secular art galleries; their makers—to judge from the field evidence—intended them to be laid down in closed and covered human graves. This deep difference between ancient and modern perceptions, often seen as a peculiarity to Cycladic, is widespread, as one notices when it is put in these terms; indeed, studies by one of us with Michael Vickers shows that fundamental confusions over this central point are commonplace in the modern studies of classical art and archaeology (Vickers & Gill, 1994).

Nor, unfortunately, does a fidelity to the well-being of the object exempt the conservator or restorer from the consequences of their work. Conservation, restoration and the manner of mounting for display all have consequences for perception, marketability and value in all its aspects; just as there are material and intellectual consequences of esteem for Cycladic figures so are there material and intellectual consequences of conservation and of restoration for Cycladic figures. An ethic of conservation cannot confine itself to the well-being of the object itself, for that well-being is differently perceived by the several interests and the several attitudes to Cycladic figures and their proper treatment. To respect 'the object itself' without considering the consequences is to become a party to the attitudes of whichever interest directs what happens to the figure in question.

Is Cycladic a special case?

In 'Esteem', we explored Cycladic as a case-study in attitudes to beautiful ancient objects. We chose Cycladic because the archaeological and the aesthetic approaches to this body of material evidence has chanced to take such a pattern that the two can be seen more clearly.

In discussion, Dr Eisenberg contended that Cycladic was a unique and eccentric case: even if the view set out in 'Esteem' is true (which Dr Eisenberg seemed to doubt), it has no consequences outside Cycladic. We disagree. Firstly, the several attitudes—archaeological, aesthetic and other—that apply to Cycladic are not unique to Cycladic, but are the common threads in the study of ancient art and archaeology everywhere, and certainly with respect to all the ancient 'high cultures': they may be more visible, and the consequences more demonstrable in the case of Cycladic, but the fundamental issues are the same. Secondly, Cycladic is not unique in the story of a high esteem leading to a surge of material 'surfacing' on the market, either looted or faked; the Cycladic story is echoed by other classes of material not just from the classical world, but also in regions as far removed as the Mayan lands and China. Thirdly, the disjunction which we see between the Classical world as it existed in antiquity and the Classical world as archaeologists, art historians, aesthetes and connoisseurs have imagined it in times since is amply documented by the changing fashions, habits and intellectual frameworks of classical studies over the centuries. Cycladic may be an extreme, but it is not the only extreme; and the extreme is simply the routine in a stronger and less easily overlooked form.

References

Broodbank, C., 1992. 'The spirit is willing: review-article on Colin Renfrew, *The Cycladic spirit* (1992)', *Antiquity* 66: 542–6.

Chippindale, C., 'Conserving the past, restoring the past, re-making the past?: review-article on James Beck with Michael Daley, *Art restoration: the culture, the business and the scandal.* (1993)', *International Journal of Cultural Property* 3 (1994): 397.

Getz-Preziosi, P., 1987. *Sculptors of the Cyclades : individual and tradition in the third millennium BC* (Ann Arbor MI).

Gill, D. and Chippindale, C., 1993. 'Material and intellectual consequences of esteem for Cycladic figures.' *American Journal of Archaeology* 97 : 601–59.

True, Marion (ed.), 1993. *The Getty* kouros *colloquium: Athens 25–27 May 1992.* (Malibu (CA): J. Paul Getty Museum; and Athens: Nicholas P. Goulandris Foundation).

Vickers, M. and Gill, D. 1994. *Artful crafts: Ancient Greek silverware and pottery.* (Oxford: Oxford University Press).

Bad laws are made to be broken

Geraldine Norman

Those involved in the antiquities field, most especially those with power or influence in countries where ancient civilisations are buried beneath the soil, should reconsider what laws are suitable for protecting this heritage.

If laws exist that run counter to human nature, people are going to break them. In general, most countries—the details vary from country to country—have instituted two lines of defence. Firstly, antiquities which are still buried are considered the property of the state; secondly, their export is banned. It is arguable that such laws are inevitably going to be broken because they run counter to human nature and are therefore bad law.

The ancient trade of tomb robbing has flourished since antiquity. Obviously, in a poor country, a peasant who manages to find valuable artefacts is not going to hand them over to the state archaeological service for nothing. If he can profit by selling them to smugglers, without incurring much danger, that is what he is going to do. In most countries, illegal trade channels are well known to villagers.

A total export ban is equally illogical in countries where customs officers are easily bribed. Moreover, it seems crazy to try and keep every artefact that is unearthed in the country of its origin. Most nations would like their ancient cultures to be appreciated by others. Export controls which permit the sale of duplicates or less important pieces make cultural and financial sense.

Surely, the principle of 'finders keepers' should, as far as possible, be enshrined in law—since that is the principle that people are gong to follow anyway. Either, finders should be allowed to own antiquities, subject to reporting their finds, or they should be paid compensation roughly equivalent to current market value. At the same time, the export of antiquities should be permited subject to a licensing system which requires the state to pay market value for anything it wants to stay in the country. A modest tax on what they allow to leave would pay for what is retained.

If the laws were internationally perceived as fair, upright people would not break them. At present, in deed, if not in word, the whole of the antiquities trade and most museum curators condone antiquities smuggling for the reasons that have been adumbrated—the laws in the countries of origin make no sense.

In twenty years as an art market correspondent, I have never met an antiquities dealer who did not happily handle smuggled goods. The nearest

I have come was a London dealer who told me that he would not buy from smugglers himself although he considered it acceptable to buy smuggled goods at auction.

In 1992, at the trial for theft of James Hodges, the former adminstrator of Sotheby's antiquities department, some fascinating evidence was produced. It made clear that Sotheby's was dealing directly with the major names of the Turkish smuggling trade that runs through Munich. The 'pezzo grosso' in Rome, whose name I was told a few years ago when I interviewed an Etruscan tomb robber, also featured as one of their major clients consigning material for sale from Switzerland.

The preparedness of great museums to acquire smuggled material, without asking too many questions, has been underlined by two recent press sensations, the return of the Lydian hoard to Turkey by the Metropolitan Museum, New York, and the Getty Museum's hitherto unsuccessful negotiations over the acquisition of the Sevso silver. Whatever virtuous noises they make in public, the actions of these museums make it clear that they will still pay top dollar for smuggled material.

The Metropolitan tried to fight off Turkey's claim for something over five years. As I understand it, they finally gave in for two reasons. They had found a memo on file indicating that the museum had known from the start that the Lydian treasure came from a specific illegal dig in Turkey; indeed, through a succession of purchases Dietrich von Bothmer had tried to bring together all the material found at this particular site. The museum was thus unable to argue ignorance. Moreover, they realised that, even if they could win a trial on purely legal grounds, press reports would make their dealings with smugglers sound terribly unethical. A trial would be very bad for the museum's reputation.

In the case of the Getty, bad press over the acquisition of an Aphrodite, supposedly from Morgantina in Sicily, and other antiquities has made them very sensitive. The museum's lawyers have drawn up a very elaborate procedural document for the acquisition of antiquities, which, among other things, involves notifying authorities in possible countries of origin. The crucial clause in the document, however, is that which requires a signed guarantee from the vendor that a piece has not been smuggled. It is an interesting reflection on both the museum and the antiquities trade that the world's leading dealers, whose names I shall not cite, regularly sign this clause when selling to the museum. The curators are not fooled, of course. The dealers, or at least those with whom I have discussed the subject, regard their signature as a pure matter of form; in the event of a dispute, it ensures that the dealer will carry the financial loss resulting from a successful claim by a country of origin rather than the museum itself.

The point that I have tried to make, and I hope that it has come across, is that the very civilised people who deal in the best antiquities or curate museum collections, will continue to ignore export laws until such time as they perceive such laws to make sense.

A Layman's Attempts to Precipitate Change

in Domestic and International 'Heritage' Laws

John Browning

I present this paper strictly as a layman, who, until recently knew little about archaeology and nothing about the law as it affects archaeology and all that that entails. I now know rather more than I did and the views I have developed are shared by many.

What I am about to tell you are strictly personal views and must apologise if some of my opinions sound a little cynical, but I have been compelled to think cynically and I draw much comfort in realising that I am not alone.

After very lengthy negotiations between my US lawyers and lawyers representing Leon Levy and Shelby White and the Ariadne Galleries the saga of the Icklingham Bronzes was settled some 18 months ago, and, due to some strange complications in documentation, a statement, prepared by all parties, concerning the settlement was never released at that time. I read it publicly for the first time at the conference on *Conservation and the Antiquities Trade* in December 1993.

> 'The Ariadne Galleries Incorporated, Torkom Demirjian, Leon Levy, Shelby White, John Browning and Rosemary Browning are
> pleased to announce that litigation presently pending in the United States District Court for the Southern District of New York concerning a group of antiquities known as the Icklingham Bronzes has been terminated in a manner satisfactory to all parties. As part of the settlement, Leon Levy and Shelby White have agreed to bequeath the Bronzes to the British Museum upon the latter of their deaths. The remaining terms of the settlement are confidential.'

This statement still has not been released by any other parties!

In resolving the question of the Icklingham Bronzes, to the best of my ability, I have perforce had to learn a lot about the whole vexed question of the antiquities trade and the grave lack of any coherent policy at

Government level, either to protect our own past, or to co-operate with other countries to help in protecting what is rightfully theirs.

As things stand, and have stood for some time, London has become a major clearing house for works of art and antiquity which can only politely be described as being of dubious provenance.

It is easy to look at impressive collections and admire the beauty of the pieces and hold in awe the skill of their creators but try looking that little bit further. Ask where did each piece come from, when was it discovered, by whom was it discovered, what was the archaeological context of its discovery? Very rarely can these questions be fully answered but I urge everyone to turn detective and seek out these answers. In so doing, the owners, be they collectors, dealers, auctioneers or museums, might feel pangs of embarrassment if not of guilt and hence behave in a more circumspect manner in acquiring or handling such pieces in the future. I think it was a certain Conservative Party leader and Prime Minister who once spoke of the damage done by the oxygen of publicity for certain bad elements in society. I would argue that, handled properly, certain of the bad elements among the art and antiquities trade can be dealt a severe blow by the administration of large doses of what I will call the carbon monoxide of publicity!!

In early 1989 I was told by the British Museum that my biggest problem in trying to recover the Icklingham Bronzes was the United Kingdom's non-ratification of the seriously needed 1970 UNESCO Convention. I subsequently learned that virtually all archaeological, antiquarian and museum bodies thought likewise. For this reason I sought reasons from Government for this state of affairs. The Office of Arts and Libraries, as it was then, under Richard Luce, provided a list of reasons for not becoming party to the convention. These reasons include such points as 'a major additional workload and a difficult exercise for Customs in controlling illegal import and export'. Is that not why we have a customs service?

I was assured that cost of compliance was not relevant but one 'difficulty' cited was 'the allocation of substantial administrative resources'. Also mentioned was 'interference with rights of ownership'. This surely is what the convention exists to prevent.

Since these excuses for not accepting the UNESCO convention have met with some degree of ridicule, I have more recently been informed that UNESCO would not have helped in the Icklingham Bronzes case, *anyway*, because it only applies to public property and not to private property. Having read the convention carefully, I find this is manifestly untrue and my lawyer agrees with me. The convention covers 'property found within the national territory' and requires a 'list of important public and *private* cultural property'. It also requires that 'publicity is given to the disappearance of *any* items of cultural property' and that 'actions for the recovery of lost or stolen items of cultural property can be brought by or on behalf of *the rightful owners*' (my italics). However, I could understand that it was a complex document and could be seen to be, if not unworkable, at least unpalatable.

Case Histories

I next approached Richard Crewdson, the Chairman of the Cultural Property Law Committee of the International Bar Association. From him I learned that at the request of UNESCO a working party was looking at ways of overcoming the imperfections of the convention. This gave rise to the draft UNIDROIT *Convention on Stolen or Illegally Exported Cultural Objects.* After bringing this to the notice of the Office of Arts and Libraries I was asked to procure two copies of the draft: one for the Office of Arts and Libraries and one for the Lord Hesketh who was at that time a junior heritage minister. I still find it staggering that a Suffolk farmer should be asked to tell government ministers what UNESCO and its international working group were doing.

Conservation in the wider community tends to mean whales, hedges, orchids, newts, toads and all things living. If a threat to some living species is perceived, then legislation aimed at alleviating that threat is rushed through both the Upper and Lower Houses at Westminster with astonishing rapidity, not only because it is important, but also because there are votes to be won.

Legislation for our non-living heritage is either not there, not workable, or as in the case of Treasure Trove and Market Overt, it is there, has been there since mediaeval times and remains on the statute books as an embarrassing anachronism, chiefly for the benefit of looters and thieves. It is right and proper that the legitimate finder of Treasure Trove should be duly rewarded but, as all too often happens, the finder is committing an offence at the time of discovery and is still able to collect the full monetary value of his spoils. In effect, the laws governing Market Overt and Treasure Trove can be seen, in my view, as crime sanctioned, rewarded and encouraged by the State.[1]

Rewards for finds of Treasure Trove should not come from the acquiring museum but directly from the Treasury and, in this way, I believe a crippling burden can be removed from museums—principally the British Museum—and the Treasury would be sure to see that its money, our money, was spent wisely and only on those who have acted properly.

We currently have some 14,000 scheduled ancient monument sites in the country and this is to be doubled during the next ten years. Every time a site is scheduled its importance becomes a matter of public record and in this way it is more often than not targetted by the criminal element among the metal detecting fraternity. The sites we already have enjoy little or no protection from thieves but very good protection from their owners who often bear very substantial costs in caring for their sites properly. So what hope does our heritage have when the number is to be doubled unless the protection afforded them is changed.

I have two adjacent fields. One is a scheduled site and the other is not. If I were to catch two people treasure hunting at night—one in each field—and prosecute both: one under the 1979 Ancient Monument and Archaeological Areas Act and the other under the Theft Act, the former would most likely be fined £150 to £200 and be allowed to keep his metal detector; the

latter, prosecuted under the Theft Act, could expect a fine of about £500 and would have his equipment confiscated. Why, oh why, do we have special laws for scheduled sites which have fewer teeth than ordinary common criminal law?

When I was informed that the so-called Icklingham Bronzes were in New York I resolved to do all I could to recover them through the due process of the law, but, in seeking advice on how to do this, I was told by almost everyone that there was nothing I could do at all. However, one person, a journalist of high repute in the arts field, advised me to go to the United States, get bought off for a large sum of money and have the United Kingdom say 'goodbye' to the bronzes. This I believed was to put myself on the same immoral level as the metal detecting thief and so I resolved to pursue my claim through litigation. The bronzes will eventually return to this country but the lack of sensible, practical laws has been dramatically demonstrated.

Mr Richard Spring, my Member of Parliament, is concerned about the state of affairs which prevails and he sought and was granted an adjournment debate in the House of Commons on October 27th 1993, reported in Hansard of 28th October. His information gathering in preparation for the debate found the great depth of support I have enjoyed in seeking to rationalise heritage laws and, in particular, portable antiquity laws.

There has, however, been a deafening silence from the major auction houses. This is not altogether surprising when Miss Felicity Nicholson, a department head at Sotheby's, was reported in the *Telegraph* on 25th October 1991 as saying that she found the shady side of her business not uncongenial!

I digress. In the adjournment debate Mr Ian Sproat was able to confirm that since 1st April 1993, exports from the European Community are regulated (whatever that means) and from the middle of December 1993 it is hoped that a Council Directive will be implemented which will permit the recovery from another member state of any stolen 'National Treasure'. I look forward to hearing how this will be defined.

I have now been trying in my small way to precipitate essential changes in domestic and international laws which affect the protection of our heritage—in particular portable antiquities for nearly five years. I am most grateful for all the help I have received from the Suffolk Police who have been thwarted in their efforts by the Crown Prosecution Service. This leads me to wish to start a new campaign to see the introduction of an appeals procedure against questionable Crown Prosecution Service decisions. That, however, is another digression.

The hopelessness I have felt for so long in coming up against Government inertia now looks more encouraging. There are signs that messages are getting through and some progress may be made but the pressure to achieve sensible and rational change must be maintained or increased.

Since I have been pursuing my campaign to have some laws with teeth implemented there have been five Art/Heritage ministers in four years: Richard Luce, David Mellor, Tim Renton, David Mellor again and Peter Brooke. If the reshuffles continue at this rate the pack will soon be worn out. We must have continuity of constructive and informed thought. Archaeology is our ultimate non-renewable resource, and yet, it is being callously destroyed either by ignorant use of metal detectors or criminal detectorists spurred on by the high prices paid by many undiscerning antiquities junkies who must have their 'fix'.

Note
[1] Since the presentation of the paper 'Market Overt' has been abolished and a bill is before parliament to make dramatic changes to the law of 'Treasure Trove'.

The Saga of the Lydian Hoard:

from Uşak to New York and back again

Lawrence M. Kaye and Carla T. Main

A Short Legal History of the Case

The fabled Lydian Hoard antiquities, held for more than 25 years in New York's Metropolitan Museum of Art, have finally returned home. They are now proudly displayed in Ankara's Museum of Anatolian Civilizations. And displayed as never before—as the inaugural attraction in the Museum's splendid new wing—in their proper context and in a manner which for the first time highlights not only their sheer beauty but also their historical significance and relationship to the many objects recovered from the thieves at the time of the original looting. The more than 360 objects recovered from the Metropolitan are expected at some point to be displayed in other Turkish museums, including the Uşak Museum, located in the centre of the region from which they were originally taken. The Hoard includes objects of various types, including fragments of wall paintings, marble sphinxes, vessels such as pitchers, bowls and incense burners made of gold, silver, and bronze, and jewelry of gold, silver and glass.

The Lydian Hoard's long journey began in the mid 1960s, when tumuli in the Uşak region of west-central Anatolia, reputed to contain treasures dating from the age of the legendary King Croesus of Lydia, were broken into and looted by villagers. Although a number of the objects were recovered by the police, many of the finest were smuggled out of Turkey and made their way into the hands of a well-known antiquities dealer on New York's Madison Avenue, as well as other dealers. In short order, between 1966 and 1970, the objects were acquired by the Metropolitan's Department of Greek and Roman Art.

Rumours of the Metropolitan's acquisitions began to circulate in the early 1970s, but although the Metropolitan's own documents reveal that the Museum recognised the objects as among its greatest acquisitions, the purchase of this magnificent collection, essentially intact, was not her-alded—nor even announced—by the Metropolitan. Worse yet, the objects were relegated to storerooms in the Museum's basement, and, inquiries by officials of the Republic, initiated in response to the rumours, were met with varying degrees of disinformation.

On a few brief, infrequent and unpublicised occasions, some of the antiquities from the Hoard emerged from the basement coffers. It was not,

however, until some of the pieces were put on permanent display in 1984, as part of the Museum's so-called East Greek Treasure, that the Republic was able to conclude that the Museum's objects *were* those looted from the Uşak tombs. Before doing so, and wishing to avoid a long and expensive dispute with one of the world's great museums, the Republic tried, in 1987, to work out some sort of amicable resolution, but its overtures were summarily rejected. What turned out to be a six-year, expensive and often bitter lawsuit followed. Finally, after so much time and expense, the Museum did what it should have done in the first place and returned the objects to Turkey.

What was the Metropolitan trying to accomplish? There can be no doubt that the Museum knew at the time of the acquisition that the objects came from Turkey. Notwithstanding the recent suggestions by the Museum that all of this came as some sort of shocking revelation, it is the Museum's own documents that make clear that the true provenance was known to it at the time of the acquisitions—the most damning of these being the minutes of the acquisitions committee in connection with the second of the Museum's three principal purchases, which noted, among other things, that the objects being acquired were said to come from the same part of central Anatolia as those acquired earlier. Yet, in pretrial testimony given during the course of the legal action, the curator who purchased the objects continued to insist that no effort had been made at the time to determine the true provenance of this obviously unique and newly discovered treasure and that no such information had been acquired.

What was the result? The objects were largely kept from the public for 25 years. Those that were put on display in 1984 were relegated to a few crowded showcases, while others, including unique sphinxes, wall paintings of historical significance and some of the most extraordinary Lydian jewelry and goldsmith's tools ever unearthed, lay unseen in the basement storage rooms. Was art served? Was history served? Was scholarship served? Were the members of the Metropolitan and the viewing public served?

A former Metropolitan director has said that the Metropolitan's acquisition of the Lydian Hoard objects was a prime example of the 'age of piracy' in the museum community, an era he says ended in the early 1970s. But did it? As the papers in this volume demonstrate, even today, the flow of illicit traffic in stolen antiquities continues to proliferate. The Metropolitan met the Republic's claim in 1987 not with an apologia for its 'act of piracy', but with an application to the Court to dismiss the action on a technicality— the statute of limitations. Resolution of this preliminary issue was not only time-consuming, but extremely expensive. After three years, the motion was denied, and the merits were finally turned to. Only then could could the Museum begin to be interrogated—through the 'discovery' process—about its knowledge of the objects' provenance and its conduct in acquiring them.

Professor Gerstenblith has provided us with a splendid overview of the statute of limitations under United States law, showing how this issue

can play a significant role in cultural repatriation cases (see Gerstenblith in this volume). However, the New York statute of limitations rule applicable to the Metropolitan case should be briefly discussed.

The seminal case applying the New York rule to cultural patrimony is *Kunstsammlungen zu Weimar* v. *Elicofon*,[1] which held that, with respect to a replevin claim against a *bona fide* purchaser (BFP), the statute of limitations begins to run at the time of a demand by the claimant for the return of the property and the refusal by the possessor to return it. In *Elicofon*, two portraits by Albrecht Dürer of Hans and Felicitas Tucher were purchased in 1946 for a few hundred dollars by Elicofon, a New York lawyer, from an American serviceman just returned from Germany. In 1966, Elicofon's possession of the Dürers was discovered, and the Kunstsammlungen zu Weimar (the Weimar Art Museum) made a demand for their return. The demand was refused. In 1969, the Museum sought to intervene in an action against Elicofon which had been started by the Federal Republic of Germany. The litigation continued for many years and finally ended in 1982, with the return of the Dürers to the Weimar Art Museum.

The defendant in Elicofon argued, among other things, that New York's three year statute of limitations began to run upon the defendant's purchase of the paintings. The Weimar Art Museum argued that, if the defendant were in fact a BFP, the 'demand and refusal' rule should apply; that is, a BFP's good faith possession remains innocent until he refuses to return the property on demand, which is the wrongful act. That is when the statute begins to run. The courts agreed and held that the Museum's claim for the Dürers was timely, because it was asserted within three years from the time Elicofon refused to return the Dürers on demand. The courts further ruled that even if Elicofon had purchased the property with knowledge of the theft, and hence was not a BFP, he would be estopped from asserting the statute of limitations because of his wrongful conduct.

The *Elicofon* case stood as good law until 1987, when a federal appellate court in New York modified the rule, holding that under New York law a claimant to lost art must also show due diligence in seeking to locate the object. In the case of *DeWeerth* v. *Baldinger*,[2] the court found that Mrs DeWeerth, a German resident, should have known, among other things, that the Monet which was the subject of her lawsuit had been exhibited at a New York gallery and that her failure to learn of this and other events displayed an absence of the requisite due diligence.

Shortly thereafter, however, in the case of *Solomon R. Guggenheim Foundation* v. *Lubell*,[3] the New York Court of Appeals reaffirmed New York's 'demand and refusal' rule, rejecting the holding of the federal court in *DeWeerth*. The *Guggenheim* court held that any alleged delay in making a demand was a question of fact that must be decided at trial and was pertinent, not to the statute of limitations defense, but to consideration of the equitable doctrine of 'laches' (under which the defendant would, among other things, have to prove that it was prejudiced by the delay).[4] Finally, in

The Republic of Turkey v. *The Metropolitan Museum*,[5] the court applied the rule enunciated by the New York Court of Appeals in Guggenheim and denied the Metropolitan's motion to dismiss on statute of limitations grounds.

New York thus favors the true owner—the victim of the theft—over the BFP. The *bona fide* purchaser is in a position to avoid the sale from a possibly questionable source; among other things, he can make due inquiry into such matters as the reputation of the seller, the validity or existence of provenance documents, and the availability of indemnification by the seller.

The Metropolitan's motion to dismiss was denied, and the parties turned to the merits of the case and began their pretrial discovery. The American pretrial discovery process, although criticised by some as unnecessarily time-consuming and burdensome, was critical to the development of the Republic's case. In this process, each party to the litigation has an opportunity to request and examine the documents maintained in the files of the other party and also to take pretrial testimony of party and non-party witnesses. The documents produced by the Metropolitan in response to the requests by the Republic revealed what the Metropolitan officials knew at the time they purchased the Lydian Hoard antiquities. The process itself compelled the Metropolitan to confront the damning nature of its own documents. Clearly, without the discovery process, it would have been much more difficult to resolve the case.

The documents produced by the Metropolitan included minutes of meetings of the acquisitions committee of its Board of Trustees at which the purchases of the objects were approved, and purchase recommendation forms submitted by the Department of Greek and Roman Art to the acquisitions committee describing the artifacts. Another key aspect of the discovery process was the opportunity afforded to the Republic to conduct an inspection, through its attorneys and a team of noted Turkish and American archaeologists, of the entire Lydian Hoard collection, much of which was long kept in the Metropolitan's basement. Archaeologists who had studied the objects recovered from the thieves and from the plundered tombs in Turkey were able for the first time to lay eyes on the vast array of jewelry, ancient tools, wall painting fragments and marble sphinxes which completed the collection. This afforded an opportunity to compare the looted objects in the Metropolitan with those that remained in Turkey, and it laid the groundwork for establishing the Republic's claim.

Now the case is over. The Lydian Hoard objects are back where they belong. A happy ending? Yes and no. Did the Museum give the Hoard back because it finally saw the light and recognised its moral, if not its legal, obligation, as some of the post-settlement publicity seems to suggest? Or was the Museum concerned about the upcoming testimony of present and former Museum officials and the prospect of a trial? Although the answer would appear to be self-evident, one should give the Museum the benefit of the doubt.

Indeed, the settlement included a good faith commitment on the part of the Museum and the Republic to look forward, not backward, and to work together to promote and develop mutually beneficial cultural projects. One also hopes that the Metropolitan, at the least, will now proceed with greater caution before acquiring any such treasure— indeed, any antiquity with a questionable provenance—without satisfying itself that the objects to be acquired have a credible, documented provenance. Perhaps the Museum will also now extend its current rule requiring provenance inquiries on certain purchases to all purchases and acquisitions by donation as well. I was most pleased to see the statement in a recent issue of the *Independent* by Professor Boylan, urging museums and collectors to avoid purchases of hoards of questionable provenance, pointing to the result in the Lydian Hoard case as an example which should send a chilling message to the world's museums, collectors and dealers. Indeed, the repatriation of the Lydian Hoard *has* already led to discussions with various institutions to resolve similar claims in a like manner.

The Lydian Hoard case presented significant obstacles, and it is a tribute to the dedication and persistence of the officials of the Turkish Government, including the then Minister of Culture, Fikri Sağlar, and the Director General of Monuments and Museums, Engin Özgen, that the case was pressed to its successful conclusion. At the time of its inception, many—if not all—commentators were most negative, questioning openly how a previously undocumented hoard could be identified and recovered. However, through the coalition of distinguished archaeologists from Turkey and the United States (referred to earlier) who were able to identify stylistic comparanda (among other things, the meticulous measurements taken when we were finally granted access to the basement storerooms showed that the wall fragments fit the walls of the tombs from which they were ripped like the pieces of a puzzle), the statements of the thieves themselves who were able to identify some of the more memorable items, and the admissions by the Museum itself, it was possible to succeed.

The efforts of other claimants have met with mixed success. But one thing is clear. In the courts of the United States, where the fundamental rule is that a thief can not pass good title to stolen property, a foreign sovereign claimant who asserts title to cultural property under a patrimony statute has a good chance of success. That has not, however, stopped the flow of illicit material, even to the United States. It is unlikely that the flow will be stemmed until dealers, collectors and museums heed the warning of Professor Boylan. There is a growing recognition in international law, as evidenced by most of the papers in this volume, that cultural property wrongfully taken from the country of origin should be returned; that it is critical to the preservation of the heritage of all art rich nations that their cultural patrimony be preserved in its geographical and natural surroundings and be available for scientific and archaeological study in its proper historical and cultural context.

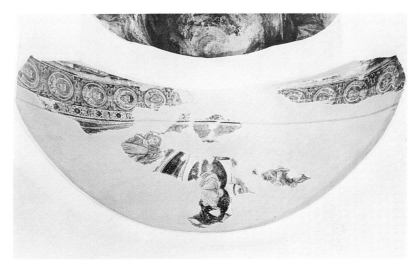

Plate 1 *The apse of the church seen from below showing the original position of the mosaic fragments. (From Megaw & Hawkins, courtesy of Dumbarton Oaks).*

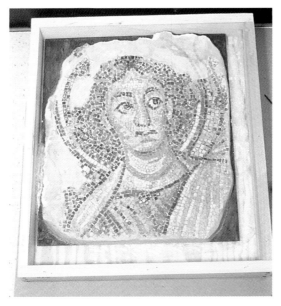

Plate 2 *North Archangel fragment as it appeared in November 1989.*

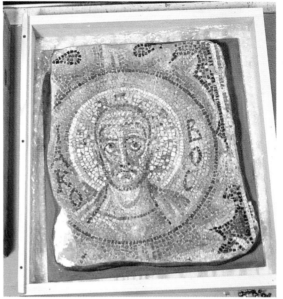

Plate 3 *Apostle James fragment as it appeared in November 1989.*

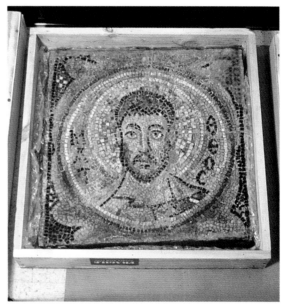

Plate 4 *Apostle Matthew fragment as it appeared in November 1989.*

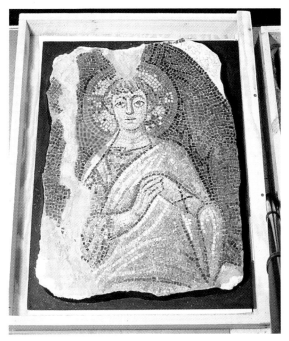

Plate 5 *Christ fragment as it appeared in November 1989.*

Plate 6 *Detail of James showing buckling tesserae, the damaged plaster of Paris surround, and the masonite board to which the fragment is mounted.*

Plate 7 *Detail of Matthew. Filled cracks through the eye and ear and to the right of the nose have distorted the features of the face.*

Plate 8 *Detail of James's halo. Pencil points to a cracked tessera immediately to the right of a larger, filled structural crack.*

Plate 9 Detail of Archangel's neck. The unevenness of the tesserae is due to the shearing off of the top surface of the white marble ones.

Plate 10 Detail of Christ showing different compensation materials used in restoration; a) pigmented wax, b) putty, and c) painted plaster of Paris.

Plate 11 *Detail of James showing remains of the* sinopia *in the plaster bed of dark tesserae and to the right of the white tesserae.*

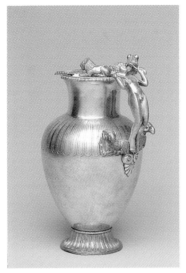

Plate 12 *Silver* oinochoe *with handle in the form of a youth, 6thC BC.*

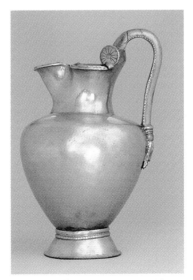

Plate 13 *Silver* oinochoe *with handle decorated with animal heads 6thC BC.*

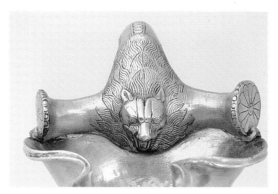

Plate 14 Detail: silver oinochoe *(see Plate 13).*

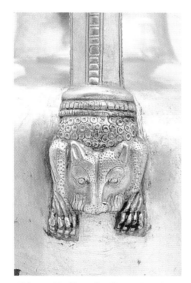

Plate 15 Detail: silver oinochoe *(see Plate 13).*

Plate 16 Silver oinochoe *with carinated surface, 6thC BC.*

Plate 17 *Silver* alabastron, *6thC BC.*

Plate 18 *Silver bowl with gold lobes in the form of Persian heads, 6thC BC.*

Plate 19 *Silver bowl with gold appliqués of king, 6thC BC.*

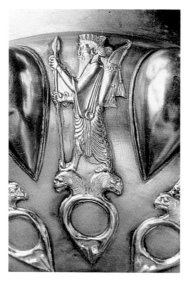

Plate 20 *Detail: silver bowl with appliqués (see Plate 19).*

Plate 21 *Silver ladle, 6thC BC.*

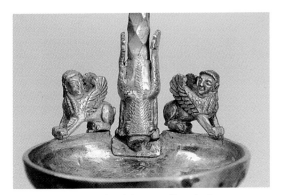

Plate 22 Detail of sphinxes: silver ladle (see Plate 21).

Plate 23 Bronze incense burner, 6thC BC.

Plate 24 *Silver cosmetic box with gold studs, and silver spoon, 6thC BC.*

Plate 25 *Pectoral necklace of gold and cloisonné, 6thC BC.*

Plate 26 *Gold bracelets with lion head finials, 6thC BC.*

Plate 27 *Gold pin with acorn tassles, 6thC BC.*

Plate 28 *Gold necklace with acorn pendants, 6thC BC.*

Plate 29 *Four gold appliqués, 6thC BC.*

Plate 30 *Gold spools, 6thC BC.*

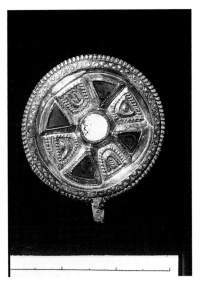

Plate 31 *6thC Anglo-Saxon gilded debased silver garnet inlaid disc brooch before treatment.*
Courtesy of M. Halliwell.

Plate 32 *6thC Anglo-Saxon gilded debased silver garnet inlaid disc brooch after treatment. Courtesy of M. Halliwell.*

Plate 33 *Anglo-Saxon bed burial* in situ.

Plate 34 *Tassel from the grave of the wife of an 8thC BC Assyrian king. Courtesy of P. Dorrell.*

Plate 35 *Folded textile from the grave of the wife of an 8thC BC Assyrian king. Note pronounced ripples. Courtesy of P. Dorrell.*

Plate 36 *X-radiograph of the folded textile in Plate 5 showing string of gold, carnelian and gypsum beads.*

Case Histories

Resolution of the Metropolitan case was not easy, and, the significance of the Metropolitan's willingness to resolve the matter should not be underestimated. One of the world's great museums has deaccessioned a major collection and returned it to the sovereign nation to which it belongs. This significant step has had reverberations throughout the museum world.

One problem is that there is a different attitude, policy and approach in certain jurisdictions where there is no duty of inquiry and good faith purchasers can get good title to stolen cultural property. As long as this view prevails, it will be most difficult to reduce or even minimize the traffic in illicit artifacts. As discussed by Prott in this volume, UNIDROIT is seeking to rationalise the conflicting views and craft a workable solution that is satisfactory to both art rich and art importing States. In this regard, it should be applauded. But there is more work to be done. The conflicting views can only be rationalised if there is a commitment to an international structure that has sharp teeth. Among other things, if there is to be compensation to a good faith purchaser, a concept that claimants of stolen cultural property find most disturbing, then one must exclude from that definition any one who does not make an investigation and inquiry into questionable provenance that is reasonable under the circumstances.

The saga of the Lydian Hoard is not to be taken as a morality tale that condemns museums. Indeed, museums really have much to gain; for, as the *Guggenheim* case in the United States shows, they themselves are often in the position of *claimants*. The Lydian Hoard case cries out for uniform rules governing the acquisition of cultural objects of questionable provenance. Hopefully, through the efforts of UNESCO and UNIDROIT and other cooperative efforts on the international level, the day will come when foreign government claimants can reclaim their patrimony without the need for expensive and protracted private litigation.

Some Comments on the Content of the Lydian Hoard[6]

As explained earlier, over 360 objects were recovered from the Metropolitan Museum. This discussion will focus on only some of the highlights of the Hoard. Comprehensive scholarly studies of the Lydian Hoard will doubtless be forthcoming now that the objects are on display in the Museum of Anatolian Civilizations where they have been reunited with the objects recovered from the thieves and the tombs, and are openly available for study. In the meantime, the beauty of the objects speaks for itself and will be complemented by these brief comments.

The objects in the Hoard fall into several categories. There are both silver and bronze vessels, some of which were used ceremonially. There is the wealth of exquisitely crafted jewelry, ancient jewelry making tools, incense burners, and cosmetic accoutrements. There are the fragments of wall paintings and marble sphinxes. Examples of the silver and bronze objects and of the jewelry are illustrated (Plates 12-30).

Understanding the geographic origin of the objects helps to place them in an historic context. The tombs plundered in the 1960s are located in west-central Anatolia, the region of modern Turkey where the ancient Lydian civilization thrived. The objects comprising the Hoard are believed to have been made c. 520-500 BC. The region of Uşak is hilly, and ancient tombs, or tumuli, were built into the hillsides. Local residents in Uşak and surrounding areas became adept at detecting likely findspots. During the investigations conducted by the Republic, one of the thieves recounted his experience in blowing open the Ikiztepe tomb. He was lowered down into the tomb, and handed up objects from the ancient burial chamber to his compatriots waiting above. Years later, he recognised many of the items he had taken from the tomb in the glossy pages of a Metropolitan Museum bulletin. This individual, had the case gone to trial, would have been an important witness for the Republic.

Perhaps the most stunning example of the silver vessels included in the collection is the *oinochoe* with the handle in the form of a youth (Plate 12). The handle is modelled in the form of a naked youth bending backward; his arms reach over his head and grasp the tails of two lions who perch along the rim of the vessel. The youth's feet rest upon two rams, and a palmette—a recurring motif in Lydian art—decorates the area immediately beneath the youth's feet. The handle is fully three dimensional; the youth's body is fully modelled. The head of the youth is decorated with long, plaited hair, which flows into the inside of the vessel. This serves a structural as well as decorative purpose, because it helps to strengthen the juncture where the handle meets the body of the vessel.

Although the fixed smile and youthful form of the body evoke the classic Greek *kouros*, an Oriental influence may be seen in the emphasis on decorative animal themes, the decorative elements on the rim and surface of the vessel. The craftsmanship is even more appreciated when one takes into account the scale of the *oinochoe*, which is between six and seven inches high. Finally, the extraordinary preservation of the silver, resulting from the tightly sealed atmosphere of the tomb in which the oinochoe lay undisturbed for 25 centuries, allows the viewer to appreciate not only the beauty of the design and craftsmanship, but the richness of the material as well.

Plate 13 is an example of another *oinochoe* from the Hoard. As the detail pictures show (Plates 14 and 15), the handle continues inside the rim of the vessel, where an animal head solidifies the juncture of handle and vessel, and the handle terminates in the head and paws of another feline. The overall design and shape are similar to the *oinochoe* in Plate 12, and the theme of decorative animals is once again apparent. As with the other silver objects in the Hoard, the extraordinary preservation of silver adds to the beauty and rarity of the object.

In Plate 16 we see an example of an *oinochoe* of a simpler design. Although the *oinochoe* is less ornate, it is not without decorative elements. The body of the *oinochoe* has a carinated surface, the slender handle

Case Histories

terminating above in a lion's head and below in the head of a Bes. A similar round shape and carinated surface are seen in a silver bowl from the Hoard.

Another type of vessel represented among the silver objects in the Hoard are the *alabastra*, used to store perfume or oil. An especially well-preserved *alabastron* is shown in Plate 17. This *alabastron*, measuring approximately 4 inches high, is elaborately decorated. On the sides of the *alabastron* are lugs in the form of ducks' heads. Use of animal heads for 'zoomorphic junctures' may be seen in several types of objects in the Hoard. The rounded base of the alabastron is decorated in palmettes, similar in style to the palmettes seen at the base of the youth's feet on the oinochoe in Plate 12.

The body of the *alabastron* is divided into four decorative zones, each depicting a different animal or human theme. The first zone shows two roosters facing each other. The zones are separated by decorative strips with distinct geometric patterns. The second zone depicts several animals engaged in battle. The third zone depicts fighting soldiers. The two soldiers seen in the centre are shown in profile; both hold shields, one brandishes a weapon, and both wear helmets and greaves. The zone continues around the sides of the alabastron, with more figures of soldiers.

Finally, the last zone shows one of several deer, its head deeply inclined. Here, with amazing sophistication, the artist captured the graceful movement and shape of the deer using just a few lines, the animal's large antlers bent far back, accentuating the elongated line of its neck. The stag shown in this detail picture is part of a parade of deer encircling the bottom zone of the alabastron.

The bowls comprise an equally compelling aspect of the Lydian Hoard. Plate 18 shows a silver bowl with lobes in the form of Persian heads. Each head is identical, with elongated eyes, a pointed beard and a headpiece. The heads are hollow, and were soldered onto the wall of the bowl. Some of the heads contain pellets, which rattle when the bowl is moved, lending auditory interest to the bowl's visual impact. The use of pellets was also employed in the gold spools, discussed below. (Plate 30). Directly above the heads is an engraved band of rosettes, remarkably similar in style to the designs seen on the small, gold appliqués which are part of the Hoard. (See Plate 29, and discussion of jewelry, below.)

Another extraordinary bowl from the Hoard is shown in Plate 19. This bowl is decorated with gold appliqués and gold lobes. The lobes, of plain, undecorated gold, are similar in size and shape to the Persian head lobes of the bowl in Plate 18. Next to each gold lobe is an appliqué of a Persian king, in full royal dress, holding a spear or staff before him. (Plate 20). The king, with his pointed beard and elongated eyes, closely resembles the heads on the lobed bowl, discussed above. (Plate 18). His feet rest on birds' heads, mounted on a gold ring terminating in a leaf design. The contrast of the gold and silver, together with the repeated depictions of the striding king, emphasise the royal nature of the Hoard vessels, and serves to

remind the viewer of the noble or royal nature of the persons buried in the tumuli.

Also included among the Hoard were several silver ladles. The ladle shown in Plate 21 demonstrates a delicacy and superb craftsmanship similar to that of the *oinochoe* in Plate 12. The handle terminates in animal heads (much like the handles of the oinochoes shown in Plates 13 and 16). At the base of the ladle, two winged sphinxes rest along the rim of the bowl; their heads turn so that they face each other. (Plate 22). They are of particular interest because of the comparison that can be drawn with the large stone sphinxes which were also part of the Hoard recovered from the Metropolitan. The sphinxes, unlike the ladle, were never displayed by the Metropolitan. Now, for the first time, scholars can compare the ladle sphinxes and the stone sphinxes, and attempt to understand the decorative and symbolic aspects of sphinxes in Lydian art and of the Persian period. It is through this type of comparison (finally possible), of one object which had been displayed without benefit of correct identification or context, and another object hidden from view, that the loss to scholarship over the past 20 years is most apparent.

Incense burners were included among the objects of the Hoard, and the example shown here was fashioned in bronze. (Plate 23). The head of the incense burner is cone-shaped, with holes cut out in the shape of arrows to allow the smoke from the incense to escape. A slender calf rests its hooves on the cover of the burner, twisting its long, exaggerated neck to face backward. The handle of the incense burner terminates in a calf's head. The cone-shaped cover with arrow-shaped holes is also seen in another incense burner in the Hoard (rendered in silver). The shape appears again on the unique slip-on lid of a bronze jug.

Cosmetics played a role in the furnishing of the tomb, and evidence of their importance is apparent among the Hoard objects. Plate 24 shows a silver cosmetic box with gold studs. The construction of the box is quite inventive. The lid swivels open to reveal four chambers, with a central round section, for the storage of cosmetics. One of the walls separating the chambers has a wedge cut into it, in which a silver spoon was stored. A secret latch, terminating in a gold stud, is attached to the outside of the box. When the lid is swivelled closed, the latch is put into place and appears to be identical to the other gold studs on the lid, making it difficult to open for anyone unfamiliar with the box. Other objects included in the Hoard relating to cosmetics are a round silver mirror disk, and a round silver tray with a silver swinging handle.

Perhaps the most startling aspect of the recovery of the Lydian Hoard has been the disentombing of the jewelry from the Metropolitan's basement. Unlike the silver and bronze objects discussed above, the jewelry, despite its rarity and unquestionable importance, went virtually undisplayed by the Metropolitan during the more than 20 years which passed following its acquisition.

Case Histories

The jewelry is remarkable for its preservation, the variety of materials, and the quality of the design and craftsmanship. Although a wide variety of types and designs are included, the various necklaces, beads, pendants, bracelets, earrings and rings are related stylistically by certain recurring motifs common to Lydian art such as animal head terminals, acorns, and rosettes. These themes also unite the jewelry with the many other types of objects in the Lydian Hoard including the bowls and the small pitchers, evidencing a similarity of artistic vision of the craftsmen.

The winged-sun pectoral necklace shown in Plate 25 shows an Persian influence. The simplicity of design, the heavy gold chain, smooth central disc and cloisonné work on the wings have a monumental quality, despite the intricacy of the craftsmanship. A bracelet in the Hoard employs a similar design, using a central disc linked to a heavy gold chain, but does not include cloisonné wings.

The use of animal head terminals is evident on several of the bracelets. Plate 26 shows a pair of gold bracelets with lion head terminals. The lions face away from each other, and the bangle of each bracelet is molded to conform to the shape of a human wrist. Another example of lion head finials, rendered in gold, can be seen on a pair of glass bracelets. There, the lions face each other, much like the animal heads on the handle of the ladle shown in Plate 22. Despite the delicacy of the material, the glass bracelets are fully intact.

Perhaps the most intriguing of the jewelry items is the tiny gold pin with acorn tassels. (Plate 27 and cover). Its subject is a composite creature, bearing: the head and front legs of a horse; the wings of a bird; and the scaled body and tail of a fish. The tiny creature—it measures approximately one inch across—is clearly in motion. His legs gallop forward, his wings are outstretched, and even his tail is flipped upward. Nine gold chains, with an acorn originally dangling at the end of each, are attached to the little creature. The remaining acorns, each as large as the creature's head, are rendered in gold and glass. It is not difficult to understand how this tiny work of art so captured the imaginations of the officials of the Republic's Directorate General of Monuments and Museums that the Republic has chosen it as the symbol of the Lydian Hoard exhibition in Ankara.

The design of the acorn tassels on the pin is strikingly similar to the acorn necklace shown in Plate 28, another extraordinary example of jewelry from the Hoard. The necklace repeats the acorn pattern, on beads strung closely together, forming a heavy, regal necklace.

Another type of jewelry included in the Lydian Hoard is the gold appliqué, used to adorn garments. Four of the larger appliqués are shown in Plate 29. A diamond-shaped appliqué was also found, in addition to round appliqués, as well as dozens of tiny square appliqués, each embossed with a pattern. As may be seen in Plate 29, each of the illustrated appliqués has a unique pattern or design embossed on its surface. A rabbit and a bird adorn one of the appliqués, and the familiar rosette pattern is visible on another and provides an interesting comparison to the small

rosette pattern on the bowl shown in Plate 18, which forms a band above the Persian head lobes. The appliqués have holes punched in the corners, which allowed the appliqués to be sewn onto garments.

Finally, Plate 30 shows a pair of gold spools. The spools contain pellets that rattle when the spools are shaken. The edges of the spools are bent and misshaped. The Republic learned in its investigation that the thieves, when they heard the rattle sound, thought the spools might contain jewels, and tried to pry them open. The telltale marks of the mutilation remain and are a testament to the type of damage to which antiquities are exposed when they are handled in the black market by those seeking no goal other than profit.

Space does not allow for detailed descriptions of the many other jewelry pieces which comprise the Lydian Hoard. For example, the gold rings inset with embossed carnelian stones, a small pin in the shape of a recumbent goat, a necklace of dozens of delicate gold fringes, a gold ornament in the shape of a bird, gold beads and earrings. Moreover, the jewelry is even more interesting when viewed and studied together with the ancient goldsmith's tools included among the Hoard objects. The tools, also long hidden in the Metropolitan's basement, are now available, for the first time, for study. Many of the tools, such as the tools used to make impressions for earrings and appliqués, can readily be seen to bear a stylistic similarity to the jewelry in the Hoard. From these tools we can gain a greater knowledge of how the craftsmen created the marvels discussed on these pages.

The Lydian Hoard, of course, is best appreciated when viewed as a whole, which can now be done for the first time. From the tiny horse pin to the stone sphinxes, the Hoard presents a rich and varied testament to the Lydian civilization. Having been twice entombed—once in antiquity and again in modern times—the Lydian Hoard is now gloriously on display for the world to see in the Republic's Museum of Anatolian Civilizations, thus ending the saga of the Lydian Hoard.

Bibliography

Akurgal, E., 1985. *Ancient Civilization and Ruins of Turkey*. 6th edition. Istanbul.

Boylan. P., 'Treasure Trove with Strings Attached.' *Independent*, (London), November 9th 1994.

DeWeerth v. *Baldinger*, 836 F.2d 103 (2d Cir. 1987), 804 F.Supp. 539 (S.D.N.Y.1992); *rev'd in part*, 1994 U.S. App. LEXIS 10850 (2nd Cir. N.Y. May 16, 1990).

Kunstsammlungen zu Weimar v. *Elicofon*, 536 F.Supp 829 (E.D.N.Y. 1981), *aff'd*, 678 F.2d 1550 (2d Cir. 1982).

Republic of Turkey v. *The Metropolitan Museum*, 762 F.Supp. 44 (S.D.N.Y. 1990).

Solomon R. Guggenheim Foundation v. *Lubell*, 77 N.Y. 2d 311, 567 N.Y.S. 623 (1991).

Turkish Ministry of Culture,1983. *The Anatolian Civilizations*, Vols 1-3 (Ankara).

Notes

1 536 F.Supp 829 (E.D.N.Y. 1981), aff'd, 678 F.2d 1550 (2d Cir. 1982).
2 836 F.2d 103 (2d Cir. 1987).
3 77 N.Y. 2d 311, 567 N.Y.S. 623 (1991).
4 After the decision in *Guggenheim*, the trial court for DeWeerth granted plaintiff's motion for relief from the original judgment. 804 F.Supp. 539 (S.D.N.Y.1992). Although that decision was reversed by the Appellate Court for technical reasons relating to federal procedural law, the Apellate Court recognised that in light of *Guggenheim*, its original decision had proven to be incorrect. 1994 U.S. App. LEXIS 10850 (2nd Cir. N.Y. May 16, 1990).
5 762 F.Supp. 44 (S.D.N.Y.1990).
6 The authors wish to thank Dr. Machteld Mellink, Professor Emeritus of Classical and Near Eastern Archaeology and the Leslie Clark Professor Emeritus of Classics of Bryn Mawr College, Pennsylvania, for her review of, and insightful comments on, this section of the paper. In addition, the authors wish to inform the readers that a complete catalogue of the Lydian Hoard will be published shortly by the Ministry of Culture in Ankara.

The Situation in the UK

Treasure Trove, Treasure Hunting
and the Quest for a Portable Antiquities Act

Peter V. Addyman

Since the first Ancient Monuments Act more than a century ago the ancient sites and historic buildings of Britain have progressively been protected by legislation until today the United Kingdom has one of the most comprehensive, as well as possibly one of the most complex, codes anywhere. It is supported where necessary by government policy guidelines such as the Department of the Environment's Planning Policy Guidance 16 of 1990, relating to archaeological sites, and its Planning Policy Guidance 15, of this year, relating to historic buildings (Hunter 1992). Not only that but this strong legal and administrative protection is supported by a firm and often vociferous public opinion, given expression by bodies such as *Rescue* for archaeology and by *Save Britain's Heritage*, *SPAB* (the Society for the Protection of Ancient Buildings) or the *Victorian Society* for the built heritage.

Yet historic buildings and archaeological landscapes, sites and monuments—as conservators will be acutely aware—are only part of the archaeological story. First there are the archaeological layers, often complex and deeply stratified and full of information, that lie around historic buildings and monuments, and within archaeological sites. These, if found undisturbed, are capable of being read through the techniques of scientific excavation to tell the sequential story of the building, monument or site and additionally the landscape, the region and the nation. Secondly, there are the artefacts contained within these layers. These portable antiquities, found in context in the stratigraphic sequence, can potentially reveal huge amounts of information about such things as the date and duration of occupation of the site; about the kind of people who lived and worked there; about the kinds of activity that went on; about the economic performance of the inhabitants, their trade links, their artistic tastes and so on. Even found unstratified on the surface of the site artefacts can at least help to define the location and extent of the site and to hint at the duration of its occupation. To do this they do not have to be beautiful, or valuable, or rare: they just have to be recorded *in situ*. At very least, even when lacking a precise stratigraphic context or find spot they may have an intrinsic interest and archaeological value which transfers to the site's

history if they are known to come from a particular provenance. That interest and value, as conservators know only too well, may not be immediately apparent. It may be obscured by corrosion; or it may only be revealed in the course of stylistic analysis, or scientific examination to determine composition, date of manufacture, production technology and so on.

All this is common ground to archaeologists in Britain and has been for 70 years or more, since the potential of stratigraphic archaeology became evident through the work of scholars such as Wheeler in the 1920s and 1930s. It is amazing therefore that portable antiquities—so vital a part of the continuum of evidence about our archaeological story, are still not protected, in England and Wales at least, by legislation except for the relatively few cases covered by the law of Treasure Trove, and except for the limited protection afforded by the laws relating to theft.

Let us briefly pause to consider the law of Treasure Trove. Seductively alliterative, and derived arcanely from the Norman French trésor trové – 'treasure found', the very words embody notions designed to thrill. Even the dictionary speaks of precious metals, gold and silver, money, riches or wealth found hidden in the ground or elsewhere, the owner of which is unknown. The concept cannot fail to appeal to people brought up from childhood on legends of gold buried at the rainbow's end. Treasure trove embodies the excitement of discovery, sudden wealth, great good luck, the stuff of fantasy. As Geraldine Norman reminded us (see Norman in this volume) it is human nature responding as it always does to the prospect of cash.

The law in England and Wales deals with treasure trove in a way which heightens the drama, involving coroners, inquests and juries, and keeps excitement up until the very last moment. A group of men and women, just and true, is empanelled and seriously asked to determine the state of mind of the person who consigned the treasure to its find spot possibly several hundred years before. If they decide the treasure was buried with the intention of recovery the treasure will be designated 'treasure trove' by the coroner and seized by him on behalf of the crown. If they decide there was no *animus revertendi*, no intention to recover, as for example with objects placed as grave goods in a grave, or devotional gifts at a shrine, then the objects will not be seized by the coroner but will be returned, usually to whoever reported them, to take their luck under the normal provisions of the law relating to property. Such Gilbertian procedures and such an arcane law are so patently ridiculous that one can only assume they have survived on the statute book for the same reason that soft-hatted gents with flags survived until 1993 as starters to the Grand National—they are a quaint old English tradition that it would be a pity to abolish.

It took an expensive disaster, resulting in the voiding of the race, to question the efficiency of flag-waving stewards at Aintree. So far as portable antiquities are concerned the nation is experiencing a disaster

The Situation in the UK

equal in proportion to that which hit the Grand National, and reform of the law of Treasure Trove, long overdue, is now a matter of urgency.

Before looking at the nature of this disaster it is necessary to pause for a moment to consider what is and what is not treasure trove. Examples are taken from York, where over the last 21 years over 700 archaeological excavations or watching briefs have been carried out. Between them these have produced over 140,000 artefacts. A tiny proportion only of these have been of gold and silver, mostly coins. The point, therefore, is that most archaeological objects do not even pass the starting gate for treasure trove legislation because they are not made of precious metal. They include Roman bronzes, Viking age leather shoes, woodwork, stonework, ceramics; and a whole host of things. Even the famous Coppergate Anglo Saxon helm does not qualify though it is arguably the most important find ever to have come from the soils of York. Despite its awesome historical value it is only made of iron and copper alloy.

There is, however, a small proportion of excavated archaeological finds from York that is of gold or silver: mainly coins and small objects. They are occasionally brought together by the coroner and given a portmanteau inquest: but even these are normally not treasure trove. They were patently mostly chance losses; but there was one exception. This consisted of a hoard of Roman republican silver coins, perhaps lost in a dropped purse, or perhaps placed intentionally as a foundation deposit since they were found buried within the footings of a wall. How could one tell? One could not; but the jury thought it could.

Triumphantly it declared them Treasure Trove—and was afterwards dismayed to realise that this meant that, of all the 140,000 finds from York, these alone would go to the British Museum, which kept some and allowed the Yorkshire Museum to acquire the rest. To put a final characteristically Gilbertian touch to it, the finder was a prisoner, working on the site by arrangement with a local prison, who could not be allowed to benefit from a reward for something he was doing during custody.

This, then, leads to the second point. Even when the law does apply it can manage to achieve the opposite to the best archaeological practice, in this case splitting up an archaeological record which would otherwise have been kept together.

Now let us turn to objects which *are* of precious metal but which are not Treasure Trove. The Middleham Jewel, also a Yorkshire find, is one which introduces the subject of metal detecting. The jewel, a superb late medieval gold lozenge-shaped amulet engraved on both sides and ornamented with a huge sapphire, was reliably described as 'the finest piece of gothic jewellery found this century'. Ostensibly it was found by a metal detector operator alongside a footpath near Middleham Castle in 1985. It was subjected to a Treasure Trove inquest. A single object found in such circumstances could quite easily have been a chance loss—with no *animus revertendi*. Whatever went through their minds the jury, anyway, decided the object was not Treasure Trove. So the situation arose again

where an object described as 'a key piece for the study of English fifteenth century jewellery' and 'of international importance for research'; as clearly a part of the local and national heritage as York Minster or indeed the Coppergate helmet; did not come under the law. Instead it was consigned to the saleroom after a negotiated agreement between finder and landowner and bought by an anonymous person who subsequently applied for an export licence. The licence was deferred under the Waverley rules about export of works of art—and the Yorkshire Museum set about raising the £2.5million necessary for its purchase. A massive fundraising campaign produced the necessary sum by the deadline, 17 August 1991—and the jewel is now in its rightful place, the Yorkshire Museum. Since then this poor museum has had to sustain the expense of three more treasure rescue appeals.

This, then, leads to the third point. Even the finest and most important objects, even when they are of precious metal, even when they are self-evidently part of the National Heritage, can turn out not to be covered by antiquities legislation, but are subject to the whims of owners or finders, or the vagaries of the market place.

It is possible to take another, arguably the most famous, example of that kind of outcome. The Sutton Hoo ship burial, perhaps the richest treasure ever to have come from the soils of England, turned out, similarly, not to have been Treasure Trove. Clearly it was buried without the intention of recovery—and so it was returned to the landowner. Mrs Pretty, the landowner, magnanimously presented it to the nation—but she could just as easily have decided to sell off this remarkable archaeological assemblage piecemeal, as the retrievers of wrecks from underwater so often do nowadays.

To summarise, therefore, our main portable antiquities legislation in England and Wales is highly selective, dependent on criteria of selection more related to material of manufacture rather than archaeological importance, subject to a meaningless and often impossible to determine *animus revertendi*, and administered through a coroner's jury system hardly likely to be able to determine archaeological values, and at present not even asked to do so.

At a preliminary meeting of a conference of archaeological societies held on 4 May 1943 came the recommendation that a Council for British Archaeology be set up with, amongst other aims, the following duty—to press for legislative change so that 'All future finds of movable archaeological material be treated as are antiquities coming under the existing Treasure Trove laws'. Fifty years on, this has still not been achieved.

The Council was set up in March 1944. It adopted those aims—and its minute books for the 50 years since repeatedly record efforts to reform portable antiquities legislation on the one hand, and to educate the public in the archaeological value of archaeological finds on the other. This includes 11 versions of one prepared bill—and another, the Abinger Bill, which actually passed the Lords but was killed off in the House of

The Situation in the UK

Commons, arguably at Government behest (Cleere 1994). Fifty years later the CBA is still at it: and archaeologists are as unanimous today as they apparently were in 1943 of the urgent necessity. Maybe that is an indictment of the ineffectiveness of the CBA—but this is not a reason to stop trying. Indeed the necessity is, if anything, even greater than it was in 1943: and the reason is the advent of cheap metal detectors, coincidentally another legacy of the last war.

Metal detecting in Britain is now a widespread and popular hobby. Detectorists are to be numbered not in tens but probably hundreds of thousands. I am led to believe that they may make as many as 2 million finds annually, not all as grand as the Middleham Jewel of course, but including every few weeks now some spectacular object or hoard. In Norfolk alone, where the County Museum and archaeological unit cooperate to record such finds, up to 20,000 objects per year are noted in the County Sites and Monuments Record.

Metal detectorists have their clubs, their codes of conduct—in which rudimentary rules for recording of archaeological finds are set out—and their own magazines. The *Searcher* is one such, describing itself as 'the top metal detecting magazine for the world's most fascinating hobby'. The April 1992 issue gave the strike rates for a typical pair of enthusiasts. The two call themselves 'Old Yellowbelly' and the 'C-Scope Kid'. They detected on 107 days in 1991, totalling 596.25 hours. They found 81 coins, producing a silver coin every 7.36 hours, a pre-modern hammered coin every 8.64 hours; a Roman silver coin every 119.15 hours; and a milled silver coin every 85.18 hours.

Their artefact rate was considerably better: amphorae 5, brooches 10, buckles 5, strapends 8, dagger chapes 4, thimbles 18, pendants 9, pins 3, studs 20, rings 11, keys 8, crotal bells 14, miscellaneous 15, total 130 with a strike rate of an attractive artefact every 4 hours 35 minutes.

No one knows how many archaeological artefacts there are in the soils of Britain, but if they are going at that speed—even multiplied by as low a factor as 10,000, then archaeology is being used up at an unsustainable rate: it is a threatened nonrenewable resource.

Old Yellowbelly and the C-Scope Kid were responsible detectorists. They only operated with the permission of landowners, with whom they split their finds. Some they sold, splitting the profits with the landowners. Some were given as presents. Important finds went to the local museum. Many pounds of lead were sold for scrap. Such metal detectorists probably belong to the National Council for Metaldetecting as well as a local club, and subscribe to the NCM's code set out in their publication *A Shared Heritage* (1993).

Archaeologists would prefer them not to do what they do, hoovering up the archaeological data indiscriminately: but at least there is a chance to record it. It has to be admitted, too, that the spate of finds has completely transformed knowledge of various aspects of archaeology in the last few years; knowledge of small Viking age metalwork in Eastern England for

example, or certain types of coins, has been revolutionised. Good or bad, the activities of responsible detectorists are likely to go on, bolstered by the publicity given to the nowadays regular discoveries of hoards like the vast Roman one found at Hoxne in Suffolk in 1992 (14,756 gold and silver coins and 200 other precious objects), or the so-called Cunobelin's gold (977 gold and silver Iron Age coins) from South Worcestershire.

But there are less responsible detectorists too. They go on sites without permission, often at night. Many are not deterred by the special protection given by the scheduling of ancient monuments. Indeed, as John Browning has indicated in relation to the finds from Icklingham (see Browning in this volume), such scheduling provides them with convenient lists of targets. What happens then? The copper alloy plaque of the Emperor Claudius from Stamford Bridge, Humberside can serve as an example. Found clandestinely in a known Roman site it was sold at Christie's, with no particular doubts being raised about provenance, for £26,000, and exported to a German museum (before the new European Community regulations, though how it ever escaped Waverley is unknown).

Luckily in Yorkshire there are also awkward dogged farmers like Mr Browning. A good friend of the writer, Richard Wood, when he heard the plaque came from his land, and with the help of the police, pursued both plaque and vendor, recovering the former and ensuring a hefty fine for the latter. Christie's repaid the purchaser and now, aptly perhaps, are left with the problem of getting their £26,000 back from the detectorist. He had used it to pay off his mortgage.

That is a happy outcome. Nighthawks more often get away with it completely—dashing down the motorway to offload in a market overt, or through the trade. As Lord Renfrew has commented, (Hansard, House of Lords, 3 November 1992, 1405) this kind of trade is one of the most common crimes, after gun-running and drugs – and in some instances it may be not unconnected with the latter.

The full unpleasantness of nighthawking was revealed recently in an example recorded in the newspaper *Bedfordshire on Sunday*, 13 December 1992. Under the headline 'Castle put on guard' the piece records archaeologists' fears that their excavation site at Bedford Castle will be 'hoovered' under cover of darkness by opportunists and professional thieves, nighthawkers, with metal detectors.

They therefore employed security guards for the excavation. The fears stemmed from experience recorded in *Bedfordshire on Sunday* the previous month, under the title 'Grave robber unearthed'. This identified Anthony Fisk as an artefact thief responsible for the rape and destruction of some of Britain's most valuable heritage. He is described as a jobless nighthawker from Foster Hill Road, Bedford, who has just completed the pillage of a Roman cemetery uncovered by archaeologists at Kempston, Bedfordshire. Fisk was happy to discuss his exploits, observing 'It's all about money. I don't give a shit what people think. I can make a fortune from

what I find. Why should it all sit in the vault of a museum? It's not difficult. By the time the cops usually arrive, I'm long gone.'

Whether through nighthawking or by the more open activities of responsible metal detectorists it is clear that huge numbers of archaeological objects are annually riven from their contexts. How many and with what effect is not known, and so the Department of National Heritage and English Heritage have commissioned the Council for British Archaeology to carry out an emergency survey of the incidence and effects – good and bad – of metal detecting in England (Dobinson and Denison 1995).

Several things are probable. Most of the artefacts recovered will, like other excavated finds, be in urgent need of conservation. Their continued existence is likely to be endangered unless they are given proper handling, packing, and storage in the right environmental conditions. Large numbers have been already submitted to lemon juice, vinegar, boot polish or the scrubbing brush. The information potential of vast numbers of objects is lost because they sit on private mantelpieces until they collapse, or someone decides to throw them away or sell them on. Others are sold immediately and go to collections far distant from their origins, where their significance is forgotten or never known.

What can be done? On the one hand, the antiquities law in England and Wales is limited, archaic and inefficient, and the Theft Act difficult to operate. The Director of Public Prosecutions refuses to prosecute even the Bedfordshire case. On the other, it is clear that the archaeological evidence for our past is being daily hoovered up by hoards of detectorists, and nightly ravaged by nighthawks. There will be no single and no simple answer. Probably the solution will require three things: education; cooperation; and regulation, and only to a limited extent a fourth: legislation.

To educate is probably the soundest long-term solution. Only a generation ago our children were cheerfully collecting birds eggs and gathering handfuls of wild flowers: now they do not. The climate of opinion has been created in which such activities are simply unacceptable. Can the hoovering of archaeological finds and interference with archaeological sites be made a similar prohibition? It probably can.

Another way ahead is through cooperation. Metal detectorists are well-meaning souls for the most part, with the gold at the end of the rainbow at the back of their minds, but with an interest in the past at the forefront. They are normally willing to discuss their finds with archaeologists and to have them recorded. A national network of recorders—like the two archaeologists who, between them, cover Norfolk—could preserve for us at least minimal information about what is coming out. It could be linked to a logbook system for finds with a duplicate copy of each certificate kept in the local archaeological Sites and Monuments Record. This has formidable resource implications, but what value does the nation put on its past? Somehow it has to be financed, perhaps by fees or a levy on dealers trafficking in antiquities. Then there is regulation. Already an EC regulation has been promulgated which requires a licence for the export of cultural

goods from one EC country to another. Now a licence is required for each cultural object: and among the list of cultural objects are all products of archaeological excavations and archaeological finds of an age exceeding 100 years and antiquities over 100 years old of any value. Something like this did exist before – but only four licences were issued last year, whereas probably hundreds of thousands of archaeological objects were exported. The regulation, as Geraldine Norman warned us (see Norman in this volume), and as Jerome Eisenberg also believes (see Eisenberg in this volume), is going to be honoured more in the breach than in the operation.

Is there any hope for legislation to regulate the internal market? Despite its fifty years experience the CBA believes there probably is, both for modest change in the short term, and for the provision of a proper portable antiquities law, appropriate to a modern developed and semi-civilised state, in the medium term. That is why the CBA has supported initiatives by the Surrey Archaeological Society to reform modestly the Law of Treasure Trove. Lord Perth's Private Member's Bill, recently introduced into the House of Lords extends Treasure Trove provisions to all objects of gold and silver (abolishing the *animus revertendi*) and includes objects of other materials found with the gold and silver in a connected series. It also introduces a measure to allow other types of object in due course to be added by the Secretary of State; and it introduces measures to deal with trespass for the purpose of metal detecting. Whether it has any hope at all of proceeding depends either on the luck of our private member's supporters in gaining a place for it in the legislative lists: or on the government giving it support: probably an unlikely eventuality. Nevertheless wishing it God speed may be an appropriate sentiment.

That aside, the CBA, the Society of Antiquaries and the Museums Association and latterly the Museums and Galleries Commission, have come together with a joint statement of Principles which should lie behind the case for reform of the protection accorded portable antiquities in England and Wales. There are 4 main principles and six consequent proposals, printed here as Appendix 1. The three bodies are determined to make these principles stick – and win sufficient hearts and minds to bring to a close the situation whereby our foreign guests can legitimately say that our country has the worst antiquities laws in the developed world.

References

Cleere, H.,1994, 'Treasure Trove Sabotage*British Archaeolgical News* 12.

Dobinson, C. and Denison, S., 1995 *Metal Detecting and Archaeology in England*. CBA/English Heritage.

Hunter, J., and Ralston., I, 1992, *Archaeological Resource Management in the UK: an introduction*, Stroud.

Hansard House of Lords, 3 November 1992, 1405-6.

National Council for Metal-detecting, 1993. *A Shared Heritage*, London.

Portable Antiquities

The Council for British Archaeology, the Museums Association and the Society of Antiquaries of London have been concerned for many years that portable antiquities in England and Wales are accorded inadequate protection. The senior officers of each have met recently to agree a Statement of Principles, which has now formally been accepted by the three organisations.

National protection of archaeological objects has education and the advancement of knowledge as its objectives. Logically such protection begins with a system for the routine reporting and recording of finds. Such are common elsewhere in the world. Sadly, there is no such system in England and Wales. Treasure trove is all that we have, and that mechanism is an irrational and ineffectual anachronism. The Statement below sets out the case for reform. It is one of principles, necessary as a prelude to, rather than an exact prescription for, change.

Portable Antiquities
A Statement of Principles

In Britain today there is no coherent statutory provision for the management of our archaeological inheritance. Britain's archaeological inheritance is a unique resource for the study and understanding of human history. This inheritance includes structures, landscapes, evidence of people's relation with the natural environment, and movable objects, whether situated on land or under water.

This paper considers the position in England and Wales, but the principles apply more widely. In England and Wales, only Treasure Trove, limited to certain gold and silver finds, provides any requirement for finds to be recorded or studied. There is no other legislation relating specifically to portable antiquities. This omission is illogical. It is also contrary to the public interest: an interest which rests in opportunity for public knowledge of our national history.

The case for bringing portable antiquities within the protection of the law arises from the following principles:

1. The archeological inheritance is an entity. Archaeological structures and objects form an essential part of the archaeological heritage. Therefore portable elements of our heritage should be accorded a status in law which is commensurate with their importance.

2. The archaeological inheritance is irreplaceable. The nation should seek to ensure that all aspects of its inheritance are subject to appropriate stewardship.

3. The archaeological material has a potential to contribute information which will help to retrace Britain's history. There is thus a valid public interest in the reporting by a finder of items which are found by chance.

4. The purpose of such reporting is to allow competent recording of information. Such reporting should be made a legal obligation upon the finder (as is currently the case with Treasure Trove), and failure to report should be an offence.

Arising from these the following further principles may be proposed:

5. It is generally the case that, at the time of discovery, the original ownership of archaeological material has lapsed through a break of continuity. Under English Law ownership at present generally lies with the landowner except in cases of Treasure Trove.

171

The valid public interest in archaeological material indicates that a new owner should be assigned to it. In the national interest this owner should be the Crown.

6. Competent authorities acting on behalf of the Crown should exercise discretion in the matter of future ownership.

7. The Crown should wish to retain material of national or regional significance in museums, for purposes of study and public display. Where the Crown retains material, a financial award may be made to the finder, and/or landowner.

8. In the case of material which it is not in the public interest to retain, the Crown would normally wish to reassign title to the finder or landowner.

9. The same principles should apply to material underwater as apply to remains on land.

10. The definition of 'material of archaeological interest' is a matter for the judgement of the competent authorities.

Notes

Definitions
For present purposes a working definition of 'archaeological material' is taken as material over 100 years old.

Contacts

For further information please contact~:
Carol Pyrah (CBA) 01904 671417
David Morgan-Evans (SoAL) 0171 734 0193
5 April 1993

The Sponsors
The Society of Antiquaries of London, founded in 1707 (with a Royal Charter), has two thousand Fellows from all over the world. It seeks to further the study of the past, in its widest sense.

The Museums Association was formed in 1889. It has over 3,300 individual and institutional members from museums and galleries. The Association's activities include the maintenance and monitoring of the highest ethical and professional standards within the museum world.

Founded in 1944 the Council for British Archaeology consists of some 365 local, regional and national bodies and societies. The CBA works to promote the study of British archaeology, and to improve public knowledge of Britain's past.

Portable antiquities and the law within the UK
In England and Wales, only Treasure Trove, limited to certain gold and silver finds, provides any requirements for finds to be reported, recorded or studied. In Scotland any archaeological material found in the ground must be declared, and can be claimed by the Crown. In Northern Ireland the Historic Monuments Act 1971 prohibits casual excavation in search of archaeological objects, and obliges citizens to report finds which are made by chance.

Treasure Trove: New Approaches to Antiquities Legislation

Rosamond Hanworth

Introduction

The Law of Treasure Trove goes back to Saxon times. King Richard I lost his life in a squabble trying to enforce it; in those days it was intended to preserve the King's interest in buried treasure, so that tax could not be avoided by burying one's assets. For some time now the provisions of this elderly law have become increasingly anomalous in meeting today's needs in an era of expanding technology and with new problems of tax avoidance added to the ancient ones.

The defects of the present legislation were highlighted for Surrey Archaeological Society by what took place at Wanborough, on a small estate lying just north of the Hogs Back, near Guildford. Here the site of a Romano-British temple was found, and a large hoard of coins discovered in 1985. Initially a few Iron Age and Roman coins had been found by responsible metal detector users who reported their finds to the local museum, and the coroner was notified. It is necessary to emphasise that there are two kinds of metal detector users, and that those who act responsibly can be of very great benefit when backing up local archaeology. Unfortunately, in the course of the coroner's inquest, the location of the site was given out in open court and thereafter the site was raided by night.

In spite of commendable police activity and later the use of surveillance equipment, it was not possible to prevent the removal of an estimated £2 million worth of coins, many of which later turned up on the American and European markets. When, subsequently, one of the perpetrators of the plunder of the Wanborough site was prosecuted for theft, his conviction was not upheld by the Court of Appeal on the basis that the Crown Court Judge had misdirected the jury. He had told them that all they had to be sure about was that there was a real **possibility** of the coins being found to be treasure trove. This was not so, in a criminal trial they had to be **sure beyond reasonable doubt** that the coins were treasure trove, before they could convict. In a civil case, such as an inquest, the standard is set at a lower level, on the **balance of probability**. This means that if a coroner's court finds that objects are treasure trove their decision is not binding in a criminal trial. The Wanborough case has underlined the fact that a coroner's inquest

is not a tool which can be used against theft of treasure trove, thus emphasising the weakness of the law as it stands today. This problem is addressed in the Treasure Bill with a clause to the effect that the findings of a Coroner's Inquest shall be conclusive.

Efforts to amend the law

In 1982 the Abinger Bill was presented to the House of Lords. It was elegant, extremely short and very simple. First, it widened the categories of object deemed Treasure Trove to include 'objects made of an alloy with an added proportion of gold or silver' and objects lying adjacent or in a container. Second, it sought to remove *animus revertendi*. *Animus revertendi* is a guessing game, in which one seeks to decide the intention of the person who deposited something in antiquity. The rule is that, if a thing was lost accidentally or was a votive deposit, it was not treasure trove. If it had been deliberately hidden and was meant to be recovered, it was. Wholly artificial legal presumptions of what the intention might have been are called for in order to solve this conundrum.

The Abinger Bill made no provisions against the growing evil of illegal treasure seeking, and it offered no protection to landowners. It ran out of time at the end of a parliamentary session. But it was generally understood that it had failed to win the support of the country landowners in the House of Lords. That was the position when, eight years ago, the Surrey Archaeological Society became actively involved.

In 1987, the Law Commission issued a report on the subject of treasure trove and recommended that an inter-departmental committee should consider the questions of policy involved and then propose the principles on which a new law should be based. In 1988, the Department of the Environment issued a Consultation Paper on Portable Antiquities and invited responses from interested bodies, which were forthcoming. But, in spite of pleasant reassurances from Government, nothing was done. There was a perpetual rumour that 'Legislation is in the offing' but it has always proven to be a non-starter. Accordingly, it was decided that the time had come for private initiative. Starting with a letter to *The Times* in October 1989 which achieved some support, efforts have been directed at drafting a Private Member's Bill to amend the law. The resultant Bill has been introduced in The House of Lords recently by Lord Perth whose support has been extremely encouraging.

Originally it was intended to produce a Portable Antiquities Bill, designed to cover a wider range of objects of archaeological or historical importance, and, to this end, a large number of interested bodies was consulted. However, it became clear that the scope of the bill would have to be limited were it to stand any chance of succeeding. It was at this stage the the British Museum offered its co-operation and it has been working closely with the Surrey Archaeological Society ever since.

Contents of the Bill as of December, 1993

The proposed bill was a result of extensive consultations with interested bodies. These include the Police, Coroners, Magistrates, the Treasure Trove Reviewing Committee, the Country Landowners Association and all major archaeological and museums organisations.

The Bill sought to clear up the anomalies and difficulties currently being experienced in relation to treasure trove: by removing the concept of *animus revertendi;* by redefining treasure trove to include objects which were not wholly or substantially made of gold or silver; by enabling the Secretary of State, with the approval of Parliament, to designate additional categories of objects as treasure trove; and by bringing within the definition, objects which were not otherwise covered but which were part of an original deposit, an element of which was treasure trove. The Bill authorised the Secretary of State to publish codes of Practice for the general assistance of finders, landowners and museums and other persons involved with treasure trove. The Bill also sought to offer a measure of protection to landowners and archaeological sites by making trespass, for the purpose of exploring for treasure, a criminal offence. The Bill further strengthened the requirement that coroners be informed of finds of treasure trove.

The Bill thus widened the definition of treasure trove, streamlined the system of administration and made the law enforceable. The Bill was drafted so as not to require any additional resources nor was it intended to have an adverse effect on those legitimately finding antiquities.

Conclusion

Subsequently, the Bill has undergone further modifications; for example, at the instigation of the Home Office which was concerned that the Bill not contain a clause involving criminal trespass. The situation is still unresolved and Hansard must be consulted for more recent developments.

Since this paper was presented at the UKIC Archaeology conference on *Conservation and the Antiquities Trade*, the sponsors of the bill have been co-operating with the Department of National Heritage and have produced with them an updated version, The Treasure Bill. This has passed through the House of Lords but it has yet to go through the Commons.

The Lure of Loot:

an example or two

Harvey Sheldon

There is an old tale, variously recorded (eg Gomme, 1908; Spence, 1937 and Braggs 1971), which concerns a certain pedlar from Swaffham in Norfolk.

According to the tale the pedlar had a dream revealing that if he journeyed down to London Bridge he would obtain news which would bring him great wealth. Journey down he did and stood on the bridge for some considerable time, though without anything being revealed to him at all.

The pedlar had almost given up when he was approached by a bridge shopkeeper, curious as to why he had been standing there. When he had recounted his tale the shopkeeper laughed heartily, telling the pedlar that he too had had a similar dream. His dream was that if *he* journeyed to a place called Swaffham in Norfolk 'if I digged behind a pedlar's house under a great oak, I should find a vast treasure'.

Fortunately the shopkeeper considered himself a wise man. 'Now think you', he said, 'that I was such a silly fool to take such a long journey upon the instigation of such a silly dream.' So he advised this less than worldly dreamer to 'learn well from me and get you home and mind your own business'.

Well presumably the pedlar didn't now need much encouragement to get home as speedily as he could. Once there he 'digged and found a prodigious great treasure with which he grew exceedingly rich'.

The treasure is variously described: in one account it is a pot 'full of old coyne'. In another the container has a latin inscription on the lid, which eventually leads the pedlar to dig deeper and find a second and even richer haul (Spence, 1937: 237-238).

Although the earliest recorded version known is as recent as the Commonwealth period (Braggs 1971) Gomme believed that the tale, particularly because of its geographical distribution, was of pre-Norman antiquity perhaps referring to the deliberate hoarding of portable wealth at the very end of the Roman period (Spence, 1937).

I mention the tale for two reasons. Firstly the 'treasure' comes from Swaffham, close to the East Anglian fen edge, an area where some startlingly rich discoveries have been made this century. A number of these

date, apparently, to the last years of Roman Britain (eg Mildenhall c.1942, Water Newton 1974/75, Thetford 1979, Hoxne 1992) and Swaffham itself may well be close to the junction of major north-south and east-west routes (OS 1978). Perhaps Gomme's temporal identification was close to the mark and the tale itself reflects an early example of the discoveries which have become more familiar this century.

Secondly, the tale demonstrates the antiquity of the practice of digging in the search for 'prodigious great treasure'. In this case the end seems to have been achievable even without the use of the metal detectors which apparently make location easier than reliance on mystical dreams!

It would be fair to emphasise that many who use metal detectors today, as a hobby, individually or within clubs, and with or without the encouragement of archaeologists, would not contemplate disturbing known sites nor looting others for profit.

It is clear that in areas like Norfolk where there is cooperation between archaeologists, detector clubs and individuals, metal detecting can lead to the accurate plotting of finds and their entry into the County Sites and Monuments Record. Such cooperation will entail enthusiasts concentrating on surface recovery, rather than the interference with potentially undisturbed deposits. It may even mean the ultimate deposition of objects into public rather than private collections. The discoveries can result in the pinpointing of sites and their subsequent protection or archaeological investigation in the context of changing land-use. Harnessing the enthusiasm of detector users and working with them can, therefore, have a very positive side.

However what is of much more concern than the activity of the socially responsible detector users is that of what might be termed the 'hard-core minority'. Individuals or groups who, in the words of the Surrey Police when referring to Wanborough Temple, indulge in 'highly organised plundering'. In that case, they operated, often at night, in considerable numbers apparently causing some fear to the local population. It is probably safe to assume that members of this fraternity are immune to all forms of educational or moral pressure and are concerned solely with getting rich from the antiquities they unearth.

One only has to look at contemporary newspapers to find examples of their activities.

As recently as October 1993, the *Daily Mail* (October 10th 1993) reported the case of a treasure hunter, a member of 'The Nighthawks', not a pop group, up before York Crown Court accused of stealing.

He had, it was alleged, unearthed a bronze plaque portraying the Emperor Claudius in a field at Scoreby. This, according to the *Mail* report, was sold via Christie's to a German museum for £26,000, without the landowner's permission. Apparently the finder believed he had a right to it, claiming 'I saved the treasure from the plough'.

Then there was the gentleman, reported in *The Times* June 24th1993 who had dug up a gold torque in a field near Warminster and who objected

to it being taken as Treasure Trove, even with compensation. 'It's worth millions' he is reported as saying: 'why should the crown be allowed to *steal* it'!!

Yet the messages given by the newspapers, even the broadsheets, are not unambiguous.

For example, *The Times* reported that London had become 'an international centre for stolen artifacts because Britain has few import and export restrictions compared with other European counties (July 28th 1993). Scarcely two weeks later the same paper was informing its readers that 'unearthed antiquities can fetch a fortune in Britain', in an article about how to start collecting them! (August 14th 1993)

An example of an important site where considerable damage has been caused by looters is that of Wanborough close to the North Downs Way, about four miles west of Guildford.

It was discovered more than twenty years ago in a field-walking exercise on farmland and followed by trial excavations conducted by the Surrey Archaeological Society. Subsequently, finds of coins by metal detector users led to Treasure Trove inquests: the consequent publicity resulted in an escalation of looting and destruction necessitating an emergency dig by the Surrey Society in 1985.

Before the archaeological excavations, there were said to be, at times, 30 or 40 people digging away overnight. They came, apparently, from far and wide including Kent, Dorset, and Norfolk, encouraged by articles in a treasure hunting magazine.

The subsequent excavations revealed the stone walled foundations of a 'Romano-Celtic' temple with a central cella or shrine, surrounded by an ambulatory. The treasure hunters in their search for finds, had dug away a large area, mainly in the *temenos* or 'sacred area' beyond the temple walls but in some places within the building's ambulatory.

The excavation produced about 500 coins, mainly in disturbed contexts and a similar number were either handed in or retrieved by the police. It is estimated though that about 9,000 were removed earlier by the treasure hunters and consequently found their way onto the market. Perhaps all had come from a hoard deposited on the site early in the Roman period. Some of the coins have been reported in Belgium, Switzerland and Germany: others as far afield as New Zealand. Coins were not the only objects looted from Wanborough. A number of Romano-British bronzes, perhaps parts of priestly regalia such as sceptres and chain headdresses, also went onto the market. Surrey police believed that this was a well organised operation and commented that 'the metal detector world is becoming a shadowy subculture with hundreds of people ready to make fast money without asking too many questions'. (*Rescue News* 38 Winter 1985/86.)

Even after the excavations the treasure hunters returned re-digging the site after a new crop had been sown. By now, though, the damage to the archaeological deposits had largely been done.

The Situation in the UK

It is not clear how effective the landowners notice was. It warned 'persons found digging' that they would be prosecuted and of the further 'danger because … our farm team are constantly out shooting vermin'!

In contrast, a rather more satisfactory treasure hunting experience occurred at Hoxne, in north Suffolk, in November 1992. As is now widely known a hoard of more than 14,000 late Roman coins, mainly silver, together with other objects such as gold bracelets and silver spoons, was located in a field, apparently while searching for a hammer! The prompt reporting of the find to the Suffolk Archaeological Unit meant that the circumstances of the discovery could be examined. This established at least that the objects had been buried within a rectangular wooden container.

Two coins in the assemblage revealed that the hoard could not have been deposited at least until the brief reign of the usurper Constantine III, at the end of the first decade of the 5th century and, therefore, the very eve of Britain's separation from Rome. What chance would there have been even of that information emerging if the hoard had been broken up and found its way secretly and bit by bit in the Wanborough fashion onto the world market?

Once the news of the find was out the site was 'visited' and photographs show holes similar to those that were dug at Wanborough. Fortunately it is believed, the vast majority of the objects had by then been removed and were in safekeeping.

In the case of the Hoxne treasure, the circumstances, especially the attitudes of the finder and landowner and their relationships with the Suffolk archaeologists, led to a successful outcome. The necessary processes of conservation and scholarly enquiry could take place, and the objects, together with information on their significance for the understanding of late Roman Britain, should be made available for all.

Yet compare this with the outcome of the events at another site in Suffolk, Icklingham, theoretically protected as a Scheduled Ancient Monument from where Roman objects apparently looted in the early 1980s seem to have found their way to the United States.

This appalling episode is only enlightened by the tremendous efforts made by the farmer, John Browning, an individual struggling against what appears to be the complacent inertia of those who are supposedly empowered to protect our archaeological sites and their contents (see Browning in this volume).

What can be done to prevent more destruction to our finite stock of archaeological sites? Those metal detector users who do damage innocently, in the pursuit of their hobby or in the excitement of discovery, present less of a problem than those engaged in 'highly organised plundering'. It should not be beyond the abilities of archaeologists to channel the enthusiasm of most metal detectorists, through education and persuasion into activities which are acceptable. It would, perhaps, be appropriate to undertake a study to find out how best this is being done locally so that it

can be applied elsewhere. The latter group of metal detector users pose a much more formidable problem. Their activities will only be countered if there is a clear and well enforced law in Britain providing for the routine reporting, recording and conservation of finds. This is likely to involve the ownership of portable antiquities passing from the landholder to the Crown.

The omens for improvement are hardly good. The government's reaction to Lord Perth's recent bill, which would extend Treasure Trove to a much wider range of objects however they had been deposited in the ground, was depressing but hardly surprising (DNH Press Release, April 20th 1994).

Perhaps it is now timely for archaeological organisations to collect as much information as they can on the damage that has been, and is being, done nationally and seek the support of other political parties.

After all, if there is now legal provision in Scotland that requires all archaeological finds to be disclosed and empowerment for the Crown to claim them (see Sheridan in this volume), then there does seem to be a basis in law, at least to this layman, which could be extended to the rest of the United Kingdom.

Acknowledgements

I would like to thank David Bird and Judith Plouviez for their help in the preparation of this paper.

Bibliography

Braggs, K.M., 1971 *A Dictionary of British Folk Tales.* Vol II, RKP.

Gomme, G.L., 1908. *Folklore as an Historical Science.* Methuen.

Ordnance Survey., 1978. *Map of Roman Britain* 4th Edition.

Spence, L., 1937. *Legendary London.* Robert Hale & Co.

The Trade in Antiquities:

a curator's view

B. F. Cook

Since I have now retired from the British Museum and no longer have any official standing, what I have to say must be taken as a personal statement. Like Julius Caesar's Gaul, my curatorial career was divided into three parts. During the first part (September 1960 to March 1969) I was on the curatorial staff of the Department of Greek and Roman Art at The Metropolitan Museum of Art, New York; during the second part (April 1969 to November 1976) I was Assistant Keeper in the Department of Greek and Roman Antiquities at the British Museum. From November 1976 until January of this year I was Keeper of Greek and Roman Antiquities, and it was only during this third part of my career that I had the authority as head of department to make decisions on purchases myself.

Collecting is usually considered to be one of a curator's major responsibilities. Although Stephen Weil of the Hirschorn Museum has disseminated Peter van Mensch's tripartite 'new paradigm' of the basic museum function, 'Preserve—study—communicate', with collecting seen only as an early stage of preserving (Weil, 1990: 57), for many curators collecting is paramount. In the words of a former Director of The Metropolitan Museum of Art, Dr Thomas Hoving: 'education, outreach programs, liaison with colleges and universities, publishing books and articles is important—but they all pale in comparison to collecting treasures. Collecting is what it's all about' (Hoving, 1993: 272). Sometimes objects can be acquired directly from excavations, sometimes from old private collections, but many come from the antiquities market. I must admit at the outset that my attitude to the antiquities market has changed over the years. During my time in New York and for some time afterwards I had no difficulty in accepting the ethic that generally prevailed before the 1970 UNESCO Convention on the transfer of cultural property: that it was perfectly legitimate to acquire anything that appeared in the international market so long as the vendor had legal title to it, and that it was the responsibility of the countries of origin to enforce their own laws and to police their own borders—a view that, as we shall see, is still held in some quarters.

I no longer accept either of these propositions. I fully support the policy of the Trustees of the British Museum not to acquire recently smuggled

objects; and I have come to realise that the antiquities market is fed by clandestine excavations during which the archaeological context is destroyed. I do not need to add anything to Lyndel Prott's admirable summary of the evil effects of clandestine excavation (see Prott in this volume), but I might add a comment here that the British Museum's Board of Trustees includes distinguished archaeologists, usually co-opted or appointed by bodies like the British Academy or the Society of Antiquaries of London. As examples I might quote former Trustees like Sir Mortimer Wheeler, Dame Kathleen Kenyon and Sir Max Mallowan, and current members like Professor Rosemary Cramp and Professor Lord Renfrew of Kaimsthorn, who writes so passionately about looting and the destruction of the context (see Renfrew in this volume).

In inviting me to contribute to the conference which preceded this volume, Kathy Tubb specifically asked me to comment on whether I had ever been under pressure from Trustees to buy objects of dubious provenance. In view of the composition of the British Museum's Board of Trustees, you will not be surprised when I say that the answer is a definite negative. In fact my problem was usually to persuade them (often without success) to approve the purchase of objects that did meet the acquisition guidelines. Their problem was to apportion the inadequate funds for purchases provided by the Government, especially since a high proportion often had to be allocated to acquire for the Nation expensive objects for which export licences had been withheld. Although I did not quite embrace Stephen Weil's doctrine, I did on occasion suffer from the suggestion that a department that did not collect much was somehow 'moribund'. This charge, which was not levelled at Trustee level, I had to counter by an active programme of education conducted within the Greek and Roman Department through exhibitions and publications, and by a discreet programme of acquisitions, including material from excavations in countries far-sighted enough to permit *partage*, as well as some important objects from old collections, sometimes after the withholding of export licences. A summary of the results is published in the *Journal of Hellenic Studies* (Cook, 1994).

A different and, for me, more frustrating problem arose from having to refrain from buying interesting objects, even if they had been in private collections for decades, if there was nothing to dispel a suspicion that they might originally have been exported from their country of origin without a licence. This happened all too often because reliable documentation on the origin of objects is rather rare, and because there is so much material of dubious provenance in the market that all undocumented objects come under suspicion. There is no Magna Carta for antiquities; as Professor Sir John Boardman has recently been quoted as saying: 'Every object is guilty unless proved innocent' (Checkland, 1993). This may seem a hard judgement, but it is inescapable if strictly ethical criteria are applied to what is known about the antiquities market and the previously unknown objects that appear in it.

In the context of this volume it is not necessary to labour the point that

there has to be a connection between looted sites and the unprovenanced antiquities that flood through the market. Unfortunately the evidence is purely circumstantial, the links between the two ends of the chain being hidden, as clandestine as the original excavations themselves. Indeed, although clandestine excavation and unlicensed export are both usually criminal activities in the countries of origin, at some stage along the chain of transactions legal title can be acquired, so that it becomes legal to sell in Britain objects that have been illegally exported from other countries. To the responsible curator, of course, the acquisition of such material, although legal, is unethical, and it was this conflict between the legal and the ethical points of view that led me in 1985 into a public clash with Sotheby's that was widely reported in the world's press. There was particular interest in Italy because we were dealing with objects that had self-evidently originated there.

In considering unprovenanced antiquities the question of source can be approached on two different (though related) levels: Where precisely was each object found? and: What is the likely country of origin? Both questions are obscured by the clandestine nature of the antiquities trade in our own day, and the answer to the first question – the precise provenance – usually remains unknown. It is sometimes possible to answer the second question – that of the country of origin, in the sense of where an object was discovered – but even this can be complicated by what happened in antiquity, since many objects passed through normal commercial or other channels from the place where they were made to the place where they were lost or buried, and it is not uncommon for the place of manufacture and the place of discovery to be in quite separate countries today. Two examples elucidate this. In 1993 a New York court dismissed the claims of Croatia and Hungary on the so-called Sevso Treasure: there are too many geographically possible countries of origin, and no convincing evidence was produced to assign it to either claimant. The Hungarian claim that a topographical reference in an inscription could be used as evidence not only for its place of manufacture but also for its country of discovery in recent times simply does not stand up. The second moves from a particular to a more general example: pottery made in the neighbourhood of Athens from the sixth to the fourth century BC was widely exported in the Mediterranean and Black Sea areas. When unprovenanced Attic pottery appears in the market, although it was plainly made within the boundaries of what is now Greece, it carries no internal evidence about where it was found. To use soil samples and other remains to establish a provenance in the Sherlock Holmes manner would require an enormous database of information. On the other hand, South Italian red-figured pottery was hardly exported at all in antiquity, and when large quantities of it turn up on the market in pristine condition, it is almost beyond conjecture that it was found in Italy in the kind of built tomb that keeps pots intact over the millennia. The same argument about the identity of the places of manufacture and discovery can be applied to objects like Etruscan terracottas, but not to Etruscan bronzes,

which were widely exported.

Material of this kind is not uncommon on the London market, as perusal of almost any recent auction catalogue will confirm. In 1985 the Italian authorities sought to intervene in a sale of South Italian red-figure pottery at Sotheby's, and I gave them my support on ethical grounds. Sotheby's defended their position on legal grounds. No one claimed that the objects had actually been stolen from an existing museum or collection, and the Italian authorities were of course unable to provide any actual proof of the specific find spots of these particular objects (Watson, 1985 b). The sale went ahead, and my comments on the ethics of the sale were airily dismissed by a member of Sotheby's staff, who was quoted in the press as saying that I was 'fussy' (Watson, 1985 a). Well, on the sticks and stones principle I cannot complain of being hurt, but there is an equally well-known principle that the descent to verbal abuse is an admission that the intellectual and ethical arguments have been lost.

Ethical guidelines for curators have been promulgated at national level by professional bodies like the Museums Association, and at international level by ICOM. A more recent statement is the so-called 'Berlin Declaration'. This consists of a series of principles that were the subject of a 'Round-Table' discussion at the Thirteenth International Congress of Classical Archaeology held in Berlin in July 1988 (Berlin, 1990; cf. Heilmeyer, 1988). Central to the Berlin Declaration is the importance of the archaeological context. Since the loss of context through illicit excavation is unacceptable, certain consequences follow for both institutions and individuals: 'Museums must ensure that they do not acquire by purchase or gift, or accept on loan, objects that have recently become available through the illicit market (that is, those which have been acquired in or exported from their country of origin in violation of that country's laws), and therefore lack information on their origin. All archaeologists should avoid aiding this illicit trade by providing authentications or other advice to dealers or private collectors' (Berlin Declaration, Article 8).

The Berlin Declaration was not simply negative. It went on to recommend international cultural collaboration, including a system of short-term and long-term loans from the antiquity-rich countries of origin to institutions elsewhere, 'subject always to the constraints imposed by conservation requirements' (Berlin Declaration, Article 9). Even in that forum, condemnation of the antiquities market was not unanimous. During the discussion the opinion was expressed that it was all very well for curators of large and long-established collections, such as those in London and Berlin, to abjure the illicit market, but that allowance should be made for the growth of newer collections, for instance on the west coast of the United States and in Japan.

One of the difficulties is that there are more than two sides to the question. The free-market approach is naturally favoured by private collectors, who could hardly pursue their interest without it, by those dealers whose profits are dependent on it, and by some curators. It is condemned

by most archaeologists (including curators like myself) and by govern-ments in the countries of origin—but not necessarily for the same reasons. Archaeologists stress the value of the archaeological context and deplore its destruction. Politicians tend to be more concerned to keep antiquities within their own national borders for purposes of prestige and to encourage tourism. This kind of cultural nationalism that allows dealers and collectors to operate provided that they declare objects to the authorities and do not attempt to sell them abroad does nothing to protect the archaeological context.

It is regrettable that this narrow attitude underlies the approach of the 1970 UNESCO Convention. To quote Article 2: 'The States parties to this Convention recognise that the illicit import, export and transfer of cultural property is one of the main causes of the impoverishment of the cultural heritage of the countries of origin.' However, you will search in vain in that document for any reference to the importance of the archaeological context for the cultural heritage of all countries: but, of course, the Convention was essentially drawn up by politicians. It does have its uses, but it is not a universal panacea. To be fair, it is over twenty years old: thinking has advanced since 1970, partly due to the Convention itself, and it is excusable that in this respect at least its underlying philosophy is now rather out of date.

The neglect of the archaeological context has been aired recently in the magazine *Archaeology*: 'The present Greek Government and Archaeo-logical Service... sometimes seem to lay stress as much on avoiding the illicit export of antiquities as on preventing looting' (Renfrew, 1993: 16). Renfrew's article, which is worth reading in its entirety, was prompted by a review by Ricardo Elia of his book, *The Cycladic Spirit* (Elia, 1993 a), and the article's title is taken from what Renfrew describes as 'Elia's splendid aphorism: "The truth is that collectors are the real looters." ' Renfrew goes on to suggest, 'The time is clearly ripe for a re-examination of the ethics of collecting', and to look for 'some significant changes in the outlook of museums and of scholars, and then of collectors, and finally perhaps of dealers'. Elia has no doubts about the present attitude of collectors: 'Every serious collector knows that the object he or she has purchased in all likelihood came from a clandestine excavation or was stolen; in either case, it was probably smuggled out of the country of origin' (Elia, 1993 b). There is no room in this uncompromising view for buying in what is called 'good faith',or for the question of legal title and how it is acquired and passed on.

When it comes to buying objects to which dealers have legal title although it must be clear that at some stage they have been clandestinely excavated and probably illegally exported from their countries of origin, collectors tend to have their own justification. Perhaps the most ingenious is the claim by George Ortiz that 'fully 85 per cent of discoveries of antiquities are chance finds by farmers and especially by construction crews,' (Theodorou, 1991; cf. Moncrieff, 1993: 42) and that the objects would be destroyed if they were not 'rescued' by the market. Such

destruction, it is said, would follow because developers in some countries are unwilling to endure the delays imposed by local regulations for rescue archaeology. The failure of the authorities in the countries of origin to pay proper compensation promptly for chance finds is also advanced as a reason why antiquities find their way into the clandestine market. The existence of looted sites and the appearance in the market of large quantities of evidently related material must cast doubt on the figure of 85 per cent, but the rest of the argument has some justification. The deliberate bulldozing of part of the *heroön* at Lefkandi is perhaps the most notorious case in Greece (Catling, 1981: 7). Geraldine Norman criticised the short-comings of many government systems of compensating finders of antiquities (see Norman in this volume). Italian archaeologists were if anything even more forthright in their criticisms of their Government's policy at a conference on the problems of the archaeological heritage held at the Accademia dei Lincei in Rome in 1991 (Rome, 1992; cf. Cook, 1993).

Although I was unfortunately unable to attend that conference in person, I did contribute a paper, in which I discussed four topics: the London antiquities market (in particular the legality of its operation under UK laws), the acquisitions policy of the British Museum, the Treasure Trove system, and the regulations then in force in Britain on the export of works of art (Cook, 1992). I agree of course with Peter Addyman that 'reform of the law of Treasure Trove is long overdue' (see Addyman in this volume), but the point I wanted to make in that forum was that even in its present form it does encourage finders of objects in precious metals to declare them to the authorities. The system works not simply because it is backed up by legal sanctions for non-compliance, but because in practice it can be seen to work by providing adequate rewards promptly and fairly. The contrast with the Italian system was not lost on our Italian colleagues.

In discussing the procedure for granting or withholding export licences under the so-called 'Waverley system' I described the purpose of the system as 'to control the export of objects of major importance, such as would be listed under Article 5 (b) of the 1970 UNESCO Convention, while at the same time facilitating both the operation of the art market in objects that are not of national importance and the work of the Civil Servants whose duty it is to make sure that the system works according to the law' (Cook, 1992: 20-1). I still think that is a fair and accurate description. What is clear is that the system was never intended to inhibit the market in objects clandestinely excavated abroad.

Equally, it was not intended, and should not have been used, to give a spurious appearance of respectability to objects that had originated elsewhere and had merely passed through the London market. This misuse of the Waverley system was roundly condemned by the Reviewing Committee on the Export of Works of Art: 'There have been cases where licences have been applied for the export of objects (mostly antiquities) which have probably not been within the UK for 50 years and which may, quite possibly, have been illegally exported from their country of origin. UK

export licences are then unjustifiably used as evidence that the objects in question were legitimately on the market in the first place. This practice is, of course, wholly unacceptable' (Reviewing Committee, 1992: 4).

Actual evidence of specific cases is hard to come by because of the secretive nature of the trade. The only authenticated instance I can quote is the reference to a British export licence in the background paper that, after an outcry in the press, the J Paul Getty Museum in Malibu issued on the purchase of an unprovenanced statue of Aphrodite that, as mentioned by Geraldine Norman in her paper in this volume, has been alleged to have been found in Sicily (Getty, 1988). This background paper, which was described by Professor Albert Elsen as a 'smokescreen' (Elsen, 1992: 130), did not include evidence of legal export from the country of origin, as theoretically required by the Getty acquisition policy (Walsh, 1992: 133). Instead it relied on an admission by the Italian Ministero per i Beni Culturali that they had no information on the history or provenance of the statue (Getty, 1988: 3). You do not need to have a doctorate in logic to see the flaw in the Getty argument: there was no possibility of the Italian Ministry having information, since, as Etienne Clément has explained (see Clément in this volume), in a clandestine market all evidence on the provenance of objects is deliberately suppressed. This ingenious, or rather disingenuous, stratagem seems to have been invented at The Metropolitan Museum of Art in the 1970s. As the Metropolitan's Director remarked to the dealer who supplied the Euphronios *krater*, 'We've been getting some flak from UNESCO on smuggled art, and I've introduced a new procedure. The curator must verify in writing the provenance of any ancient piece. If nothing is known, then we send photos and detailed information about the piece to all countries where it could have been found. We ask the appropriate officials if it's okay' (Hoving, 1993: 316).

I know from experience that, as suspected by the Reviewing Committee, there have been many instances when applicants for export licences incorrectly stated that the object had not been imported within fifty years. When challenged, some of them would back down, others would simply reply that the object had changed hands so often in the trade that it no longer had any documentation on its original import. I cannot, of course, quote individual cases, because I am still bound by the rules of confidentiality: you will just have to take my word for it that this happened often enough for me to devise a form letter to deal with it. Whether behind it there were motives more sinister than mere laziness by the dealers I have no means of checking, but I suspect that if some of them were to face the American courts they would find it hard to demonstrate that they had made the enquiries on provenance required of a commercially reasonable purchaser.

One case I can quote because it was made public, and, indeed, was the immediate cause of a development of official practice. It concerned an Etruscan helmet that I had to refer to the Reviewing Committee because it was evidently of high quality and because on enquiry the auctioneer

insisted that it had been consigned for sale from within the United Kingdom (Christie's, 1989, no. 518). Evidence was eventually forthcoming that it had been smuggled out of Spain quite recently, and a licence to re-export could not therefore be withheld. The Reviewing Committee was understandably displeased: 'We cannot allow our procedures to be used as a camouflage to give a spurious provenance to smuggled objects. In future, therefore, when the Expert Adviser has strong doubts as to the date at which an object has been brought into this country, we shall recommend that a licence should be granted even if the object is of Waverley standard' (Reviewing Committee, 1990: 10).

In theory the passage of smuggled antiquities through the London market should not be a common occurrence, since a Code of Practice for the fine art and antiquities trade was signed on 1 April 1984 by representatives of the Society of London Art Dealers, the British Antique Dealers' Association, by Christie's and by Sotheby's. According to Article 2, 'Members of the UK fine art and antiquities trade undertake, to the best of their ability, not to import, export or transfer the ownership of such objects where they have reasonable cause to believe:

a) The seller has not established good title to the object under the laws of the UK that is, whether it has been stolen or otherwise illicitly handled or acquired.

b) That an imported object has been acquired in or exported from its country of export in violation of that country's laws.

c) That an imported object was acquired dishonestly or illegally from an official excavation site or originated from an illegal, clandestine or otherwise unofficial site.'

There are two points to notice in particular. First, that the code takes note not of the country of origin but of the country of export: so antiquities smuggled out of, say, Turkey and later legally exported from, say, Germany are legitimate, according to the code of practice. This situation was explored in a television programme by Roger Cook, in which Sotheby's declined an opportunity to comment. Second, that experience of the application of the code suggests that 'reasonable cause to believe' means 'on production of documentary proof'. I have discussed this point in detail elsewhere, and do not need to enlarge on it here (Cook, 1991: 534). The antiquities market evidently does not subscribe to Boardman's dictum that every object is guilty unless proved innocent. It should perhaps be noted that the art market's code of practice was signed on All Fools' Day.

At the meeting of the Advisory Council on the Export of Works of Art in 1992, which includes representatives of the trade as well as the Expert Advisers, I took the opportunity to raise the question of the flow of unprovenanced antiquities through the London market in spite of the code

of practice. What I had to say horrified some members of the trade, and I was urged to write to the Chairman of the British Art Market Standing Committee, Judge Stephen Tumim, better known as HM Chief Inspector of Prisons for England and Wales. The Committee's reaction to my letter was that it was very interesting, that the wording of the code might be reconsidered, but that action would be postponed in case the situation changed as a result of the new EC Regulation, which was at that time under discussion.

Mention of the EC Regulation brings me almost to the end of my curator's view of the antiquities market. At one time I thought that the Draft Regulation might actually have some effect on the traffic in antiquities. Under the old Waverley system for granting export licences from the United Kingdom there were a series of levels of value below which licences could be granted without reference to the Expert Adviser or the Reviewing Committee, but for antiquities found in Britain the level was zero: all applications had to be submitted to the relevant Expert Adviser. Under the Draft EC Regulation this zero limit was to apply to antiquities from all member states. Perhaps I need hardly say that the proposed zero limit came under strong attack, especially from the trade, when the matter was debated in the House of Lords in November 1992. The attack was based on two reasons supported by an excuse. The reasons were that it would have been bad for the London art market and that it would have made too much work for the Civil Service; the excuse was that the countries of origin fail to enforce their own laws.

Lord Carrington, who declared his interest as Chairman of Christie's, was quite specific on the last point: 'We in this country, whether we be dealers or auctioneers, should not be asked to share the burden of policing different rules which different countries have for preserving their own heritage. Why should they lump it upon us if they have much stricter rules, as the Italians and the Spanish will? They should have the onus of policing their own regulations' (Carrington, 1992: 1394). It seems hard to reconcile that uncompromising position with Article 2 (b) of the Code of Practice to which Christie's are a signatory. The Earl of Gowrie, formerly Chairman of Sotheby's, also complained about antiquities legislation in other countries: 'Unable to police the legislation themselves, our partners would like the art trade in the Community, where London predominates, to act as customs, civil servants, tax gatherers and police in respect of rules which few of their own nationals are inclined to obey' (Gowrie, 1992: 1396).

Worries about the effect on the art market were expressed by Baroness Elles, Lord Strabolgi, Baroness Robson of Kiddington and Baroness Hilton of Eggardon; comments on the administrative burden were made by Baroness Elles and Lord Hacking; both issues were taken up on behalf of the Government by Viscount Astor.

In this company, Lord Renfrew of Kaimsthorn was a lone voice crying in the wilderness. He pointed out breaches in 'the code of practice nominally followed by the London dealers and auction houses' (Renfrew, 1992: 1406), brought forward a suggestion from the Lincei conference that a distinction

should be made between antiquities 'where context is of paramount importance' and works of art like paintings, and denied that strict rules on the export of antiquities were desired exclusively by the countries of origin: 'They are much desired by many in this country who value the world's archaeological heritage in terms other than the commercial, and they are necessary to reduce the large trade in looted antiquities and, more particularly, to reduce the level of looting, which is by far the largest current threat to our world's historic heritage today. One hopes that the London art market will maintain its primacy but, in my view, in order to do so it would do well to look again at its legitimacy' (Renfrew, 1992: 1408).

To be fair, the Earl of Gowrie's point that the countries of origin have 'rules which few of their own nationals are inclined to obey' is a valid one. It has to be admitted that clandestine excavation is the prerogative of nationals of the countries of origin, even though greater profits may be made by foreign dealers. Indeed, it has been noted earlier that their governments sometimes seem to be more interested in having antiquities within their own borders than in protecting the archaeological context.

Carolyn Morrison presents the official position since the new Regulation came into force on 1 January 1993 (see Morrison in this volume). My understanding is that the zero limit survives in theory, but that the United Kingdom has taken advantage of a provision in Article 2 (2) of the Regulation to make it ineffective in practice for antiquities from other countries of origin if they are judged to be 'of limited archaeological or scientific interest' (DNH, 1993). Indeed Felicity Nicholson of Sotheby's has said of the new EC Regulation: 'It doesn't seem to have affected us at all, and I don't foresee a problem' (Theodorou, 1993). (It should perhaps be pointed out that the Department of National Heritage has by definition no responsibility for the International heritage.)

More disturbing is a report in *The Times* that Professor Engin Özgen, General Director of Turkish Museums and Monuments, has announced an agreement with Sotheby's under which they will 'consult Turkey in advance of offering for sale any Anatolian objects' (Finkel, 1993). This it seems will give Turkey the opportunity to claim anything considered of national importance, and will no doubt legitimise the sale of the rest, in that respect resembling the Waverley system. It seems that Sotheby's will have carte blanche with minor antiquities provided that they do not sell things like the silver hoard recently surrendered to Turkey by The Metropolitan Museum of Art (see Kaye in this volume cf. Montebello 1993). It is sadly reminiscent of the deal that Sotheby's did with the Greek Government over the Erlenmeyer collection (Gill and Chippindale, 1993: 607). This sort of thing, although it may satisfy the cultural nationalism of the countries in question, will do nothing to help protect the archaeological context. We need a new paradigm for collectors and a new paradigm for the trade. Without them, my own prognostications for the future of the archaeological context are extremely gloomy.

References

Berlin 1990. Kunstexport, Neuerwerbungen, Leihgaben. In *Akten des XIII. Internationalen Kongresses für Klassische Archäologie Berlin 1988*, 642-3. Mainz: Zabern.

Carrington, Lord, 1992. Speech in the House of Lords, 3 November. *Hansard* 539, No. 52: 1394.

Catling, H. W., 1981. Archaeology in Greece, 1980-81. *Archaeological Reports for 1980-81*: 3-48.

Checkland, S. J., 1993. The forbidden treasure. *The Times*, (London) Saturday August 14: 2.

Christie's 1989. *Sale Catalogue (Fine Antiquities) 6 June 1989*. London: Christie's.

Cook, B. F., 1991 The Archaeologist and the Art Market: policies and practice. *Antiquity* 65: 533-7

Cook, B. F., 1992. The Transfer of Cultural Property: British Perspectives. See Rome 1992: 15-23.

Cook, B. F., 1993. Conference Report, Eredità Contestata? *International Journal of Cultural Property* 2: 189-95.

Cook, B. F., 1994. British Museum, Department of Greek and Roman Antiquities, Acquisitions 1980-92. *Journal of Hellenic Studies* 114: 243-7.

Cook, .R., 'Raiders of the Lost Art.' *Cook Report*. Central Independent Television 1991.

DNH 1993. *Guidance to Exporters of Antiquities*, 3 March 1993. London: Department of National Heritage.

Elia, R. J., 1993. A Review of Colin Renfrew, 'The Cycladic Spirit'. *Archaeology* 46/1: 64-9.

Elia, Ri. J., 1993b. *Archaeology* 46/3: 17.

Elsen, A.,1992. An Outrageous Anomaly, reprinted from 'ARTnews' in *International Journal of Cultural Property* 1: 129-31.

Finkel, A.,1993. *Times* (London)13 November: 14.

Getty 1988. *Background Paper on the Museum's Acquisitions Policy and the Aphrodite, September 30, 1988*. Malibu: J. Paul Getty Museum.

Gill, D. W. J. and Chippindale, C., 1993. Material and Intellectual Consequences of the Esteem for Cycladic Figures. *American Journal of Archaeology* 97: 601-59.

Gowrie, Earl o,f 1992. Speech in the House of Lords, 3 November. *Hansard* 539, No. 52: 1395-7.

Heilmeyer, W. D., 1988. Kunstexport, Neuerwerbungen, Leihgaben. *Jahrbuch Preußischer Kulturbesitz* 25: 117-24.

Hoving, T., 1993. *Making the Mummies Dance: Inside The Metropolitan Museum of Art.* New York: Simon and Schuster

Moncrieff, E., 1993. Leaving Footprints. *Royal Academy Magazine* 41 (Winter 1993) 40-3.

Montebello, P. de, 1993. (quoted) *Archaeology* 46: 20.

Renfrew of Kaimsthorn, Lord, 1992. Speech in the House of Lords, 3 November. *Hansard* 539, No. 52: 1404-8.

Renfrew, C., 1993. Collectors are the real looters. *Archaeology* 46: 16-7.

Reviewing Committee, 1990. *Export of Works of Art 1989-90. Thirty-Sixth Report of the Reviewing Committee.* London: HMSO.

Reviewing Committee, 1992. *Export of Works of Art 1991-92. Thirty-Eighth Report of the Reviewing Committee.* London: HMSO.

Rome, 1992. *Convegno Internazionale sul tema: Eredità Contestata? Nuove prospettive per la tutela del patrimonio archeologico e del territorio (Roma, 29-30 aprile 1991). Atti dei Convegni Lincei* 93.

Theodorou, J., 1991. Who Owns the Past? *Minerva* 2/4 (July/August 1991) 33.

Theodorou, J., 1993. New EC Rules on Cultural Objects. *Minerva* 4/5 (September/October 1993) 20.

Walsh, J., 1992. Nothing to Hide. Reprinted from *ARTnews* in *International Journal of Cultural Property* 1: 131-5.

Watson, P., 1985a. Sotheby's sells 'smuggled art'. *Observer* (London) 1 December: 3.

Watson, P.,1985b. Sotheby's 'blind eye' on vases. *Observer* (London) 8 December.

Weil, S. E., 1990. Rethinking the Museum. *Museum News* 69/2 (March/April 1990): 56-61.

Portable antiquities legislation in Scotland:

what is it, and how well does it work?

Alison Sheridan

Introduction

To judge from the current publicity surrounding Lord Perth's New Treasure Bill, it seems to be a poorly-known fact that the law in Scotland relating to portable antiquities is, in key respects, significantly different from that obtaining in England and Wales. That this ignorance of, and confusion about, the law in Scotland is nothing new is clear from previous commentaries on Scottish Treasure Trove (eg Rhind, 1858; Stevenson, 1969). Since one of the key themes to emerge from the *Conservation and the Antiquities Trade* conference was the question of the efficacy of rigorous portable antiquities legislation, the Scottish experience would seem to offer a useful test case. This paper presents a summary description of the legal provision for Scottish portable antiquities and the procedures for applying the law. It then offers a critical assessment of how well the system works, based on the author's experience as a Secretariat member for the Scottish Treasure Trove Advisory Panel and involvement with recent maritime casework.

The law and its application

Scottish portable antiquities[1] are covered by several laws and regulations. Some of these deal specifically with the question of their ownership; some focus on the findspots, and regulate removal of artefacts therefrom; some are concerned with their export, and with the return of illegally-exported items; and some relate exclusively to maritime finds. Many of these laws and regulations are of UK-wide application, and can be dealt with swiftly below; the law relating to ownership will, however, be described in more detail as it is peculiar to Scotland.

Restrictions on the removal of objects from specific findspots
The UK-wide 1979 Ancient Monuments and Archaeological Areas Act prohibits the unlicensed disturbance of ground, or use of metal detectors,

within Scheduled Ancient Monuments. The Secretary of State for Scotland is charged with enforcing this law in Scotland, and its day-to-day administration is carried out by Historic Scotland (Breeze, 1993). So far, there have been two successful prosecutions of metal detectorists under this law: in both cases, the individuals were caught at night-time, on a Roman fort in the Borders, by a river bailiff patrolling the Tweed for poachers!

Other landowners in Scotland have imposed restrictions on the use of metal detectors: the National Trust for Scotland and some Regional and District Councils, for instance, have a blanket ban, whilst the Forestry Commission operates a licensing system. Many smaller landowners also discourage their use, although they have difficulty in denying users access to their land, owing to the nature of Scots law with regard to trespass.

Export and return of objects
The export of Scottish antiquities from the UK is covered by the current UK-wide system, administered by the Department of National Heritage, which stipulates that objects which fulfil the Waverley criteria require licences for their exportation. Similarly, the issue of the return of illegally-exported Scottish cultural objects falls within UK-wide concerns: the Return of Cultural Objects Regulations 1994, recently debated in both Houses of Parliament (*Hansard* 14 and 24 February 1994), represents the Government's most recent response to the Draft EC Regulation and Directive on Cultural Goods.

Maritime legislation
Maritime finds are covered by a complex and overlapping set of laws, and it is not intended to discuss them or their operation in detail here. Some of these laws are exclusively maritime in their ambit, whilst others are principally terrestrial but extend incidentally to cover some shoreline and undersea finds (see McGrail, 1989 for a definition of 'maritime'). The chief maritime laws are the 1894 Merchant Shipping Act, the 1973 Protection of Wrecks Act and the 1986 Protection of Military Remains Act. All apply UK-wide; more information can be found in 'A Guide to Wreck Law', issued by the Department of National Heritage and the Receiver of Wreck in 1993. The relevant terrestrial legislation comprises the aforementioned 1979 Ancient Monuments and Archaeological Areas Act (which extends to fixed structures below the mean High Water Level and to vessels) and, in Scotland, the Treasure Trove/*bona vacantia* provisions (under which the Crown can directly claim objects found between Mean High and Low Water Levels and in harbour waters).

Just as the law is complex, so also is its administration. Responsibility for the 1894 Merchant Shipping Act rests with the Receiver of Wreck (RoW), who operates under the aegis of the Department of Transport and is based in Southampton. Responsibility for administering the 1973 Protection of Wrecks Act in Scotland lies with the Secretary of State for Scotland; on his instructions Historic Scotland designate sites in Scottish waters and

the Royal Commission on the Ancient and Historical Monuments of Scotland maintain an up-to-date database. Responsibility for the Protection of Military Remains Act 1986 rests with the Ministry of Defence, while administration of the aforementioned 'terrestrial' legislation is undertaken by Historic Scotland and the Crown Office respectively. Monitoring of maritime sites and diving activities is undertaken for the Department of National Heritage by the Archaeological Diving Unit.

In practice, most maritime finds fall within the RoW's responsibility, and must be reported to her. If they remain unclaimed by their owner for a year and a day, the RoW sells them and the finder usually receives a salvage award. The RoW ensures that the interests of Scottish archaeology are served, by offering first refusal to those museums eligible to receive terrestrial finds (see below).

Ownership of finds

Although the term 'Treasure Trove' is used loosely to describe the main Scots law relating to portable antiquities (and will be used in this manner henceforth, unless specified otherwise), in fact two ancient common law rights of the Crown are involved: the right to Treasure Trove in its strict sense, and the right to *bona vacantia* (ownerless property). Both form part of those royal privileges which are termed *regalia minora* (lesser, and alienable, royal rights); the latter is of very broad application, and encompasses the former. (For a detailed introduction to the law, see Turnbull 1989.) Although other legal provisions and regulations relating to found objects do exist (eg those regarding Lost Property), the Treasure Trove provisions overrule all others where ownerless objects are concerned.

Definition

Treasure Trove, in its narrow Scots sense, relates to precious objects which had been concealed under the ground or in a building or some other place. As the famous court case surrounding the Pictish hoard from St Ninian's Isle, Shetland, demonstrated in 1963 (ibid., 96-7; Small *et al*, 1973), the definition of both 'precious' and 'concealed' differs from that which obtains in English and Welsh Treasure Trove law. Whereas in the latter, only objects made of gold, silver and alloys of these metals above a certain purity count as 'Treasure', in Scotland the term has been interpreted to cover other materials – extending even, in the St Ninian's Isle case, to an unworked porpoise bone found with the metalwork. Similarly, in defining 'concealed', Scots law does not concern itself with whether the owner deposited the material with the intention of recovering it.

The right to *bona vacantia* extends the Crown's right yet further beyond that obtaining in England and Wales, since it covers *all* artefacts whose owner or rightful heir cannot be identified, under the Civil Law doctrine *quod nullius est sit domini regis* ('that which is the property of no one, belongs to the Crown'). Thus, Scots law covers all ownerless objects irrespective of their raw material or circumstances of deposition. Other

points to note are: i) Scots Treasure Trove law appears to have no statute of limitations: in other words, there is theoretically no time limit within which the Crown can exercise its rights; ii) until and unless the Crown chooses to give up its right to an ownerless item, it is illegal to sell or buy it, and similarly it cannot be donated, since it does not belong to the 'donor'; and iii) where an ownerless object is found, the owner of the land has no claim to that item, or to any monetary reward which may be paid to the finder. These points will be returned to later, when the efficacy of the law's operation is discussed.

Operation

The procedure by which this law currently operates is as follows. Finders are obliged, not only by the Treasure Trove law but also by the Civic Government (Scotland) Act 1982, section 67, to report finds. The 1982 Act stipulates that a find be reported to 'the police or owner of the property or person having right to possession of it'; since ownerless objects belong to the Crown, the 'person having right to possession of it' is the Queen's and Lord Treasurer's Remembrancer (henceforth Q<R—the Crown Office agent responsible for Treasure Trove). In practice, notification of finds reaches the Q<R via a variety of routes: a finder may report to the police, the local Procurator Fiscal (the local representative of the Crown Office), the National Museums of Scotland, local museums, Regional and Islands Archaeologists, or directly to the Crown Office. (Other individuals and institutions have, in the past, also acted as conduits.) All agents intermediate between the finder and the Q<R are obliged to pass on the information. The requirement to report finds applies equally to those engaged in formal archaeological excavation, as to individuals who find objects by chance or by fieldwalking or metal detecting. The Q<R has the power to instruct Procurators Fiscal to send the Police to search premises, if the deliberate non-reporting of finds is suspected.

The Q<R decides whether the Crown's rights are to be exercised, and if material is claimed, then decides the level of the reward (if one is to be paid) and the recipient museum or museum service. Only those institutions on the Scottish Museums Council's Approved List, and the National Museums of Scotland, are eligible to receive material: this ensures that certain standards for the curation, display, storage and conservation of the finds are met.

In this work, the Q<R is advised by the Treasure Trove Advisory Panel (TTAP), which comprises the following: a Chair, acting as the Q<R's Assessor; two representatives of Scottish local museums; and a representative of the National Museums of Scotland. Responsibility for appointing TTAP members has recently passed to the Scottish Office from the Treasury, although overall responsibility for administering the law still rests with the Q<R. Casework preparation is handled by the TTAP Secretariat, based in the Archaeology Department of the National Museums of Scotland. A special arrangement exists to deal with excavation

The Situation in the UK

assemblages wholly or partly funded by Historic Scotland, and with finds from approved works on Scheduled Ancient Monuments: if the Crown does not wish to assert its rights, ownership is passed to the Secretary of State for Scotland, and the disposal of finds to eligible museums or museum services is arranged through the Finds Disposal Panel (Historic Scotland 1994).

Payment of a reward to the finder is discretionary. No payment is made if: i) the finder has broken the law in obtaining, or deliberately avoiding reporting of, the material; ii) the finder is a paid or otherwise contracted member of an archaeological team. (The latter condition applies automatically to publicly-funded excavations and is beginning to be acknowledged formally in the contracts relating to privately-related excavations; the situation regarding other excavations, eg those by local societies, is less clear-cut but the assumption is that the Crown would not be inclined to offer a reward.) Where a reward is paid, this is usually set at the full market value of the material. Under new procedures introduced in March 1994, finders are invited to submit any evidence which they feel is relevant to the establishment of the item's full market value (eg recent sales figures for comparable material).

History

Payment of a reward, and disposal of finds to the public domain, have been features of the operation of Scots Treasure Trove law for well over a century. Although the Crown's rights to Treasure Trove and *bona vacantia* date back many centuries, and were originally exercised as a way of enriching the royal coffers, it is clear that from as early as 1808 they were used to the benefit of Scottish archaeology (Stevenson 1969): in this year, over 100 base metal coins were disposed to the museum of the Society of Antiquaries of Scotland (SAS) in Edinburgh.

The intention to safeguard Scotland's portable antiquities for the benefit of the public was explicitly stated in a circular sent by the Q<R in 1846 to the Procurators Fiscal, urging them to ensure that the Crown's rights were being exercised. This arose from the concern that 'very frequently articles of Treasure Trove are... not accounted for to Her Majesty, whereby many rare and valuable objects of antiquity are lost... to the use of the public generally, being locked up in private museums and collections, instead of being... presented...to public institutions' (quoted in Stevenson 1969: 26). The loss of important antiquities – not just to private collections, but also to the melting-pot – had been evident from cases such as that of the hoard of Pictish silverwork from Norrie's Law, Fife (Graham-Campbell, 1991). Found around 1819, and with an estimated original weight of 400 ounces, the hoard was almost entirely sold off and melted down before its archaeological significance had been realised; all that survives today is the 24 ounces' worth of artefacts retrieved from a formal search in 1822. In publishing the donation of the latter to the National collections, it was noted 'The precise facts connected with this remarkable

discovery were never ascertained, owing to the apprehension of the interference of the Scottish Exchequer to reclaim the "treasure trove"' (*Proceedings of the Society of Antiquaries of Scotland* 6 (1864-6): 7).

At the time of the Q<R's circular, however, no reward was offered to finders. Concerned at the continuing loss and dispersal of finds, and keen to enhance the growth of a national collection of Scottish antiquities (aided by the imminent conversion of the SAS museum to the Government-run National Museum of Antiquities of Scotland, NMAS), Henry Rhind campaigned for the introduction of a reward system in his 1858 publication, *The Law of Treasure-Trove: How Can It Be Best Adapted to Subserve the Interests of Archaeology?* In this document—published, incidentally, at a time when a Private Members Bill by Lord Malahide was proposing to amend English and Irish Treasure Trove law!—Rhind pointed to the successes of the Danish system, where rewards were paid and great efforts made to protect the nation's archaeological heritage. Rhind's reward recommendation was accepted, and in January 1859 the Q<R sent out 10,000 copies of a circular notifying the public that the 'full intrinsic value' of finds would be paid.

Although even this move was not enough to remove some finders' deep-seated suspicion of Crown agents, the decades following the publication of this circular nevertheless saw the addition of many significant finds to the national collections - not least the major Viking silverwork hoard from Skaill, Orkney, whose delivery to the Q<R after its dispersal among the local community was effected through the 'prompt and zealous exertions of Mr. George Petrie' (Anderson, 1874, quoted in Graham-Campbell, 1984).

The way in which the law has been applied over the last 50 years has recently been summed up elegantly by Lord Stewartby, during the Second Reading of Lord Perth's New Treasure Bill (*Hansard*, 9 March 1994: 1495). Recalling a conversation with the late Robert Stevenson, former Keeper of the NMAS, during which he had asked how the Scottish law worked in relation to the large range of objects to which it could potentially be applied, he reported 'in Scotland they took a pragmatic view about the implementation of the law. [Stevenson] thought that it did not really matter whether they tacitly waived rights over a whole range of objects so long as they had the ability to apply the law to those objects which... were of historical, archaeological or cultural importance.' This will be returned to below.

How well does the Scottish portable antiquities system work?

It is clear, from the above, that the network of laws and regulations pertaining to Scottish portable antiquities offers a level of legal protection far superior to that applying south of the Border. Furthermore, those responsible for administering the law have traditionally shown a commitment to the principle of preserving Scotland's material culture heritage for the benefit of all. What, then, are the 'performance indicators' by which the

success of the system can be judged?

One obvious index is the amount, range and quality of the portable antiquities which reach the attention of those charged to deal with them. Whilst we may never know what proportion of all Scottish finds are represented, it is clear that a significant number of finds of archaeologically important material are indeed being reported. Over a hundred Treasure Trove cases, and five Receiver of Wreck cases, have been handled over the past two years, and material disposed to public collections in recent years has included items as diverse as the following:

- a Civil War hoard of nearly 1400 gold and silver coins; a Late Roman hoard of nearly 300 denarii
- a Middle Bronze Age gold bar torc from the sea bed
- an Anglo-Saxon gold and garnet stud, reused in antiquity
- a 13th century Limoges enamelled copper alloy crucifix mount
- grave goods from several Early Bronze Age and Viking graves
- an Early Historic painted pebble
- a Neolithic flint knife, almost certainly imported from Yorkshire
- decorated bone mounts from a Late Roman or Early Historic artefact; a decorated Norse whalebone disc
- a 6000-year old yew flatbow - the oldest bow in Britain and Ireland
- a composite organic object, dating to c. 1500 BC, possibly a boot lining, consisting of a mat of cattle hair with twisted woollen cords and plaited horsehair cords attaching.

A similarly varied selection of artefacts – albeit with fewer organic objects – is to be found in Christison *et al*'s 1892 pamphlet, *Report on the Operation of the Law of Treasure Trove*, which lists cases between 1808 and 1882.

Another obvious indicator is that of successful prosecutions and similar enforcements of the law. Whereas there have been no recent prosecutions for failure to report finds (in contrast to one 19th century case, where a finder was imprisoned for six months!), the two successful prosecutions of metal detectorist 'nighthawks' under the 1979 Ancient Monuments and Archaeological Areas Act did provide useful publicity for the law, and arguably helped to deter some from illicit activities. Furthermore, the recent successful attempts to persuade Christie's New York and Sotheby's London to withdraw from sale two Scottish carved stone balls which had not been cleared through Treasure Trove have served to remind dealers and collectors of the existence of robust Scottish portable antiquities laws.

Despite such successes, it is clear that the current system is far from perfect. Whilst some of the problems identified by this author in an earlier paper (such as the slowness of the Treasure Trove system; Sheridan, 1989) have been ameliorated, the key issues remain, and are worth restating here, as follows.

Ignorance of, and confusion about, the law

Whilst a recent Historic Scotland leaflet campaign has served to raise public awareness of some of Scotland's portable antiquities laws, ignorance of and/or confusion about Treasure Trove remains widespread. Not only do those outside Scotland and the majority of the Scottish public seem unaware of the law; so, also, do many of those who should know – including some collectors, dealers, local museum curators, excavators, landowners and even solicitors! This problem can, however, be addressed by a major and sustained PR campaign, and moves are afoot to raise awareness in this way (eg by producing new leaflets, exploiting mass media opportunities, arranging closer liaison with metal detectorists, etc.).

Suspicion of the authorities, and wilful breaking of the law

This remains a perennial problem. Although the deliberate destruction of antiquities (as witnessed during the 19th century) no longer occurs, the keeping of finds, or their sale to private collectors and dealers, undoubtedly continues. The principal reasons for this are: i) finders do not trust the authorities to pay what they consider to be the full market value of a find; and ii) finders may be loath to part with 'their' finds–particularly if, as sometimes happens, the objects end up in Edinburgh, far from their findspots. Unfortunately, media coverage often perpetuates these beliefs (eg by hyping the value of finds, or encouraging local *versus* Edinburgh sentiments).

The extent of this loss is hard to assess. Whilst it is true that the level of metal detecting and collecting in Scotland is far lower than in much of England, and that large areas of Scotland are probably very artefact-poor, the looting of specific sites in well-known 'hot spot' areas (for instance, the Borders) is known to have occurred. The recent attempted sale of a major Roman find to an English collector—prevented only by the swift intervention of a local amateur archaeologist—demonstrates the willingness of some collectors to defy Scots law, and the interest generated by Christie's above-mentioned proposed sale of a carved stone ball underlines the fact that interest in Scottish antiquities extends far and wide. The deliberate obfuscation of findspots by some of those involved in the antiquities trade is also a possibility, as suggested by advertisements of Roman artefacts in some dealers' catalogues as 'property of a gentleman: from the north of Britain'. (It is generally impossible to tell between a Roman find from Hadrian's wall and one from the Antonine Wall or elsewhere in Scotland.)

Whilst such activities will probably never be eradicated, moves are afoot to change opinions about the trustworthiness of the Treasure Trove system by making it more open and accountable. Further test-case prosecutions would also serve to underline the seriousness with which the law is regarded.

The Situation in the UK

Disposal disputes

These currently take two forms: disputes between local museums and the (now-named) National Museums of Scotland, and latterly also disputes between local museums or museum services with overlapping collecting areas.

Until the 1970s, virtually all material claimed as Treasure Trove was disposed to the (then-named) NMAS, along with many other finds which were simply 'donated'. The principal reason for this centralisation of Scotland's portable antiquity archive was the fact that the NMAS was the only museum with the financial wherewithal to afford the nationally-important objects claimed as Treasure Trove. Although numerous local museums had been established during the 19th and early 20th centuries, and indeed had received many 'donations', they were at a financial disadvantage. Local museums also generally suffered a poor reputation: early reports criticised them for 'neglect to label or catalogue the objects...lack of general care... the actual removal of objects, or the breaking up of the collections' (Christison *et al*, 1892; cf Anderson, 1888), and the problem of the dispersal of collections persisted well into the 20th century (Miles, 1986).

With the establishment of the Council for Museums and Galleries in Scotland (now Scottish Museums Council, SMC) in 1964, and the eventual emergence of a list of institutions approved by SMC to receive finds from government-funded excavations, pressure mounted to dispose Treasure Trove material to local museums and museum services. Over the last decade, some 60-70% of all Treasure Trove material has been so disposed. However, the NMS have not ceased to collect altogether, and the inevitable competition for certain objects often leads to acrimony. Regrettably, space does not permit a fuller account of the debate on local *versus* national claims over Scotland's archaeological heritage: suffice it to say, however, that the issues involved echo the wider political debate over nationalism *versus* regionalism.

The recent emergence of disputes between local museum authorities with overlapping collection areas is a by-product of the proliferation of SMC-approved institutions: as with the local *versus* national museums debate, the legitimacy of the various claims, and the impartiality of the Treasure Trove system, is usually challenged. However, attempts to overcome this problem are underway in parts of Scotland: the Highlands and Islands Museums Forum is currently preparing a policy document aimed at harmonising arrangements for bidding for and displaying finds.

Inconsistency of operation

The pragmatic approach to applying Scots Treasure Trove law which Lord Stewartby praised has had its disadvantages, which recent developments have served to exacerbate. A diffidence about exercising the Crown's rights to ownership of antiquities in private collections has created some difficulties, particularly where their subsequent sale on the open market has taken

place. Furthermore, the universal and traditional (albeit illegal) museum practice of accepting 'donations' has had the negative effects of: i) creating confusion over title to objects, ii) perpetuating the 'local *versus* national museum' dispute, iii) undermining the SMC's attempts to establish a proper local museum service, operating to professional standards (ie with access to proper curatorial and conservation expertise on finds identification, documentation, storage, curation and display), and iv) denying those finders who are ignorant of the law their rightful entitlement to a reward – a move which undermines the Crown Office's attempts to operate a fair and open system.

Resolution of these complex problems will be difficult. Experience outside Scotland suggests that some continuing degree of pragmatism would be of greater long-term benefit to Scottish archaeology than an absolutist application of the law; but much needs to be done to agree on the nature and extent of this pragmatism. That the Crown agents have been capable, and willing, to press home the Crown's ownership of finds in the past was demonstrated by two 'test cases' in 1833 and 1864, when objects which had been acquired by the SAS museum by purchase or 'donation' were removed, in one case permanently (Christison *et al*, 1892).

Resourcing problems
Shortage of resources is a perennial, serious and near-universal problem, which hinders the efficient working of any portable antiquities legislation system by creating difficulties with its policing, enforcing and application. Typical examples of such difficulties in Scotland are:

- Historic Scotland's limited ability to monitor illicit activities on Scheduled Ancient Monuments; the Archaeological Diving Unit's limited ability to monitor maritime treasure hunting activities; and museums' limited ability to monitor the discovery of finds in general;
- the expense of undertaking legal proceedings to retrieve illicitly sold or exported items: neither the Crown Office, nor interested museums, could currently countenance undertaking a major international court case without outside assistance;
- the difficulty of administering a successful system, with a burgeoning number of cases (the current costs to the NMS alone, for Treasure Trove casework processing, amounting to many thousands of pounds);
- problems with finding reward money, particularly when the antiquities market is bullish: although the National Art Collections Fund and the Local Museums Purchase Fund are available to help museums, a case such as the recent Hoxne Roman hoard would place severe stress on the system. (In any case, the perceived superior purchasing power of the NMS continues to generate ill-will among some local museums.) Given the increasing public awareness of the financial value of antiquities (thanks to the *Antiques Road Show*), the number of finders willing to forgo a reward is dwindling.

Conclusions

A glance at Christison *et al's* report on the operation of Scots Treasure Trove law, written 103 years ago, reveals that the key problems facing Scotland's portable antiquities system remain depressingly constant. Many of these problems are extremely hard to solve, although there is room for significant progress with some.

Notwithstanding these problems, Scotland enjoys a better track record than England and Wales (and indeed many other countries) in the preservation of its portable antiquities for the good of all. Although some local museum curators in Scotland may not be heartened to know this, the National collections are amongst the most comprehensive and representative of any nation's portable archaeological archive.

This author takes issue with Geraldine Norman's protestation (see Norman in this volume) that rigorous portable antiquities laws are bad laws, made to be broken. What Ms Norman fails to realise is that the possession of rigorous laws is but one of several necessary steps. As experience in Scandinavia has shown, and as our Irish colleague Eamonn Kelly reveals in his contribution to this volume, the prerequisites for an efficient and effective portable antiquities system (designed so that the heritage can be enjoyed by all, in perpetuity) are:

- rigorous and unambiguous laws, consistently and prudently applied;
- the wherewithal to police and enforce them; and, most importantly,
- positive support for the system, both from the public (whose heritage it is) and from those responsible for its operation.

It may well be that the Scots' greater sense of national identity and pride has helped to make the system work as well as it has done; the current pressure to decentralise the portable antiquities archive does not detract from the philosophy of public stewardship of the archaeological heritage. Whether other countries will find the will and the wherewithal to develop a similar system, whilst avoiding Scotland's problems, remains to be seen.

Acknowledgements

The author is indebted to Kathy Tubb for the invitation to present and publish this paper, and to the following for their invaluable comments: David Clarke, Bill Gilchrist, Veronica Robbins, David Breeze, Noel Fojut and Richard Welander. Any errors are solely the author's.

Note

[1] Ironically, the term 'portable antiquity' has no precise legal definition in Scotland. Whilst this may lead to disagreements over the status of artefacts such as earth-fast Early Historic sculptured stones (some of which are protected as Scheduled Ancient *Monuments*), the term's vagueness allows the law to be used to maximum effect to protect Scottish antiquities.

Bibliography

Anderson, J., 1874. Notes on the relics of the Viking period of the Northmen in Scotland, illustrated by specimens in the Museum. *Proceedings of the Society of Antiquaries of Scotland* 10 (1872-4): 536-94.

Anderson, J., 1888. Reports on local museums in Scotland, obtained through Dr R.H. Gunning's Jubilee Gift to the Society. *Proceedings of the Society of Antiquaries of Scotland* 22 (1887-8): 331-422.

Breeze, D.J., 1993. Ancient Monuments legislation. In *Archaeological Resource Management in the UK: an Introduction* (eds J. Hunter and I. Ralston), 44-55. Stroud and Dover NH: Alan Sutton and Institute of Field Archaeologists.

Christison, D., Munro, R. and Anderson, J., 1892. *Report on the Operation of the Law of Treasure Trove.* Edinburgh: Society of Antiquaries of Scotland.

Graham-Campbell, J., 1984. Two Viking-age silver brooch fragments believed to be from the 1858 Skaill (Orkney) hoard. *Proceedings of the Society of Antiquaries of Scotland* 114: 289-301.

Graham-Campbell, J., 1991. Norrie's Law, Fife: on the nature and dating of the silver hoard. *Proceedings of the Society of Antiquaries of Scotland* 121: 241-60.

Historic Scotland, 1994. *A Policy Statement for the Allocation and Disposal of Artefacts.* Edinburgh: Historic Scotland.

McGrail, S., 1989. Finds from maritime sites in Britain. In *What's Mine is Yours! - Museum Collecting Policies* (ed E Southworth), 23-9. Liverpool: Society of Museum Archaeologists.

Miles, H., 1986. *Museums in Scotland: Report by a Working Party.* London: HMSO (Museums and Galleries Commission).

Rhind, A.H., 1858. *The Law of Treasure-Trove: How Can it be Best Adapted to Subserve the Interests of Archaeology?* Edinburgh: Thomas Constable & Co.

Sheridan, J.A., 1989. What's mine is Her Majesty's: the law in Scotland. In *What's Mine is Yours! - Museum Collecting Policies* (ed E Southworth), 35-40. Liverpool: Society of Museum Archaeologists.

Small, A., Thomas, C. and Wilson, D.M., 1973. *St Ninian's Isle and its Treasure.* Oxford: Oxford University Press.

Stevenson, R.B.K., 1969. 'Treasure Trove' in Scotland. *Cunobelin* 1969: 26-8.

Turnbull, A., 1989. The right of the Crown to Treasure Trove in Scotland. *Review of Scottish Culture* 5: 95-7.

United Kingdom Export Policies in Relation to Antiquities

Carolyn Morrison

Within the limitations of a short paper, it is hoped that sufficient issues can be raised to stimulate further exchange and dialogue among those interested in the trade in antiquities. To begin with then, it is certainly no business of the United Kingdom government to condone theft in any way and the Department of National Heritage is at one with archaeologists in wishing to restrict and eliminate clandestine excavation. So, if that fact is borne in mind together with the following remarks, it may become evident that the difference lies in seeking the best means of achieving the objective of site protection and the general debate needs to be seen in perspective also in relation to the private collector and dealer. The problem of illegal export is a somewhat more tricky one and will be addressed later.

The excitement of collecting seems to be a built-in human foible parallelled by jackdaws and some exotic kinds of antipodean birds. Antiquities are a specialised taste. Not everyone wants to litter their sitting room with discarded goods of other civilizations – Roman glass, ancient terracotta pots or fragments of metalwork; but, objects representing the art of the ancient world, whether from the east or the west, command high prices and the respect of connoisseurs. In finding such objects, mankind through the ages has looted graves, plundered sites and destroyed probably more than he has saved for posterity. Much of this is now locked into museums worldwide, safe one would think, but no, we are now subject to the new age traveller philosophy of some governments that there should be a day of reckoning when museum objects whirl around the world seeking their country of origin, their true home. Those that remain at large in private collections are objects tainted by the same sort of looted provenance albeit from ages long ago but they, too, one day will be legitimised by being captured for, ideally, the 'politically correct' museum collection in the country of origin.

If this scenario is to work, one is then left with objects which are the product of present day and recent clandestine excavation which would then only have a market which is underground, black as the soil from which the objects presumably were dug out. Antiquities dealers would have a clear choice, they would either have to become criminals or would need to get on their Bond Street bikes. A remark by Professor Lord Renfrew (see Renfrew

in this volume) was particularly striking. He stated that the ownership of antiquities must become as shameful as wearing fur coats. But, if one goes to the Mediterranean countries or to central and Eastern Europe, on a day which has the first whiff of the cold air of winter, what does one see? Every lady over thirty-five has rushed to the cold fur storeroom to fetch her fur coat. She would not be respectable without it. What one does not see much of are fur coats made of the fur of spotted cats and, even if one does, they will say these were handed down from a less enlightened generation. Modern furs are popular, an important commodity. Their existence does not appear to encourage trade in endangered species and, if the making of fur coats were banned, it would not stop men hunting and trapping their source, particularly where the animals need to be culled or controlled as vermin. The fur police would have a difficult job cracking the provenance of a fur coat stopped in the street, said to have come from 'my grandmother's attic,' whatever the species of fur. This analogy will not be carried any further but there are some similarities in one's thoughts in these matters when the antiquities trade is considered.

What role should the United Kingdom government play in all this? The trade in antiquities is regulated by two forms of control: domestic laws to protect known archaeological sites and objects found which could be treasure trove, and export laws to protect nationally important objects. The former have been adequately dealt with to date and will not be discussed here. Instead, the export related controls will be examined. These controls have as their basis the need for fairness and for the balancing of interests between legitimate trade, the owner and the museum and the heritage world. This is the same for antiquities as it is for all cultural objects.

The United Kingdom government approaches controls generally (controls in the broadest sense) in a pragmatic way. If it wants something from its citizens, like taxes, it will operate a system of sticks and carrots to involve the citizen in the system and to persuade him there is something in it for him if he cooperates and heavy penalties if he does not. So it is with the ownership of works of art. There are significant tax concessions to be exploited and, in return, the museum world knows the whereabouts of most important objects in private hands. Contrast this to the punitive monolithic systems in Italy, Spain and even France where concealment is everything and the temptation to smuggle to find a better market for cultural goods is ever present.

This presents the United Kingdom with a dilemma. We are asked under the EC Directive to give recognition to these unworkable controls of other member states. We are potentially asked to do the same for many more countries under the draft Unidroit Convention (see Prott in this volume). Yet the United Kingdom operates its own controls which encourage trade, and encourage the cooperation of the trade with museums in order to identity and offer important objects into the public collections. A minimally bureaucratic system with hundreds of thousands of items allowed to leave the United Kingdom under an open general export licence

is also operated. This applies to the antiquities which are not of UK origin (see Cook in this volume). This means that, under a value limit of £39,600, these goods require no form-filling, no certificates and no specific individual permissions and pieces of paper before they exit the country. So there is a built-in antipathy to any convention which would entail excessive bureaucracy however laudable the objectives of that convention. A description of the obligations the United Kingdom would be put under if the government were to ratify the 1970 UNESCO Convention is given by Etienne Clément in this volume. For a major trading country, this would be impossible to carry out and, insofar as I am aware, the United States has not got very far in doing so.

How does this broad United Kingdom approach affect the trade in antiquities? Examination of the figures for exports of antiquities which could have been Waverley standard, that is they had been in the United Kingdom more than fifty years and were considered by expert advisers such as Brian Cook and his colleagues at the British Museum to be United Kingdom national treasures, make interesting if depressing reading. It must be remembered that the licensing threshold for antiquities which are not from United Kingdom soil or territorial waters is £39,600 but that it is pounds zero for UK antiquities so every object of whatever importance or value needs a licence. In 1992-93, licences were issued for these potentially Waverley standard items; one for an Egyptian antiquity, ten for Greek and Roman antiquities, seventeen for Japanese, forty-seven for Oriental other than Japanese and three for Western Asiatic antiquities. These add up to seventy-eight licence applications. To this, one has to add many other licence applications for B2 licences where goods over those value thresholds have been imported into the UK within the last fifty years. Separate records are not kept for the number in this category but it would be considerable. Those goods which went out under the Open General Export Licence under £39,600 are also not recorded separately but clearly represent a large volume of goods. But what about UK goods? Remembering there is no monetary threshold, only twenty licence applications were made in a year.

This zero monetary threshold exists for only one other category of goods, archives and manuscripts where, until the Cultural Property Unit of the Department of National Heritage issued EC licences, a bulk licensing system was operated whereby certain dealers in antiquarian books and manuscripts were able under an open individual export licence to take out goods under £600 and make a quarterly return to the British Library detailing which of these goods they had so exported. Thus, there was a quality control, albeit after the event. The Cultural Property Unit has never had any diificulties with the dealers' judgment of what items required a licence being applied for them. It is the government's intention, incidentally, to remove this onerous obligation of individual EC licences, which applies to any manuscript or item from an archive, at the earliest opportunity in

Brussels, since it clearly is a nonsense that an individual may be required to apply for a licence for one or more of their great grandmother's postcards.

Some order, some practical reality, needs to be put into that area of the EC licensing. But, now, under the 1992 EC Regulation, there are archaeological items from any source whatsoever, including outside the European Community, also requiring a licence at zero monetary value (Cook, *op cit*). It is interesting to speculate whether the United Kingdom antiquities trade is so limited in its interest to buyers and sellers and to exporters that only twenty items were exported last year. And, if, as seems likely, this is not the case, what should be done about it? This is of concern to the United Kingdom government. Was Professor Renfrew on the right track when he said the real problem is controlling the clandestine excavation of antiquities and not whether they leave the country or not (Renfrew, *op cit*). The United Kingdom government believes so. This zero limit needs to be looked at again to see what part it plays in encouraging clandestine trade. Mao Tse-tung had a saying that a man must walk on two legs. One leg here must be the carrots of reporting finds, being free to sell them if unwanted by the museum world and encouraged to apply for export licences by a discretionary system such as already exists with non-British antiquities under the EC regulation, and the other leg for Mao Tse-tung would be the heavy punishments for being caught in violation of any of these steps.

Cook (*op cit*) has described the derogation in the European Community regulation for export as a loophole. On the contrary, this is a derogation which makes practical common sense when these items of limited archaeological and scientific importance are involved. It would be a nonsense if the Cultural Property Unit were to be swamped with licence applications for items such as Roman glassware, oil lamps, combs, any small items of metalwork and, of course, any coins, no matter how common, which had an archaeological provenance at any time in the past, when the fact that millions of them were minted in ancient times is taken into consideration. The United Kingdom had to make this the point on which there was agreement on a Regulation and Directive in Brussels or there was not. The Department of National Heritage was not trying to avoid its duties towards the archaeological community. On the contrary, this was regarded as being a means of singling out important archaeological items for which the application for a licence would be expected and for which heavy penalties would be sought in the event of an individual being caught in the act of evasion.

It is true to say that the United Kingdom would have blocked the vote on this issue, not because the trade mounted a strong lobby in the House of Lords and elsewhere, but because the trade made a case which was indisputable in its common sense; namely, that to be licensing upwards of half a million individual items would have made no sense. It would have necessitated the creation of a department on its own for the licensing of antiquities. If the United Kingdom example of these twenty licence applica-

tions at zero value limit is used, the assumption that licence applications would simply not be made, is likely. As a practical solution, a lower monetary limit of something like £10,000 for archaeological goods would have been preferable, but, this was political dynamite to the other countries, to the southern countries in particular. Archaeological goods, quite rightly, cannot be given a pure monetary value. They obviously can have a low monetary value and a high archaeological importance. Therefore, quality controls in the Regulation, subjective and imperfect as they are, had to be looked at. This led to the agreement in Article 2.2 of that Regulation to exclude items of limited archaeological or scientific importance from the need for a licence. The United Kingdom has now laid down guidelines for the interpretation of this. These guidelines, which are available from the Cultural Property Unit, were formulated in discussions between the British Museum and the antiquities trade. They attempt to establish parameters whereby responsible dealers will interpret the derogation and act accordingly.

This does not include United Kingdom archaeological items but, perhaps, it should. Would this help to encourage more licence applications if it is assumed that the volume of goods leaving the United Kingdom of archaeological provenance from the United Kingdom, is greater than that twenty? One thing is certain, the reality of pending prosecution for smuggling important objects of UK provenance does lead to a flurry of applications for licences. This has happened very recently and it is confidently expected that the statistics may look somewhat different for the next year. But equally, the department does not want to be flooded with applications for objects and coins of little importance to the UK and the profession. So it is necessary to think about the antiquities problems flexibly and to encourage an open trade which will in turn help to identify find sites and encourage reporting. Like those fur coats, the sources are constantly at hand of new objects but must not be driven into elaborate and false provenance. It is not realistic to outlaw the trade in antiquities. It is realistic to reach agreement on what really matters to society. This is at the heart of the United Kingdom government's approach to international agreements as well as to national controls.

Certainly, the scope of Unidroit is crucial (Prott, *op cit*). Those countries which see such conventions as somehow solving their problems of clandestine excavation and subsequent smuggling are placing too heavy a burden on the Convention which would make it unacceptable for a number of trading states. There is hope for a compromise, for extending mutual assistance and access in the courts, but this must be against a realistic set of objectives for the protection of important archaeological sites and individual objects. The international archaeological community has a duty to influence this politically and go beyond idealistic positions and nationalistic positions which have seldom been attainable. If the Levys and

George Ortizes of this world are discouraged from collecting the cream of the antiquities market, what would be the effect? Perhaps the prices would go down but will the punters go away? Is it not possible that a more dubious breed of punter, less concerned with the beauty, rarity and scholarship of his collection and much less inclined to share it with society, might be in danger of being encouraged? The sources of fresh objects are forever there. It is the practical help on the ground, so to speak, that will be the international community's real contribution, backed up by discriminating and workable export controls and discriminating and workable international legal instruments.

The United Kingdom never enters international obligations lightly. It takes implementation seriously. Everyone is aware of the accusation that the United Kingdom is alone of the countries in the European Community that burdens its civilian population with instruments to which other countries merely pay lip service. Therefore, the United Kingdom must assess the objectives of any convention in this field and whether the steps to be taken in implementing it are proportionate to its objectives and to the damage which could be done to other essential United Kingdom interests; namely, a flourishing and multi-million pound art trade. The government is not persuaded that UNESCO 1970 is an appropriate convention and the jury is out on Unidroit. The United Kingdom always stands ready, as was explained to the Commonwealth two weeks ago when they adopted a scheme for the protection of the material cultural heritage, to act informally and bilaterally on particular and important cases should another state make an approach. However, in signing up and ratifying international conventions, the United Kingdom is very mindful that it needs to have an equal balance, as it has with its national export controls, between the various interested parties affected by such conventions.

The Way Ahead

The Antiquities Trade:

towards a more balanced view

James Ede

Most of the papers in this volume have highlighted a number of important misconceptions about the trade in antiquities, and before discussing the International Association of Dealers in Ancient Art (IADAA) and its aims, I would like to take this opportunity to balance some of the views put forward.

Firstly, there seems to be an idea that the trade is a single entity, unified in its views and aspirations. Catherine Sease (see Sease and Thimme in this volume) referred to conservators 'aiding and abetting the antiquities trade' as though this were necessarily unethical. She should, I feel, have added the word 'illegitimate' before the word trade. Following the presentation paper on the Kanakariá mosaics at the conference on *Conservation and the Antiquities Trade* in December 1993, a delegate said to me, with a slightly malicious glint in his eye, 'This won't be very good for your trade'. This attempt to unify the whole trade has as much validity as grouping back street abortionists with the consultants at Guys Hospital, and leads me on to the second premise that all dealers are crooks. The truth is, that as with all areas of human endeavour, there is a spectrum between two extremes. Friends of mine in the academic community (of whom I am happy to say I have many) are apt to say 'Of course we don't mean you Jamie, when we refer to the trade as illegitimate', but in effect the stance that is often taken lumps all dealers and smugglers together.

All the members of our organisation have worked hard to win a reputation for reliability and integrity, and realise that our reputation is of paramount importance. Of course my gallery contains unprovenanced items (although none of major importance) but thousands of items have lost their provenance for perfectly good reasons, since trading in antiquities began in the first century, when the Romans were avid collectors of classical Greek works. One suggestion is that the burden of proof be shifted, and a piece presumed to be illicit unless otherwise proven. This is precisely the sort of approach that leads liberal governments to be suspicious of instruments such as the UNESCO treaty: how many individuals would support the concept of 'guilty until proved innocent' in any other area of law? Such an approach runs directly counter to our western legal tradition

which, as no one needs reminding, was based on the precepts of ancient Greece and Rome.

Secondly, there is a feeling that dealers and collectors are only interested in money. Of course, we all have some interest in money: there is even a shocking rumour that one day archaeologists and conservators might be paid! Any decent dealer or collector loves not only the objects, but also the study of their context. The truth of this is tacitly accepted by those who bemoan the dialogue between academic researchers and the trade. It is often the case that collectors are damned whatever they do. On the one hand, the loss of provenance is described as appalling while, at the same time, on the other, collectors like the Levys are taken to task for putting labels on their objects detailing find spots. In the same way, private collectors are criticised for providing a disservice to the community of the world by removing objects from the public domain, and yet any attempt to publish collections or organise exhibitions is met with opprobrium—witness Lord Renfrew's attack on George Ortiz's exhibition at the Royal Academy, held in the early part of 1994 (see Renfrew in this volume).

We do not, of course, have identical interests with archaeologists. Aesthetic considerations weigh more heavily with us. But who can honestly say that they are not thrilled by the beauty of the Lydian hoard illustrated in part in this volume? Would a pile of coarse-ware sherds (however exciting their context) have had the same effect?

It is important to remember that disciplines such as archaeology exist not in isolation, but to educate all of us, and that for most people, it is beauty that will spark the first interest in the field. We were all shocked by the tale of the Kanakariá mosaics, not only because of the blatant theft but because of the wilful destruction of such beautiful works. I would like to point out also that none of the principals in that sorry affair was an antiquities dealer.

Bona fide dealers often find antiquities departments in source countries to be very uncooperative. I will digress briefly to relate an anecdote detailing what happened to us in one instance. The country concerned will be nameless. We purchased at public auction a small Mycenaean vase, of some importance, which had an excavation number written on it. Painstaking research revealed that it had come from a site excavated just after the Second World War. It further revealed that the excavated objects from this site had been split three ways. The majority had gone to the national museum of the country concerned, a large proportion of the balance to the museum of the country sponsoring the dig, and a small proportion to the archaeologist in charge. We wrote to the authorities concerned, giving all the details of this information, and requesting in which group our piece had ended up. The response was a brief letter telling us that, if we wished to keep our good reputation, we would send the piece back by the next post. This we felt disinclined to do, and wrote again repeating our question. It turned out eventually that our piece had been given to the archaeologist in charge, who in turn had given it to a prominent British diplomat. On that gentleman's death, the piece had been sold by his heirs. The tale is salutary

The Way Ahead

and you will understand that it discouraged us from pursuing such enquiries in the future although, in fact, we have continued to do so. There is then a legitimate trade. It is our belief that by strengthening it and allowing its operation under sensible regulation, we will find the surest way to curtail the looting which we all deplore.

To this end two issues need to be addressed. Firstly, the regulation of the trade within art rich countries must be reviewed. We fully accept the need of countries to protect national treasures, but we do not believe that all objects must remain in their country of origin, any more than we believe that all Georgian brass candlesticks should remain in the UK. Most of you are agreed that the prime archaeological value of an object lies in its context. Once recorded after controlled excavation, why should not duplicate and minor pieces be freely traded? An export tax placed on such goods could raise enough revenue to pay for the proper protection and preservation of unexcavated sites. A proper system of rewards for finders should also operate in all countries.

Secondly, a serious and functioning system of export licences for legitimately held pieces should be in place. This would accord with the spirit of the UNESCO agreement. It has been said that such mechanisms do exist (Boylan, P.J. personal communication, UKIC, Archaeology Section conference on *Conservation and the Anitquities Trade* 1993). But to take the case of Italy, they are little more than a farce: virtually no export licences have been granted since the Second World War, even for pieces which have been in private collections for hundreds of years, and it is rumoured that any claim for reward after a chance find results in immediate tax investigation. As Italy's incredibly complicated tax laws mean that no one's fiscal affairs will bear close examination (from ex-members of the government down as has been recently reported), this effectively debars people from coming forward. In Egypt, the situation is even more parlous. It is reported that if a farmer hands in a find, his land is likely to be removed from cultivation until full excavation has been carried out (a lengthy process which he obviously cannot afford). If he sells it, and is caught, he faces a long period in jail. As a result, we have heard that many pieces are simply being thrown in the Nile.

Finally, a sensible definition of national treasure is required. Blanket definitions are hopeless as was shown by the case of a British MEP Patricia Rawlins, who had her portrait painted in Italy, and then experienced the greatest difficulty in getting an export permit for this 'national treasure'. Even in the UK we have the anomalous position that I could technically be prosecuted if I leave the country with a letter written by my great-grandfather to my grandfather for which I do not have a licence. I was delighted to hear from Carolyn Morrison, former Head of the Cultural Property Unit, Department of National Heritage, that this particular nonsense is to be challenged by the UK government in Brussels.

In an attempt to find a way forward IADAA was formed and the various trade bodies have been in active consultation with the Department of

National Heritage to try and help the smooth running of new EC legislation concerning the movement of works of art. IADAA was formed in London in July 1993 by a concerned group of 39 leading dealers from France, Germany, Great Britain, Israel, Italy (where dealing in antiquities is legal, despite the widely held view to the contrary), the Netherlands, Switzerland and the United States. Among the aims of the organisation, in addition to furthering interest in the study of classical Egyptian and Near Eastern antiquities throughout the world and the exchange of information within the trade, is the encouragement of the protection and preservation of ancient sites by promoting a more liberal and rational approach to the import and export of works of art. It is a widely held misconception that blanket laws forbidding the movement of antiquities help to preserve sites whereas, in fact, they have the opposite effect by driving a good part of the trade underground and encouraging smuggling.

Members of IADAA are expected to follow a strict code of ethics. They have undertaken, to the best of their ability, to make their purchases in good faith and to establish that an object has not been stolen from an excavation, public institution or private property. Members will refuse to dismember and sell separately parts of one complete object and will pay particular attention in the case of architectural fragments and monuments.

We do not feel that intemperate comment and the use of highly emotive language (such as words like 'trafficking' when applied to the legitimate trade) are helpful. We hope that our efforts to find a way forward will meet with a positive response from the archaeological community. We all have an interest, though from different perspectives, in the preservation and understanding of the past. I do not feel that simply to leave things in the ground, where they are subject to decay and damage through economic development or war, or refusing to restore objects which have not got definite provenance, can be seen to help that aim.

Any help that IADAA can give in framing workable laws to discourage illicit trade in works of art and encourage legitimate trade will be readily and enthusiastically given.

Ethics and the Antiquity Trade

Jerome M. Eisenberg

Introduction

In December 1993, I presented this paper at the conference *Conservation and the Antiquities Trade*. I am grateful to the organising committee for giving me this opportunity to speak with two hats on, one as Editor-in-Chief of *Minerva*, the international review of ancient art and technology, which I founded in 1990, the other as one of those much castigated villains, an antiquity dealer and collector. The programme, with its title being 'Ethics and the Antiquity Trade' did indeed appear to be very one-sided: twenty-two speakers with only one representing the antiquities trade—and, in fact, it was my understanding that one of the original two 'trade' speakers invited was going to be a member of the legal staff of an auction house often mentioned at the conference, not even a dealer. Thus I welcomed the occasion to present some of the issues involved from our point of view, no doubt not often heard by many of those in attendance. The publication of this book extends the audience to whom my remarks are addressed.

Unfortunately much negative publicity for the trade has been engendered by the recent review by Ricardo J. Elia, Chairman of the Office of Public Archaeology at Boston University, in the January/February 1993 issue of *Archaeology* of a book by Professor Lord Colin Renfrew: *The Cycladic Spirit: Masterpieces from the Nicholas P Goulandris Collection*. In it, he writes that 'Colin Renfrew has missed an excellent opportunity to educate collectors and art historians about the barbarity of collecting' and he also states that 'The truth is that collectors are the real looters'.

Professor Elia further writes in the May/June 1993 issue of *Archaeology* that 'I have often wondered why the great collectors of ancient art, most of whom are highly educated and socially prominent, are so willing to publicly engage in an activity that is widely known to be mired in criminality, corruption, and sleaziness'. And to top it off, he states that Professor Renfrew 'is doing exactly what art dealers do out of financial self-interest—assume that everything is genuine', because he did not condemn anything in this outstanding collection, now the keystone of the Goulandris Museum in Athens. Dr Patricia Getz-Preziosi, perhaps the world's leading specialist on the expertise of Cycladic idols, confirmed to me recently that in her opinion there are no forgeries in this collection. Perhaps Professor Elia knows better and has hidden his knowledge of Cycladic art from his peers.

ANTIQUITIES Trade or Betrayed

In the past there have been a number of forgery workshops specialising in specific areas such as Cycladic and Anatolian idols, especially in the 1960s, but today's expertise precludes virtually all of these from reaching the public as genuine items. I have seen good reproductions from major museums that are better than most pieces made specifically to defraud.

Dr Elia's assumption that dealers place their blessing on the authenticity of objects rather casually is moderately amusing, since a single questionable or false object in a gallery's stock is enough to damage its reputation and a few such pieces would destroy it; I defy Professor Elia to find one single forgery in my entire inventory or in my past six catalogues, which illustrate nearly 1800 antiquities. Confidentially, there actually was one minor terracotta forgery published, which escaped many critical eyes for over a year... but I leave it for him to discover.

Since my doctoral thesis, written nearly 25 years ago, was on 'Forgery and Fraud in Ancient Art' and since I have written and lectured on this subject for over twenty years, I have put this expertise to good use in assisting my professional colleagues and auction houses in spotting the occasional error in judgement. It has always been of the utmost importance for those in our profession to keep our inventories beyond reproach. A dealer who does not point out a possible forgery in a colleague's stock is doing both of them and the profession a disservice. A dealer's reputation is on the line when he places a piece on display, when he affixes his signature on his expertise or guarantee of authenticity, and especially when his objects are published, whether by him or by others.

For Dr Elia's edification, I might quote from my paper on 'The Aesthetics of the Forger', originally presented at the annual meeting of the Archaeological Institute of America in 1970 and again in *Minerva* in May/June l992: 'It must be emphasised that forgeries are not just created for financial gain, but often to boost the reputation of an excavator or a scholar. It is therefore essential that one should first expertise, *then* categorise.' In other words, determine the authenticity of the object *first*, then attempt to place it in its historical context. This is a 'canon' which I have preached for over twenty years.

Yes, there is a rotten apple or two in nearly every barrel, even antiquity dealers, perhaps even more if we include the notorious Turkey-to-Munich trade, but this is true the world around in every endeavour, even in the hallowed halls of academia. Professor Elia should observe the proceedings of a nominating committee for the entry of an antiquities dealer into an international art fair or its vetting committee confirming the authenticity of the objects to be exhibited. Objects are eliminated quickly for over-restoration, or if the specific restoration is not noted on the label. How many times has Professor Elia actually passed judgement on a work of ancient art?

This is certainly not the first time that Profesor Elia has so vehemently attacked the collecting of antiquities. He wrote a seven page review and attack in the *Journal of Field Archaeology* (Vol.18, 1991) on the first issue

of *Minerva*. In it he makes the astounding supposition that 'Every antiquities dealer and museum curator knows, but few would be willing to admit, that most of the antiquities pictured in *Minerva*'s ads were surely plundered from ancient sites and smuggled out of their countries of origin; others are probably forgeries'. He then goes on to state that 'the antiquities trade has more in common with drug trafficking and organised crime than with most legitimate commercial enterprises'. It is painfully apparent that Professor Elia has simply borrowed upon the style of the exposé articles in the weekly tabloids; any attempt to make a fair assessment of the trade is woefully lacking.

By the way, the assessments of the moneys involved in the antiquities trade are highly exaggerated in the press. The entire annual world-wide turnover in Classical, Egyptian and Near Eastern antiquities is perhaps US$200 to 300 million.

He then writes that he considers the collecting of antiquities to be 'both irresponsible and morally repugnant'. Finally he recommends that 'responsible archaeologists and art historians, however, should think twice before they submit articles to – and thereby validate and endorse – a magazine that promotes an antiquities market that is founded on greed, plunder, and smuggling. And scholarly advertisers… should stop contributing to the subvention of this offensive publication'.

Copies of this 'offensive publication' were distributed at the Conference so that the participants could form their own opinions of its worth!

First of all, Professor Elia has obviously made no study of the antiquities market, otherwise he would realise that there are many tens of thousands of antiquities currently for sale that come from museum sales and deaccessions or private collections formed over the past two hundred years and more.

The total number of objects still in private hands, but acquired before 1973, must number in the hundreds of thousands. They are not, as was stated recently, similar to endangered species. His condemnation of the plundering of ancient sites is shared by any responsible dealer. For, contrary to Geraldine Norman's statement (see Norman in this volume), most of the art market *does* have a serious concern about ethics. As I have written in *Minerva*, a more cooperative attitude by states and their museums in the controlled sale and export of antiquities could perhaps help 'to create a friendlier atmosphere and lessen the polemics of certain "dirt archaeologists" and academics who cannot tolerate the personal possession of such timeless treasures' (*Minerva*, September/October 1993).

Secondly, I am pleased to state that *Minerva* is entering its fifth year of publication and has been honored to have a continuous flow of articles by curators and scholars from the most prestigious museums and universities around the world. In four years of publication we have had but one negative letter from our readers in over 50 countries concerning our editorial neutrality and ethics. Secondly, Professor Elia should consider himself fortunate that I am not litigious, as his comments certainly leave him

open to a lawsuit for libel and defamation of character – of myself and my colleagues. I consider his comments to be typical of those of other extremists and zealots. I feel more pity than anger for those who are unable to approach issues or problems in a rational manner and must make such remarkably uninformed statements in print, based almost solely on the innuendos of such 'sensationalist' authors as Thomas Hoving. Attacking antiquity dealers appears to be Dr Elia's claim to fame.

I must apologise for these lengthy remarks and quotations, but since Professor Elia is a contributor to this volume, it seemed apposite to respond to his former articles and to present the other side of the coin to forestall any further outpouring of venom without a chance of rebuttal.

I also read with great interest, albeit with some amusement, the lengthy article by Dr Christopher Chippindale, and his colleague Dr David Gill, on 'Material and Intellectual Consequences of Esteem for Cycladic Figures' in the October 1993 *American Journal of Archaeology*, of which 19 of 59 pages are devoted to a detailed survey of which of the published Cycladic figurines have proper provenance. Virtually all of this was compiled from other publications, though not in a tabular summary, and one cannot understand their obsession for such an odd compilation which truly serves no purpose, especially in view of today's need for conservation of paper.

We heard from Dr Chippindale that none of the Cycladic idols in the Virginia exhibition has a proper provenance. But he neglected to mention that virtually all of them were acquired by purchase by museums and collectors from dealers in the 1960s onwards. None could have been formally excavated; thus his figures are 'stacked'.

As Dr Chippindale mentioned, they bemoan the fact that of the 1600 or so known Cycladic figurines, only 143 were found in over 1400 archaeologically excavated graves, thus all of the information contained therein has been lost. How many graves must be excavated before we have secured the greatest percentage of information about a prehistoric people with an extremely small population but with some gifted craftsmen. There is, certainly, a point of diminishing return. There *is* no true connection between these primitive though elegant idols and early Greek art.

No one can condone the pillaging of the Keros deposits and the hundreds of other sites, but certainly the Cycladic sculptures would be a very minor chapter in Western art history, probably still ignored by nearly all art historians and archaeologists, if it were not for the passion of a few collectors and museums in the 1960's. Unfortunately these passions ran too high and a few dealers and collectors created two cottage industries, one of pillaging and the other of faking.

Drs Gill and Chippindale quote a letter written by Dr Getz-Preziosi, an authority on the expertise of Cycladic figures, which I would like to share since it reflects an attitude which straddles the often extreme views of some scholars and the rather loose attitudes of others: 'However destructive illicit digging may be for the archaeological record, I believe that the objects

The Way Ahead

found in this way deserve full scholarly attention. Although the circum-stances of their recovery may be illegitimate, the objects themselves are not. They should not be ignored because their discovery context is lost or because they lack the credentials conferred by authorised excavation to assure their authenticity. I regard it as my responsibility to learn as much from the illicitly found material as possible and to share the objects and my ideas about them through publication. This does not mean that I condone the looting of sites. I do not.'

I might remark here that Dr Chippindale not only has no interest in aesthetics, he appears to scorn all forms of abstract or stylised art. Cycladic idols are no more than statistics to him and he denigrates art collecting as well as artists.

It is unjust for Drs Gill and Chippindale to state that most antiquities for sale have never been published, accessioned into a museum, or come to proper scholarly attention. Quite the opposite is true. For example, we have dozens of scholars visiting our main gallery every year. My associate, F. Williamson Price, spends perhaps a day each week corresponding with scholars throughout America and Europe, supplying hundreds of photo-graphs annually for their use in publications. We keep extensive colour photo and negative files of thousands of objects. No request for information remains unanswered. We have published thousands of pieces, as has Dr Cahn in Basle, Mr Puhze in Freiburg, and Mr Ede in London, among others, all of whom issue catalogues regularly.

As Profesor Paul M. Bator has pointed out in *The International Trade in Art* (University of Chicago, 1983): 'The international trade in art is surrounded by emotional and over-simplified debates. There are archae-ologists who insist that antiquities, because they constitute evidence of the past, must always remain chastely invisible until properly excavated, and who rather sanctimoniously dismiss as frivolous the love of such objects for their beauty alone... extreme claims are made on behalf of national patrimony'.

As a dealer in antiquities for nearly 40 years and in ancient coins for over 50 years, I have always tried zealously to comply with all of the American and English government regulations and international treaties to which they are signatories and have never, in all those years, bought antiquities in countries that prohibit their export. Though I have never purchased an antiquity in Greece, nor in Italy since 1971, nor in Egypt since 1966, I am perhaps, unfortunately, at the same time, a hypocrite, since I have no doubt unknowingly bought a number of objects legally from galleries and auction houses throughout Europe, especially in England, that might have once been exported illegally from their country of origin. I refuse to patronise, as do most of my colleagues, certain auction sales in a European city where I am aware that many of the pieces offered have been recently exported from Egypt, no doubt with false papers or perhaps no documents at all.

I have been informed only twice in the past 38 years that objects which

I had purchased legally—once in Rome and once in New York—had been stolen, both in Italy – with a combined value of only about $7500. They were, of course, returned at no expense to the owners, an action, I am sure, any of my colleagues would have taken.

As is the practice with many other dealers, I will not buy any architectural element forming an integral part of a dismembered monument that does not have a proper provenance, in accordance with the regulations of the new EC directives, and based on the UNESCO Convention of 1970.

The illicit trade could, without doubt, be reduced significantly by allowing a limited and carefully controlled legal export of antiquities from those states presently prohibiting their exportation. The sale of duplicate objects of minor value by the member states from their museum depots could bring a significant revenue for their use. It would also deter the production of most of the occasional forgeries that are offered for sale on the market, such as a new workshop of small South Italian vases, examples of which have reached the American market in the past few months.

As I have written several times in *Minerva*, until those states with an abundance of antiquities decide to allow the legal export of objects truly unimportant to a national patrimony there will continue to be an active illicit trade creating artificially high prices.

Smuggling on an international level can be greatly reduced by offering serious rewards to private individuals from the State for antiquities, increasing the value if kept *in situ*. The prohibition of the export of antiquities just increases their values.

Meanwhile, a good percentage of the literally millions of minor objects in museum depots is slowly deteriorating through lack of proper conservation or is stolen due to the lack of adequate security, because proper maintenance and security do not come cheaply.

Although most archaeologists are loath to admit it, probably 99 per cent or more of the objects now being uncovered do not lead to any further significant insight into our past history or knowledge of ancient art. Once catalogued, the sale of these minor objects could secure major funding for conservation, upkeep of the museums, proper security, and ongoing and future excavations. They could also serve as the foundation for acquisitions by new and smaller museums.

In such difficult economic times as we are currently going through, it would not be necessary to lay off personnel and cut down the accessibility of museums to both scholars and the public. Even in such hallowed halls as the Metropolitan Museum of Art, much of the Egyptian and Classical galleries are open only half-days. Yet untold hundreds of millions of dollars in minor ancient objects lie forgotten in storage in museums in Europe and America.

It has been a strict policy of the American Association of Museums that member institutions cannot dispose of any objects except for the purpose of acquiring other items – even if the museum was threatened with its survival. In May of this year a modification was proposed by the Board of

The Way Ahead

Directors that proceeds of the sale of collection objects could also be used towards direct care of the collections. Hopefully this compromise will be passed.

Eastern European museums cannot find the funds to pay their curators a salary of perhaps thirty dollars a month, and are often threatened with closure, yet they are prohibited from selling their duplicates. How many countries are overflowing with excavated objects with which they are unable to cope? When new finds are discovered in Egypt, they are now very often temporarily reburied as the funds for proper excavation are so severely limited.

The importance of countries publicising thefts of antiquities from sites and museums cannot be over-emphasised. If the relevant institutions were to send out photographs or release information on the stolen pieces as soon as the thefts occur it would help immeasurably in cutting down on the number of these occurrences. The well-documented publication of the stolen objects recently from a museum in Palestrina, Italy, no doubt was instrumental in their recovery.

On the other hand, it is extremely difficult to obtain information and photographs of objects stolen from the museums of Greece. In the past year there were several thefts in Greek museums, in Aegina, Paros, Tegea and elsewhere, but repeated requests to the authorities in charge in Athens, including a personal visit by myself to the Minister of Culture and the Head of the Department of Archaeology, brought no information.

Eighteen Cycladic objects were stolen from the Paros Museum last year. Six nearly illegible photos were published by *IFAR Reports* a year later; we are still waiting for copies. The outdoor storage area of the Acropolis Museum was also sacked in 1992. Where is the information on the missing pieces? The head of a Greek archaic kore was apparently stolen from the National Archaeological Museum in Athens six months ago, but I have been unable to obtain specific information about it. It is a surprising attitude from a country so proud of its ancient heritage. Instead of crusading for the return of objects that were taken long before Greece became a modern state, the authorities should devote more time to the protection and conservation of their existing monuments and museums.

As an observer and participant in the fourth session concerning the UNIDROIT *Convention on the (International Return of) Stolen or Illegally Exported Cultural Objects*, which was held in Rome in the autumn of 1993, I am pleased to note that the final draft will now consider the definition of a 'cultural object' to include the defining term 'which is of importance'. I would agree with the delegate from Germany that it would have better served the purpose to use 'outstanding' to avoid a possible mountain of future paperwork through the misapplication of the phrase 'of importance', which can be very loosely interpreted by scholars to include very minor objects only 'of importance' to their own studies and to perhaps virtually no one else. Hopefully the diplomatic conference will redefine 'cultural object' more tightly.

The Antiquities Trade:

a police perspective

Richard Ellis

The law in this country does not differentiate between the trafficking in stolen art, antiques or antiquities. Furthermore, it is no offence to import into this country an article which has been illegally exported from another. So how does this affect 'Law Enforcement' in Great Britain?

Firstly, let us be clear as to the areas of responsibility and 'policing'. The importation and exportation of Fine Art, Antiques and Antiquities is regulated by the Department of National Heritage, and policed by Customs. One of the benefits of conferences such as *Conservation and the Antiquities Trade* is to establish those contacts necessary to ensure good cooperation between interested parties. There is good cooperation between the Department of National Heritage and the Arts and Antiques Squad, however, I will not pretend to be able to talk on behalf of Customs, other than to say that to police effectively the large volume of cargo moving in and out of this country is no easy task.

The role of the Police, then, is to investigate thefts from within our own jurisdiction, and to respond to requests received from foreign countries to locate, and seize property stolen from within their borders, and to assist in the return of such property to the lawful owner.

Investigating thefts from within our own borders does not require further explanation. However, I should mention here a recent investigation undertaken by one of my colleagues, Tony Russell, who mounted a covert operation following information from the British Museum concerning Celtic artifacts. Three people were arrested, and most importantly, the find site was identified.

Of great concern to us, and an area in which we are frequently asked to operate, is in the recovery of antiquities which have surfaced at a London auction room or dealer's gallery. We receive more than 200 requests for assistance a year through Interpol, and, if criminologists are correct, this can only be the tip of an iceberg many times larger. In each case, before we can seize the property, we must prove it to be **stolen**.

This brings us back to the central point about the looting of sites, resulting in no records existing in the country of origin. The standard of proof in a Criminal Court is much higher than that of the Ciat the conference on

222

The Way Ahead

Conservation and the Antiquities Trade in December 1993vil, namely Beyond Reasonable Doubt, as against the Balance of Probabilities. This means that the requesting country **must not only** be able to identify the object, **but also** show when it was stolen. It is not good enough to say it is the type of article found in our country and we have a total ban on exports (as was requested by Italy, concerning the contents of an entire auction catalogue.)

If the first test is passed, and we have identified our items as **stolen**, then the next stage is to investigate their origin. This usually requires some investigation of the vendor, and can lead to the next stumbling block—the effect of international law on title. For example, when a transaction takes place abroad in a country such as Switzerland or Italy, where a purchaser in good faith, *and they all are*, buys title. In Germany, if you buy at auction, you buy title, and an English court in deciding the issue of title will apply the law of the country in which that transaction took place. Therefore if a sale is shown to have taken place in a 'Good Faith' country, if we seize that object, we will be acting unlawfully and could be sued.

If an article passes all the necessary tests, then we will seize it, and assist the loser in its return. You may feel that this process is stacked against the loser, and it is. Most dealers in this country will actually show the point of purchase as being Zurich, to ensure they are covered by the 'International Loophole'. In order to rectify the problem of illicit trading in antiques, I believe, it is to the 'end user' that you must look. Remember, the Police can only enforce the law as it currently stands. We cannot enforce Codes of Conduct, or unsigned conventions.

Consider the collector of Far Eastern antiquities who contacted me one day to inform the Arts and Antiques Squad that he believed some items he was about to be offered had been stolen from a museum. You might think that this deserved a round of applause, but, in effect, what he went on to say was that it was alright as a collector to buy smuggled goods, everyone does it, two-thirds of any auction house catalogue of antiquities is smuggled goods (and I can well believe it) but buying goods stolen from a museum was not on.

Consider the dealer who, when I asked him if the verdict in the Peg Goldberg case would affect his business owing to the 'due diligence' aspect of the case, assured me it would not and went on to say that Peg Goldberg had been stupid. He himself had been offered the mosaics and had only to look in a book in his office to know they were stolen. He didn't buy them, neither did he inform the Police, the Cypriot Government or any other interested party, as to do so would have jeopardised a '**source**'. Had that notification been given, the mosaics could have been prevented from falling into the 'restorer's' hands (see Sease and Thimme in this volume).

Before I go on to outline how I would go about changing the laws, if given the chance, let me tell you about a case that we undertook, that raises serious problems in the enforcement of any international agreement.

We received information that a dealer in London was trafficking in antiquities plundered from Pakistan and Afghanistan. We investigated the dealer, obtained search warrants and seized about 40 Gandharan Buddhas and temple friezes. All had substantial amounts of soil on them from which forensic tests could have been conducted to prove a find site. Most importantly, we found a map marking the find site of the largest piece, and we identified the smugglers, together with their route from Pakistan, via Japan, to the West. We compiled a full report, together with photographs of every object seized, and handed a copy to the Pakistan Embassy in London. We sent another copy direct to the National Museum in Pakistan, and we sent a third copy via Interpol to the Pakistani Police, all with a view to proving that these objects had been stolen from Pakistan, in order that we could prosecute the dealer for dishonestly handling the items within our own jurisdiction.

That was more than 18 months ago, and despite umpteen telephone calls to Pakistan, follow up calls via Interpol, and frequent visits to the Embassy, the sum total of Pakistan's response is a message to the effect that 'smuggling' is an offence in Pakistan. Unable to show the goods to be stolen, and under the threat of civil litigation from the dealer we have had to give all the items back, **not** to Pakistan, but to the dealer. **Why**?—because in Pakistan, this dealer has 'bought off' the police, customs officers and any civil servants who might pose a threat to his trade.

We cannot help those who will not help themselves, and those examples make me agree with Geraldine Norman that bad laws, if not made to be broken, will be broken (see Norman in this volume). Pakistan has a 'total ban on the export of its cultural heritage, yet its officials are so easily bought that it makes a nonsense of their law.

There is one area, however, in which I will come to the defence of that country's Police Force. They are poorly paid, and poorly equipped, and if you are going to ask them to prevent the smuggling of antiquities from Afghanistan which pass through their territory, then you are asking them to commit suicide. Those antiquities are, I am sure, brought out by the same smugglers who bring out the heroin, people so well armed that they were able to stop the Russian Army. The police, should they risk intervening, would be instantly out-gunned and killed. Who can blame them for turning a blind eye?

Pakistan is not the only country with these kinds of problems. India, South America, Africa, the Far East, all face the problem of attempting to police a trade which can easily afford to buy off, or simply eliminate, poorly paid and poorly equipped police officers.

So, from a Law Enforcement standpoint, what can be done?

The example of Turkey in fighting for the return of its heritage items, and winning in the courts, is one way of discouraging an end user—the museum. Carefully considered treaties and legislation, that is enforceable legislation, must be introduced. Bad legislation is useless; look at our own recent Criminal Justice Act, which was so bad and unenforceable, it was

withdrawn almost at once. It must be legislation which will eliminate the middlemen, such as the Edip Tellis of Munich, prevent the collector from purchasing stolen/smuggled items, provide a high chance of detection and conviction, and yet not drive the trade underground (if that is the right word in this context). Blanket bans are bound to do just that. Look at the Drugs Trade—no country permits drug trafficking, yet no country can prevent it. Such a treaty must therefore have an element of realistic reward for finders, and heavy penalties for those who do not register a find.

In that way, countries of origin could regulate the trade, issuing licences for permitted exports, ensuring the thirst of museums and collectors is satisfied and thereby removing the necessity for illicit trade.

Litigation, as with Turkey, will persuade museums to buy only provenanced pieces, and auction houses to sell only provenanced goods. Who knows, the fall in sales may even make them give up the auction of antiquities altogether.

It is a question of balance. An unbalanced treaty, convention or law, will result in theft, smuggling and associated crimes, and result in the uncontrolled haemorrhage of a country's heritage. A balanced law is the only way to regulate the trade effectively, and when that is achieved, police officers like myself will be able to spend more time investigating the fakes and forgeries which flood the market, resulting in many a criminal deception taking place. Who knows, we might even get to the bottom of Michel van Rijn's claim about the Avar Treasure. Seriously, this area of our work can be just as complicated, often requiring expert opinions and forensic tests. It is in this area that we need the professional help of the conservator. I would encourage conservators to contact us if they are in doubt as to the provenance of an object that comes into their hands. We can have enquiries made in the probable country of origin faster than Interpol. Through the establishments of contacts at conferences, together with investigations previously conducted, we have created a network (except in Pakistan) through which a phone call, or fax, will often bring a fast response.

Operating in this way, we actually had a man arrested on Rhodes, by using the facilities of a Greek travel agent liaising directly with the local police. He is now serving eight years for the theft of korans.

We always try to achieve a successful outcome to our investigations, and we welcome enquiries and contacts from all areas of the art and antiquities world, so please do not hesitate to call us. I assure you I will not hesitate to call you.

The Arts and Antiques Squad

John Butler

The Arts and Antiques Squad based at New Scotland Yard is a unit of the International and Organised Crime Branch (SO1). It was first formed in May 1968 as the 'Philatelic Squad' as a response to violent robberies that were occurring against stamp dealers. It became known as the Arts and Antiques Squad in 1976 and retained a manual index of stolen art until 1984 when the system was computerised (description only) and the Squad disbanded. The need for detectives with specialist knowledge of the art world was recognised and the Squad was formed again in April 1989. It then consisted of two Detective Sergeants who received specialist training from auction houses and helpful dealers while using their personal interest in the subject. Those two officers are still employed in the Unit but it has since been re-organised with Detective Inspector Jill McTigue in charge of operations.(See editor's note.)

It now has an intelligence unit confined within an operation arm and has a civilian team of six processing material for the new computerised database. The effect of having an Art and Antiques Squad as part of a larger branch of the Metropolitan Police with an international remit has opened up the use by DI McTigue of a total of forty officers substantially enhancing our ability to react to art crime.

The reason for closure in 1984 has often been questioned but it was simply a re-deployment of resources at a time when violent street crime was a particularly important priority for police. It brings to the surface the whole question of whether art crime is or should be a police priority. The level of attention given varies significantly from Force to Force. In my view a seriously inhibiting factor has been the association of art with minority elitism. To overcome this problem a serious attempt was made by us to change the emphasis of the Unit's work. This was done by deliberately talking about collectable items instead of works of art.

As a side issue we conduct some limited research and by using government and private statistics estimated that about £300 million pounds of collectable items were stolen in 1991. This did not take into account the fact that some large organisations were not insured for theft; nor did about 25 per cent of the country houses carry household insurance. The figure world-wide based on the same statistics could not be less than £3 billion pounds. The figures for subsequent years would show a small increase. It

is important to point out that the theft and transportation of cultural property across state borders accounts for a small but significant proportion of the above quoted statistics.

I joined the Unit in 1991 and it quickly became apparent that the single most important issue facing us was one of identification. Thousands of items of property were being recovered by police only then to be returned to known thieves and receivers of stolen property simply because it could not be identified and owners found for it.

Descriptive databases had proved totally inadequate for the task and, logically, photographic computer images were the way forward. Armed with an idea and no money I successfully persuaded 'First option' a Hampshire based software company to help with the development of such a system.

It is now possible for us to log photographs and stills taken from videos on ACIS (Article, Classification, Identification System) together with the details of the crime. Additionally, footprints, fingerprints and other material that can be scanned into the system can be logged giving us a complete photographic record of all details of the offence. All of this information can of course be researched and suspects and areas targeted for work by operational police teams.

One side effect that was not immediately apparent was the huge amount of work that would eventually have to be done in a field of crime prevention, for without photographs the system is redundant. A 'photograph your valuable' campaign was launched in the media together with an expansion of our work at art and antique fairs, exhibitions and through local community groups.

The Arts and Antiques Squad is pioneering work with a major worldwide computer company in the use of mobile communications for the transference of picture images. When this becomes a reality, and it will be within two years, the ability of officers attending premises containing suspected stolen property to check remotely on this property through a mobile network will have a devastating effect on the ability of thieves to 'fence' their stolen goods.

Turning to the art trade, I think that it is important to state that the majority of dealers, most especially those in the Trade Associations, largely support our work. We have persuaded many of them to provide photographs and provenance with articles when they are sold.

We have not been so successful in the antiquities market where, quite frankly, there are too many items floating about without any checkable background. However, we must not tar all dealers with the same brush and recognise that the trade has a significant role to play in measures that are needed to curtail the theft and dealing in stolen cultural antiquities. In my view it would be almost impossible to make a significant impact upon this problem without the help of some honest and committed dealers. I would like to add that to build on this help requires a sensible and workable set of regulations that the trade could adhere to. Self regulation has proved time and time again to be virtually useless. I would urge cooperation between

conservators and those reputable dealers with the aim of providing trade regulations in a draft form which could then be the subject of consultation and discussion.

The spur to hurry this along could well be the knowledge that in the not too distant future, given the Art and Antiques Squad's strong links across the world, we will be able to exchange information making the identification of stolen antiquities an easy matter. The threat of arrest and prosecution for receiving stolen property and laundering the proceeds of crime should focus the mind of disreputable dealers and discourage them from some of their excesses.

Finally I would like to remind you that the three most important issues in cultural property theft are IDENTIFICATION! IDENTIFICATION! and IDENTIFICATION!

[*Editor's note.* The information given in this paper was correct at the time of submission of the manuscript by John Butler in 1994.]

Thesaurus and the Tracing of Cultural Property

Peter Cannon-Brookes

Conservation and the antiquities trade are on the face of it uneasy bedfellows, and yet their respective spheres of interest overlap substantially and this volume, based on the conference *Conservation and the Antiquities Trade*, provides a major opportunity to examine in context a number of interrelated problems. After reviewing the legal issues, and specific case histories on an international basis, it is possible to turn to the special problems experienced in the United Kingdom today, and finally put forward proposals as to the way ahead.

Theft and unlawful export are problems which the antiquities trade shares with those in art and antiques, but special to it is that of illegal excavation. All too often, the very existence of an artefact—*vide* the Sevso Treasure—is only known to a few before it has already passed through a number of hands and its origins are shrouded in mystery or obfuscation. Consequently, any programme of action intended to address the problems currently posed by the antiquities trade—the conservation of the artefacts themselves, together with the information associated with them, and the protection of the contexts from which they have been removed—depends upon a clear understanding of how that market operates and the possibilities open to those seeking to influence it. Draconian legislation has proved to be largely ineffective, if not actually counter-productive, and even in respect of those states where authoritarian regimes hold sway, the scale of illegal excavation, theft and unlawful export in many of them has increased vastly in recent years.

Consequently, the future lies in using the mechanisms evolved by the market place itself, with minimum legislative intervention, to create a trading environment which finds illegally excavated, stolen and unlawfully exported cultural property less profitable and thus less attractive. The key lies in information, and huge amounts of it, readily accessible to both purchasers and vendors, so as to make the market as transparent as possible. This alone would have the effect of strengthening the separation between legitimate trading and the operations of the black market, but of that more anon.

To be effective, from the viewpoint of the purchaser entering the market and wishing to obtain both good title and value for money, adequate

information has to be available at the point of sale. Under *caveat emptor,* the purchaser without independent sources of information has had little option but to accept in good faith the assurances of the vendor and hope that the latter has himself provided them in good faith as well. However, as the old saying has it: 'There are none as blind as those who do not wish to see', and both parties need much greater information resources if they are independently to exercise the higher standards of diligence embodied in the latest European Community draft directive on restitution of cultural property. This higher standard will apply across the board, to private transactions between individuals as well as to public auction sales, and the wise purchaser will as soon as possible wish to satisfy himself that the vendor has good title to the artefact being offered for sale, and that it has not been illegally excavated, or unlawfully exported.

In the trading community of a free country it is not possible to monitor transactions between individuals without their cooperation, and, in the last resort, even taxes are levied only by consent. The presumption, in respect of the 'black market', has to be that, for planning purposes at least, illegitimate transactions cannot be monitored. Indeed, monitoring can only begin when the artefact and the immediate transactions involving it emerge into the open marketplace. The vendor, almost by definition if the proposed transaction is legitimate, will wish to obtain the best price possible—in the given circumstances—for the artefact, and any willingness to dispose of the artefact privately at a price fixed at substantially less than the market value cannot but raise questions. Under the standards of good faith, the less than scrupulous purchaser can avert his eyes and congratulate himself on a bargain, but under the higher standards of diligence, he is obliged to satisfy himself as to the reasons for that exceptionally low price being asked.

The traditional separation between 'scholarly' collecting and 'amateur' collecting used to be defined on the basis of their respective attitudes to documentation. In the 'scholarly' collection of antiquities, each object is accompanied by precise records as to where it was found and details of its former context, with precedence given to the archaeological dimension rather than the visual attractiveness of any particular artefact. On the other hand, the 'amateur' collector of antiquities was seen to be primarily interested in the visual appearance of the object and totally disinterested in the context from which it had been removed. Notwithstanding the aesthetic pleasure which can undoubtedly be gained from such cultural orphans, they are virtually valueless for scholarly purposes and their removal from their find site without adequate records being made has destroyed much of the scientific value of the find site in the process. Once an artefact and its documentation have parted company they can rarely be reunited, and, in theory at least, the museums adopt the position that the physical preservation of the artefact, together with the corpus of knowledge about it, is the prime responsibility of any institution calling itself a museum.

The Way Ahead

This viewpoint is characteristic of most European museums, which consequently deprecate the use of metal detectors and all forms of 'treasure hunting' because of the appalling damage inflicted on archaeological sites, but it has been difficult to hold the line in the face of the institutional schizophrenia demonstrated by some of the most important museums in the United States of America. These have acquired high profile antiquities as 'specimens of ancient art' with no provenances, etc., and have chosen to ignore their dubious status as archaeological specimens. Setting aside the uncomfortable exposure to fakes and forgeries of all kinds, the purist would claim that an antiquity shorn of its documentation is rarely a 'museum object', no matter how showy or otherwise desirable it might be. The Metropolitan Museum of Art has many reasons to regret past collecting practices in the field of antiquities, but much fewer regrets in respect of the activities of its other departments. Boards of trustees in the United States of America have been shown with uncomfortable clarity the need to rein in ambitious directors and curators, as well as the less scrupulous of their own numbers. The change in attitude of these museums is of crucial importance because, in the final analysis, it is their ability and willingness to pay top-of-the-market prices for antiquities without provenances which funds the market structure extending down to the bulldozer operators in the Lebanon and those with rock-saws in the jungles of the Yucatan. With the adoption of rigorous scholarly standards in those flagship museums one important component in managing the antiquities market is put into place.

Integral to this approach is the creation of a substantial and growing price differential between documented and undocumented artefacts passing through the market. This is very attractive, not least because once that differential has been established and generally recognised, the market itself will police it internally. Just as the contractual relationships between vendors and purchasers increasingly cover the individual artefact with regard to its physical characteristics, condition, etc., its documentation will automatically fall into precisely the same category as soon as it possesses a definable financial value. If the provenance subsequently is proved to be incorrect in an important respect, the purchaser can make a claim on the vendor. An object which once formed part of the collection of a particularly discerning connoisseur carries a premium over the same item when it is a cultural orphan.

The scale of the problem of provenance and other documentation in respect of antiquities is demonstrated by the Sale of Antiquities held by Sotheby's in London, 8 July 1993, though others mounted by different auctioneers would serve equally well to demonstrate the point. Excluding the first 11 lots, which were of books, and two job lots—one of which was a hoard of bronze objects from Thuringia—737 items were on offer in 318 lots. However, every one of the 34 lots with top estimates between £5,000 and £9,999 were offered for sale anonymously, and of those only six provided any information concerning previous ownership and/or whether it

had been published or exhibited publicly prior to the sale. Of the 31 lots with top estimates of £10,000 or above, all but eight were offered for sale anonymously, with ten lots providing information as to previous ownership, while seven of those lots had been published or exhibited publicly prior to the sale. Note should also be made at this juncture of the slightly ingenuous habit of providing a recent appearance in an auction sale as 'Provenance' without any indication as to whether it had been a bought-in lot! The cynical bidder interprets such statements as tantamount to providing a *terminus ante quem* of possible illegal excavation and/or export of the item in question. The fabricating of provenances and other 'documentation' has been prosecuted with both enthusiasm and ingenuity for centuries, at least since the Middle Ages, and any new demand for documentation would be God's gift to the forgers, but large bodies of fake documentation have an uncomfortable habit of rapidly revealing themselves as such, particularly when an appreciable part of the pecuniary value of an individual artefact depends upon it.

Until recently the would-be purchaser had no means of checking the status or provenance of an artefact which had not been fully published in an exhibition or permanent collection catalogue, etc., and most of the effort was put into various schemes for listing stolen and other missing cultural property with the intention that those trading in such goods would be inspired to check their stock against those databases on a regular basis. Interpol publishes some 3,000 notices each year, describing approximately 15,000 items, while by November 1993 the *Art Loss Register* had entered 60,000 missing items into its database and was currently adding some 2,000 additional items per month. These have to be set against the 253,000 recorded art thefts in Italy alone during the two decades between 1970 and 1990, and the explosion of thefts of cultural property in Central and Eastern Europe since 1990, as well as the looting of the Lebanon and areas of the former Yugoslavia.

The legitimate and black markets are inextricably bound up together and, for the reasons noted above, a missing or suspicious artefact can only hope to be identified when it surfaces in the legitimate market. On the other hand, the quickest and most convenient way of laundering a stolen or otherwise illegally acquired artefact is through the system of public auctions where the vendor can adopt various strategies to disguise or conceal his identity. Until recently the victim of theft had no means of checking the millions of items passing through the auction sales, just as the would-be purchaser had no means of checking whether an artefact which was not fully published had passed through the market recently, but with *Thesaurus* an inexpensive but powerful tool is now available to scan virtually every auction sale catalogue in the United Kingdom as it is published, as well as earlier sales stored in the historic database.

The Way Ahead

In 1992 *Thesaurus* scanned and stored approximately 2.5m lots derived from 6,054 auction catalogues issued by 465 auction houses (approximately 40 per cent of those published worldwide), while between I January and 26 November 1993 6,675 auction catalogues had been received and scanned with a total of some 3.3m lots made accessible to subscribers. Earlier in 1993 *Thesaurus* purchased the Leggatt Brothers archive with its runs of over 10,000 annotated catalogues dating from 1836 until 1992, and they will soon be available as part of the historic database. The 35,000 or so more recent auction catalogues already scanned and entered into the database have been available on-line from early in 1994, while all the Leggatt Brothers catalogues will have been scanned and entered, together with their annotations of prices and purchasers, before the end of 1995. However, *Thesaurus* is basically a tool by which any printed matter is scanned, entered into the database and searched against each subscriber's Word Profile, which is made up of Phrases and Keywords. That Word Profile can, at no additional cost to the subscriber, be extremely long and complex, and thus a person wishing to be notified of specific goods appearing in the auction sales has only to prepare the appropriate Word Profile to cover those interests.

Similarly, a person wishing to establish surveillance of the auction market for specific stolen property has only to prepare a Word Profile in respect of those items in order to be informed by fax or by letter of any lots matching any word-string defined in that Profile. Whereas the specialist databases of stolen and missing property list only them and invite persons to check items against it, *Thesaurus* provides a powerful tool to check the auction sales for the emergence of missing items into the legitimate market. Rapid response to the loss of cultural property is critical, and with *Thesaurus* the appropriate Word Profile can be prepared and put into place within hours of a loss being discovered, and if a missing item surfaces in an obscure provincial auction room, the victim will receive the relevant information by fax or post within a day or so of the publication of the catalogue, and while that item is still in the physical possession of the auction room. Furthermore, the victim can 'post' in the Thesaurus current database—without disclosing his identity, if so desired, but quoting a P.O. Box number—a schedule of the missing items, thereby automatically alerting all those subscribers whose Word Profiles match with the missing items listed. Those subscribers are precisely the people to whom the missing property is likely to be offered, but it should be emphasised that throughout all these information exchange processes both the identity and the Word Profile of each subscriber remains entirely confidential, and that the latter can be updated at will without incurring additional charges.

In their information requirements, the academic and commercial worlds share a much larger community of interest than is often recognised, and the cultural property market is not only concerned with the problems stemming from stolen and smuggled artefacts. *Thesaurus* is dedicated to providing a neutral information forum which caters for much more broadly-

based information requirements and it was set up as a computer-based tool intended to facilitate the development of profitable commercial enterprises. The identification of stolen and smuggled cultural property is only one component and, apart from making available auction sales information to subscribers, selected by means of their individual Word Profiles, the system allows those subscribers to tap into an ever-growing range of other information relevant to their individual interests. *Thesaurus* is committed to a policy of broadening the range of the information sources being scanned and entered into the database, and thus establishes a dynamic relationship with its subscribers who are encouraged to update their Word Profiles to reflect both changes in their individual information requirements and the new resources being made available to them.

No single tool can hope to monitor more than part of the huge flow of cultural property through the market each year, but in targetting the auction market it is essential that the tool chosen is appropriate for the job—neither a sledgehammer to crack a nut, nor a pin to goad an elephant! All too many information gathering and distributing mechanisms have in the past been set up with sublime disregard for the scale of the information flow requirements involved for full operation. *Thesaurus*, however, has been designed from the outset to be able to handle many millions of items each year through its current database, before downloading into its historic database where they continue to remain readily accessible.

Protecting Ireland's
Archaeological Heritage

Eamonn P. Kelly

Although Ireland cannot be regarded as a major importer of art and antiquities, the Irish authorities are willing to play their part, fully, in international efforts to counter the illicit trade in such works. However, the main emphasis is placed on effective protection of the national patrimony.

Antiquities legislation in the Republic of Ireland is very different to that which obtains in England, Wales and Scotland. The law in Northern Ireland is closer to that in the Republic but there are important differences, especially in relation to title. In the Republic of Ireland, since 1930, the *National Monuments Act*, has regulated, by licence, the excavation, export and conservation of all archaeological objects. It also requires that all finds of archaeological objects, casual or otherwise, be reported to the National Museum. The Act was amended in 1954, partly in response to the illegal export of an eighth century reliquary, known as the Emly Shrine, which was acquired by the Museum of Fine Arts, Boston, USA.

The introduction of cheap metal detectors, during the 1970s, introduced a new situation. The law did not prohibit the use of the devices to *search* for objects, although a licence was needed in order to *dig* for archaeological objects thus found. However, the fact that offenders faced a fine of only £10 encouraged people to ignore the law and made enforcement difficult. There is evidence that many metal detecting enthusiasts adhered, initially, to a self-imposed code of practice, which required that archaeological sites be avoided and finds of historical interest be reported. By 1980 this trend had changed and it became clear to the National Museum authorities that most metal detected finds were being located on archaeological sites.

The discovery of a hoard of early church treasure at Derrynaflan, Co. Tipperary, in 1980, accelerated this trend and popularised metal detecting. Of eighth and ninth centuries AD date, the hoard consisted of a chalice, paten, strainer and bronze basin. It was uncovered by a man and his son, using a metal detector, within a large monastic enclosure, a portion of which was a protected National Monument. A finders reward, offered by the State, was rejected as insufficient and the finders embarked on legal proceedings

to secure the return of the find. In July, 1986 the High Court ruled that the find, or its value (IR£5.5m), should be returned to the finders. The State appealed to the Supreme Court, which delivered its judgement in December, 1987. The treasure was declared to be State property and the finders received a reward of £50,000. (In an earlier settlement with the State, the two landowners had accepted payment of £25,000 each.) The ruling extended the State's ownership to include all antiquities of national importance, where the true owner (the person who lost or deposited the object, or their heir) was not known. Effectively this meant that all archaeological objects found within the jurisdiction became State property. The Supreme Court laid down guidelines on the payment of finder's rewards and dealt with the relative merits of claims by landowners and finders.

By the mid 1980s, although it was realised that treasure hunting had become a lucrative business, the official response remained uncoordinated. Throughout the early 1980s the National Museum of Ireland acquired metal-detected finds, often via middlemen and most appeared to have been found on archaeological sites. The site of a crannóg or lake dwelling in a dried-out lake at Newtownlow, Co. Westmeath produced a large number of early medieval finds which included a silver inlaid bronze plaque and an elaborate whetstone of 10th or 11th century date. The whetstone, although much later in date, may be related to the sceptre found in the Sutton Hoo burial.

Elaborate mounts from the door of an early Christian monastery were found at Donore, Co. Meath. Other important finds included a bronze bowl of 1st century BC date found containing a cremation burial within a hillfort at Fore, Co. Westmeath and a decorated bronze mount, possibly a book cover, from the monastery of Inchbofin, Lough Ree, Co Westmeath.

During 1984 the illegal excavation of Staad Abbey, Co. Sligo resulted in the first successful prosecution of a metal detecting enthusiast. The culprit, Mr. Patrick Davis from Co. Dublin, was fined the maximum £10, with £250 costs. Staad Abbey overlooks Streedagh Strand where three Spanish Armada ships were wrecked in 1588. During 1993 the Irish state was involved in legal proceedings, in which it contested the claims of a diving group to be salvors in possession of the wrecks.[1]

Investigations revealed that there were a number of treasure hunting groups active, most notably in the midlands, where the wealthiest sites are located. The favourite sites to be targetted were crannógs. Many of the objects located on such sites lay underwater, either because of erosion of the sites or because objects had been lost in the water in antiquity. In order to recover these the treasure hunters had trained as divers. Some travelled abroad for training, to ensure that there was no record, in Ireland, of their diving abilities.

Among the important crannóg finds to be recovered were a hoard of 16th century gold and silver coins and a gold ring found on Cherry Island, Lough Ennell, Co. Westmeath and five Viking Age ingots, weighing nearly seven pounds each, from Rocky Island, Lough Ennell. A huge hoard of

The Way Ahead

Viking Age silver ingots, having a total weight of sixty pounds were found at Carrick, Lough Ennell. Although the Carrick hoard was not metal detected, some of the ingots were taken illegally to Belgium from where they were recovered subsequently. Three Viking age hoards of silver were found on Big Island, Lough Ennell. These included ingots weighing more than one pound each, similar to those found at Carrick, as well as hack silver and coins. There were about two dozen silver coins in one of the hoards including Anglo-Saxon, Carolingian and Cufic coins. An attempt to export the coins and hack silver to the United Kingdom was blocked by the National Museum and Garda authorities. Hoards of Anglo-Saxon, Viking and Cufic coins are common on crannógs, one such hoard from a crannóg in Lough Lene, Co. Westmeath was recovered from a number of sources in Britain and Ireland. Containing Hiberno-Norse and Anglo-Saxon coins, the Lough Lene hoard had been broken up and sold in London. An important Anglo-Saxon coin hoard from a crannóg in Bishops Lough was also recovered from both an Irish dealer and the London coin market to which some of the coins had been exported illegally.

A crannóg in Lough Derravarragh, Co. Westmeath yielded large numbers of valuable finds including an enamelled bronze plaque from an Early Christian shrine and Viking bracelets.

Among the many thousand other crannóg finds recovered, subsequently, by the authorities, were an elaborate 8th century bronze and silver bucket from Clooneenbaun, Co. Roscommon; an 8th century silver chalice and paten from Lough Kinale, Co. Longford; a silver brooch with gold filigree panels from Rinn Lough, Co. Leitrim; decorated bronze plaques, believed to be harness mounts, found in Templehouse Lake, Co. Sligo; a twelfth century bell from Rockville, Co. Roscommon and a late medieval pectoral cross from Tristernagh, Co. Westmeath.

A hoard of hack silver from Lough Kinale, which was illegally exported to Australia, was recovered some years later as were two Viking silver bracelets from Rathmoley, Co. Tipperary, which, though not treasure hunted, had been exported without application having been made for an export licence. In the same category as the bracelets were two gold-covered Late Bronze Age bullae, found within a ceramic vessel at Annaghbeg or Monasteredan, Co. Sligo and a bronze cauldron, believed to be from Co. Clare. The bullae and cauldron had been offered for sale in London.

Ancient river fords were another favourite target of treasure hunters. At one such site on the river Shannon near Athlone a four-man gang used a moveable rope grid, 10,000 square meters in area, to assist them search for antiquities. Hundreds of prehistoric bronze weapons as well as objects of later date were recovered from this and other ford sites. Among the most important was a large bronze shield dating to the 8th century BC and the mounts for an elaborate saddle of early 7th century date, both found near Athlone.

Elsewhere, there were groups searching monuments located, mainly, on farmland, who, in order to avoid detection, operated, usually, at night

(so-called nighthawk gangs). One such gang, which was operated along military lines, targetted sites situated mainly in Leinster. During a night-time search of an Early Christian site at Hurdlestown, Co. Meath the gang were interrupted by the police. However, due to the fact that they were wearing camouflage gear, the looters avoided detection despite efforts by the police to locate them using a vehicle-mounted searchlight.

Some very important finds have been recovered by the National Museum from nighthawk gangs but for legal reasons these cannot be described. More routine finds included a late medieval jetton mould found on a National Monument at Clonmines, Co. Wexford and the enamelled terminal of an early medieval bracelet found at Carbury, Co. Kildare. While engaged in searches for illegally excavated antiquities the police have recovered photographs of objects which it is believed were sold on the black market.

The treasure hunting groups maintained close contact and swopped intelligence. Regular meetings were held to discuss the strategies they might adopt to counter official actions being taken against them. Black market dealers and private collectors, some of whom were themselves treasure hunters, participated in these activities. The looters were well equipped and had done their research thoroughly. Equipment included sophisticated metal detectors and other remote sensing devices, subaqua gear and boats. To locate archaeological sites, aerial photographs were consulted and, on occasion, treasure hunters undertook their own aerial reconnaissance. Library research was undertaken and most treasure hunters had built up their own reference libraries. One such library was sold some years ago for approximately £30,000. Of particular interest were monuments inventories, which were used as 'hit lists' by the looters. It is ironic that publications designed to assist the planning authorities protect monuments from destruction, came to be abused in this manner. Extensive illegal conservation work, some of it of a surprising standard, was carried out on objects looted from monument sites.

In 1986 the National Museum became aware of the finding of two major pieces of eighth century metalwork. The discoveries proved crucial in that they led to a high level decision being made to take effective action against treasure hunting. The finds were a processional cross, believed to have been found in Tully Lough, Co. Roscommon and a book shrine, found in Lough Kinale, Co. Longford. Illegal export of the Lough Kinale book shrine was considered by the finders but dismissed as unfeasible. Evidence was heard at a court case in Athlone of an attempt to sell the Tully Lough processional cross to the Getty Museum, in California, for $l.75m.

The first step taken by the authorities to counteract the problem was the setting up, towards the end of 1986, of a committee, composed of personnel from the Arts and Culture Section, Department of the Taoiseach (the Prime Minister's Department) and the National Museum of Ireland. It was decided to target not only the treasure hunters but also the black market dealers and antiquities collectors who are key participants in the

illicit trade. Early in 1987 the committee was expanded to include repre-
sentatives from the National Monuments Service, Police Headquarters and
the Chief State Solicitor's Office.

An analysis of the situation determined that progress would need to
be made in a number of areas if a successful outcome was to be achieved.
For operational reasons, it would be unwise to provide details of the precise
steps taken. It must be obvious however that great emphasis was placed
on intelligence gathering and some individuals within the treasure hunting
scene were persuaded to assist. Some of these people placed themselves
in considerable danger. One man was advised by a senior police officer
about his personal safety following a series of threats and what was
believed may have been an attempt to shoot him. Some years earlier
National Museum officials unexpectedly visited a former treasure hunter
whose assistance they required in connection with a police investigation.
In the process, they stumbled upon four Provisional IRA men, recently
escaped from prison in Northern Ireland. One escapee had to be prevailed
upon not to shoot the curators whom he mistook for police officers. This
incident underlined the unexpected dangers which could be encountered
in undertaking this type of work. Although, on a number of occasions the
activities of treasure hunters have overlapped with those of criminals and
paramilitaries, it would be wrong to create the impression that there was a
major involvement in treasure hunting by paramilitary organisations. Nor is
it the case that it was an activity engaged in, mainly, by unemployed
persons seeking to provide a livelihood. Many, if not most, of the top
treasure hunters were reasonably well off and thus able to invest the funds
necessary to purchase the equipment needed such as metal detectors,
subaqua gear, Ordnance Survey maps and books.

In addition to the incident described earlier, National Museum of
Ireland personnel encountered many other problems while engaged in this
work. Substantial bribes were offered as an inducement to assist the
treasure hunters; threats were issued; personal property was vandalised;
blackmail was attempted and a campaign of vilification of certain officials,
was embarked upon.

The involvement of the police at a high level was essential to the
overall success of the effort. The fact that there is a single police force in the
Republic of Ireland is of considerable operational advantage and decisions,
taken at a high level, can be implemented down the line. Since 1987 the
police have been involved in a series of investigations which have led to the
recovery of a large number of treasure-hunted antiquities. This includes an
enamelled mount and a decorated gilt bronze mount found on a monastic
site at Linns, Co. Louth, which were recovered by the police in Drogheda.

Recent joint National Museum and Garda operations have recovered
a large number of antiquities and silver coins found on monument sites, in
respect of which prosecutions are pending. Some of the antiquities in
question were recovered at Dublin airport. In seeking to recover looted or
stolen cultural property which was taken abroad, the Irish police and the

National Museum of Ireland have liaised closely with foreign police forces. There has been successful cooperation with police forces in Britain and with the Royal Ulster Constabulary, as well as with Interpol and the FBI. Some specialised assistance was provided by the Irish Army Ranger Unit which is an elite anti-terrorism force along the lines of the SAS.

The Committee had a major input into new legislation which was enacted in July, 1987. Under the provisions of the new *National Monuments (Amendment) Act, 1987* the use of metal detectors, magnetometers or other electronic detecting devices, to search for archaeological objects, other than by licence, was made illegal. Police powers were included in the act which would enable the police to conduct searches, under warrant, for looted antiquities.

It was not only inland archaeological sites which were the subject of attention by looters. Twenty-six Spanish Armada vessels and many other important historic wrecks are situated around the Irish coast and it was known that some of these had been targetted. Currently the Irish Government is seeking the return of two Tudor cannon removed from a wreck off the Co. Waterford coast and purchased subsequently by the Royal Armouries, Tower of London. A small bronze cannon found by English divers off the Co. Cork coast was returned to Ireland following a tip-off from the Manchester City Museum. The 1987 *National Monuments (Amendment) Act* gave automatic protection to all wrecks over 100 years old.

Anyone wishing to dive on any underwater archaeological site, or historic wreck, must first obtain a licence. This would only allow divers to visit the location: they would not be entitled to remove anything, or otherwise interfere with the site. Penalties for offences under the *National Monuments Act* were increased from £10 to a fine of £50,000 and a year in prison. It was made an offence to promote treasure hunting and this provision effectively banned the sale of certain publications within the jurisdiction.

The question of the ownership of archaeological objects had been resolved by the Supreme Court ruling on the Derrynaflan find. This opened up the route whereby civil actions could be initiated to recover looted property. A number of such actions are in train currently. Another act which has been used effectively is the *Police Property Act*. Under its provisions, a court ruling can be obtained directing that antiquities recovered by the Garda can be handed to the National Museum of Ireland, even in cases where prosecutions have not been taken successfully. In the case of stolen antiques or works of art recovered from criminals, but not identified, the court may direct that the items be sold by public auction and the proceeds given to the State.

The campaign against treasure hunting and the looting of ancient sites generated much publicity, particularly when the recovery of objects from abroad was involved. Many thousands of looted items were recovered in Ireland and material was also recovered from Britain, continental Europe and as far afield as Australia and the United States.

The Way Ahead

Decorated stonework located on numerous early monastic sites is extremely vulnerable and many pieces have been stolen for the illegal antiquities trade. Some of the thefts were by metal detecting treasure hunters. Over a number of years, museum officers and the police recovered decorated stonework stolen from protected monastic sites at Iniscealtra, Co. Clare; Clonmacnoise, Co. Offaly and Carrowntemple, Co. Sligo. The theft of these objects, some of which were destined for illegal export to the United States, resulted in a number of prosecutions. International publicity surrounded the recovery, in 1991, of Early Christian carvings which were offered for sale in the United States. The carvings—decorated and in-scribed Early Christian gravestones and a cross-inscribed pillar stone—had been stolen, by a treasure hunting gang, from an ancient monastery on the island of Inchcleraun, Lough Ree, Co. Longford. The site is a National Monument. The theft was the most ambitious operation known to have been attempted. The main character involved was Peter Kenny, a retired sailor who used his own boat to transport the material to Miami, Florida. From there, Kenny transported them by road to Boston, where he at-tempted a sale to Boston College. Mr. Kenny had first come to the National Museum's attention in 1987 and his activities had been watched closely by the authorities. An elaborate 'sting' operation was mounted by the Terror-ism and Fugitive Squad of the FBI in Boston, assisted by the Irish police and the National Museum of Ireland. After his arrest, it was with great surprise that Peter Kenny learned that Mr. Ed Clarke, the wealthy patron of Boston College, with whom he had sought to negotiate a sale price of $2.5m was, in fact, a senior FBI officer. During questioning, Mr. Kenny admitted that he intended to make a substantial donation from the proceeds to Noraid, an Irish American Republican support group. Simultaneously, a second 'sting' operation was mounted which led to the arrest, in Ireland, of Peter Kenny's associates who were attempting to steal other stone carvings for sale to Boston College. Two men were prosecuted and were fined up to £10,000. A third man, a serving police officer, resigned from the force. The Peter Kenny affair was not an isolated one. Other stolen carvings have been recovered such as a cross-inscribed pillar stone retrieved from Germany. Following a tip off, the attempted export of part of a high cross was blocked and the object was acquired by the National Museum.

Some other aspects of the illegal trade in antiquities should be referred to in passing. Numerous fakes have been manufactured and sold as genuine antiquities. A popular line has been stone carvings which are purported to be of Early Iron Age or Medieval Age. Other forgeries or fakes which have appeared, allegedly as metal detected finds, have included silver Anglo-Saxon coins as well as silver copies of coins of the 16th and 17th century. In two separate cases Egyptian gold earrings were offered for sale as examples of Irish Late Bronze Age ring-money.

In October, 1990, the Taoiseach, Charles Haughey, intervened to ensure the recovery of a Bronze Age gold collar, or *lunula*, known to have been illegally removed from Irish jurisdiction through the treasure hunting

network and offered for sale by Christie's, London. Because the *lunula* had passed through the hands of metal detecting enthusiasts, it was believed that the object had been found by treasure hunters and that it was State property.

However, once it was returned to Ireland detailed examination in the National Museum revealed that the object was one of a number of antiquities stolen from the Limerick City Museum in 1969. The object had been altered, presumably to disguise its origins. Recently the Royal Ulster Constabulary recovered a penannular brooch which was among the objects stolen with the *lunula*. They arrested a man who is a spokesperson for metal detector enthusiasts in Northern Ireland. The RUC also recovered unreported antiquities believed to have been found in recent years within Northern Ireland and antique weapons, the origins of which are being investigated. Police investigations are in train currently to locate the rest of the objects stolen from the Limerick Museum.

There is close cooperation between the state archaeological bodies in Northern Ireland and the Republic of Ireland. A Liaison Committee on Metal Detecting has been in existence for a number of years and representatives of the state archaeological authorities from both jurisdictions have met in Dublin and Belfast to share intelligence and to pursue and coordinate joint policies to counteract the problem of treasure hunting.

Recently, new legislation has been placed before parliament which is designed to seal off any loopholes in the law. The bills in question are the *National Monuments (Amendment) Bill, 1993* and the *Merchant Shipping (Salvage and Wreck) Bill, 1993*. Under the first of these bills the State's ownership of archaeological objects will be expressly established. It will become an offence to trade in unreported antiquities or to withhold information about archaeological discoveries. In certain circumstances the police may, without warrant, sieze equipment used in the course of illegal diving or excavation. Wider protection of monument sites will be provided for and the State will acquire the power to purchase monuments compulsorily. The maximum term of imprisonment for offences will be increased to five years. Under the terms of the *Merchant Shipping Bill*, Receivers of Wreck, on taking possession of any wreck, must notify the Director of the National Museum. Where no owner establishes a claim, the Director, should he decide that any part of the wreck is of historical, archaeological or artistic value, shall inform the Receiver, who will retain it on behalf of the State. Offences under the *Merchant Shipping Bill* may incur a fine not exceeding £10 million and a five year term of imprisonment. Whereas the provisions of these two bills remains to be enacted, it should be pointed out that existing legislation enjoys widespread public support and cross-party political support.

At present it is believed that the campaign against the organised looting of archaeological sites, in the Republic of Ireland, has been largely successful. A great quantity of material has been recovered and is undergoing study. Criminal prosecutions are pending and a number of civil

actions await hearing by the High Court. This success could not have been achieved without the availability of strong protective legislation, which enjoyed public support, backed up by effective action by the authorities. Official government spokesmen have stated the determination of the Irish government to protect the archaeological heritage from looters This determination has been demonstrated by the personal intervention of a number of ministers, including the Prime Minister, to ensure the recovery of stolen or looted objects This strong political commitment opens up the possibility of achieving cooperation with other governments. Such cooperation is vital if the international trade in stolen and looted antiquities is to be tackled effectively.

Note

[1] The results of the Court rulings on the three Spanish Armada vessels found at Streedagh, Co. Sligo are as follows. On 26th July, 1994, in the High Court (Admiralty), Mr. Justice Barr ruled that three Spanish Armada vessels found at Streedagh, Co. Sligo and their contents, were the property of the Irish State. He also ruled that salvage law did not apply to the vessels and that the National Monuments Act was the appropriate body of legislation. These aspects of the ruling were fully in favour of the position adopted by the Irish authorities. However, two other aspects of Mr. Justice Barr's ruling did not find in favour of the State and were the subject of an appeal to the Supreme Court. Mr. Justice Barr criticised the Commissioners of Public Works for their failure to grant an excavation licence to the finders; he ruled that the finders were entitled to their expenses incurred in locating and investigating the wrecks (judged to be £72,000 at a separate High Court sitting). Mr. Justice Barr ruled that the finders were entitled to a generous reward. The State's appeal was successful. On 29th June, 1995 the Supreme Court ruled that the Commissioners of Public Works were correct in refusing an excavation licence as there were no adequate conservation facilities to deal with the finds. The Court also found that no legitimate expectation had been created by the State's actions which would entitle the finders to either a reward or their expenses. The Supreme Court refused to nominate a reward figure on the basis that the payment of a reward was a discretionary matter for the State – although such a reward could be reviewed judicially if it was deemed to be unfair.

Conservators and Unprovenanced Objects:
Preserving the Cultural Heritage or Servicing the Antiquities Trade?

Ricardo J. Elia

Introduction

In this paper the role of experts who offer professional services to dealers, auction houses, and collectors is considered. Since this paper was written for presentation at a conference entitled *Conservation and the Antiquities Trade*, it focuses on the activities of conservators, but it should be understood that conservators are not being singled out because their involvement in the trade is necessarily any more problematic than that of the art historian who writes a catalogue description for the upcoming sale of a Cycladic figure, or of the scientist who authenticates a Mali terracotta by thermoluminescence testing. The conservator is only one type of professional whose work may be promoting, however unintentionally, not the preservation of the world's archaeological and ethnographic heritage, but rather its destruction.

It may seem ironic, even shocking, to assert that conservators—members of a profession devoted to preservation—may be contributing to the destruction of the cultural heritage. The argument in its simplest form may be stated thus. The antiquities market consists, in large part, of trade in unprovenanced cultural objects, most of which are illegally excavated and illegally exported from their countries of origin. Conservators who accept objects from dealers, auction houses, and collectors are more likely than not working on the products of clandestine excavations and smuggling. By conserving, cleaning, and restoring unprovenanced objects the conservator enhances their market value and in some cases authenticates them. These activities facilitate the buying and selling of looted and smuggled objects and promote an increase in market demand, which in turn leads to more looting.

In the following discussion an attempt will be made to explore the relationship between conservators and the antiquities market. Beginning with a brief discussion of the market, and its basic nature and scope, an attempt will be made to demonstrate how conservators who work on

The Way Ahead

unprovenanced cultural objects play an indispensable, if unintentional, role in promoting the commercial value of antiquities and also in cloaking the shady practices of the antiquities trade in a mantle of academic and scientific legitimacy. It is suggested that these effects of the conservator's craft run counter to the fundamental professional and ethical tenets of conservation as espoused by the conservators themselves. Finally, the suggestion of a practical way in which conservators might distance themselves from the most troublesome aspects of the antiquities market as it is currently constituted is tendered.

The Antiquities Market: A Synopsis

The illicit art market is frequently compared to other major international criminal enterprises, especially drug trafficking and gun running. In fact it shares many characteristics with the drug and weapons trades: annual sales in the billions of dollars, 'clandestine deals, codes of silence, smuggling networks, laundered titles, and phony export licenses' (Elia 1991:96). But the comparison breaks down because only the illegal attributes are shared. What makes the art market so remarkable is its transformation of looted artifact into legal art: objects that are illegally acquired and transported out of one country end up being offered for public sale by legal businesses in another.

Those who study the antiquities market, the author included, regularly make the mistake of talking about the 'illicit' market and the 'licit' market as if they were two separate entities, when in fact they are one and the same. That is why the antiquities market is so insidiously successful, and so destructive: archaeological material, ripped out of its context, can be stolen from a people, smuggled into another country, and wind up in a dealer's shop where it will be legally sold. The collector, unknowing or uncaring, relies on the 'reputable dealer' to provide him with material that is clean, both legally and literally; collectors generally do not loot, they rely on dealers to acquire material that has been, as it were, 'pre-looted'.

As in any business where a code of silence regularly serves to mask illegal activity, the art market is easy to characterise in terms of impressions and generalities but difficult to pin down with solid statistics. Thus it is impossible to ascertain accurately the volume of illicit material in the market at any given time or to estimate its commercial value. Still, there is a broad consensus among virtually every group that has studied the question, including government specialists, cultural property experts, archaeologists, museum officials, journalists, and even dealers, that the looting of archaeological sites throughout the world to supply the art market has reached critical proportions.

This fact has been well recognised for over two decades. A major milestone in terms of public and professional awareness, of course, was the 1970 Unesco *Convention on the Means of Prohibiting and Preventing the*

ANTIQUITIES Trade or Betrayed

Illicit Import, Export and Transfer of Ownership of Cultural Property. This convention, now a quarter of a century old, was the culmination of a deliberative process that began at Unesco in 1960. The problem of looting and the art market was also brought to public attention in the 1970s with books like Karl Meyer's *The Plundered Past* (1974) and Bonnie Burnham's *The Art Crisis* (1975).

Unfortunately, by all accounts, the situation is worse now than in the 1970s. Certainly the inflation in art prices and the strategy of collecting art as an investment have done nothing to discourage the market. Today the volume of stolen art is estimated at between $2 – 6 billion per year (Walsh 1991:86). Writing in 1990, Thomas Hoving (1990:119), the former director of the Metropolitan Museum of Art, described the market in ancient art:

> '… the choice of ancient pieces is bigger and better than at any other time in collecting history. The reason is that the tomb robbers and illegal diggers have become more proficient than ever. As for the smugglers of artistic treasures from Turkey, Italy, and Greece, well, the evidence shows that they have become practically unstoppable.'

There is no doubt that the illegally acquired objects that appear on the market have been systematically plundered by looters intent on supplying the demand for antiquities. Recent studies, for example the investigations of the looted Moche tombs in Peru (Nagin, 1990; Kirkpatrick, 1992), have traced in detail the movement of specific antiquities from their original find-spot in the ground to dealer's shop and collector's mantelpiece. Equally telling are the descriptions of looted sites reported by archaeologists throughout the world, images of pitted landscapes and shattered sites that resemble military bombing ranges—empirical evidence of organised commercial destruction on an unprecedented scale: in the Greek islands, an estimated 10,000 to 12,000 Cycladic tombs, perhaps 85 per cent of all the tombs of that culture, rifled to supply marble figures to wealthy collectors (Gill and Chippindale, 1993:625); more than 5,000 looters' pits recorded in the Cara Sucia region of El Salvador, and every known site affected (U.S. Cultural Property Advisory Committee, 1987:7); in the Inland Niger Delta of Mali, virtually every site plundered by work forces organised by local dealers and numbering up to 200 peasants (Chippindale, 1991:7); looting so common in Costa Rica that the looters, for a time, had a legal trade union (Wilson, 1987:123); a majority of recorded sites in Belize plundered, with ceremonial centers hardest hit and archaeologists reporting the discovery of looters' camps with bulldozers and housing for 70 or 80 people (Pendergast and Graham, 1989:52). The list goes on and on with mind-numbing repetitiveness.

How much ancient art being offered by dealers and auction houses has been illegally excavated and illegally exported? Again, accurate figures are impossible to obtain, but the consensus is that an overwhelming percentage of antiquities on the market have been acquired by plunder and

The Way Ahead

smuggling. Bonnie Burnham, in her 1975 book *The Art Crisis*, states that 'illicit excavations supply a large majority of the antiquities on the market— probably around 60 per cent' (Burnham, 1975:95). In 1990, arts corre- spondent Geraldine Norman estimated that 'eighty per cent of all antiquities that come on the market have been illegally excavated and smuggled' *(Independent*[London]): 24 Nov. 1990) And, in a 1993 report in *The Antique Collector*, an expert on art theft stated that most British dealers have sold smuggled art; the report also states, based on figures from Interpol, that an estimated 600 of London's 2,400 art dealers have knowingly handled smuggled art (Roberts, 1993:3).

Thomas Hoving (1988:19) describes the illicit antiquities trade as 'the hottest multinational business on Earth these days... Each year hundreds of thousands of spectacular cultural treasures enter into various art markets, and the numbers are increasing'. Referring to the current market in the United States, he says: 'Deep down, you just know that every antiquity... that you are being offered could not have come from a private collection over fifty years old... There is no way to kid yourself about some things: that almost every antiquity that has arrived in America in the past ten to twenty years has broken the laws of the country from which it came...' (Hoving, 1990:119).

But surely, one might argue, there are reputable dealers who do not deal in looted and smuggled antiquities. Indeed it is the dealers (and their colleagues in the auction houses) who are the key players in the antiquities market. They are the ones that obtain the pieces and make them available to eager collectors. They not only serve the market but also promote, manipulate, and exploit it: the more interest they can generate in collecting, the more business they will do and the higher prices they will obtain for their wares.

Elsewhere the author has argued that, ultimately, the collectors establish the demand for antiquities and must bear responsibility for the looting situation, but it is the dealers who are the ones primarily responsible for the movement of looted and smuggled antiquities (Elia, 1993:64–69). Oscar White Muscarella (1977:159-160) describes the antiquities dealer as 'the middleman between the plunderers and the purchasers... Most dealers, in fact ,work with paid agents and runners who bring them material smuggled... from its country of origin'.

But what of our 'reputable dealer'? According to Muscarella, the definition of an 'honest' or 'reputable dealer' is simply one who will not knowingly sell forgeries. Burnham agrees that the 'reputable dealer' will guarantee authenticity. Both also agree that the definition of a 'reputable dealer' does not include a guarantee that an object has not been illegally excavated or illegally exported (Muscarella, 1977:160; Burnham, 1975:93).

Muscarella (1977:160) says: 'It must be understood that the use of the honorific adjectives mentioned with regard to dealers does not speak to the methods used by the latter to acquire their material, methods that more often than not involve not only the destruction of archaeological monu-

ments, but smuggling and bribery to remove the object from the country of origin.' Burnham came to the same conclusion.

The reason so much illegally excavated and illegally exported material ends up on the art market is because most art-importing countries do not enforce the export legislation of other countries; thus, it is not illegal to import an artifact into England merely because it has broken the cultural heritage and export laws of Greece, for example. This peculiarity of national law in art-importing countries virtually guarantees that buyers and sellers will encounter few, if any, legal obstacles while trading looted and smuggled antiquities. In addition, if the artifact came from a clandestine excavation, the country of origin is not likely even to be aware of its existence, so recovery of the object once it has left the country is nearly impossible.

Antiquities dealers have always relied on this state of affairs and have converted practice into principle, arguing that art-importing nations should not enforce the export laws of nations with broad declarations of ownership of cultural heritage. They believe in the international movement of art but apparently not in international law, which acknowledges a country's sovereign right to own, control, and manage archaeological sites and cultural heritage within its borders. A variety of reasons has been given in defense of disregarding the laws of countries of origin. They range from chauvinistic sentiments such as the notion that developing countries are not reliable custodians of their own patrimony to blatant assertions of self-interest, as exemplified in the *amicus* brief filed in the McClain case by the American Association of Dealers in Ancient, Oriental and Primitive Art, which argued that 'the livelihood of the members of the association will be drastically affected' by a legal decision that would restrict their ability to sell illegally exported art (quoted in Greenfield, 1989:198).

In addition to being protected by the existing legal regimes of art-importing countries, there is one other essential feature of the art trade that ensures the free flow of looted material and protects the dealers from legal action: this is the long tradition in the trade of non-disclosure. Art dealers, auction houses, and many museums that acquire unprovenanced objects steadfastly refuse to disclose the details of art transactions, ostensibly to protect the confidentiality of the seller. In fact this code of silence makes it possible to launder looted antiquities and to cover up their true source by creating fictional pedigrees like the 'old European collection'. More than anything else, non-disclosure is the linchpin of a trade that remains fundamentally unregulated and un-self-regulated. It is a trade where it does not pay to ask too many questions. Albert Elsen (1989:196), referring to the practice of non-disclosure among museums that acquire ancient art, called it 'an archaic, unjustified, and outrageous anomaly'.

The Way Ahead

Conservators and the Antiquities Market

A picture of how looted and smuggled artifacts enter into the legal art trade virtually unimpeded having been sketched, the role of conservators and other experts in this commerce will now be considered. Their role may appear to be very minor: an occasional scientific test here, some minor cleaning there. In fact the involvement of experts often constitutes an absolutely critical aspect of the marketing plan of the dealer. Let us consider a hypothetical sophisticated collector considering the purchase of an antiquity. The collector, knowing the way things work in the trade, is likely to be concerned about three things before being willing to hand over a substantial sum of money. These are first, not whether the material has been looted or not—chances are he can live with looted material—but rather whether he will have good title to the object once he buys it. Second, is it authentic or a forgery?—a reasonable concern, since forgeries are widespread in a trade where dealers are unable, or unwilling, to show proof that the material came out of the ground as opposed to some forger's shop; and third, is the object important in terms of artistic quality?—part of this question involves the answer to another: What is the condition of the object?

Of the three questions on the mind of our potential purchaser, the last two can really be answered only by experts in art history, science, and conservation. Many dealers and auction houses lack sufficient expertise in these areas, and so they often engage the services of outside consultants, preferably those in academia whose credentials and institutional affiliations are likely to inspire public trust and confidence. To our hypothetical buyer, these tests, along with the art historical analyses—all conducted by experts at well-known research laboratories and universities—would surely suffice to put to rest any doubts about the authenticity, quality, or condition of the material.

The work of the conservator who treats antiquities prior to sale may include cleaning, stabilisation, restoration, and authentication of objects. These activities may seem rather innocuous, but a careful consideration of the conservator's task suggests that the conservator plays a direct, and possibly decisive, role in the dealer's ability to market and sell objects of suspicious origin. Conservation is, in fact, the final stage in the laundering process which transforms looted antiquities into art commodities: objects go in dirty, corroded, and broken, and come out clean, shiny, and whole.

Conservators study how objects are made; what technology was employed in their fabrication; how they were used, repaired, and modified in the past, and so forth. Because they work so closely with an object, they frequently obtain substantive evidence regarding the object's authenticity, even if authentication is not part of the services they are being paid to provide. This is especially true when the conservator conducts or commissions specialised analytical tests that date or otherwise characterise an object. For example, in the case of unprovenanced antiquities, dating an

object by radiocarbon or thermoluminescence testing is tantamount to authentication because the date will distinguish forgeries from genuine objects. Thus, conservators frequently provide the dealer with one of the things he needs most: independent confirmation of authenticity.

Cleaning and restoration serve to enhance the appearance—and, ultimately, the marketability – of cultural objects. Removing corrosion, reattaching handles, making precious metals gleam again: these things make objects more beautiful, more desirable, more valuable. Conservation is a way of 'improving the past', to use David Lowenthal's phrase (1985: 278). In some cases, the conservator, by the simple action of cleaning, may in fact be removing evidence of clandestine excavation, perhaps even of the location of the find-spot—evidence that may someday be relevant in a court of law. In the Southwest United States, for example, there have been recent cases where looters were convicted in part because micro-analyses of soil particles adhering to the looted artifacts confirmed that the objects originally came from archaeological sites on federal lands (Monastersky, 1990). Thus, some conservators may find themselves in the uncomfortable position of destroying material evidence of looting—a final bit of literal laundering—while in the employ of an antiquities dealer. If that scenario is not awkward enough, a conservator may also find herself testifying in court as a paid expert witness on behalf of an art dealer who is being sued by a country seeking the return of the object conserved.

Towards a Solution

Conservators, like art historians, tend to be object-oriented; they work on a day-to-day basis with articles of material culture. But the conservation profession as a group professes a concern for the cultural heritage that transcends the individual object. The United Kingdom Institute for Conservation's 'Guidance for Conservation Practice', for example, states that 'the conservator's first responsibility is to posterity'. The code of ethics currently being drafted by the American Institute for Conservation of Historic & Artistic Works (AIC) calls for conservation professionals to be 'governed by an informed respect for the unique significance and character of the cultural property and for the people who created it'; the conservation professional should 'serve as an advocate for cultural property, its preservation, and its appropriate and respectful use'.

The AIC's draft 'Guidelines for Practice' call on the conservator to 'be cognizant of laws and regulations that may have a bearing on professional activity', including those dealing with 'sacred and religious material, excavated objects… and stolen property.' Referring to this guideline, the drafting committee's Reference Document states: 'Conservation professionals should carefully consider the implications of their involvement with cultural property derived from illegal excavation [and] cultural property thought to be stolen…'.

The Way Ahead

It has already been demonstrated that the implications of the conservator's involvement with looted and smuggled cultural property are likely to be of some consequence: enhancing the marketability of the object, by cleaning, conserving, and restoring; confirming the object's authenticity; instilling public confidence in the respectability of the transaction; perhaps even removing traces of illicit excavation. What steps might a prudent and conscientious conservator take in order to avoid direct involvement in the illicit antiquities trade? Is it possible for a conservator to work for the antiquities market without eventually handling looted and smuggled objects?

Considering the realities of the antiquities market, any attempt to answer this question must begin with a basic fact: that all unprovenanced cultural objects currently on the market are tainted with the suspicion that they have been looted and smuggled out of their country of origin. If one is to be honest about the problem, one must assume that unprovenanced objects are the products of illegal excavation and illegal export unless there is documentation that proves otherwise.

Admittedly, this approach is the opposite of the traditional way in which this problem has been treated: normally, objects are assumed to be legal unless there is positive evidence to the contrary. But given the art trade's non-disclosure policy, the old approach simply stacks the deck against the possibility of learning the truth.

For example, in their Code of Practice (1984), members of the United Kingdom's fine art and antiques trade undertake not to deal in material that they 'have reasonable cause to believe' has been illegally excavated or illegally exported. As Brian Cook (1991:533–534) has pointed out, 'reasonable cause' seems to signify, to at least one major auction house, only positive evidence of illegality presented by someone else, and does not imply any obligation 'on the part of the auction house to make inquiries concerning the origin of objects. One must question the sincerity of a code of practice whose terms may be fulfilled by a member's ignorance and inaction. It is like the collector who claimed that he never *knowingly* bought looted antiquities (eg, Chesterman, 1985: 538): the key word is 'knowingly'—if one does not ask one cannot know.

But to return to the matter of 'reasonable cause', it is arguable that under the present circumstances the appearance on the market of *any* cultural object without proper documentation constitutes, *ipso facto*, reasonable cause to assume that the object was illicitly acquired. In that case, there seem to be only a few options available to the conservator who is concerned about participating in the illicit antiquities trade. The most obvious is simply to refuse to work on any antiquities in the hands of dealers, auction houses, and private collectors. There is much to be said for this approach, although it might result in a loss of revenue. For one thing, it would avoid the problem that all professionals have who work with the antiquities market—the possibility that their professional involvement will serve to legitimise and promote the trade.

If complete forbearance appears to be too extreme – or too financially damaging – one might undertake to establish an acceptance policy that allows the conservator to work only on material that is accompanied by documentation that the conservator defines as adequate.

Since 1990, the Services Division of the Institute of Archaeology has had such an acceptance policy in place. Citing its opposition to looting and smuggling, the acceptance policy requires that 'a prospective client must demonstrate the history of any object tendered for examination or treatment... Documentary evidence of ownership for a considerable number of years will be of assistance in indicating that an object does not derive from the recent outburst of illicit activity'.

This policy is a laudable statement: it identifies the problem, has a clear goal, and requires documentation of prospective clients. The effectiveness of its application, however, is difficult to judge because some of the critical language is less than clear. The policy statement says that evidence of ownership 'for a considerable number of years will be of assistance in indicating that an object does not derive from the recent outburst of illicit activity' but gives no sense of what 'a considerable number of years' is or what is meant by 'the recent outburst of illicit activity'. In view of the fact that the looting problem has been a continuous and growing phenomenon for more than two decades, how long should an object be residing in a collection before it is acceptable? Twenty years? Thirty? Fifty?

A preferable alternative would seem to be an acceptance policy derived from the recent resolution of the Committee for Archaeology at Oxford University concerning Mali terracotta artifacts (Inskeep, 1992). Many are familiar with the story of how numerous archaeological sites in Mali have been plundered in recent years in order to acquire terracotta figures for the art market (eg Dembélé and van der Waals, 1991). A film about the looting called *African King* reported that the Oxford University Research Laboratory for Archaeology and the History of Art was engaging in thermoluminescence dating of Mali figures to authenticate the objects. In the journal *Antiquity*, Christopher Chippindale (1991: 8) noted how the TL dating certificate was affecting the prices of these terracottas: figures offered without certificates had pre-sale estimates averaging £175, while those offered with certificates had estimates averaging £1200.

Stung by the public exposure of its involvement in authenticating Mali figures, Oxford passed a resolution pertaining to 'fired clay artefacts of West African origin' (Inskeep, 1992). In the future, the Research Laboratory would restrict its services to the dating of three categories of material, each of which must be fully documented: 1) specimens recovered from legal archaeological excavations, submitted by a responsible person; 2) 'specimens held in the collections of recognised museums (excluding private collections/museums);' and 3) 'specimens which may be the subject of litigation involving the police or public prosecutors' offices'. The Oxford policy, responding to the specific case of looting in Mali, ends with a statement that 'testing/authentication will no longer be carried out for

private individuals, salerooms, or commercial galleries'.

An alternative acceptance policy might be based on the three catego-
ries of allowable material, as specified in the Oxford policy, with some
modification for conservators who may wish to work on antiquities that are
on the market or in private collections without contributing to the illicit
aspects of the trade. As it stands, the Oxford policy would not allow the
conservator to work on material that really has been in old, established
collections, despite the likelihood that it was originally looted or smuggled.
Although the 'old European collection' is all too often used in the trade as
a fictional provenance designed to cover up illicit activity, there are, of
course, many antiquities that actually were acquired over the centuries that
sometimes come onto the market or are submitted for conservation by a
private collector, and it seems unreasonable to exclude these items.

Therefore, the second item of the Oxford resolution, which excludes
'private collections/museums' might be modified to make it include 'speci-
mens held in museums and private collections'. Then all that would remain
would be to choose a date for our new acceptance policy: objects that can
be documented as having been in existing collections before a certain date
would be acceptable for study; objects collected after that date would not.
Perhaps one could use 1970, the date of the Unesco Cultural Property
Convention, since after that date no one could reasonably claim to be
ignorant of the worldwide crisis of looting.

Would such an acceptance policy be effective? That is difficult to say,
and would first depend on whether a majority of conservators would agree
to adopting such a policy. Let the great academic research institutions that
offer conservation services take the lead and see who follows. Assuming
that conservators generally endorsed such a policy, what might be the
result? Would the dealers and auction houses give up their cherished
secrecy and move towards the disclosure of art transactions? Perhaps
some would; others would probably resist to the death. But at least this
proposed acceptance policy has the virtue of striking at the heart of the
matter—the tradition of non-disclosure that serves as a cloak for criminality.
This would not be the only attempt to try to push the art market towards full
disclosure: the draft Unidroit *Convention on the International Return of
Stolen or Illegally Exported Cultural Objects* focuses on the same issue,
and attempts to encourage purchasers to make diligent inquiries to ensure
that they are not buying stolen cultural objects (Prott 1991); and since
purchasers usually buy from dealers, the effect of the convention would be
that purchasers would require greater diligence on the part of the dealers.

Openness and accessibility are basic principles espoused by all
preservation professionals: archaeologists, historians, scientists, and con-
servators all believe in the fundamental principles of integrity of research
and access to data. Secrecy and non-disclosure are as inimical to the
advancement of knowledge about the past as to the present. Only the art
traders and connoisseurs cling to antiquated notions of secrecy and selfish
proprietorship.

The author would like to conclude with a plea to preservation professionals, a plea for responsibility. All those who value the cultural heritage as something other than an economic commodity must realize that if they work indiscriminately for the antiquities market they are legitimising a trade that is causing the destruction of an irreparable part of our past. Those who care about the past are responsible for its protection. They should not, for the price of a consultant's fee, be the agents of its destruction.

References

American Institute for Conservation of Historic and Artistic Works, 1993a. 'Code of ethics and guidelines for practice.' Revised draft, July 1993 *AIC News* (September): 15-17.

1993b. 'Reference document.' Washington, D.C.

Burnham, B., 1975. *The art crisis.* New York: St. Martin's Press.

Chesterman, J., 1991. 'A collector/dealer's view of antiquities.' *Antiquity* 65:538–539.

Chippindale, C., 1991. 'Editorial.' *Antiquity* 65: 6–8.

Code of Practice 1984 'Code of practice for the control of international trading in works of art.' (Signed by members of the United Kingdom fine art and antiques trade, April 1,1984).

Cook, B.F. 1991. 'The archaeologist and the art market: policies and practice.' *Antiquity* 65: 533-537.

Dembélé, M. and van der Waals, J. D., 1991. 'Looting the antiquities of Mali.' *Antiquity* 65:904–5.

Elia, R. J., 1991. 'Popular archaeology and the antiquities market: A review essay.' (Review of *Minerva: The International Review of Ancient Art & Archaeology*). *Journal of Field Archaeology* 18: 95–103. 1993 'A seductive and troubling work.' (Review of Colin Renfrew's *The Cycladic Spirit: Masterpieces from the Nicholas P. Goulandris Collection*). *Archaeology* 46 C Jan./Feb.): 64–9.

Elsen, A., 1989. 'An outrageous anomaly.' *Connoisseur* (Perspective), no. 6: 196.

Gill, D. W. J. and Chippindale, C., 1993. 'Material and intellectual consequences of esteem for Cycladic figures.' *American Journal of Archaeology* 97: 601–659.

Greenfield, J., 1989. *The return of cultural treasures.* Cambridge: Cambridge University Press.

Hoving, T. 1988. 'Hot antiquities.' *Connoisseur* (My Eye), July (1988): 19.

Hoving, T., 1990 'Should you or shouldn't you?' *Connoisseur* (My Eye), January (1990): 119.

Inskeep, R.R. 1992 'Making an honest man of Oxford.' *Antiquity* 66: 114.

Institute of Archaeology 1990 'Policy on the acceptance of objects and materials.' Institute of Archaeology, Services Division, London.

Kirkpatrick, S. D., 1992. *Lords of Sipan: A true story of pre-Inca tombs, archaeology, and crime.* New York: William Morrow.

Lowenthal, D., 1985. *The past is a foreign country.* Cambridge: Cambridge University Press.

Monastersky, R., 1990. 'Fingerprints in the sand: Federal agents use dirty evidence against archaeological thieves.' *Science News* 138 (Dec. 22 & 29): 392–394.

Nagin, C., 1990. 'The Peruvian gold rush: A tale of smugglers, scoundrels, and scholars'. *Art and Antiques* (May): 98 ff.

Norman, Geraldine 1990 *The Independent* (London), Nov. 24.

Pendergast, D.M. and Graham, E.,1989. 'The battle for the Maya past: The effects of international looting and collecting in Belize.' In Phyllis Mauch Messenger, ed., *The ethics of collecting cultural property: Whose culture? Whose property?*, pp. 51–60.

Prott, L. V., 1991. 'Unidroit draft convention focuses on purchasers.' *Museum* 172: 221–224.

Roberts, A., 1993. 'London is smuggling capital of art world.' *The Times* (London), Feb. 24:3.

United Kingdom Institute for Conservation of Historic and Artistic Works, 1987 Guidance for conservation practice.

United States Cultural Property Advisory Committee, 1987 Report of the Cultural Property Advisory Committee to the President and Congress regarding the request of the Republic of El Salvador for U.S. import restrictions under the Convention on Cultural Property Implementation Act. Washington, D.C.: U.S. Information Agency.

Walsh, J., 1991. 'It's a steal.' *Time* (Nov. 25): 86–88.

Wilson, R. L., 1987 *Rescue archeology: Proceedings of the Second New World Conference on Rescue Archeology.* Dallas, Tex.: Southern Methodist University Press.

The Antiquities Trade:

an archaeological conservator's perspective

Kathryn Walker Tubb

Antiquities/archaeological objects/artifacts and their preservation are the archaeological conservator's *raison d'être*. Most conservation work is done in laboratories and tends to be generated by archaeologists. Conservation, therefore, is not usually at the cutting edge but exists in a rarified, secluded environment. Conservation is described using medical terms and by means of medical analogies. Objects are 'examined'; their condition 'diagnosed' using diagnostic tools such as 'X-radiography;' problems are identified as 'bronze disease', or 'warts' and 'treatments' are prescribed. It is hardly surprising then that many conservators regard objects as patients. In that context, how an object comes to be presented for treatment is often regarded as immaterial—in much the same way as an oncologist treats a smoker suffering from lung cancer. The moral imperative is to arrest the deterioration of the object and to endeavour to preserve it for posterity.

Ethics in conservation has always been a question of reversibility of treatments; of not overstepping the bounds between conservation and restoration; and of maintaining full and well-documented records of treatments.

Now, the destruction on a massive scale of a finite resource and the annihilation of the contextual information of whole cultures[1] make it essential for the conservator to re-examine his/her role in this process. Reports in the press to the effect that London is 'the capital of the world for the market in looted antiquities' (Stead, 1990), and that '…antiquities are currently high fashion… . The fashion conveniently ignores the fact that 80% of all antiquities coming on to the market have been illegally excavated and smuggled from their countries of origin' (Norman, 1990b) cannot be ignored. Prott and O'Keefe (1983: 79-80) highlight conservation involvement stating that 'Objects which have been illicitly exported, and frequently have also been stolen or clandestinely excavated, are often sent to another country for restoration… .It is also true that "restorers" are sometimes used to camouflage stolen goods…'.

Active conservation modifies objects. As with excavation, processes are at the same time both destructive and constructive. Removal of concretions and associated dirt runs the risk of obscuring the origin/ provenance of an object.[2] Also, in exposing the detail and enhancing the

interpretability of the object, the value is often raised by increasing the desirability and aesthetic appeal of an artifact (Plates 31 and 32).[3] Conversely, during the examination and conservation of objects, the conservator will reveal pastiches, notice disguised repairs, detect unnatural and fake patinas. In these cases the value of the artifact plummets. These commercial implications are inextricably bound up in exercising conservation procedures.

Archaeological conservators are not merely glorified dusters of objects. Those in the profession do not perceive their role to be solely the providers of a service. Rather, the conservator is ideally placed to initiate and conduct research, since the conservator is likely to spend more time in close communion with an artifact than anyone else. Even draughtsmen scrutinise objects for shorter periods. The archaeological conservator focuses attention on the object, stimulating research by undertaking analysis and by bringing in various experts as required to study the technology involved in its production and to identify and examine associated materials such as food residues, scraps of textile, ancient adhesives and pigments.

The transmission of this information either in the form of a condition report or by incorporation in a treatment record can be used as a certificate of authenticity, again with repercussions in the market. The authentication of objects is in direct contravention of the International Council of Museums *Code of Professional Ethics*. Indeed, the spirit of the code can be violated in this way when an unscrupulous conservator undertakes a commission designed to camouflage authentication activities which involves evaluating the condition of an object including specific analytical studies. Obviously, the identity of the commissioning agent often gives a clue about the ultimate use to which the information will be put. The alternative of suppressing this kind of information is also fraught with peril for the ethical practitioner since it may result in prospective buyers being defrauded. Instead of sustaining the loss of value of such an item, the temptation may exist to sell such a piece on. Another request, which poses ethical problems also, arises, not infrequently, when the owner, be he a curator, dealer or collector, may request that the conservator mask areas of loss/damage or join unassociated pieces.

Client confidentiality, which is often demanded by clients of private conservators for security reasons, is also open to abuse entailing a danger for the conservator of collusion in nefarious practices. The art market cloaks itself in secrecy. The ownership, origins, history and destination of an artifact are rarely divulged even in response to a direct question and are regarded as privileged information. Indeed, asking such questions feels like a breach of etiquette. There is cause for disquiet here not only because much of this information may be germane in diagnosing or assessing the problem, in choosing the best solution or formulating the treatment and in advising on storage and display conditions essential for the long-term preservation of an object, but also because it smacks of corruption.

Archaeological conservation is unlike any other specialism in conservation because archaeological conservators treat objects recovered from archaeological contexts, which is to say, the artifacts have been buried. Clandestinely excavated objects cannot be protected by incorporation into an inventory. Consequently, it is exceedingly difficult for the rightful owner to establish ownership of such material. In the author's experience, the vast majority of antiquities in the trade requiring treatment are the product of clandestine excavation and illegal exportation with the concomitant destruction of the archaeological record. Such objects are diminished and truncated in their archaeological significance, their worth reduced in large part to the aesthetic by this loss of contextual information. Association with this material involves participation in this loss and involves complicity in illegal activities. This situation is totally unacceptable for anyone professing to care about the past, let alone an archaeological conservator dedicated to preserving that past. A distinction is sometimes made between archaeological conservators and objects conservators despite the fact that the training is often shared. This distinction is valid although it need not be hard and fast. Objects conservators are primarily concerned with the decorative arts. They do not share the archaeological conservators' motivating force which is a drive to expand our knowledge of previous civilizations. The intrinsic value of an object is not the object *per se* but what the object tells us about the culture which used it, the way in which it was used, the light it can shed on the development of early technologies and on the customs and lifestyles of a particular population at a particular time.

This question of context cannot be laboured enough and can be illustrated by the example of a bed burial (Plate 33) discovered during the excavation of an Anglo-Saxon cemetery site in Barrington, Cambridgeshire (Malim, 1990). Certain individuals, presumably of great social standing, were interred on a bed. This type of burial is extremely rare in England. Only one other had previously been excavated scientifically and its significance was not recognised until post-excavation study of the small finds (Speake, 1989). In this situation, the difficulty of interpretation lies in the fact that the major part of the bed, being wood, has not survived except where it has been minerally replaced by iron salts in the immediate vicinity of the cleats and eyelets.

Reconstruction of one of these beds, because of the paucity of the remains, is highly skilled and depends on *in situ* accuracy in recording the orientation of these uninspiring pieces of corroded metalwork. Their positions relative to each other plus examination of the mineral replaced organic material associated with them enables specialists to collaborate in recreating the bed which would otherwise be lost. The reconstruction of the Swallowcliffe Down bed is impressive but, because the bed burial was recognised immediately in Barrington, it is hoped that a more faithful reconstruction can be achieved. The physical remains are plainly useless without contextual information. Even so, retrieval of that information requires expertise.

The Way Ahead

Archaeological objects are often utilitarian and are the products of craftsmen and artisans. They will frequently have deteriorated to the point where they seem unrecognisable and yet preserve jewels of information within themselves to the informed observer. Two tassels from the 8th century BC grave of the wife of an Assyrian king discovered by archaeologists at Nimrud illustrate this point (Plate 34). The tassels now look like cylindrical, heavily corroded copper tubes with threads passing through them They are green and rather powdery and appear to have been wrapped with thread or textile. Elizabeth Crowfoot, an expert in textile technology, identified these curious unprepossessing objects immediately and then promptly reproduced one (Crowfoot, forthcoming). The green copper salts colouring the tassels had derived from the copper alloy coffin as it corroded.

Such objects are worthless to looters of sites. As the sites are churned up and destroyed, these objects are lost, together with fragile, sensitive materials that cannot withstand excavation without immediate intervention by a skilled, fully trained conservator. Another artifact from the same context as the tassels referred to above illustrates this point. Ostensibly, it is a dark brown indefinitely-shaped friable mass which is comprised of innumerable layers of folded very finely woven textile (Plate 35). Elizabeth Crowfoot concluded that pronounced ripples observable on the mass indicated loose pleating. Fibres taken from scraps of textile in a better state of preservation were identified as linen for Miss Crowfoot by the author. With this information it is easy to conjure up a diaphanous linen robe perhaps similar to those depicted in the *Funeral Procession of the Vizier Ramose*, a wallpainting in one of the Theban tombs of the Nobles. Caught up in the mass is part of a string of gold, carnelian and gypsum beads which were revealed using X-radiography (Plate 36). Whether the beads were separately strung or constituted an integral part of the textile is still to be determined. Clearly, this glimpse of the past would not have survived the depredations of clandestine excavation.

There can be no justification for this loss. Because of this dealers and collectors usually defend their actions by attacking their critics. Some of the most common arguments are as follows.

Firstly, it is stated that archaeologists frequently do not publish the results of legal excavations which results in similar loss. Such a comment displays ignorance of the processes of archaeology and archaeological publication. The production of a final excavation report, which is to be the definitive statement on a site with all its exhaustive detail, is a lengthy and time-consuming process, and is not something that can be dashed off like a salesroom catalogue. However, nearly every archaeologist publishes interim reports promptly after the respective season's work and, indeed, failure to do so is deplored by the archaeological community also and usually leads to the suspension of financial backing for future seasons or projects. Furthermore, the field notebooks, although not easily accessible to lay people, exist as an archive of raw data.

Secondly, it is stated that objects are poorly housed and cared for by museums. Sadly, this is often true because of limited resources; but, it is equally true that, unless a site is threatened by development, any finds which survive would be better served by being left undisturbed in the equilibrium they have established with their burial environment, an environment which has already enabled them to survive for hundreds if not thousands of years. If an object has been excavated scientifically and studied thoroughly, private ownership may be preferable to public in many cases, provided the object does not disappear from the public domain. Today's collectors are often tomorrow's benefactors. On the other hand, any assumption that private ownership must, of necessity, be equated with good curation and conservation is clearly misplaced also. Collections of a more pedestrian nature assembled by dedicated antiquaries are particularly susceptible to dispersal and neglect, for example, when they are inherited by disinterested descendants.

Thirdly, it is often stated that the country of origin really does not care about its cultural heritage or it would protect it with effective legislation and policing of that legislation. Instead, it is perceived that the local inhabitants collude with the trafficking and that officials are venal. Since, as a general rule, the major source countries are desperately poor, this situation is hardly surprising. Even the major art-importing countries are unable to control looting of sites effectively. Some Anasazi sites in the southwestern United States (Neary, 1991), have been devastated and there is the example of the Icklingham bronzes in this country (see Browning and Sheldon in this volume and Harrington, 1993). In any event, two wrongs do not make a right. Arguments by dealers and collectors (see Ede in this volume and Ortiz, 1992) for less restrictive legislation by the art rich countries should certainly be heard but the total disregard of such legislation smacks of cultural imperialism and is as much to be decried as nationalistic chauvinism. Voracious consumers and high prices fuel the market. The supermarket approach adopted by some dealers (Norman, 1990 a) ensures that even commonplace artifacts are unsafe from this type of depredation.

An academic argument often advanced for studying this looted material is that the repertoire of available legitimate examples is so restricted as to be insufficient for drawing any valid conclusions. Surely, scholars would be better served by conducting their own *bona fide* excavations with the collaboration of the appropriate antiquities departments. This would yield information much more slowly but with the prospect of recovering a fuller understanding of the relevant culture ultimately.

Private conservators who work on antiquities often focus on the object alone and avoid asking questions which they consider to be peripheral and not essential. Others argue that this material *must* be treated (the moral imperative referred to earlier) and that they are in a position to limit the damage which has already occurred. This can be done by retrieving what information remains. This investigative aspect is rarely funded by the dealer

unless it can be used to enhance the value of the object. It is therefore questionable whether a commercial operation could survive while undertaking much of this type of work. Also, any information saved in this way accrues on an *ad hoc* basis in response to the objects submitted and cannot form part of a specific research design. Perhaps the most difficult argument to refute is the contention that, if a reputable fully trained conservator refuses to conserve these artifacts, they will not survive for posterity because they will be treated by an unqualified individual, sometimes 'cowboys' or 'back street restorers' and sometimes amateurs. Such dire concoctions as lemon and salt, zinc and caustic soda, brake fluid and Harpic toilet cleanser are used on bronzes causing untold damage, sowing the seeds of renewed corrosion in the future and possibly dealing the *coup de grâce* to fragile pieces. Suffice it to say that by intervening the object becomes more saleable which encourages the trade and makes the conservator an indirect participant in the destruction of the archaeological record. There are enough artifacts of undisputed provenance awaiting conservation treatment to keep conservators busy for years to come. Sadly, in times of financial constraint, the resources may not be there to employ them to undertake the work.

An easy way for conservators to steer clear of the horns of this dilemma has been to avoid confronting it at all by avoiding working privately. Any queries regarding objects of dubious provenance are referred to those reputable practitioners in the private sphere who have decided that the individual object/antiquity needs reputable treatment irrespective of its past. Since it is not easy to refuse assistance, this alternative serves as a palliative. However, rumour has begun to circulate that conservation departments in museums, archaeological units and universities are being regarded in a new light by managers and policy-makers who are beginning to perceive them as potential money-spinners. The provision of authentication and conservation services may be thrust upon conservation scientists and conservators regardless of scruples, provided, of course, that the price is right. Should these rumours prove to be substantive, conservators may find themselves desperately compromised.

It is clear that the profession needs to ensure that it is not excluded from issues of policy. Conservators must not remain isolated in their laboratories (often tucked away in basements) focussing on artifacts to the exclusion of all else. Rather, conservators must be informed and must inform. Many different disciplines converge in their cultural heritage interests. Communication is vital.

Notes

[1] That this statement is not exaggerated is illustrated by the devastation of the Nok and Jenne-Jeno civilizations of western Africa where systematic mattocking of sites to recover highly prized and priced terracottas of extraordinary power and resonance for sale to collectors is causing catastrophic loss. This was the

subject of a documentary screened as part of Channel 4's *Rear Window* series in which Dr van Beek of Utrecht University (1990) concludes 'Enabling a few to make huge profits at the expense of the national heritage of many destroys world history. We agonize about the destruction of wildlife in these countries but do nothing to help them protect their past.' This problem has also been discussed in the pages of *Antiquity* (Dembélé and van der Waals, 1991 and Inskeep, 1992) which debated the involvement of the Oxford University Research Laboratory in the thermoluminescence dating of Malian terracottas, an issue also addressed by van Beek.

2 Consider the case of the *Tamil Nadu Siva Nataraja* in which the bronze statue had been consigned for conservation, was seized during its treatment and was subsequently sampled. These samples, including adherent soil and detritus which would ordinarily be removed, at least in large part, by the application of accepted conservation procedure were material in the claimant's recovery of the piece (Bennett, 1990 and Renton, 1991).

3 This Anglo-Saxon disc brooch was initially cleaned mechanically using a scalpel. The remaining basic copper salts and cuprite were removed using small quantities of 10% formic acid neutralized with 15% sodium carbonate. Iron salts from the corroded spring mechanism were removed using the di-sodium salt of ethylene diamine tetra-acetic acid in a 5% concentration. It was lightly polished using Duraglit silver wadding polish. Areas exposed to chemicals were washed thoroughly using distilled water and industrial methylated spirits (van der Meulen, 1992).

4 Interestingly, at some stage, the site had received the attentions of a metal detector user whose former presence was revealed in one grave where all that remained of one of a pair of brooches was a green stain caused by the copper corrosion products of the missing artifact which had been absorbed by the bone underlying it. The archaeologists had also invited a local metal detector user to help excavate the site. The collaboration was successful providing the detectorist with first-hand experience of the concerns of the archaeologists. He developed a proprietorial feel for the site also and was protective of it in showing fellow enthusiasts around. Although members of the excavation team took it in turns to sleep on the site, it was never looted during the archaeological season. The site and its excavators also fulfilled another vital service by welcoming parties of schoolchildren on visits. In addition to the areas being excavated, a small photographic exhibition had been set up in a Portakabin adjacent to the site. Finally, conserved objects were displayed at a local National Trust property. The site was being excavated because its existence was threatened by ploughing.

References

Beek, W. van, 1990. 'The African King: An Investigation.' *Rear Window*. Channel 4 Television.

Bennett, W., 'Statue of Siva in Landmark Case for Religious Artefacts.' *Independent,* (London), July 5th 1990.

Crowfoot, E., 1995. 'Textiles from Recent Excavations at Nimrud.' *IRAQ* 57.

The Way Ahead

Dembélé, M. and Waals, J. D. van der, 1991.'Looting the Antiquities of Mali.' *Antiquity* 65: 904-905.

Harrington, S. P. M., 1993. 'British Museum to get Icklingham Bronzes.' *Archaeology* 46: 25-26.

Inskeep, R. R., 1992. 'Making an Honest Man of Oxford: Good News for Mali.' *Antiquity* 66: 114.

Malim, T., 1990. *Barrington Anglo-Saxon Cemetery: Interim Report.* Cambridgeshire County Council.

Meulen, D. van der, 1992. 'Laboratory Number 6431.' unpubl laboratory treatment record, University College London Institute of Archaeology.

Neary, J., 1991. 'Chaco Canyon Under Seige.' *Archaeology* 44: 50-51.

Norman, G., 1990a. 'Antiquities off the Shelf' *Independent*, (London), March 24th.

Norman, G., 1990b. 'Great Sale of the Centuries.' *Independent*, (London), November 24th.

Ortiz, G., 1992. 'The Collector and the Regulation of the Art Market.' Pp 147-158 in *La libre circulation des collections d'objets d'art*, ed. Q. Byrne-Sutton and M-A. Renold (Etudes en Droit de l'Art 3). Zurich.

Prott, L. V. and O'Keefe, P.J., 1983. *National Legal Control of Illicit Traffic in Cultural Property* UNESCO.

Renton, A., 'Siva Figure should be Returned to Temple.' *Independent*, (London), February 14th, 1991.

Speake, G., 1989. *A Saxon Bed Burial on Swallowcliffe Down: Excavation by F. de M. Vatcher.* HBMC Archaeological Report 10. London 1989.

Stead, J., 1990. *Guardian*, (London), July 7th.